DIGITAL
VIDEO
HANDBOOK

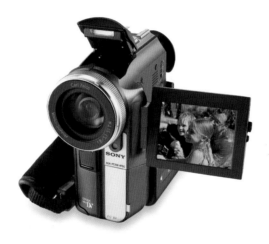

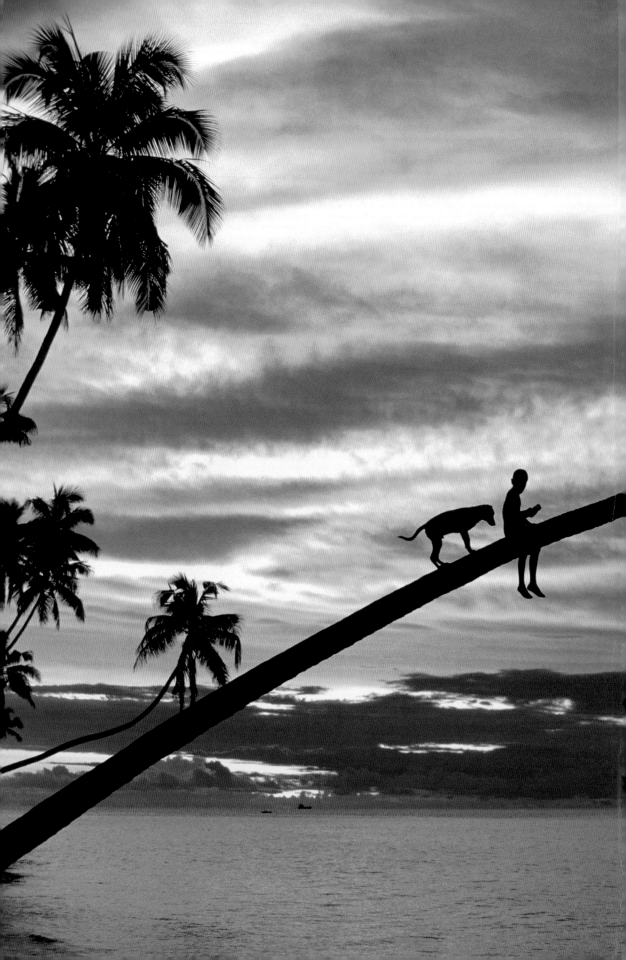

DIGITAL VIDEO HANDBOOK

TOM **ANG**

LONDON, NEW YORK, MUNICH,
MELBOURNE, DELHI

Contents

To Wendy

Project Editor Nicky Munro
Designer Jenisa Patel
Picture Research Carolyn Clerkin
DTP Designer Karen Constanti
Production Controller Jane Rogers

Managing Art Editor Karen Self
Category Publisher Stephanie Jackson
Publishing Manager Linda Martin
Art Director Bryn Walls

Produced on behalf of Dorling Kindersley by
SANDS PUBLISHING SOLUTIONS
4 Jenner Way, Eccles
Aylesford, Kent ME20 7SQ

Project Editors David & Sylvia Tombesi-Walton
Project Art Editor Simon Murrell

First edition published in Great Britain in 2005
by Dorling Kindersley Limited
80 Strand, London WC2R 0RL

A Penguin Company

Copyright © 2005 Dorling Kindersley
Text copyright © 2005 Tom Ang

2 4 6 8 10 9 7 5 3 1

A CIP catalogue record for this book is available
from The British Library

ISBN 1 4053 0636 X

Colour reproduction by GRB Editrice s.r.l., Italy
Printed and bound in China by
R.R. Donnelley Global Inc.

See our complete catalogue at www.dk.com

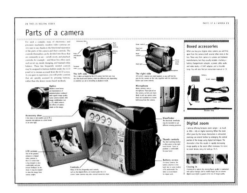

Chapter 2
Camera and sound techniques

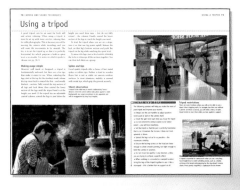

Chapter 3
Understanding and using light

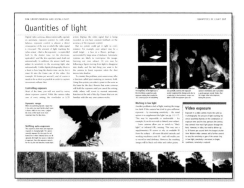

Contents

Chapter 6
Going further with DV

Chapter 7
Advanced video production

References

Introduction

The extraordinary revolution that is digital video can turn your garden into a movie studio, transform your study into an editing suite, and make you a director. Technically, it sounds simple enough. Instead of recording an image frame by frame on to film or tape, we convert moving images into a series of numbers. Yet this one change opens up the entire enterprise of movie-making to anyone with a modern personal computer. Whereas the aspiring movie-maker once needed the support of a highly specialized industrial infrastructure, much of that is now redundant. Movie-makers – and that means you or me – can now go it alone: a single person can shoot broadcast-quality footage, record high-fidelity sound, and edit and post-produce it on their own and at home. And from there, to reach the rest of the Internet-connected world is only the click of a mouse away.

For us, the inconvenient and tiresome craft of editing film frame-by-frame is consigned to history's cutting room. Better still, the formerly very high cost of editing video is now almost vanishingly small. Even better, the once daunting scale of movie distribution – which used to need huge investments – can now be almost lost in the domestic budgets of any family able to afford an Internet connection, and feature-length movies can be reproduced for pennies.

While it is true that open access to technology is a seed-bed for great movie-makers – the teenager who makes gory movies for fun grows up to be the architect of the *Lord of the Rings* trilogy – its significance to the

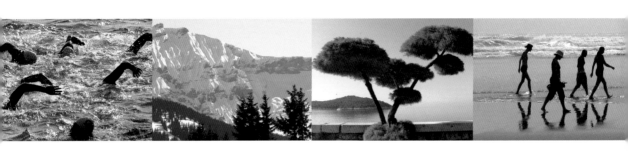

majority of users is even greater. Incidentally, Peter Jackson could not possibly have shot three feature-length films simultaneously, as he did, without lashings of help from digital technology.

Technology in the arts is nothing if it does not help you create new ways of seeing and telling, and today's digital video opens a world in which you can manipulate time, reach into your viewer's hearts, entertain or enthral them, and even horrify or scare them. Above all, digital video gives you the power to create as never before.

In *Digital Video Handbook*, I share with you the thrilling, fast-expanding, and entertaining world of video and movie-making. You can keep it simple, making shorts intended for your friends and family, you can make feature-length movies using actors on location, or you can put together an investigative documentary. Whatever your level of interest, this book offers you all the key information you need to start, giving you a firm foundation for more ambitious projects.

And the best thing is this: you will never have to put up with the movie mogul who declares "My indecision is final!" or the equally infamous "You have my definite maybe."

1
This is digital video

Starting out

Digital video is a magical world in which almost anything goes. Here, the many aspects of digital video are explained, including the different levels of camera and the various formats, as well as how digital video does what it does. This is a road map for navigating your way through a new, creative environment.

Choosing equipment

The first steps towards selecting the right tools for the job are often tentative ones. Finding your way around the camera, familiarizing yourself with its features and learning how to use them are covered, as is the whole range of video accessories. Almost a book within a book, this chapter gives details of specific equipment as well as general information about the functions that you are likely to find most useful.

Computing necessities

Helpful tips on choosing computers and computing accessories are given, and there is a rundown of the different software available. The chapter rounds off with advice on how to set up an editing studio.

Digital video pathways

Digital video has added a host of possibilities to movie-making that were once the province of the professional film studio. The key to this explosion in potential is the partnership between the relatively inexpensive digital video camera and the widespread availability of powerful personal computing. And the icing on this rich cake is the Internet. By adding two elements – movement and sound – to the still image, it is possible to go much further in digital video than in digital photography, in terms of creativity.

Sourcing material

Digital video can secure images from a range of sources. You can shoot new material directly with a digital video camera or work with still digital photographs. If you have old material on analogue video tapes, you can convert this to digital. Footage from broadcasts can also be used, but be sure not to infringe copyright (*see p. 92*). Sound can be sourced at the same time as video taping, or it may be added later, from music or sound-effects CDs, for example.

Subject

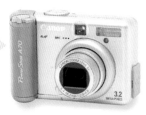

Digital camera
Many digital cameras can record short clips – 30 seconds or longer – of video. You may not be able to zoom or focus during the clip.

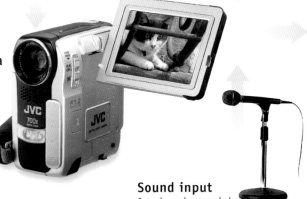

Digital video camera
Modern cameras offer near-professional facilities in increasingly compact form, with good image quality. Ensure the camera is compatible with your computer before purchase.

Sound input
Sound may be recorded separately, either to be used as ambient background noise – or room tone – or for voice-overs, for example.

Analogue video
Breathe new life into your analogue video tapes by converting them into a digital form.

Video capture
Play your analogue tapes through a video-capture device connected to your computer to compress and encode the video ready for editing.

Analogue and digital technology

The development of video is intimately linked to advances in magnetic-tape technology. Images are recorded by varying the magnetic strength of minute portions of the tape. The principle is exactly the same as used in music cassette tapes. To reconstruct the signal on video playback, the variations of magnetic strength are read off, amplified, and used to alter the voltage of the electron guns at the back of a TV set.

With digital video, magnetic tape is still used (some cameras record directly on to DVD; *see p. 30*), but now the magnetic information is limited to just positive or negative. It is easier and more accurate to read positive or negative information, rather than measuring the strength of magnetism. However, this system can record much less information than analogue tape. This is why compression (*see p. 47*) is a vital element of the digital video process.

DVD
With DVD-mastering software, you can create DVDs complete with special audio tracks and extra features.

Domestic TV
A very convenient way to view your own videos is on the family TV screen. You can play them through your DVD player or direct from your computer or video camera.

Internet
Hundreds of hours of video clips are available for download. Equally, you can make your work available for others. You could also set up a web log so that a web site is constantly updated with your recordings.

Processing in the computer
Images captured in your camera or downloaded can be worked on in your computer, allowing you to add titles and edit sound and vision.

Printer
You can print out individual frames from your video footage, but the quality will not be as high as with images taken with a digital camera.

The processing line

Making a digital video can be as straightforward as taking a digital photograph. You can simply point the camera and shoot footage to show events exactly as they happened, without editing or correction. Because you can "project" the results straight on to a television screen by connecting it to your video camera, you do not even need a computer. While this is effortless, it can result in dull viewing. Without planning your video, it is difficult to tell a story and the narrative will be rambling and difficult to follow. It will be the visual equivalent of sending a letter full of mistakes, changes of mind, and crossings out.

The importance of editing

When you record a movie digitally, you turn an analogue process – the response of your camera sensor to changing light, colour, and subject – into a digital form, as data that are recorded on to tape or disc. You also record the sounds of the scene at the same time. You might turn from one scene to another, perhaps wait for some development, then attempt to capture what happens next. In the process, you will sometimes catch the movement a little too early; at other times you may miss the start. The result can be a

jumble of clips, with some that are successful and others that will have missed the moment you were hoping to capture.

Editing is the video equivalent of going through a stack of photographs and putting them in an album or an exhibition. It is important to realize that your movie does not have to show events in the order in which they actually happened – even documentary work does not have to respect the arrow of time. Video editing aims to make the best use of the material that you have recorded (*see Chapter 5, from p. 162*).

The rendering process

The next step in the process of turning your footage into a watchable movie is "rendering". This is the point at which your software program, having been instructed by you of your editing decisions, makes the transitions from scene to scene and turns your video footage into a movie. At the same time, frame by frame, all of the data is transformed into a standard format, such as QuickTime.

The rendering process can be extremely taxing on the computer, requiring a great deal of computing power, and it will produce a very large

Editing

The principle behind video editing is similar to that for forming meaningful and elegant sentences out of a jumble of words. Your raw video footage – like that of any movie-maker, beginner and experienced alike – may be in a random order, such as this sequence (*top right*) of a walk in Pisa, Italy. From the street, to indoors, and out again: there is no narrative. The edited sequence (*below right*), however, moves logically from street level to the first view of a cathedral, before stepping inside for a tour. In addition to simply reordering your footage, editing also gives you control over the pace and rhythm of the visual experience. For example, even if you shot only a few seconds of a detail, in editing you can hold the view for several seconds longer.

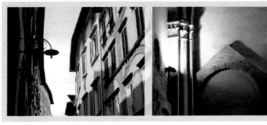

Unedited sequence

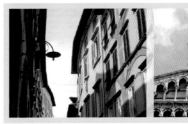

Edited sequence

file – possibly more than 1 GB for 5 minutes of video, for example. It is, therefore, important that your computer is running to its full potential, so shut down any programs you do not need.

From render to print

The term "print" is borrowed from the film industry, where it refers to making the final projection copies of a film from the edited master. In digital video, it is possible to print frames from your rendered movie on to paper. But more often you will want to "print" your movies on to CDs or DVDs. You can even upload your videos to a web site so that they can be viewed online (*see pp. 200–1*).

If you create DVDs of your movies, you can add titles, chapters, and subtitles, just like those on a commercial DVD. This will enable viewers to jump to different parts and be treated to a professional movie experience (*see pp. 194–7*).

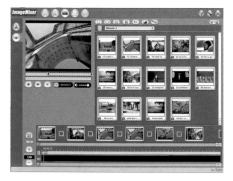

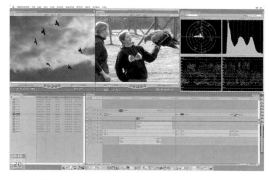

Simple editing

Software such as ImageMixer (*above*) may be bundled with your digital video camera. Although such applications are free, they are very capable: this one will organize albums of pictures, movies, and sound, as well as produce a basic VCD (video CD).

Non-linear editing

Of all the learning curves in digital working, the one for non-linear editing is perhaps the steepest. The terminology is confusing, the technical traps numerous, and the software can be daunting, as the screenshot above shows.

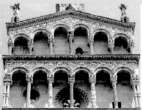
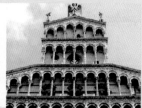

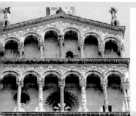

Video media

The variety and mutual incompatibilities of video media and formats may appear chaotic, but they reflect the course of technological development, as well as the competition between manufacturers. In addition, digital video has to work under the shadow of television broadcast standards that were adopted when the most stable time base was the alternating current of the mains power supply. These standards resulted in oddities such as the American NTSC display rate of 30 fps (frames per second) actually being 29.97 fps. Although outdated, the standards still apply.

Medium and format

It is helpful to distinguish between the recording medium being used and the format being written to it. The medium is the physical device – tape, disc, or solid-state memory – that holds your video footage. The format is the way in which the information is coded and organized. In some cases, the format and the medium are effectively the same because only one format is written to the medium – an example is Hi8 tape, used only for analogue video. On the other hand, MiniDV tape, for example, is used for the DV format but can also be used for the professional DVCam format. More blurring of boundaries will occur as solid-state memory – that is, without moving parts – is increasingly used to record MPEG-compressed movies as well as still images.

Consumer media

In the consumer arena, the emphasis is on the most compact form compatible with acceptable quality. Professional media are larger and more robust than consumer media, allowing rougher handling and higher tape speeds.

DV

Originally DVC (for Digital Video Cassette), DV is an international standard for consumer digital video created in 1993 by a group of electronics companies. Known as the DV consortium, the group now includes more than 60 companies. The group defined factors such as the way the image is compressed and cassette sizes. For example, DVC can carry more than 4 hours' worth of tape and measures 125 x 78 x 14.6 mm. The MiniDV cassette holds 1 hour of recording and measures 66 x 48 x 12.2 mm. In this book, we will be working almost wholly with the MiniDV cassette, since that is what most non-professionals use. The DV standard has given rise to two competing professional formats: DVCPro and DVCam.

MicroMV

The MicroMV cassette holds only 70 per cent of the tape of MiniDV, yet it records a full hour by compressing the image in MPEG-2, the same format used for DVD movies. The small cassette allows for extremely compact cameras.

MiniDV
Running for 60 minutes in standard play, MiniDV tape (often simply DV) is similar in size to professional-format DV.

MicroMV
This is the smallest available medium, but limited numbers of new cameras use it. Its future may be limited.

Digital8
The digital version of Hi8 (*right*) offers good quality, but the fact that it is larger than DV makes it less popular.

Digital8

The Digital8 cassette format is something of a hybrid in that it combines digital video compression with Hi8 tapes. However, the tapes are run faster than normal: for PAL, a 90 minute tape will run only 60 minutes; for NTSC, it will run for just 45 minutes (*see p. 22 for more on PAL and NTSC systems*). Digital8 cameras are less expensive than their DV equivalents, but they are also larger. Image quality is equal to that of DV.

Hi8

This is a relatively modern analogue format capable of recording up to 90 minutes of video on a single cassette. Hi8 cameras are less expensive than their digital equivalents. Clean transitions between scenes are possible and sound quality is acceptable, but the overall quality is lower than that of DV.

Solid-state devices

For some, even the diminutive MiniDV tapes are too large. A growing number of digital video cameras are incorporating solid-state memory. This means they have no moving parts, consume very low levels of current, and are very robust. The drawbacks of solid-state media are that they are limited in capacity and relatively costly. However, they can be reused thousands of times. Popular solutions are the SecureDigital, xD, and MemoryStick cards. In situations that require very small cameras (such as restricted spaces) and where limited filming times are acceptable, these are ideal.

Discs

Should you prefer a camera that is less compact than a MiniDV equivalent, you can benefit from using DVD (Digital Versatile Disc) as the video medium. This has the advantage that you can play the disc immediately on your DVD machine or DVD-equipped computer. However, spinning the disc and powering the laser will quickly run down your battery pack. Other media, such as MiniDisc and Super MiniDisc, may be used too, although there may be problems with compatibilities.

Why is digital better?

Digital video is preferable to analogue video for the great majority of recording purposes. Some of the key reasons for this include:

● Resolution of digital video is about double that of VHS or 8 mm tape – that is, 500 lines instead of 250.

● Digital does not suffer colour blur or noise to the same extent as tape, which is very susceptible to these errors because data can spread (cross-talk) on analogue tape; digital offers far cleaner colours.

● Sound on digital video can equal that of CDs, which is vastly superior to VHS sound.

Hi8
This analogue format is superior to VHS and uses a far smaller tape, but its quality is inferior to that of DV.

Solid-state devices
The future lies with devices such as these. New professional systems are tape-free, using large solid-state memory cards.

DVD
One advantage of writing to DVD, as some cameras do, is access to clips without using fast-forward or rewind.

Connecting up

The ability to see an instant replay of a moving image seconds after it has been shot is a stunning display of technology, even more impressive than reviewing digital camera shots. The great majority of modern digital video cameras now have their own high-quality screens. Using this screen, not only can you watch recently shot footage, you can also watch feature films copied from DVD or VHS.

In addition to reviewing your footage on this small screen, you will also want to plug your camera into a TV set to watch your movies, and for this it is crucial that your connections are correct. As you acquire more equipment, you will need more cables, leads, and connectors. Keep them in good condition and keep track of which connector should be plugged into which piece of equipment. The following pages describe the main types of connector and their associated cables. One advantage of digital technology is that the connectors can be made much smaller and the cables more lightweight than in analogue systems.

Composite

A simple jack carries a composite video signal on a single line – that is, the signal components are combined into one and sent to the TV set, which needs a filter to untangle the signal. The

Using connectors and cables

The cost of cables and the fact that they are a possible source of danger mean you should handle with care.
● Label cables as you acquire them: a tie-on plastic tag is preferable to a sticky label.
● Mark the top of a plug so that it matches with the socket on the equipment – that way, you will know which way round it should be inserted.
● If the connector will not fit, do not force it. Some look similar, a pin may be bent, or the plug may be of inferior quality. Check carefully before proceeding.
● Do not bend, fold, or kink interconnects or cables.
● Keep interconnects away from cables carrying the electrical power supply.

vast majority of cameras use a composite socket for the video output. This lead will plug straight into almost any TV set.

S-Video

This is a signal system that carries separate channels or data streams. It can produce very high quality images and is widely used in home cinema set-ups with DVD players.

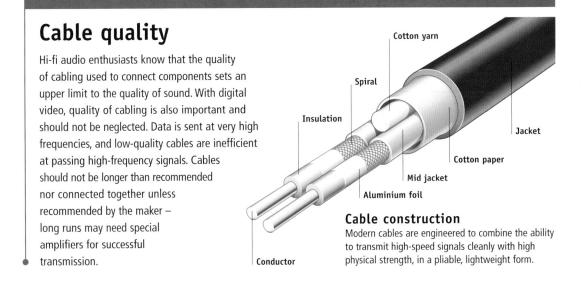

Cable quality

Hi-fi audio enthusiasts know that the quality of cabling used to connect components sets an upper limit to the quality of sound. With digital video, quality of cabling is also important and should not be neglected. Data is sent at very high frequencies, and low-quality cables are inefficient at passing high-frequency signals. Cables should not be longer than recommended nor connected together unless recommended by the maker – long runs may need special amplifiers for successful transmission.

Cotton yarn

Spiral

Insulation

Jacket

Cotton paper

Mid jacket

Aluminium foil

Conductor

Cable construction

Modern cables are engineered to combine the ability to transmit high-speed signals cleanly with high physical strength, in a pliable, lightweight form.

Socket	Plug

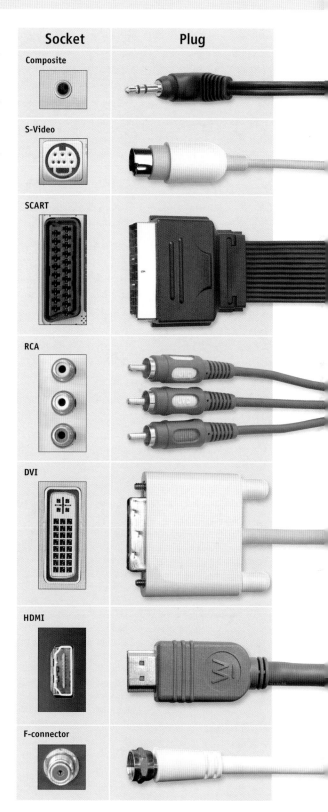

SCART

The SCART (Syndicat des Constructeurs d'Appareils Radiorécepteurs et Téléviseurs) connector is used for combined audio and video signals. It is also known as a Peritel connector or a Euroconnector. It allows different pin configurations for different video devices to be set physically or by software control. Widely used between VCRs (video-cassette recorders) and domestic TV sets, it is a large connector requiring a heavy cable.

RCA

Also known as a cinch connector, the RCA consists of a tip partially surrounded by a semi-rigid sleeve: the tip carries the video or audio in or out, while the sleeve carries the return signal. It is very widely used, thanks to its simple and inexpensive construction. It can be combined in sets – for example, three working together can carry component video signals.

DVI

The Digital Video Interface is designed for use with modern LCD screens that are run from the video card of a computer. It is able to provide very high image quality because the signal is purely digital.

HDMI

High-Definition Multimedia Interface is an all-digital audio/video interface. It can connect any audio/video source, such as a set-top box or DVD player, with an audio or video monitor, such as a digital television (DTV). HDMI supports standard and high-definition video, as well as multichannel digital audio. It is also compatible with the older DVI.

F-connector

This is a termination for coaxial cables that is widely used in cable TV. It consists of a central metal shaft with a metal band that is made to screw or slip on to a corresponding F-jack on the back of a television or VCR.

How digital video works

All video images, during capture and display, are built up, or "drawn", in a scanning process. The image of a frame is built up line by line from, say, the top corner running across to the opposite side, then back again at a slight angle so that the whole screen is covered. For the next frame of video, the process is repeated: each frame is drawn in a sequence of scan lines.

Interlaced video

In the early days of television, the image was created by phosphors that glowed when hit by a beam of electrons; these phosphors glowed (phosphoresced) for only a very short time. It was found that the early scan lines of the image would start to fade before the last lines were drawn, leading to the top of the screen appearing darker than the lower.

The ingenious method of working round this problem is to draw the frame in two steps: the first line is drawn, the next is skipped, the third line is drawn, the fourth is skipped, the fifth is drawn, and so on. This takes half the time to draw than a full frame would because alternate lines are missed.

All the lines that were skipped – that is, all the even-numbered lines – are then drawn in between the existing lines. In this way, although the first lines are fading, it is not so apparent to the viewer because only the early, odd-numbered lines are losing strength, while the early even-numbered lines in between still appear bright. This technique is known as interlacing, and each frame of the video is displayed as two interlaced semiframes.

With modern screens, rapid decay of phosphorescence is less of a problem, and with plasma and LCD screens it is not a problem at all. However, this system is so widely used that it is likely to be with us for quite a while longer.

Progressive-scan video

There is, however, a growing trend towards the progressive-scan image. This simply means that there is no interlacing and that each frame is drawn in its entirety in one pass.

For NTSC, which runs at 30 fps (frames per second), this is highly acceptable. In contrast, the slower frame rate of PAL/SECAM of 25 fps sometimes leads fast action to appear jerky and uneven, because each frame needs slightly longer to draw than it would if the video ran at 30 fps.

However, because the standard cinematographic frame rate is 24 fps and the PAL/SECAM frame rate is closest to it, that is the system that is being adopted as the preferred setting for achieving a filmic look (*see p. 96*).

Interlacing principles
An interlaced video frame is drawn by scanning first one set of lines (say, the red ones), and when the scan reaches the bottom it flies up to the top again – without writing to screen – to draw the next set (shown here in blue).

Odd lines
Here, the first, third, fifth, and other odd-numbered lines have been drawn in the frame of the dog relaxing. Along with the second interlaced frame (*near right*), which is made up of even-numbered lines, it forms the whole image (*far right*).

How video tape works

The roots of video tape go back to the origins of cinematographic film. The most practical form of "talkies" – movies with sound – were those in which the soundtrack was carried on the film together with the image frames. With the advent of video, not only was the sound encoded as magnetic data, but the images too. In digital video, the images are coded as changes in the polarities of patches on the magnetic tape – that is, as positives or negatives. Apart from the image, other data are needed to keep track of the image information and to enable correction of any errors (*see below*). Depending on the tape format, the subcode track may carry signals that control the head as well as carrying error-correction. The video tracks themselves may be subdivided and carry error-correction or timecode data – all of which is read off by the tape head.

Helican scan tape

When you load a video tape into a camera, the whirring and clicking you hear is a mechanism in the camera pulling out some tape and partly wrapping it around a drum that spins very rapidly. The drum leans at an angle and records a slanted track on the tape as it runs past: this method of recording means that more information can be accommodated than if the track went straight across the width. With NTSC, for example, ten tracks cover a frame of video, with different parts used to hold audio and other data.

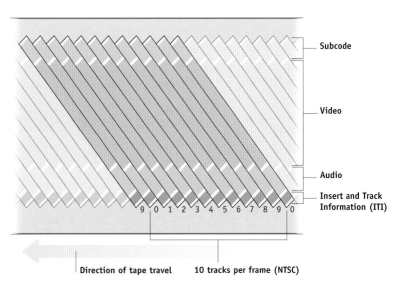

Subcode

Video

Audio

Insert and Track Information (ITI)

9 0 1 2 3 4 5 6 7 8 9 0

Direction of tape travel 10 tracks per frame (NTSC)

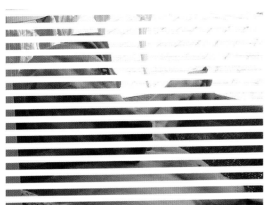

Even lines

The second half of the pair of interlaced frames shows all the lines of the image in between those in the first interlaced frame (*near left*). If the subject moves between these two frames, it can result in artefacts in the image.

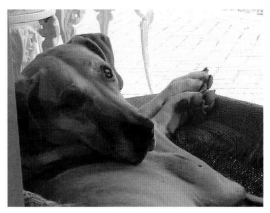

Interlaced result

With a still subject, there is no real difference between a full interlaced pair of frames and a progressive-scan frame. However, with moving subjects, a progressive-scan frame looks more film-like, making it increasingly the preferred mode.

Output formats

Regardless of which format or media you record your movie in, it is independent of the final format on which you show it to an audience. There are machines and software that can turn virtually any recorded format into any other. But if you want viewers to be able to watch your movie on a TV, you must comply with television standards, because digital video must operate within the broadcast-television environment. This is seen most clearly in the screen proportions – a nominal 4:3, or nearly square, landscape derived from domestic TV tubes. Despite the format being referred to as standard, few cameras or screens produce exactly a 4:3 ratio. And to add to the confusion, growing numbers of cameras offer a 16:9 ("widescreen") format, a few producing a true 16:9, and others only simulating it.

Television standards

The TV world is divided in two: the PAL/SECAM zone of Europe and much of the world; and the NTSC zone for North America, Japan and much of South America. NTSC (National Television Systems Committee) provides a more stable image with its frame rate of nearly 30 fps but has less detail, with 525 scan lines, compared to PAL (Phase Alternating Line) and SECAM (Sequential Colour and Memory). The European system offers slightly more detail at 625 lines but is displayed at a slower (and sometimes jerky) frame rate of 25 fps. The two systems also differ in the way they handle colour information.

Widescreen

As standard, digital video cameras shoot to a rectangular format with a 4:3 ratio. As HDTV (high-definition TV) and widescreen TVs become increasingly common, there is more need for cameras to shoot to the widescreen ratio of 16:9. Some cameras can switch between 4:3 and 16:9, but this comes at a cost. Some cameras appear to shoot in widescreen but actually crop off the top and bottom of the image.

4:3 screen ratio (yellow) and 16:9 screen ratio (red)

Broadly speaking, the video covered in this book is coded and compressed according to MPEG protocols and rendered to conform to either PAL/SECAM or NTSC standards.

To avoid the confusion, ensure you are clear about how you expect your movie to be viewed. If the movie is intended for a standard TV, most digital video cameras record in 4:3 (width:height). For a widescreen or HDTV screen, set the camera to 16:9 format if possible. If you want to show your movie on the Web, 4:3 is the safest option.

Unchanging features

A classic TV set from 1954 (*near right*) shows the same basic features as all but the most modern domestic TV sets. These include the 4:3 screen ratio and interlaced frame rates based on the alternating-current cycle of the mains power supply. One major advantage of modern sets (*far right*) is the flat, square screen.

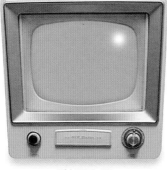

Mid-1950s TV

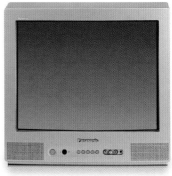

Early 2000s TV

The versions of MPEG

MPEG stands for Motion Picture Experts Group, which was set up by international standards bodies to create a standard for compact video and audio signals. The various MPEG versions are referred to throughout the video and computer world: it is important to match version to use and distribution format. Each version does a different job.

MPEG-1 was designed for use with CD-ROM applications and to accord with CD standards. It is the format for VCD, and the quality is visibly below that of VHS, despite being digital.

MPEG-2 was introduced to code the interlaced images normal to television. It is used for DVD. When you convert DV footage to MPEG-2, it is usually recommended that you convert with "variable bit rate". This offers higher quality because the software assigns more data to complicated or quickly changing frames (*see below*), but you will fit less footage on a disc.

MPEG-3, created for HD usage, was abandoned when existing standards were deemed suitable.

MP3 is one of the layers of the MPEG-1 standard (the others being the system and video). It is widely used for compressed digital music.

MPEG-4 is a highly complex standard that supports video and sound as well as 3D objects, text, and sprites (animated graphics). Based on the QuickTime format, MPEG-4's sophisticated compression technology means that its files are smaller than other MPEGs. The music layer provides CD-quality sound.

How MPEG works

The MPEG standard was introduced in 1991 as a way of digitally representing moving images derived from film, television, or video. It works by first pre-processing to remove non-essential data. Next, motion compensation scans "macro blocks" within each video frame to spot those that will not change in position in the next frame, as well as any "predictor blocks", which will change. This saves on transmitting redundant data from one frame to the next. Following this, the data are treated mathematically to save space. MPEG defines three types of frames: intraframes are references used to create predictor frames, while bidirectional frames use data from frames on either side, according to which is better. The widespread use of digital video would not be possible without the reduction in file sizes through MPEG compression.

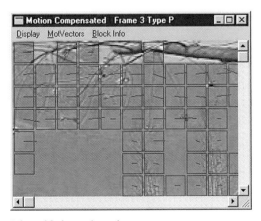

Unchanging blocks
In this frame, which shows a tree in a field, blocks in the frame that are unchanged from the previous frame are represented in grey in PixelTools Expert-1. The tree is not greyed out because it moves in the next frame.

Identifying the changes
The next step of compression is to identify the changes. In each block shown enlarged here, the pixels that offer the best match to the next frame – the motion vectors – are shown as short blue lines: these are noted and used to construct the next frame.

Parts of a camera

For such a complex mass of electronics and precision machinery, modern video cameras are very easy to use, thanks to the functional separation of the parts of the camera and their controls. The controls themselves can be divided into those that are constantly in use – on/off, zoom, and playback controls, for example – and those less often used, such as set-up, mode changing, and manual white balance. These less frequently needed controls may be assigned to buttons hidden under the LCD panel or to menus accessed from the LCD screen. As you gain in experience, you will prefer controls that are quickly accessed by pressing buttons, rather than the slower menu-based methods.

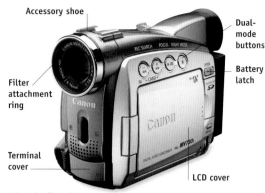

Accessory shoe

Dual-mode buttons

Battery latch

Filter attachment ring

Terminal cover

LCD cover

The left side
This is taken up largely by the LCD screen, but here you may also find dual-mode buttons, which do different jobs depending on whether you are in recording or playback mode.

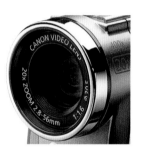

Optics
Modern zoom lenses are masterpieces of miniaturization combined with superb image quality. Some camera models offer image stabilization (*see p. 27*), which reduces the effects of camera shake on the image.

Accessory shoe
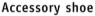
A hot shoe or slot enables you to fit a separate microphone on a short boom or an extra light.

REC SEARCH FOCUS NIGHT MODE

CARD

EFFECTS ON/OFF OPEN

MultiMediaCard SD

DATA CODE AE END

CARD MIX / SLIDE SHOW / REC PAUSE

MENU

LCD screen
One of the greatest advances in digital video cameras is the LCD screen that is big enough to view comfortably and give instant feedback on the shoot. It may be rotated to view the image from various angles.

Controls
Many of the less frequently used controls, such as the digital effects, are tucked under the LCD screen. Some cameras may also conceal connectors here.

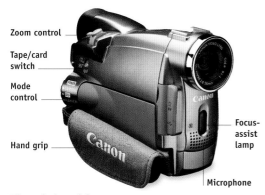

Zoom control

Tape/card switch

Mode control

Hand grip

Focus-assist lamp

Microphone

The right side
All modern cameras are right-handed, so you will find the grip for the camera on this side, together with the start/stop button and zoom controls.

Microphone
Many cameras carry a microphone. Those placed on the camera, as here, are more likely to pick up camera noise than one mounted on a boom held away from the camera.

Viewfinder
The electronic viewfinder may be movable to suit different viewing positions.

Thumb controls
The vital start/stop button is often given to the right-hand thumb. Check its position is comfortable for your hand.

Battery access
On many cameras, the battery attaches to the back, but on some models it fits underneath. The latter is inconvenient for tripod work.

Boxed accessories

When you buy your digital video camera you will find, apart from the camera itself, several other items in the box. These vary from camera to camera and between manufacturers, but they usually include a battery, a battery charger/mains adapter, a power cable, audio and video leads, a SCART adapter, and a shoulder strap. You will also find an instruction manual or CD.

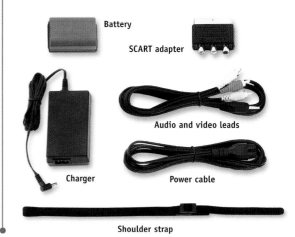

Battery

SCART adapter

Audio and video leads

Charger

Power cable

Shoulder strap

Digital zoom

Cameras offering fantastic zoom ranges – as much as 300x – rely on digital zooming. When the zoom effect given by the lenses themselves is exhausted, zooming can extend further by enlarging the central portion of the image using digital techniques. The downside is that this results in rapidly decreasing image quality as the zoom effect increases. For more on zoom lenses, see p. 62 and pp. 74–5.

Closing in
Zooming in to capture the moving figure, quality is maintained with optical changes (*left to middle image*). But an extreme digital zoom (*right*) is gained at the loss of image quality.

Holding the camera

Ask any professional video-maker what is the best way to hold a camera, and they are likely to answer "Not at all". Any movie camera is best kept steady on a tripod or other support. This was a necessity when video cameras weighed as much as – and were as unwieldy as – a suitcase packed for a long holiday. Paradoxically, the argument for camera support is just as strong, if not stronger, now that video cameras weigh less than a paperback novel: tiny, lightweight modern cameras move with the slightest intake of breath.

Stabilizing the shot

Some shooting styles demand a mobile camera, one that is entirely free from encumbrance. And there are scenes within movies – such as those showing field games, riotous parties, or conflicts – where the unpredictable, unsteady movements of the camera are entirely appropriate.

Furthermore, there are many video-makers who do not wish to be encumbered with heavy tripods. The main principle for holding the camera

steady is that you need a firm grip on the camera. Avoid tensing up, since this will tire your arms and increase the risk of camera shake. It is possible to practise to improve steadiness: you may need to learn to relax your body, to keep your back straight, and not lock your knees in order to keep your body and stance loose and flexible. This way, you will move more smoothly and be able to absorb any unevenness in terrain. A camera mount, which spreads the weight of your equipment over one or both shoulders, can also help keep your shooting steady and your movements smooth. Some camera mounts even spread the weight to your hips.

Ideally, you should not be free-standing; instead, brace yourself against a wall or a heavy piece of furniture, for example. Bear in mind, however, that resting your weight on anything also has a tendency to slow you down: it is easy to become stuck in position – both physically and mentally – so that you move off later than you should to follow the action.

Standard hold
In the most basic camera hold, your hands cradle the video camera, your elbows are kept close to the body, and your fingers are positioned over the main controls – such as the zoom button – so that you can activate them without moving the camera.

Unsupported hold
Many tourists video this way, using the flip-out screen, because it is a comfortable hold and the view of a large screen is reassuring. However, it is very hard to hold the camera steady, impossible to check sharpness, and, in bright conditions, it can be extremely difficult to view.

Using the LCD screen
This position is steadier than the unsupported hold (see *left*), but the perspective may be too low down. It has its uses – for example, when you want to capture people acting naturally but holding the camera up to your eye would alert your potential subjects.

Hinged LCD screen

The introduction of the hinged LCD screen – that can be flipped out, turned around and upside down, and reversed – has revolutionized digital video camera technique. Having a monitor screen separate to the viewfinder was formerly a luxury afforded only by the most expensive and best movie and broadcast cameras. Now almost every digital video camera has one.

The hinged screen means that you can shoot a scene from angles that were impossible before. In a crowd, you can hold your camera above your head and shoot down, yet still be able to see what you are shooting.

With a mere flip of the screen, you can record right at ground level – great for dramatic shots of movement or grass-roots nature shooting – without having to put your nose to the ground. If you need to, you can record surreptitiously with the camera held casually at waist level. Reversible LCD screens even make it possible to video around corners.

Image stabilization

As cameras become smaller and lighter, camera shake is the main cause of blurred images. Built-in electronic image-stabilization systems reduce the effect of camera shake by moving the image in the opposite direction to the shake to neutralize the movement.

Double vision
This indoor portrait was taken with the video camera's image-stabilization mode turned off. It has been spoiled by camera movement, leading to typical double-fringed images.

Increasing your height
This technique is useful not only for avoiding heads in a crowd; it also offers a different perspective even where there is no obstacle to your recording. Try this next time you are out shooting: even with a little elevation, the change in perspective can be entrancing.

Leaning on support
When you need a little support in order to steady your shot, a pillar or wall can be very helpful. This kind of support is especially good when you are using a long focal length, since this is when the entire system needs as much steadiness as you can give it.

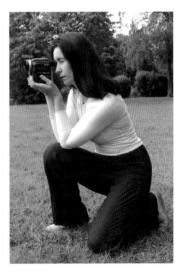

Supporting yourself
If there is nothing available for you to lean on, and you do not mind a lower viewpoint, then go down on one knee and support the camera by resting your elbow on the other. Unfortunately, this position restricts movements, so you may find it inhibiting.

Entry-level cameras

The inventors of television would be wide-eyed with wonder at the size and capabilities of even the lowest-cost and simplest digital video cameras on the market today. Leaving aside the video-recording modes on mobile telephones, the simplest models of video camera offer a great deal of fun, as well as easy operation not reliant on wading through tedious instruction manuals; at the same time, some can deliver a quality of recording that could have been accepted for broadcasting not so many years ago.

SP and LP

SP stands for "standard play" and LP for "long play", referring to the recording and playback tape speeds. Standard play offers the best balance between quality and length of recording (a higher speed could squeeze even more quality out of the tape, and this is exactly what professional versions of DV do). Long play, on the other hand, slows the tape speed – by varying amounts depending on the tape format – to give much longer recording and playback times. The drawback is that the quality suffers and tends to be adequate at best.

Small and compressed

The easiest way to make a small camera is to make the recording medium small: even the MiniDV tape cassette is relatively large compared to other media. The smallest cameras in this basic range use flash memory – that is, small cards of memory chips that have no moving parts. In fact, the latest professional cameras use flash memory too, and we can expect an increasing number of cameras to use this medium.

Small lenses – with limited aperture and restricted zoom ranges – also facilitate the manufacture of smaller, cheaper cameras. However, for much of your shooting, you will not need extremes of focal length.

With the smallest cameras, it is important to check that you can work the controls easily and handle the camera comfortably. Even for people with small hands, some cameras demand the manual dexterity of a neurosurgeon. In general, with small cameras you pay a premium for the miniaturization of the various parts. However, you are likely to gain more features and quality by purchasing a slightly larger camera rather than a similarly specified but much smaller competitor.

Logitech Pocket Video 750
Models such as this can be so compact in form because they record directly to a memory card. The lens is fixed and zoom is digital. Power is supplied by four AA batteries. It connects directly to a TV and can download to a PC.

Panasonic SVAV50A
This device is a little larger (and considerably thicker) than a credit card but incorporates an MP3 audio player, video camcorder, and digital stills camera. Video is recorded in MPEG-4 on to SD (SecureDigital) cards.

Sanyo Xacti VPC-C1
A growing class of MiniDV cameras records conveniently on to memory chip: this model offers a proper zoom lens of 10x and a fair-sized LCD screen. However, capable cameras such as this test the limits of their MPEG-4 format.

Light weight vs sturdiness

Another factor to be aware of is that the entry-level models are generally made lightweight for undemanding and gentle use. They will not withstand serious bumps or shocks, nor will the mechanisms withstand the rigours of recording numerous tapes or being used extensively as a playback machine. In theory, cameras with solid-state memory should be very reliable, as well as being lighter in weight and more economical with batteries – these are three good reasons why they are becoming more popular.

Entry-level model

Models costing less than a basic computer offer ease of use and a fair range of features and are good value for money. This model has a 16x zoom and a swing-out LCD screen; it can also record stills images, but only to tape.

Viewfinder

Lens

Fill light

Microphone

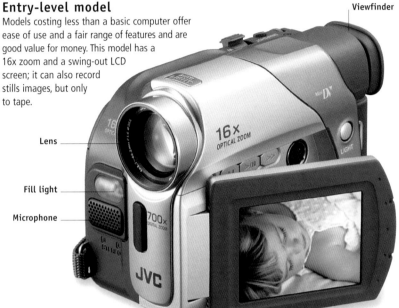

JVC GRD23

To keep prices low, lenses offer limited zoom range supplemented by digital zoom.

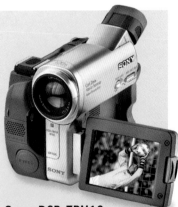

Built-in microphones record from the camera position, so their usefulness is limited.

Sharp VLZ100

Even some of the least costly modern DV camcorders offer features such as 16:9 format framing (letterbox). With a 10x zoom and bright LCD screen, and a 2-hour capacity standard battery, models such as this are ideal for a keen beginner.

Panasonic NVGS11

Cameras such as this offer excellent value. With a wide-ranging 24x zoom, webcam facility, remote and microphone handset, and DV output, this is a surprisingly well-specified camera for the price.

Sony DCR-TRV19

It is possible to find well-specified, substantial cameras even in this class: this compact model offers a fast 10x zoom lens with image stabilization, an 800,000-pixel chip, a good range of controls, and a large LCD screen.

Intermediate cameras

For those who can afford them, intermediate-level digital video cameras present the best value for money. By offering more features and controls, these models give good-quality results. You can further increase the amount of features you get for your money by choosing a larger model, since smaller ones tend to be more expensive.

Cameras in this category are likely to offer zoom lenses with a good range; colour viewfinders, both on a swing-out LCD and under the eyepiece; and digital-video in and out sockets. Some also have "luxury" additions such as image stabilization and transition effects. In addition, higher-resolution chips help improve the image quality. The top

Intermediate model

Semi-compact upright designs offer a compromise between high quality – a 3-megapixel chip – and small size. Placing the majority of settings on the LCD touch-screen helps keep the camera compact.

Sony CDR-PC330

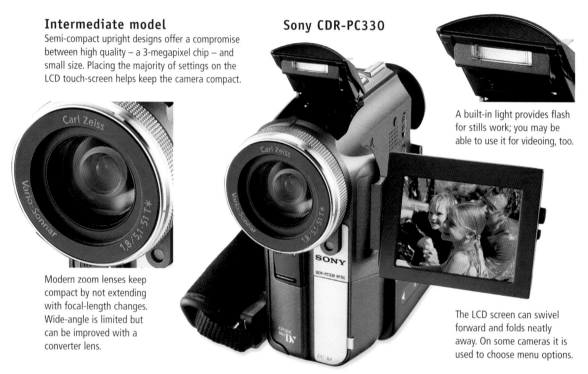

A built-in light provides flash for stills work; you may be able to use it for videoing, too.

Modern zoom lenses keep compact by not extending with focal-length changes. Wide-angle is limited but can be improved with a converter lens.

The LCD screen can swivel forward and folds neatly away. On some cameras it is used to choose menu options.

Canon MVX3

At the top end of this category, sensor resolutions reach 2 megapixels – as in this model – or higher, with a fast lens, image stabilizer, and video effects. Small but not compact, cameras of this size are easy to use.

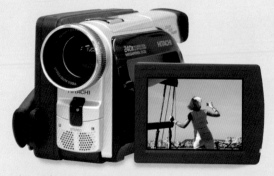

Hitachi DZ-MV270E

The intermediate category includes cameras that record directly on to DVD. All the usual digital video features are available, but the main selling point is the ability of these machines to play back as well as write DVDs.

cameras in this category include triple-sensor cameras: these use three relatively low-resolution chips to provide better colour than a single chip.

Increasingly, intermediate cameras offer still-image capture, which means a memory-card slot will be provided. If you have a digital stills camera too, try to ensure that the cards used on both your cameras are compatible. Users of Sony cameras beware: old models use MemoryStick, whereas new ones use MemoryStick Pro. Card readers for MemoryStick may not read the Pro cards.

Ultra-miniature cameras

Extremely small digital video cameras make their entrance in this category: some are so lightweight and small – easily fitting into a trouser pocket – that you need a separate control to access their features. These models are convenient and good for snap-shooting, but check that you can work the controls comfortably before buying.

Holding steady

One of the main disadvantages of miniature video cameras is that they are difficult to hold steady, and even breathing can cause movements. These movements may seem okay in the viewfinder, but they will soon frustrate you when seen on a TV screen. Consider this when choosing a camera.

Taking stills

It is becoming more and more commonplace for intermediate digital video cameras to be able to take still images. A few models record the stills on to tape, by combining two interlaced fields into one (*see pp. 20–1*). This is not the best way, and can be identified by cameras that do not have a separate, removable flash memory. Other models record the stills to memory cards. However, operation is usually slower than in digital cameras and image quality may not be equal to similar images from a digital camera.

Two-in-one convenience
Given comparable resolutions, a stills camera will almost always outperform a video camera taking stills. However, it is useful to have both options in one camera.

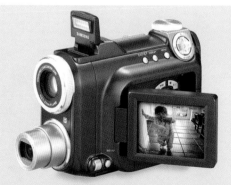

Samsung VP-D6050i
Innovative designs are most likely to appear in this middle band of the market: this example offers both DV and stills recording without compromising either. It also supports four types of memory card, offering the user a range of options.

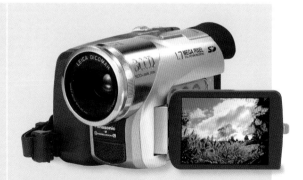

Panasonic NV-GS120
In this category, you will find the least expensive triple-chip cameras, which provide good moving-image quality, especially if supported by image stabilization, and a high-quality lens. Still-image capture may suffer from the low-resolution chips.

Prosumer cameras

The term "prosumer" is derived from "professional consumer", which means a non-professional user who likes to use the best-quality equipment or materials without paying full professional prices. Cameras in this category offer very high-quality results and, even though they are not cheap, they cost a fraction of the price of broadcast-quality cameras.

Triple sensors

The feature most typical of prosumer-class digital cameras is the use of triple-sensor assemblies, one each for red, green, and blue. The improvement in image quality gained by using three sensors is significant and, to the perfectionist, essential. The incoming image is split by a complex of prisms or semi-reflecting mirrors into three beams, each of which is relayed to its own sensor. Each sensor is dedicated to recording only one colour separation, and the three signals are combined to extract the luminance and the chrominance data for the video signal. The splitting of the image beam requires precision manufacture and a certain amount of space, meaning that triple-sensor cameras are not the most compact. But even with the use of sensors with relatively low pixel counts, the image quality can be high because of the fullness of the colour data captured.

Lens quality

Another characteristic of prosumer cameras is the high quality of the integrated lens. Good-quality lenses can provide image sharpness, colour fidelity and purity, as well as freedom from flare. The way in which these lenses handle is also appreciably better than that of consumer cameras: the controls are often smoother, easier to operate, and responsive to expert touch – zooming slowly and smoothly or snapping from one setting to another as quickly as required.

Some prosumer models accept interchangeable lenses, including those intended for 35 mm photography – these are worth considering if you already own suitable lenses.

Broadcast quality

This term is often used to mean professional quality or the highest quality attainable. Some prosumer cameras may produce broadcast-quality images, but they cannot claim to attain true broadcast quality. This is because not only image quality is involved, but also adherence to broadcasting standards, including stability of timecodes, ways in which signals are processed, and compression (*see p. 47*).

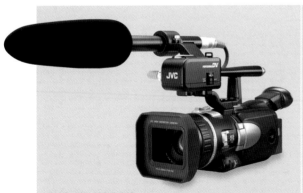

JVC JY-HD10U
Modern high-definition cameras using a single chip can produce very high quality indeed, as well as offer flexibility in formats and frame rates, all in a compact body and recording to standard MiniDV tapes.

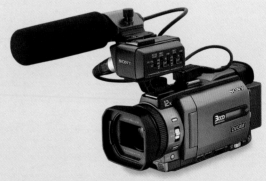

Sony DSR-PDX10
Using slightly larger chips than intermediate models to improve image quality, this model records in the widescreen 16:9 image ratio in DVCam format, offering a good level of control in a very lightweight and compact camera.

Sound quality

The quality of sound recorded by most video cameras, even prosumer models, leaves much to be desired. The best way to improve the quality of recorded sound is to use a separate microphone. If you feel strongly about the sound in your movie, there is no alternative to independent recording with separate hi-fi equipment. A simpler option is a good microphone on a boom attached to the camera – this is not only practical but also produces entirely acceptable sonic quality. (*See also pp. 80–7 for more on sound.*)

Prosumer model

Very compact and lightweight DV cameras such as this – using three sensors and equipped with a high-quality lens – are suitable for the non-professional user who requires high-quality images.

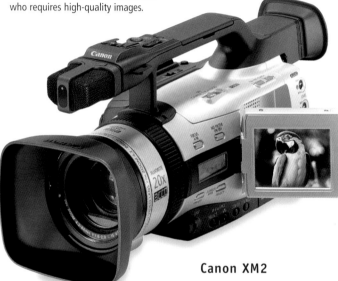

The provision of a sturdy accessory shoe allows the user to attach a lamp or a high-quality microphone.

Canon XM2

A microphone set as far away from the camera as possible is the first step towards good sound recording.

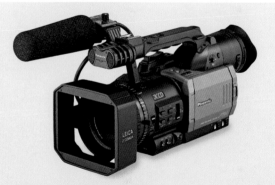

Panasonic AG-DVX100

This model is typical of the generation of triple-chip cameras with extensive camera controls and balanced audio inputs. It creates a widescreen effect by blanking out the top and bottom portions of the 4:3 image format.

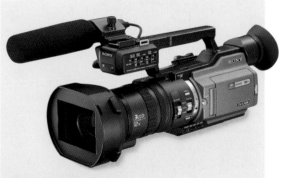

Sony DSRPD170P

Much favoured by documentary video-makers, this model has proven reliable and offers balanced audio input. It records to the professional DVCam tape format.

Digital video accessories

There is a huge number of accessories available for the digital video enthusiast, and it would be easy to fill a room with all your equipment. For this reason, it is important to distinguish between the truly vital accessory and the attractive gimmick that is used once and forgotten forever.

Camera case

The first essential is a case that will protect your investment while at the same time being easy to use and appropriate to the conditions you work in. Unfortunately, the best protection is given by the heaviest cases, while the easiest to use offer the least protection. If all you video are family parties and holidays, you probably do not need a case that can survive being dropped down a mountainside or dipped in the sea. There is a lot to be said for a case that does not advertise the fact that it is carrying expensive equipment. In general, a padded case that can be carried easily over the shoulder is ample for most needs.

A specialist waterproof housing is useful for a range of conditions. Besides the primary protection against water – to depths of 10 m (33 ft) or more – a waterproof housing can also protect the delicate parts of your camera from dust, sand, and debris.

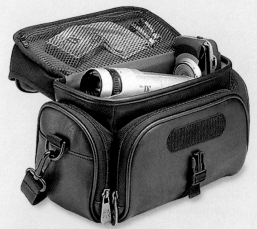

Camera bag
Soft-sided, padded camera bags provide a good balance of light weight and fair protection for your equipment, but they are not dustproof.

Waterproof housing
Essentially tough plastic bags, waterproof cases are excellent protection against splashes and sand. Although costly, they are well worth the investment.

Battery charger
Portable battery chargers are an excellent reserve in the field, but they can be costly.

Alternative battery
It is possible to buy alternatives to manufacturers' power sources, such as the professional Lithium-Ion series from specialist manufacturer SWIT.

Delicacy of video mechanisms

The recording head of a digital video camera spins several thousand times per minute, in extremely close contact with the tape, which runs at nearly 19 mm (⅘ in) per second, laying data tracks narrower than a human hair. The gap between the recording head and the tape is precisely maintained and is equal to a small fraction of the thickness of a human hair. As a consequence of these fine tolerances, the smallest dust particle causes drop-outs, or gaps, in data, which will show up as flecks of "snow" in the image. The recording mechanism is very delicate: always pay attention to any "Do not" labels on the equipment.

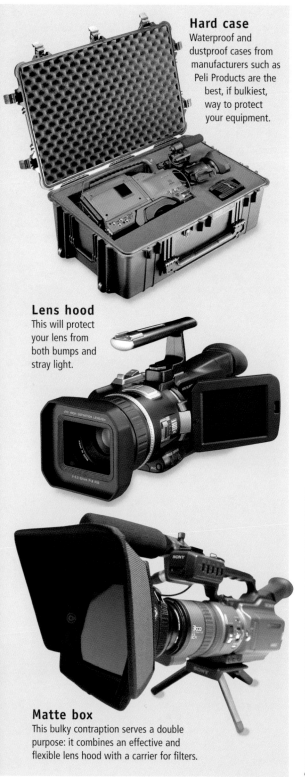

Hard case
Waterproof and dustproof cases from manufacturers such as Peli Products are the best, if bulkiest, way to protect your equipment.

Lens hood
This will protect your lens from both bumps and stray light.

Matte box
This bulky contraption serves a double purpose: it combines an effective and flexible lens hood with a carrier for filters.

Flare prevention

A lens hood is essential for protecting the lens from damage, and it also helps prevent flare (unwanted light reflecting into the optics). A matte box (*see below left*) provides even better protection, particularly if the zoom is not active. The sides of the box can be extended for maximum shielding for the focal length in use. Another approach is to use a card on a flexible arm, such as the Flarebuster: this mounts on the hot shoe or tripod and carries a flexible arm with a clip on the end, so that it can be positioned easily and stays in place.

Batteries

The efficiency and capacity of modern batteries are excellent examples of high technology. Those people who have been in the video business for very many years will remember having to transport their camera batteries on a little trolley. Today's cameras, as well as other equipment, have very low power requirements. These two factors combined mean that batteries small enough to fit in your pocket will store enough power to last for hours. Some brands of battery tell you how much longer you can work before recharging.

Battery care

Follow these tips to achieve the optimum performance from your video camera batteries:
● Discharge the battery fully before recharging for the first two or three cycles. This improves the capacity and longevity of modern NiMH and Li-Ion batteries. Thereafter, you can recharge when the battery is only partially discharged.
● Always use the manufacturer's battery charger: another may look similar and even provide the same charging power, but it may lack electronics that monitor battery condition.
● Keep the battery's contacts clean: do not touch them, and use the cover whenever possible.
● Do not expose batteries to excessive heat or cold.

Filters

Placed over the lens to alter the image entering the camera, filters can be subtly tinted – to correct imbalances in colour temperature – or strongly coloured or patterned.

The key technical issue is this: the more work you put into the image when shooting, the less work you need to do later. For example, if you achieve colour balance with a filter, there will be no need to make white balance corrections in post-production. This helps maintain technical quality.

Plain or UV filters

Your expensive zoom lens, possibly the single most costly part of your camera, can be protected by using a plain glass or UV filter (strictly, minus-UV since they block UV). Keep it on at all times, but keep it clean – even on the inside, since dust trapped there will settle on the lens or filter.

Graduated filters

A common need is to darken a bright sky without making the foreground too dark. You need a filter that is strongly tinted at the top, fading to transparent at the bottom – a graduated filter. The shading may be neutral coloured (grey) or tinted with blue to increase the colouring of the sky, for example. Graduated filters also come in various strengths to suit different scenes: strongly coloured for high-contrast or bright scenes; weakly tinted for lower-contrast scenes.

Original

Original

With filter

Cut-out filter

You can use a cut-out to give shape to an otherwise formless shot. Here, the lines of a formal garden are softened and broken up by the filter. Cut-out effects vary with lens aperture and zoom setting. Many cameras use aperture to control exposure, so you may have to experiment with the zoom to achieve the effect you want.

With filter

Graduated filter

The graduated, or "grad", filter is widely used to give colour to a blank cloudy sky. However, it is easily overdone. Experiment with different strengths of filter. Here a tobacco-coloured grad has been strongly applied with the lens set at its widest: with longer focal lengths, the effect is reduced.

Polarizing filters

Used primarily to reduce the effect of reflections in glass and water, polarizing filters are just as useful for increasing the intensity of colours where there are many shiny surfaces, such as plant leaves.

Special-effects filters

Starbursts, rainbow, and diffusion all come under the special-effects banner. They are occasionally useful, but overuse will reduce their impact.

Colour-correcting filters

Filters with very soft colour tints are often used by professional movie-makers to create subtle changes in the mood of lighting.

Working with filters

Just as filters affect your footage, your camera can also have an effect on the way filters behave.

- Turn off the automatic white balance, since it will negate the effect of any coloured filters.
- Use graduated and special-effect filters sparingly.
- The appearance of an effect – especially with graduates – may vary with aperture. Check at the working aperture before committing to tape.
- The appearance of the effect may vary with zoom setting. Do not shoot without first checking.
- Check special-effects filters through the lens, not by holding them up to the eye.

Original

Original

With filter

Limited-field filter

Filters that look like varifocal spectacle lenses – with one part of a different strength than the other – can limit depth of field. This is valuable in digital video, which tends to give enormous depths of field. Here, the filter has been used to focus attention on the nearest flower, throwing the background out of focus.

With filter

Split-image filter

For fantasy or dream sequences, there is a place for filters that split or fragment a view. The filters are available with varying numbers of facets, like a cut and polished gemstone. They can thoroughly confuse the autofocus system, so set to manual focus. Here, the garden scene is broken into five repeating sections.

Tripods

Although they are cumbersome and can be awkward to carry around, tripods are vital in a wide range of shooting conditions to achieve a steady shot, which would be impossible to achieve with a hand-held camera. It is entirely possible, and may even be necessary, to shoot a documentary or travelogue without a tripod, but even the fastest-paced documentary could feature an interview with an expert; or a travelogue may show the placid, lazy flow of a great river. It is sensible to be prepared for an unplanned shot. Paradoxically, it is not the static shot that benefits most from the stability of a tripod; a steady shot is most useful when recording movement.

Even the cheapest tripods come with pan and tilt heads to help you create smooth camera movements within static shots.

Pan head

The best way – some would say the only way – to obtain a steady movement that pans across the scene is to use a tripod equipped with a panning head, which rotates on a vertical axis around a large, smooth bearing. Buy the best you can afford, because precision machining of the parts of the head is critical for controlled movement. If you use very heavy equipment or you wish to pan with the zoom set to a very long focal length, you should consider using a fluid head – that is, one in which the bearings are separated by a lubricant at high pressure. Fluid heads are costly, but they provide a smooth, silky action that is second to none.

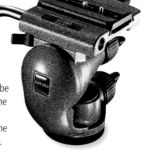

Fluid head

A fluid head has pan and tilt movements whose resistance can be adjusted to match the weight of the equipment for smooth operation. Markings enable you to position the head in the same place repeatedly.

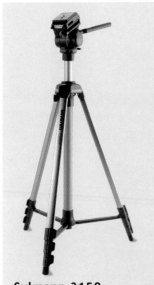

Culmann 3150

For occasional use, an inexpensive but still relatively stable tripod is a good investment. This model has a simple centre column with a locking screw and locking clips on the legs.

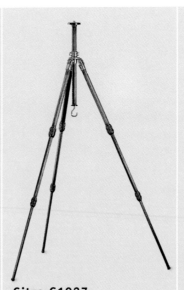

Gitzo G1027

Carbon-fibre tripods offer exceptional rigidity with relatively low weight. They are costly but highly reliable. This one weighs less than 800 g (1.75 lb) and is only 45 cm (17.7 in) long.

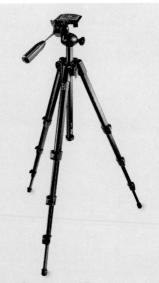

Manfrotto 728B

Tripods offering four sections, a rising column, and built-in pan/tilt head are ideal for a wide range of work and situations. This model has a reversible column for very low level shots.

Tilt head

For tilting, or up-and-down movements, the rotation occurs about a horizontal axis: only when the axis is perfectly horizontal will the up-down movement run vertically. The best way to control movements, with both pan and tilt, is to use a handle attached to the head. The longer the handle, the greater your control.

Do not grip the handle tightly; guide it with your fingertips to give you accurate control over the camera movements. Pan and tilt heads for use with video cameras have a friction setting to alter resistance to movement. Set the friction for both so that the camera position is held but smooth movement is possible.

Spirit level

A built-in spirit level shows when the tripod is level on the left/right and forward/back axes. Usually set into the head or leg block, the spirit level contains a small bubble that centres on an inscribed circle or cross when the tripod is level.

Stable movement

Stability during movement, or steady camera work (steadycam), is a hallmark of professional video-making. The simplest accessories use counterweights that hang below the camera on an arm. The camera is supported on a freely rotating "gimbal" and is held on a handle from below: this allows it to stay level, thereby dampening jerky, pitching movements.

Portable stabilizer
Hand-held devices such as this keep the camera level and steady while following movement. The heavier they are, the more they reduce camera shake – but they soon tire your arms.

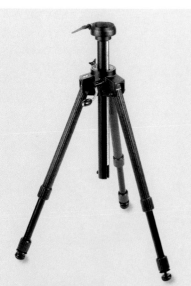

Linhof Profi 3
A good, durable tripod will give many years of service. This model rises from 25 cm (10 in) to nearly 2 m (74 in), with variable leg spread. The column is adjustable to the weight being carried.

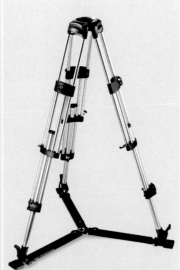

Manfrotto 5I5MVB
Supplied with a leg spreader as standard, heavy models of this design offer good stability and safety in the field. The centre interface bowl accepts the spherical ball of a fluid or pan/tilt head.

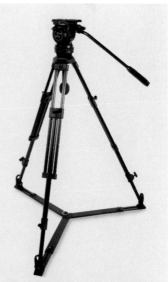

Sachtler DA-75/2D ENG
Widely regarded as the finest of all tripods, a Sachtler is costly but will last a lifetime. This model has a quick-clamping system for its two-section legs and can carry a 20 kg (44 lb) camera.

Microphones

While the digital revolution has transformed audio as much as it has transformed the visual world, the old rules still apply. Digital technology may make it easier than ever to work with audio, but it does not guarantee quality. You can mix, synthesize, and combine sound just as you can composite multiple images, but good judgment is more important than effects for their own sake.

For the best-quality results, you need the best-quality equipment. The sign of progress – and good news for movie-makers everywhere – is that extremely high-quality recording equipment can now be obtained for a fraction of its former cost.

Built-in microphones

The microphone is the audio equivalent of the lens: how well a sound is captured depends to a major extent on the quality of the microphone used. A microphone is standard equipment on all consumer-grade digital video cameras. While some are better than others, it is safe to say that the easiest way to improve the sound-quality of your movie is to bypass the camera microphone with an external microphone. The problem with a camera-mounted mic – aside from it not necessarily being in the best position to record the action – is that it will also record sounds from the camera mechanisms, as well as noises from the operator, such as breathing and inadvertent exclamations. However, if your movie will only be played back through the loudspeakers of a domestic TV, a camera-mounted microphone may be sufficient.

Choosing a microphone

Microphones can be divided into those with balanced or unbalanced inputs: balanced systems use three leads (positive, negative, and ground [earth]) whereas unbalanced systems use two, with the negative running through the ground (earth) wire. For amateur use, unbalanced microphones are cheaper and easier to use, but are more susceptible to interference (causing buzzes or hums): the majority of cameras accept the small 3.5 mm mini-jack plug for sound. Other unbalanced plugs used are the RCA and unbalanced ¼ inch (6 mm) jack plug.

If you are recording sound direct to video track and wish to use balanced inputs, you must ensure that your camera accepts balanced lines or an adaptor for them: the usual connector is the XLR, sometimes a balanced ¼ inch (6 mm) jack plug – one with three wires.

Finally, check that the power requirements, if any, of your microphone can be met by the recorder or mixer that you use.

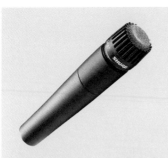

Shure SM57
This popular microphone is suitable for voices and instruments and is known for its reliability and neutral sound. It is well made and sturdy, offering a cardioid acceptance pattern and wide frequency response of 40Hz–15kHz.

Azden SGM-X
A shotgun microphone, such as this model, with a wide frequency response and low noise levels is ideal for use with small DV cameras. This microphone is powered by a small battery.

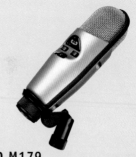

CAD M179
Microphones on which the sensitivity patterns can be altered from hypercardioid through to omnidirectional, are highly versatile. This is a surprisingly affordable condenser type, suitable for recording from a wide variety of sources.

Sound accessories

A boom – essentially a pole – is useful for extending the reach of a microphone to take it closer to the subject without it appearing in the frame. The best designs use carbon fibre for strength and light weight, with fittings to keep cables tidy. Telescopic versions allow you to extend or retract the boom to exactly the length you require. To prevent noise from wind when working on location, a windsock of velvety or furry material can be slipped over the microphone. For best results, the microphone should be housed in a zeppelin – a long, capsule-like enclosure that protects against both wind and knocks, with a handy pistol grip for aiming the microphone.

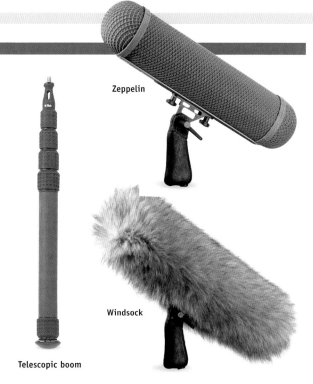
Zeppelin

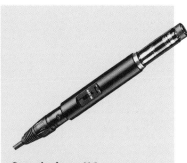
Windsock

Telescopic boom

Angle of acceptance

Just as lenses vary in terms of focal length, microphones differ in their angles of acceptance. Cardioid types accept sound from a wide angle, including a little behind the microphone. Super-cardioid types accept sound from a narrower angle, while shotgun (or gun) types accept sound from still narrower angles. Those with very long barrels accept sound from very narrow angles. Unlike lenses, however, the cut-off point is not precise. For solo video work – that is, when working without a crew – the most versatile is a short shotgun microphone mounted on a boom on the camera.

Crown PZM-30
Pressure zone microphones (PZM) record from the surface on which they are mounted, making them good for recording over a very wide area and also for ambient or foley sound: placed on a table, they will pick up sounds of items being put down.

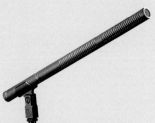

Audio-Technica AT835B
Relatively inexpensive shotgun microphones offer a good balance of quality against cost. This model is well made and offers some professional features.

Sennheiser K6
This model comprises modular items that adapt the microphone for different purposes. A versatile outfit offering high-quality sound and reliable build quality can be created, but the total cost is rather high.

Computing equipment

Digital video owes its existence and growth to powerful personal computers. However, it may seem strange that while a camera smaller than a paperback novel can capture and play back video, you will need a very powerful computer to work with the video on your desktop. This disparity is due to the computing demands of non-linear editing (NLE) – that is, software that allows you to edit clips out of chronological order.

Data streams

Video produces very swollen streams of data that have to be processed at a constant rate to enable good-quality images and accurate editing. To cope with this, it is best to work with the latest and best-equipped personal computers you can afford. The hard disk and connectors should be of the fastest type available. Similarly, the data bus – the wires that carry data around the computer – should be as quick as possible. In addition, the system should have lots of spare capacity – both in terms of free Random Access Memory (RAM) and the amount of empty hard-disk space.

Windows users need Pentium III or equivalent processors working at 500 MHz or faster, with 512 MB of RAM, and operating with Windows 98SE or later. It is recommended that you run Windows XP; of the four versions available, the most suitable is the Media Center Edition, but the Home Edition is also highly capable.

Apple users will need PowerMac computers running G4 processors or later, with at least 512 MB of RAM, and running operating system OS10.3 or later. Apple pioneered the bundling of very capable software for video editing and DVD creation together with the computers, so that any modern machine can download videos, edit them, and burn them to DVD without the need for any additional software.

Hard disks

Both Windows and Apple Mac machines should be equipped with a hard-disk drive of at least 50 GB capacity (preferably as a second, built-in drive, in addition to the master drive). Your

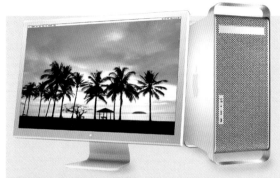

Apple Macintosh G5
Highly capable and good looking, but costly, the best Apple Mac computers are favoured by many video professionals and are well supported by the specialist accessory and software industry. A dual-processor model is highly desirable.

Apple PowerBook 17"
Large laptop computers combine considerable computing power with portability. The price is relatively high, but the gains in space saving and convenience are considerable. This model is popular with video-makers working on location.

Dell OptiPlex 160L
Mid-range computers offer perhaps the best balance of capability with cost. A model from an industry leader is also more easily serviced, with extras such as memory upgrades being widely available, resulting in greater longevity.

machine should also offer a FireWire or i.Link port with the ability to capture DV. All machines will need a CD drive for installing software (some software applications install from a DVD, in which case you will need a DVD drive), together with a DVD writer for archiving material.

Your computer will need more than 360 MB of disk space for every hour of compressed video, rising to a vast 13 GB for every hour of rendered movie. Furthermore, the hard disk must be capable of sustaining data flows of at least 4 MB/sec to display movies smoothly – that is, without dropping any frames. The installation of NLE software can take up 500 MB – even more when help files, tutorials, and effects files are included. In addition, some software will demand large amounts of free space in order to process an edit list. If possible, you should install the system software on one disk, and store movies on a separate disk (*see p. 46*).

Laptop versatility

To experienced videographers, the most amazing development is the ability to edit video on a laptop computer. With NLE software installed, modern laptops allow full editing and output while working on location. The main problem is not technical but ergonomic: their small screens are quickly filled with the many windows required by NLE software. Like desktop machines, laptops need to be supported by an external hard-disk drive.

Sony PCV-RS500
Even relatively inexpensive modern computers, such as this one, can handle modest video-editing needs. Software provided with the camera is free, so simply connect your video camera to the computer to get started.

Poweroid 9012
A number of manufacturers assemble computers specially for video editing. This model offers dual processors, the ability to run up to three monitors, massive storage capacities, and specialist video-editing cards at relatively low cost.

Sony Vaio Series W
Computers such as this model are highly versatile – able to provide computing and recording of broadcasts (for personal use only), as well as creation of DVDs and CDs: professional capabilities at domestic-machine costs.

Should you upgrade?

It is tempting to upgrade an old computer to a faster processor by substituting the CPU (central processing unit) card for a new one. However, this is costly and often creates an unstable system through the mismatching of components. Furthermore, the bottleneck in video editing is usually in the moving of data around the computer, not at the central processor. It is better to put the money towards a new computer or a second monitor. Use the old one for low-level, office-type tasks or for burning DVDs.

Monitors

A powerful computer with the best software is nothing without a good-quality monitor to view your work and ample screen space for the many windows needed for video editing.

Identifying the different types

Flat-panel or Liquid Crystal Display (LCD) monitors provide the highest image quality in a compact and lightweight unit. Because each pixel is created by a single transistor controlling the brightness, the image is absolutely stable, unlike that of the Cathode Ray Tube (CRT) monitor. This makes it less tiring on the eyes and means it is possible to use a flat-screen for longer periods than a CRT. However, lower-quality flat-screen monitors have a limited viewing angle: if you are not looking squarely on to the screen, colours can vary significantly. This is not such a problem with CRT monitors. Furthermore, flat screens cost two or three times more than a CRT with a similar display area.

For video editing, irrespective of type of screen, the viewable screen size should be at least 43 cm (17 in) across the diagonal, with a resolution of at least 1,280 pixels in width.

For the best results, you should opt for a monitor that offers high pixel resolutions over one with a larger screen area.

Video cards

Designed to enhance the video experience, video cards can be slotted into a computer's motherboard to add new capabilities. The most basic types take over the job of controlling the monitor: they process the video signal, relieving the computer of that task. Thanks to the demands of computer gamers, powerful video cards can also benefit the digital videographer by making the computer and monitor more responsive.

Another type of card captures analogue video for conversion to digital. It may be combined with a TV tuner for terrestrial broadcasts. This way, you can make digital recordings of broadcasts on your computer.

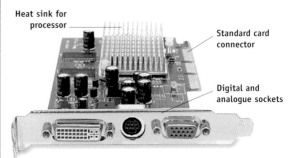

Heat sink for processor

Standard card connector

Digital and analogue sockets

Radeon 9200
Modern video cards, such as this one, for accelerating the response times of computer monitors are fast and powerful. They were created to meet the demands of computer gamers.

Apple LCD
For a good design allied with superlative image quality, models from Apple are hard to beat, but the quality exacts a high price. There are no extras, such as built-in speakers, although USB ports are provided.

Formac LCD
As well as being highly functional, stylish models such as this are also becoming desirable objects in themselves. This one offers a 43 cm (17 in) anti-glare screen and a two-port USB hub.

BenQ LCD
A mid-market LCD screen costs considerably more than an excellent CRT screen. However, this product is not only stylish, it also takes up little power and even less desk space. It is easy to move around and images are stable.

Using extra monitors

For the serious video-maker, there is no substitute for a "production monitor" on which to test effects and transitions. Glitches that may be barely visible on a computer monitor become apparent on a TV screen. Having a production monitor plugged in is more convenient than having to take a DVD to the player and screen in your living room.

A different use for an extra monitor is to enable the spreading of palettes and windows in your editing software between the two screens. This can greatly increase your productivity and can be more effective than upgrading an existing screen.

Monitor calibration

As viewers, we are tolerant of quite wide variations in colour balance in the moving image. This is partly because of the low-quality colour on domestic TV sets. However, because digital video cameras produce such superb colour images, you really should work with a calibrated monitor.

Your screen may appear to give bright, crisp colours but, in fact, produce higher contrast and stronger colours than normal. You will naturally adjust the images so that they look right on your screen, but your video will then seem lacking in contrast and colour if viewed on a screen that produces normal, less brilliant images.

If you are an Apple Mac user, the calibration process is free: you select it from the Preferences panel of OSX or the Control Panels of OS9. Windows users need the Gamma control panel that is provided with Adobe Photoshop. Better still, though, is a colorimeter, which matches the monitor's colours to a standard. The settings recommended for domestic television are gamma of 2.2 and a white point of 9,300 K.

Note that these comments do not apply to a field monitor used to assess images for broadcasting, which is set up to different standards. (*See also p. 199 on monitor calibration.*)

Colorvision Spyder

A hardware device such as the Colorvision Spyder offers a reasonably accurate means of calibrating your monitor. This process is automatic and the equipment is very easy to use.

KDS RAD7 LCD

This model has a 43 cm (17 in) flat screen and built-in speakers. With its combination of 1,280-pixel resolution and compact size, it is an ideal choice for video-editing work.

Formac Pronitron CRT

Large CRT displays offering a viewable screen of 56 cm (22 in) are large and heavy and produce a great deal of heat. But they cost less than smaller LCD screens and offer top-quality colour reproduction.

LaCie CRT

Although they take up a lot of space, large CRT monitors, such as this 48 cm (19 in) model, offer the best value combination of excellent image quality – especially in colour reproduction – and affordability.

Storage and peripherals

The items featured in this section may not be absolutely essential, but they will improve your overall experience of digital video.

Storage

The best technology for storing digital video is the hard disk. Apart from random access memory, they are the fastest available technology and the cheapest per unit of storage – much less expensive than removable media, such as DVDs and CDs. Also, only modern hard disks can maintain the rate of data stream needed for smooth video rendering.

The best type of hard disk is installed within the computer, sharing the data bus with other components. Ideally, you should keep all the systems and applications software on one disk, as well as small files such as text documents, while a secondary, or "slave", drive holds your movie files. Select the Serial ATA or Parallel ATA hard-disk drives that spin at 7,200 rpm or faster. Lower spin rates of, for example, 5,400 rpm are insufficient to maintain video's number of frames per second.

In addition to a hard disk in the computer, you are also likely to need extra drives. The most convenient type for data storage is the bus-powered unit, which draws its power from the FireWire (IEEE 1394) cable.

While desktop units are less convenient, they offer higher capacities with faster spin rates to assure better video performance. Purchase the largest capacity hard disks you can afford – even with a 200 GB capacity disk, there is little room left from downloading just ten 1-hour tapes.

Removable media

For archiving your movie work – both edited and rushes (the raw movies as you shot them) – and sharing it with others, the best medium is DVD. This is relatively inexpensive, being able to store more than 4 GB per side for a cost comparable to that of digital video tapes.

Writing to and reading from DVD are quite slow processes, so working with large files is time-consuming. For shorter movies and compressed QuickTime files, save on to CDs instead.

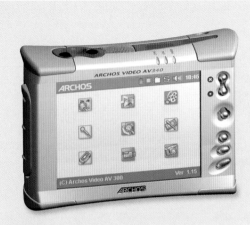

Portable storage device
There are compact devices available, such as the Archos AV, that feature a small LCD screen, powered by a compact hard-disk drive able to store and replay video, images, and audio files. This model can also record from a TV.

External hard drive
Modern hard-disk drives – such as this 120 GB model by LaCie – are neat, silent, and highly reliable. Their data capacity and compact size make them technical marvels of low-cost precision engineering, as well as the best value for data storage.

DVD writer
There are many plain DVD writers, but this Hewlett Packard model combines a video digitizer with a DVD reader/rewriter and CD reader/writer to simplify the writing of video. It accepts composite and S-Video inputs, but not FireWire.

Making life easier

Because the jog and shuttle movements (needed for searching through frames of a movie) tend to be undertaken by using the mouse, non-linear editing is very hard on the hand. After only a little time at the computer, your hand may ache. This is an indication of injury. It is important to stop work at these warning signs. Take them as a cue to make more use of keyboard commands, so that the work is shared between both hands.

Tools such as a specialized mouse and shuttle or a graphics tablet (*see left*) are worth installing. Use them alternately to give your hand a break from the same repetitive movements.

Although this sort of additional equipment is not strictly necessary for your computing work, once you have used it, it is hard to go without. Many of the available peripherals have been designed for maximum comfort by people who work at their computers for days on end.

Graphics tablet

This is a flat surface on which you "write" with a special pen; the logic is that for many movements it is easier on the hand to manipulate a pen than a mouse. A graphics tablet is invaluable for graphics and digital image work.

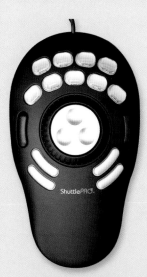

Specialized mouse

This oversized ShuttlePro 2 mouse brings some of the convenience of an analogue edit desk to the computer worker. The many keys can be programmed for repetitive tasks, while the large shuttle wheel makes it easy to scroll through clips. Before you purchase, ensure your computer is compatible with the driver software.

Custom keyboard

Keyboards may be customized for software or may be built from a standard keyboard with custom key caps marked for the application. The colour-coded shortcut keys with icons make direct keystrokes easier to remember.

Subsampling and compression

It is important to distinguish these key concepts, both of which refer to technologies that enable cameras and computers alike to encode moving images in colour without having to handle more data than really needed. Subsampling reduces the amount of data that is captured in the first place, whereas compression reduces the file size of the captured data.

Subsampling works because we are more sensitive to tones of light and dark than we are to colour. To save on the amount of data gathered, subsampling collects less colour information than tonal, or light and dark, data. For example, 4:2:2 subsampling picks up half the amount of colour data for the two colour channels (2:2) that it does for the luminance channel (4), thus saving 33 per cent on the data load.

Compression works by storing code in more efficient, space-saving ways and by losing a good deal of high-frequency data that cannot be seen in the moving image (see also p. 21).

Non-linear editing software

Parallel with the development of digital video cameras has been an astounding growth in non-linear editing (NLE) software. Arguably, one could not have prospered without healthy progress in the other. The result is that you can now edit and process video with very reasonably priced software. Even with professional software, the cost is a tenth of what it was in the first years of digital video.

Basic editing software

Some video-editing software is now available free of charge or is bundled with your computer's system software.

With Microsoft Windows XP, you obtain not only the Windows operating system but Windows Movie Maker. This offers basic editing functions, with a great deal of help for the beginner. A basic gallery of transitions and effects is available, as well as a titler for adding credits to your movie.

On the Apple platform, the outstanding software is iMovie. This application marked the arrival of NLE at the enthusiast's desktop. Suddenly, basic video editing could be fun and easy and need not cost a fortune – indeed, it was offered free with all Apple computers. It is possible to edit on the timeline; there is a large range of transitions and effects, supplemented by a growing number of commercially available plug-ins; and

titling effects are powerful and easy to control. Currently it is offered as part of a suite of software at prices that are effectively handling charges.

Intermediate editing software

The battle of NLE software producers is hardest fought at the intermediate level – and almost entirely for the benefit of the Windows user. Pinnacle Studio offers a good range of features with usability. Its wide range of import formats is attractive and integrates DVD authoring. The handling of music is versatile, with ability to add voice-over narration and background music. Other tools can correct sound and video problems, including stabilization (to correct camera shake) and noise reduction. Pinnacle Studio is able to capture and edit 16:9 widescreen format.

Roxio VideoWave offers asset control with a timeline editor supporting up to 14 tracks and in-place editing. It includes many transitions, titling, and effects and can customize DVD layout and create transitions synchronized to music.

For those working on Mac OS, Final Cut Express is the obvious choice for intermediate-level work, because it is currently the only full application available. It is much less costly than the full professional version, yet it will do just about everything even a keen amateur will want.

Adobe Premiere Pro
This basic software captures video and still images, and effects, transitions, and titles are easily applied. It offers integrated DVD authoring features and support for the 16:9 window.

Apple Final Cut Express
With its remarkably full specification for a mid-level application, Final Cut Express combines ease of use with near-professional power and flexibility. It can handle a wide range of media.

Sony Vegas Video
Vegas Video offers an integrated solution for digital sound and video, combining recording, mixing, and creation of Internet streaming content as well as of surround-sound effects.

Despite its versatility, it is easy to get started, and users of iMovie will have few difficulties becoming productive in a short time.

MacXware MediaEdit offers an interesting mix of features including the ability to create anaglyph movies for 3D effects (visible using red/green shades over the eyes), a good picture-in-picture feature for this level, and high levels of Undo for reversing mistakes.

Professional editing software

For a long time, Adobe Premiere was the most popular NLE application for the desktop video-maker, in both Windows and Mac operating systems; it has even been used to edit Hollywood films. It has almost everything you could need but, although still a favourite in Windows, and certainly one of the most capable applications, it is no longer being upgraded for the Mac OS.

Avid Xpress DV is a very powerful editor, with all the features and functions needed by all but the most demanding professional, but is not easy to get started and is dongle-protected – that is, it needs a special USB attachment to work. It is by far the most costly of the desktop editors. The Pro version is even more expensive, but it offers a level of customization to different ways of working, and that flexibility is appreciated by the industry.

Apple Final Cut Pro

Despite its popularity and long-standing status as standard, Adobe Premiere has been pushed off the Mac OS platform by the success of Apple's Final Cut Pro. This NLE application manages to be both powerful and fully featured, supporting high-definition, yet it is relatively intuitive at working with more than one way of completing the majority of tasks. It also features excellent correction tools. It has a good range of transition effects and works well with peripheral software – for example, for sound editing – and video cameras. The instruction manual is a model of clarity and thoroughness. For videographers who prefer working on the Apple Mac, Final Cut Pro is rapidly becoming the NLE application of choice.

Final Cut Pro

MacXware MediaEdit Pro
MediaEdit Pro works more like a painting application. There is a choice of some 200 effects, filters, and transitions, and the user is able to design personal filters and effects.

Ulead VideoStudio
Support for beginners is offered here with Ulead's step-by-step guidance. More than 700 effects, video frames, and graphics are supplied. This is a wide-ranging and popular package.

Ulead MediaStudio Pro
This suite of applications offers MPEG capture with good real-time capabilities, video and sound editing, painting effects, and graphics. DVD authoring tools makes content creation easy.

Specialist software

The technical demands of video are not unlike those of any other digital technology: so complex and involved that no one piece of software can be expected to perform all jobs adequately. As you progress in your digital video work, you will find yourself increasingly in need of specialist software that will add an extra dimension to your hobby while helping you achieve high-quality results. What you find necessary will depend on your work: if your output demands are modest and unvarying, you do not need a media cleaner or compression software; and if you shoot vast amounts and want to keep track of everything, you will need some kind of management software. The software featured here is not exhaustive of the range available, but covers the most popular.

Effects

Adobe After Effects is the application by which all other effects software is judged. Not only is it easy to use, it provides a full range of movement and visual effects such as tracking changes in scale and position and distortions (including bulge, scatter, skew, and twists). Compositing in 2D and 3D is not difficult, and files can be imported from major 3D applications such as Maya. The range of effects can be supplemented with plug-ins. For all its power, it is surprisingly inexpensive to purchase.

Roxio Toast
This is one of the most popular applications for writing data to CDs and DVDs: it is reliable and easy to use, with basic authoring capabilities, and supports a wide range of burners. It comes bundled with software for working with audio and images.

Plug-ins

Purchasing additional effects, which "plug in" to your NLE software as you need them is sensible and economical. It also avoids burdening your software and your computer with features that you might never use.

The SpiceFX packs for Movie Maker 2 from Pixélan offer professional-looking extra effects that are simple to apply because they behave just like Movie Maker's built-in effects. Each pack supplies a related family of effects, such as picture-in-picture transitions, tonal and tinting effects, directional dissolves and pan/zoom effects.

For more advanced NLE applications, Pixélan SpiceMASTER is a more heavyweight collection of effects said to be "organic" in the sense that the transitions tend to be natural, fluid, or random.

Adobe After Effects
This effects software offers features such as network rendering, which shares the processing load across networked computers. It also works well with video editing and DVD authoring applications.

Boris FX7
This collection of filters for NLE editors offers real-time previews, essential for high productivity. The browser feature speeds access to hundreds of pre-built animations in over 20 NLE systems.

discreet cleaner
Widely used encoding software in two versions (XL for Windows and 6 for Mac OS), discreet cleaner converts nearly any video format into any other and is essential for the serious videographer.

SmartSound Quicktracks is a soundtrack creation plug-in for Adobe Premiere Pro. Its key strength is that it enables the user to add a fully composed soundtrack fitted to the length of the video. The package includes the SmartSound Elements music compilation, with many pieces of royalty-free music.

Encoding

When it comes to encoding your video, there is a bewildering diversity of output options depending on how you wish to present your movie – on discs, over the Internet, or to mobile phones. If you output to a wide range of media and standards, software such as discreet cleaner XL will help control the process of encoding your work efficiently and accurately. It offers filters and control of industry encoders to create Windows Media 9 and QuickTime 6 video, and it can master video for hand-held devices, too. More than 180 professional pre-set output options are included.

Utilities

The DiGiStudio digital video stabilizer is a software solution to shaky video footage. Based on video-motion estimation and motion filtering, the digital stabilizer can smooth out shakes and vibrations from your footage elegantly. If your work suffers from unstable images, this may be worth considering – and it is less expensive than similar functions in professional-grade NLE software.

The T-Square FootTrack software is a tool for managing your clips: it compresses your footage so you can keep your video on your hard drive for easy viewing. It also handles analogue footage. However, its key ability is that it allows you to catalogue, organize, and group video footage.

Audio editing

Audio editing is a vital element of serious video production. There are many applications available, and you will need one if you wish to edit, record, encode, and master digital audio in a variety of formats such as WAV, AIFF, and MP3. In addition, if you wish to add echo, reverberation, and other effects, as well as synchronizing to video, specialist software such as Adobe Audition, Cool Edit, or SoundSoap are among the best options.

Adobe Audition

Roxio Easy Media Creator
This popular burning application for all digital media also offers integration of image and video editing and DVD authoring applications. It also offers password-protect and encryption of data.

Digital Hotcakes
This package includes many sets of royalty-free footage, such as organic backdrops, rapidly changing lights and flashes, backgrounds and animations for wedding videos, and watery textures.

Pinnacle Commotion
A powerful and versatile application for motion and compositing effects in video. In addition to the usual effects, it has powerful painting tools and also offers real-time previews.

DVD creation

One of the main problems of working with Digital Versatile Discs (DVDs) is knowing which format to use. For all the confusion, however, DVD holds the record for the fastest up-take in new recording technology. The key reason is that it is the most compact, least expensive, and most reliable way to present, distribute, and archive digital video movies.

DVD formats

A survey of the various DVD formats is the best way to ensure you do not use the wrong disc or buy an incorrect player. Physically, all DVDs are similar to CDs in size and form. The data are recorded as a spiral trail of microscopic pits and lands (level areas); a laser beam is shone at these points and the reflections are read off.

DVD-ROM: DVD-Read Only Memory is used to supply films, audio, or software to users. It comes in various forms with differing capacities and in single- or double-sided configurations. These discs cannot be written to by the user, but they can be used in DVD players or computers with DVD-ROM drives.

DVD-R: DVD-Recordable is the recordable version of DVD-ROM, and it is able to hold a nominal 4.7 GB per side (9.4 GB in total for a double-sided disc). These discs can be written

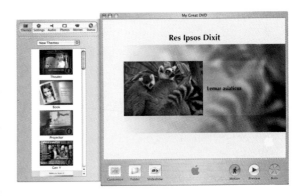

Burning a DVD
This screenshot of a basic DVD authoring program shows how you can set your movie within a stylish frame, complete with titles. Drag in or import your movie sequence, set chapters, and click Burn to create the disc – it is amazingly easy.

only once by the user, and they can be read in DVD players and computers equipped with DVD players. There are two types of DVD-R disc. To make many copies – for example, for distributing a film by duplicating from a master copy – you need the DVD-R For Authoring disc, which can then comply with the Cutting Master Format, when used with suitable software and recorders. For individual copies, use DVD-R For General discs. DVD-R can be used in DVD players.

DVD-RW: DVD-ReWritable is a re-recordable version of DVD-R that can be rewritten, it is

DVD writers
Modern desktop and even laptop computers incorporate DVD writers as standard. If you do not have one in your computer, it is easy to connect up an external drive, and it is likely to operate more rapidly than built-in writers.

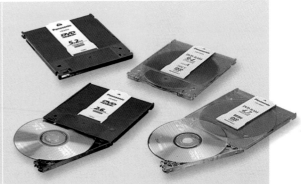

DVDs
The variety in DVD formats extends from optical/electronic elements, to whether the disc is held in a caddy, as shown above, or whether they are plain, bare discs like CDs. Ensure you buy the correct type for your writer.

claimed, up to 1,000 times. The discs can be used in DVD players as well as in computers equipped with a DVD-ROM player.

DVD+RW: DVD+ReWritable (note the plus sign) is the most confusing format. It is a variant of DVD-RW but is designed to be easy to use and suitable for video as well as data. This new format may not play in older DVD players.

DVD+R: DVD+Recordable discs are similar to DVD-RW but they can be written only once, resulting in a disc that can be read in DVD players as well as in the DVD-ROM drive of a computer.

DVD-RAM: DVD-Random Access Memory is also rewritable and is used for computer data storage, with 2.6 GB or 4.7 GB capacities for single-sided discs. The downside is that they cannot be read by standard DVD players or computers with DVD-ROM drives. While their high capacities are appealing, the typically slow read and write speeds are not.

In summary, DVDs pre-recorded with films are usually DVD-ROMs in the DVD-Video variant. DVD-RW or DVD+RW are the most convenient for archiving your completed movies. For general data archiving, DVD-RAM may be used.

DVD authoring software

There is a wide range of applications available to enable you to create, or author, a DVD – from professional authoring to the simplest DVD presentations – and they are improving all the time. Most DVD recorders come equipped with simple software that creates basic programmes.

Software that comes with computer operating systems or is available at low cost includes Microsoft Movie Maker and Apple iDVD. These offer a fair degree of control but – most importantly – they also provide many presets and professionally created styles to help you make your discs. You do not have to worry about creating backgrounds, buttons, and windows because all are provided. However, even fully professional software applications, such as Apple DVD Studio, offer simple modes with many presets made for you. For further details, see pp. 194–7.

How DVD works

DVDs work like CDs, in that a series of tiny pits on a spiral track on a metallic surface reflect a tiny laser beam – but the resemblance ends there. DVDs space the tracks extremely tightly: just three-quarters of a millionth of a metre apart; if you could unwind the spiral it would be more than 11 km (7 miles) long. As a result, a vast amount of data can be placed on the disc. Furthermore, the data capacity can be doubled by using dual-layer technologies, in which the laser beam focuses on one or other layer at a time. By using both layers on both sides, it is possible to achieve capacities exceeding 9 GB per disc.

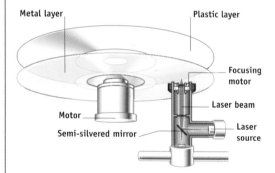

DVD mechanism
DVDs and CDs work through a close coordination between the mechanics of spinning a disc and the steady motion of the laser beam that reads the data. Correction for tiny errors in movement is a crucial part of the design.

Opto-electronics
The underside of a pre-recorded disc, with its pits and lands, is shown here. The laser beam shines on to the disc, and the flickering reflections are read by the computer or DVD player.

Setting up a workroom

Initially, your digital video workroom can be very simple, consisting of just the desk at which you have installed your computer. But as you progress, your demands for equipment will grow. Video-making spawns more technical gizmos and clutter than most pastimes, so it is a good idea to create a dedicated space in which you can work. It is also essential to be well organized, so that you can quickly find any tapes or cables that you may need.

The environment

The first and most basic requirement is often forgotten: it is the need for a darkened room with neutral-coloured walls. Cinema was born in a dark room, and nothing has changed the fundamental need to work in one. A darkened room ensures that viewing conditions such as light levels are kept constant. And the neutrality of colours ensures that your eyes will not adapt over the course of a day to a strong ambient hue, adversely affecting the accuracy of any colour corrections you make on screen. Even professionals have been caught out when they

decorated an NLE (non-linear editing) studio as if it was a domestic setting, with warm-coloured walls. The reasoning was that they should edit for a typical viewing environment. However, editors found that their images were getting colder – that is, more blue in overall tone – over the course of the day because their eyes had adapted to the ambient warm colour.

It is also important to have a comfortable chair that supports your back and is set to the correct height. This is because once you begin editing you will find yourself getting drawn in for hours – if not days – at a time. For the same reason, it is best to edit on LCD screens (*see pp. 44*) because they cause far less eyestrain than working with CRT screens. The fine labelling used in NLE software can easily cause eyestrain over a period of time.

It is also worth investing in tools that reduce strain on your "mouse hand", which will do most of the work: consider a graphics tablet or a mouse with multiple buttons. However, the best ergonomic aid – and it is free – is to use keyboard short cuts whenever possible.

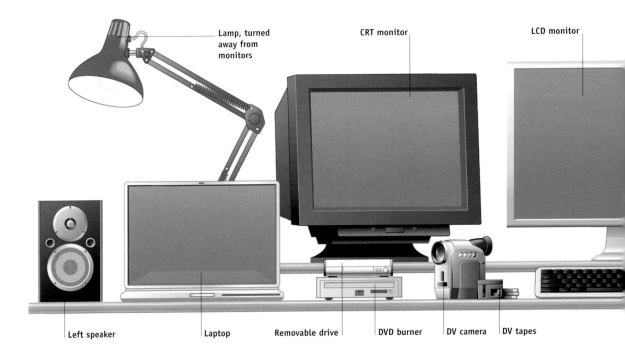

Lamp, turned away from monitors

CRT monitor

LCD monitor

Left speaker Laptop Removable drive DVD burner DV camera DV tapes

The extras

Amateur movie-making has come a long way since the days of cine film. With a typically equipped modern computer and monitor plus, of course, a digital video camera, you can shoot, edit, and disseminate complete digital movies. Some cameras can even capture broadcast transmissions that you can feed into the computer.

The first "extra" you should purchase for your workroom is additional hard disks: if these are installed internally, they will run faster and also save on desktop clutter (but they may also add to the heat and noise your computer makes).

Using a video tape recorder as the "acquire device" – that is, to run your video tape under the NLE software's control – is the best way to reduce wear and tear on your video camera's mechanisms. A second monitor is a useful extra since it increases the space available for the many palettes used by NLE software. Professionals will add a third: a CRT monitor to simulate the broadcast image. Another important monitoring device is a pair of loudspeakers – these are better than headphones, in terms of both accuracy and comfort.

●HINTS AND TIPS

"Safety first" is a good motto in the video workroom – not because the equipment is unsafe to use, but because a simple error in operation can threaten a project that has cost you much investment and effort.

● Work tidily and systematically: note down and label everything – all video tapes look the same until they are identified by labels and notes.

● Keep video tapes in their boxes to protect them from dust unless in use, and keep them away from drinks.

● Run video tapes through a machine once a year to keep them "aired" – this is said to increase their life span.

● Keep logs and actually write them up – you will save a lot of time when logging or looking for clips for stock purposes if you keep notes of every take.

● Give yourself a break. It is hard to stop in the middle of a creative flow, but you should have a stretch and walk around for a few minutes every hour. This will help in the prevention of errors.

● Back up your projects, preferably on some form of removable media. Store the back-ups in a different location from the studio. Use back-up software that can be timed to work overnight.

A dream studio

You can achieve a great deal with just the central items of camera and computer, but relatively inexpensive extras such as high-quality monitor speakers will increase your enjoyment, as well as the quality of your work. And do not forget all the back-up devices, such as a DVD burner. Existing equipment such as a VHS VCR can also be put to good use.

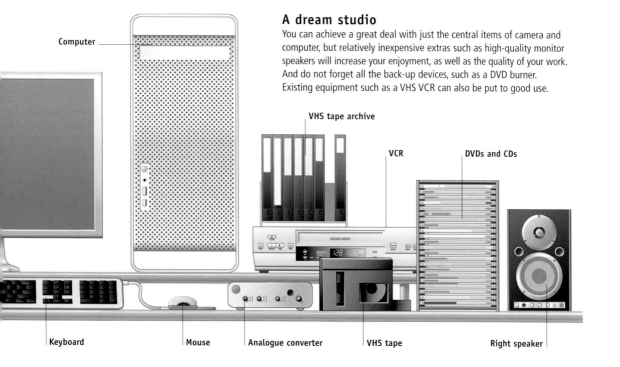

Computer

VHS tape archive

VCR

DVDs and CDs

Keyboard

Mouse

Analogue converter

VHS tape

Right speaker

2

Camera and sound techniques

Camera techniques

Great shots will make your movies stand out from the crowd. This chapter discusses composition, framing, depth of field, camera angles, and camera movements. Quick-fix solutions to some of the most common problems associated with camera handling are provided.

Digital sound

Sound must not be forgotten in the quest for impressive images. The microphone techniques and effects detailed here will help ensure clear, clean audio, while the quick-fix page offers assistance with sound issues.

Look and transitions

The use of still images and the "film look" are almost essential in creative digital video work, and these are explored here. You will also see how to transfer video to your computer – either your own recordings or those from broadcasts. The quick-fix section on copyright will help you avoid potentially costly errors.

Mastering your camera

At first sight, a digital video camera appears to be dotted with myriad randomly scattered buttons and switches. This description would bring tears to the eyes of the designers who had spent weeks, if not months, pondering where to place the buttons, their size and shape, and how much pressure they need. The design is intended to be user-friendly, with all controls easily accessible. But what makes sense to an industrial designer may not suit your way of working.

An alternative to a proliferation of buttons is a menu-driven system using an LCD touch-screen, on which "virtual" buttons respond to a fingertip touch. However, with this system, you may find it difficult to locate a particular option or to work out the meaning of abbreviations such as SMTH INT REC or D-REC. Or you may find that, even after you become familiar with the menus, a feature you use very often is inconvenient to access.

It follows, then, that you should try out a camera before you buy it. But bear in mind that you need some familiarity with it to appreciate its merits. The logic of certain ergonomics may emerge only after a few hours of using the camera.

Outgrowing automation

The complicated nature of the controls helps ensure the majority of aspiring videographers stick to automatic controls, leaving the camera to get on with the work. But allowing the camera to make decisions has many disadvantages. In summary, they are:

● Autofocus systems cannot cope with fast-moving action in which things or people move across the frame between the camera and main subject. The camera will attempt to refocus on the passing object, and the focus on the main subject will be lost when it returns to view.

● Auto-exposure systems rely on feedback loops that do not respond instantaneously: a move into a bright situation may start off overexposed then fade to correct exposure after a second or two. On the other hand, the auto-exposure may try to respond to a passing change in light, when you want to keep the exposure steady throughout the take.

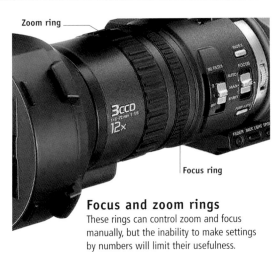

Focus and zoom rings
These rings can control zoom and focus manually, but the inability to make settings by numbers will limit their usefulness.

● Auto white balance controls may correct where you do not wish for a correction. You may wish to keep the orange colour cast of an interior scene lit by tungsten lamps, but the camera will try to create a white balance that neutralizes these atmospheric hues.

● Automatic level or gain controls for the built-in microphone work well when there is a fairly constant level of sound. But in quiet moments, microphones will pick up all the background noise – the gain control will have been raised – only to distort when there is a loud sound.

● Automatic sensitivity in the camera compensates for low light levels by increasing the amplification of the signal – this creates a picture when almost nothing is visible to the naked eye, although the

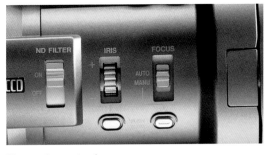

Manual controls
Autofocus can be turned off on some cameras, but the feel of the lens will not match that of proper manual-focus lenses. In addition, the extensive depth of field given by small video chips means that focusing often produces hardly any visible effect.

Types of image stabilization

Recent advances in image-stabilization technology really do help ensure a stable image, free from high-frequency movements. But with some systems there is a price to pay. Those systems that jitter the sensor itself use up some of the sensor's capacity in order to provide the space needed to correct for movement. More effective are systems that provide optical stabilization by moving a group of lenses. This solution does not compromise picture resolution.

resulting image will be grainy. You may think that you have enough light to work with because the camera continues to show the monitor picture, but the image quality may be quite unacceptable.

In short, automatic features are a superb way to ensure that you have good results when you first start shooting. As you improve and become more ambitious, however, those same features will start to hold you back.

When selecting a camera for advanced use, therefore, ensure that there is not only a manual equivalent for every important function, but also that it is easy to set and adjust. Of course, such options are found only in more advanced cameras (such as the Panasonic AGDVC-18 or 100, Canon XL2, JVC HD1, Sony DSR-PD170).

Achieving a steady shot

Cameras that are easy to travel with because they are so lightweight are poor choices for shooting with for precisely the same reason. Having bought a compact camera, it is frustrating to find that you need to make it heavier, but that is exactly what professionals do: the extra weight gives stability, which helps deliver a steady picture.

For some video-makers, the best compromise is to use a monopod, perhaps in tandem with a shoulder brace. But simply reducing vertical movements will provide a visible improvement. Another method is to use a stabilizer, rather like a monopod, with a weight at the end. The pendulum weight steadies the camera when the rig is held at the centre of gravity.

Hidden buttons
Buttons are often found under the LCD screen. Not all will be needed often, such as the zebra display, but an experienced camera operator will prefer easier access.

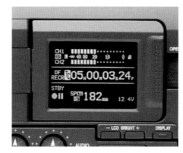

Audio display
A display of audio levels with timecode and status gives assurance to an experienced camera operator but may be confusing for the newcomer.

Audio controls
Controls on this video camera allow line levels for microphones to be controlled from the camera, together with balance between channels.

Quick fix Camera handling

Modern video technology is stable and reliable, and most problems are avoidable. Once you can identify how an error was caused – what you did or failed to do – it is easy to get it right next time.

Problem: Lens flare

Brilliant-white or coloured, disc- or lozenge-shaped spots of light appear in the viewfinder or image, or the image floods with bright light. The image appears to be too light and the colours become weak. As you pan the camera, the flare spots move in the opposite direction.

Analysis

Bright sun or light sources enter the lens at an angle and reflect off the inside of the lens, filter, or inner camera parts. This causes veiling flare (or glare), degrading the image.

Solution

Even when the sun is not visible within the image, it can still cause flare. The best solution is to use a lens hood (*see p. 35*), but an additional shade may be needed to

Reflection
Bright sunlight has shone round the lens hood and flared into the picture. At the same time, a spot of water has picked up the sunlight to reflect a focused image into the lens. It may not be perfect, but it adds a sense of brightness and warmth.

cast a shadow over the lens. Keep the sun to your back, and remove filters and other attachments. Sometimes lens flare can work in your favour if you are trying to capture a sense of heat and unbearable brightness.

Problem: Poor colour balance

Images appear to be tinged with an overall colour, such as orange or blue, in varying strengths. Attempts to correct the colour later lead to poor results.

Analysis

The perceived colour of an object can vary with the colour of the illuminating light. In normal vision, the range of correction is very wide – wider than the capacity of electronic systems. In many situations, automatic colour balance carried out by the camera is acceptable, but when it fails, it is seen in the image as strong colour casts.

Solution

When shooting strongly coloured scenes, make a manual white-balance reading. Select this option in your camera's Shooting or Set-up menu and point the camera at a neutral target, such as a white wall. In extreme situations, you can help the camera by using a filter – for example, 80B (dark blue) for domestic light. Try supplementing available light by using video lights.

Problem...

...solution

Colour correction
Under domestic lighting, everything turns cosy and warm in colour balance, but skin tones become too red. A correction of white balance improves skin tones, and other colours – as in the curtain behind – are differentiated as a result.

Problem: Movement

When you examine images from a clip, they appear to be fuzzy, with multiple outlines. The defect appears even when the camera was set on a tripod.

Analysis

Motion blur in an image is caused by movement of either the subject or camera – or both. It is often due to the effective exposure time of the video camera not being brief enough to stop action in the way you expect to see with a still image. As a result, action moving across the screen appears unsharp when viewing a single frame.

Solution

When present, motion blur is likely to appear excessive when viewed as the first frame of a clip or when you extract a still from a movie clip. However, when the clip is played, the blur seems to disappear – lost in the general action or acceptable within the context of the scene. Therefore, motion blur does not need to be corrected.

Movement blur
A moment before the eagle owl launches herself off, everything within the frame is sharp. But her movements as she flies are too fast to capture sharply on video, as seen in the second shot.

Problem: Unsharpness

The subject of the image appears unsharp, with highlights appearing as large discs of light, and the outlines of objects are indistinct.

Analysis

Unsharpness due to poor focusing is caused either by a malfunction of the autofocus or by operator error. At times, the electronics accept an unsharp image as one that is focused, because they are confused by shooting through obstacles such as water or fences. Another cause may be the imaging of bright reflections or light sources.

Problem...

Solution

If a focusing problem is persistent – that is, it occurs consistently with different situations, lens settings, and light levels – then your camera may need servicing. If you cannot see the viewfinder to focus accurately, you may need to adjust the dioptre correction of the viewfinder. Allow time for the camera to focus before starting to record; this may take several seconds. Avoid focusing on light sources or rapidly moving objects.

...solution

Correct focus
Here, we want to focus on the fish, but the camera focuses on the bubbles because they are higher-contrast targets and therefore easier to focus on. In the second shot, without distraction of bubbles, the camera can focus on the fish.

Cinematic composition

The fixed size and shape of the "film window" may appear restrictive and prescriptive, offering you no opportunity to change the proportions or shape of the frame. In fact, the opposite is true. The film window is just that – a window. But it is one that you can move around and enlarge or reduce as you wish. Through movement – implied or actual – framing for movies is infinitely more flexible and versatile than for any other medium.

Through slow panning movements, you can imply a vast, open canvas. Using tight shots from close in, you can make the viewer feel a part of the action – a technique exploited in many martial arts and action movies. And there is nothing more emotionally involving than a close-up moving slowly over a face or body.

Visualizing the canvas

One approach is to visualize the canvas that you wish to work with, then use your camera's movements and zoom, together with any cuts you might need, to draw the canvas for your viewer. For example, suppose you want to show the large atrium of a modern building. The camera lens can take in only a small fraction of the view, even at its widest zoom setting. You must plan how to give a sense of the volume and the height of the ceiling.

A simple, horizontal pan is not only boring, it only shows one level. Instead, you could track someone walking across the space, then follow them as they take a lift that rides up an exposed column to a high level, before zooming in on a small detail high in the ceiling. This sequence conveys both span and height in one continuous shot.

Creating strong images

Ideally, the image composition you should aspire to in the cinematic frame is as strong and coherent as in a still image or painting. But in a movie, the subject must have space in which to move. You can augment a strong visual impression with movement through panning or zooming.

Diagonal
A diagonal line, or one that could be drawn between principle elements, gives the most dynamism. A sweep across two axes appears to move faster and with more energy than a composition aligned solely with the horizontal or vertical.

Clean background
All objects – whether they feature elaborate or simple outlines – can benefit from being seen against an uncluttered background. Here, the lines of the rigging stand out against the plain sky and water.

Symmetrical
Where the elements of a composition are equally weighted and distributed, the psychological effects most naturally associated with it are stability, tranquillity, and calm. Symmetry can be found in natural scenes (*above*).

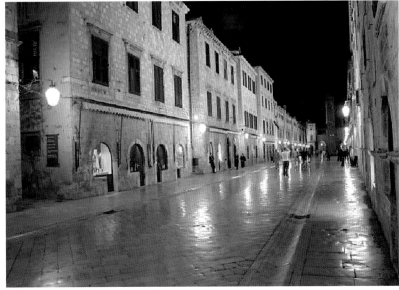

Centre of interest
Lines leading to a specific point draws the viewer's attention. If you want to lead the eye to a centre of interest, try doing it through the use of converging lines.

Framing action

Your video framing should take account of action that may take place a few moments into the take, so you should leave enough space around your subjects to capture their movements. A movement that starts outside of the frame and then appears inside can be disconcerting for the viewer, while one that starts in shot but ends out of shot can be frustrating to watch. In both instances, the problem is the lack of continuity. When you are working in a documentary or unscripted mode, or whenever you cannot fully predict which way your subject will turn, it is important to frame generously.

Composing for space

Unfortunately, the majority of amateur video-makers often leave too much space around their subject, frequently including many distracting elements. The trick, then, is to compose with generous amounts of space but without unnecessary distractions. At times, all that is required is to move slightly to one side or the other so that your subject obscures any unwanted background details in the scene.

Tracking movement

Another aspect of framing is the need to keep a subject in the middle of the frame while you are tracking its movement. Suppose you are following a bird in flight. You will find it difficult to keep the subject centred all the time. If you follow too

Allowing for movement

When videoing a pair of wallabies playing, you may be tempted to move in close. But the final frame illustrates a problem: if the subjects move suddenly in an unexpected direction, they may be cut off by the edge of the frame. Zooming out gives more space to the animals, but you lose some of the sense of involvement.

Tracking by hand

Some movements, such as a cormorant taking off (*above*), are easy to track. The hard part is keeping the bird centred. This inexpert example is partly a result of hand-holding the camera. Better results would have been achieved had the camera been mounted on a tripod and tracked with the pan/tilt arms.

Following the action

When the camera is zoomed tightly on to this ski school, the group fills the frame nicely (*above*). But what happens when they start to move off? You can start a clip with this framing, but zoom out to leave a bit more room when the skiers begin to fan out. They can then move into the space that you have allowed them (*right*). Hold the framing of the shot and let the ski group exit stage right, as it were. This will give you a timely cue to cut to another scene.

quickly, the bird will slip in the framing and could appear to be flying backwards. Worse, if the framing is too tight, then the subject will appear to be bouncing around within the frame as you try to keep up. Even modest amounts of movement show up large on the screen. Someone walking along actually bobs up and down, so if their head is too close to the top edge of the frame, either it will be chopped off or you will have to move the camera up to keep them in shot.

If, instead, you show more around the subject, its movements relative to the frame are smaller and the viewer can see more of the background. You will then find it easier to keep the subject steady in the frame.

● HINTS AND TIPS

Expert framing can make or break your movie. Some of the key points to remember are:

● For smooth tracking of irregular movement, it is best to work with a tripod.

● Hold the camera away from your body if you are walking or tracking the subject – your arms will act as shock absorbers to cushion the impact of your foot-fall.

● For unsupported tracking, heavier cameras give smoother movements. If you are using a lightweight camera, a camera stabilizer or shoulder pod will help.

● Try to give space in the frame for the subject to move into – that is, keep the subject to one side of the frame, rather than dead centre.

Framing the shot

In movie-making, perspective is far more than simply the point of view. It links a person's (or animal's) perceptions with their position, for it says, "This is what it looks like from here". Perspective puts the viewer in a position to experience, not merely to view.

That is why the approach of a hypodermic syringe as it advances towards the camera lens – as if pointing straight at the viewer – is so much more effective in expressing the fear of a soon-to-be-anaesthetized dental patient than a side view of the syringe approaching. If you are showing a field that is full of flowers, try holding the camera down near ground level instead of viewing it from your usual height: the closeness – blurred and out of focus – to the leaves and petals can be far more involving than the usual vista.

Expanding on the principle

It follows, therefore, that videoing a scene such as a family picnic or wedding reception from the same position – even with the cleverest panning and zooming effects – soon becomes rather dull. Instead, take the time to move in and out of the action. Watch a child's antics from the mother's position, but then cut and move round to watch the mother's reactions from the child's point of view. Watch an impromptu game of cricket from the side, then record through the stumps so viewers can feel as though they are the wicket keeper. Or shoot a ball game from afar, then get up close to the

ball just before it is kicked or picked up. In such a scenario as this, it is even okay to have an action coming into frame and going back out again because it is within the context of a game we all understand.

Long shot
A distant or long shot is one in which the audience can see the context and surroundings. Such a shot tends to be relaxed, leading the viewer's eye and mind to take in a general view.

Close-up
With modern zoom lenses you can home in to point out details. By then zooming back out, you can reveal to the viewer how this little detail fits into its surroundings.

Watching the crowds
Sometimes you simply need to let the scene organize itself before your eyes. Use your video camera to watch the crowds come and go. You can extract the best moments at the editing stage.

Taking it all in

From a vantage point offering such a fantastic view as this one in Dubrovnik, Croatia, you could spend the entire day bringing out its potential simply through different framings alone.

Take the time to explore the view fully. As the hours pass, the light and colours will change too. This will bring you further cinematic rewards, some of which you might expect and others you will not.

Wide close-up

The close-up wide-angle view is distorted but can be effective for a change of mood. Off-centre framing (here of a photographer at work) allows for movement, making the viewer anticipate action.

Extreme close-up

Tight framing can create a sense of intensity for the viewer, especially if held for a long time. But when working unscripted, not knowing the subject's next move, it is easy to lose framing.

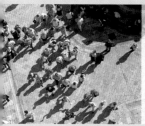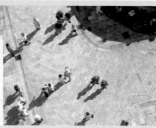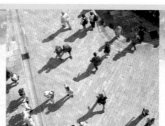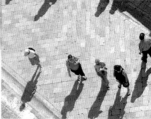

Depth of field

The term "depth of field" is used to define the measure of the extent of the scene lying in front of and behind the subject that also appears to be acceptably sharp or in focus. It is not as crucial a pictorial control in digital video-making as it is in photography. Nonetheless, the skilled videographer should be aware of the importance of depth of field, which is essential for separating subjects and movements.

Movement and distance

Because a video consists of moving images, the photographic use of depth of field to depict space and distance is reduced in importance. Indeed, rather than showing distance, it can be used to keep the viewer in suspense. For example, we focus on a sleeping child's face while, blurred in the background, a menacing figure creeps up. As the figure moves closer, the threat seems imminent... until it comes into the field of view.

Now, seen sharply, the figure turns out to be the loving mother, coming to tend to her daughter. A close-up shows mother and child together.

Large aperture, long focal length

Because feature films are made on 35 mm or even larger formats, depth of field – even with wide-angle lenses – is very limited (*see also pp. 96–7*). Therefore, limited depth of field has become one of the hallmarks of the "film look". Digital video all too easily produces a large depth of field because the sensor chips are very small, so the lenses are relatively short – even at the longest zoom settings. The easiest way to decrease depth of field

Distant depth of field

Even with the zoom set to maximum shooting under an overcast sky (so that the lens aperture was at its widest), the depth of field is extensive. The reason is that the sensor chip is very small so that the longest focal length is still relatively short – and depth of field increases rapidly with decreasing focal length.

is to use long focal lengths as much as possible. To replicate the sleeping-child example, opposite, set up the camera about 2 m (6.5 ft) away from the subject and use a long focal length to obtain a close-up of the face. Do not move close to the face to create the close-up.

Another method is to adjust the lens aperture, but, unfortunately, this option is not widely available on non-professional cameras. If you have a camera with variable lens aperture, you can decrease the depth of field by opening the aperture. Some semi-professional cameras offer f/2 maximum apertures – this is worth considering if you want to create the film look.

Greater depth of field

At its widest setting, a digital video camera lens offers good depth of field even with subjects within reaching distance. The lens is focused on the wire but the lion is still acceptably sharp.

Setting focal lengths

On consumer cameras – and even on some prosumer models – setting the focal length is a matter of pushing a switch until you obtain the visual effect you require. For serious work, the ability to set a precise focal length is invaluable for ensuring continuity of image size and other settings. For this, you need a zoom controlled by a ring set around the lens and engraved with focal-length markings, rather than a rocker or sliding switch.

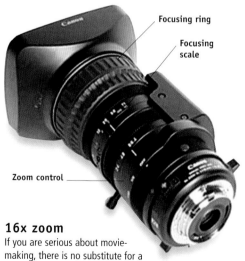

Focusing ring

Focusing scale

Zoom control

16x zoom

If you are serious about movie-making, there is no substitute for a top-of-the-range lens whose focus and zoom settings can be adjusted manually and repeated accurately, as with this lens on which focal length and distance settings are engraved.

Shallow depth of field

From the same viewing distance, but at a much longer focal length, it is evident that depth of field has decreased: the lion's face is sharp at the expense of the fencing, which is blurred.

Very shallow depth of field

With the zoom lens set at its longest setting and focused on the fence, the lion is thrown into an almost unrecognizable blur. This can be a powerful technique – called differential focusing – for exploiting the psychological effect of unfocused images.

Preparing for the shoot

So far, we have looked at composing a shot only from a static location (*see pp. 62–7*). However, to create a sense of dynamism and continuing action in the video, the shoot will benefit from the videographer moving around freely. This can be combined with panning and tracking (*see pp. 72–3*) and zooming (*see pp. 74–5*).

Needs for the shoot

Before you get to the shoot, consider your needs. This covers requirements of the shoot, ideally in the form of a shot list, as well as equipment (extra batteries, tapes, a tripod). Once at the shoot, you also need to be aware of everything that is going on, so that you can keep an eye on what may move into your frame and change your shot if necessary.

Shooting skills

When you come to record your footage, you need to combine your needs with your shooting skills to capture usable footage for your movie. You must also bear in mind the needs of the editing process. Once you are at the editing stage, you don't want to think, "Why didn't I shoot from *that* angle?"

The skills that you will need when recording your video footage are all fundamental to creating a coherent end product. They include:

- Ability to anticipate likely action. That is why wildlife cinematography is best done by experts in the animals being recorded; the same is also true for videoing sports.

- Rapid and precise focusing. This is important for unexpected changes in the action.
- A steady camera hand. The steadier your hand, the more usable footage you will have.
- Awareness of exposure consistency. Uneven exposure from one clip to another makes it impossible to achieve inconspicuous editing.

Improving your skills

Your shooting skills can be improved – to the benefit of your video-making – through practice. A playful cat or dog is ideal for perfecting your anticipation skills, as is a trip to the zoo. Changes in focus can be practised at the same time, or by trying to get close-ups at, say, a football match. A steady hand can be gained through relaxation of your body (*see p. 26*). Exposure awareness will come with increased use of your camera.

High-rise views
Looking steeply upwards while you pass tall buildings is an effective way of conveying the massive scale of architecture – in this case, that of Hong Kong. Rapid changes of view are exaggerated by the perspective and aided by the movement.

Funicular ride
When location and situation are constantly changing, it is easy to gather a good variety of shots, but do not forget the small details. Observe your fellow travellers and the light and reflections around you. The movie is then about more than just the ride.

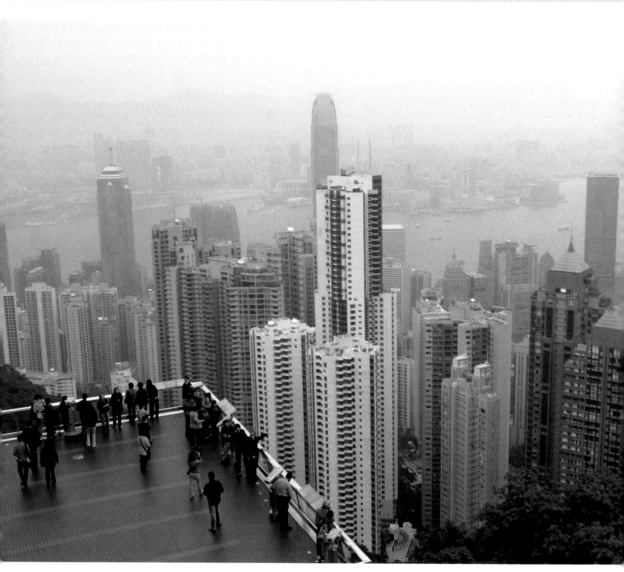

An overview

The view of Hong Kong's Peak is world-famous, having been used everywhere, from Jackie Chan movies to airline calendars, so there is little you can do to surprise an audience. It would be obvious to pan from one side to the other, or to zoom in on

details. Fortunately, the overcast, foggy day forced a different approach, emphasizing the scale of tourists against the backdrop. Starting with the overview (*above*), we cut to views from the platform (*in the sequence below*) for a change of scale.

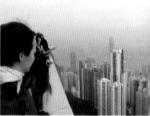

Shooting for variety

It is a good idea to shoot a scene from as many different angles as possible. This may call for both planning and anticipation. Planning your camera angles – that is, working with a sequence of perspective changes between normal, high, and low positions – is an important part of executing a shoot. A variety of camera angles creates changes in tension and pace even where there are no other changes in composition or lighting.

Variety when shooting also generates options in editing – it can be frustrating to find yourself short of footage once you enter the post-production stage. And remember: the least expensive part of the entire exercise is digital video tape. You will also enjoy videoing much more if you move around and actively search for shots.

Camera height

It is natural to shoot from the most comfortable position – usually standing or from a tripod set to a little below head level. But shooting everything from the same height can cause your movie to become monotonous. Indeed, it may be appropriate for certain subjects to be shot from a lower or higher level. Videoing from above gives the viewer a sense of observation; this makes it an ideal way in which to set a scene, perhaps before cutting right in to the action.

It is always possible to shoot from a low level: simply crouch or lie down. This is almost always more dramatic when covering movement.

Involving the viewer

A group of children working off their energy makes a lively subject. It is easy to record from a distance, but getting into the action – holding the camera low – as well as following events from a greater distance is rewarding and fun.

The swivel screen

The swivelling or hinged LCD screen – present on the majority of consumer video cameras – has been a great invention for the video-maker. Since it can swing out to be adjusted to allow you to hold the camera at arm's length in any position, you can shoot low down, overhead, or to one side, and monitor your shooting in ways impossible with a viewfinder dependent on an eyepiece. So there is no excuse for not exploiting variety in perspective. Try practising with making full use of the screen's movements so you become familiar with its possibilities.

DV camera with swivel screen

Think of the old cowboy movies in which the horses thunder past with their hooves just inches away from the camera. The immediacy of the action depends on a low camera position set close to the action.

By using a camera with a swivelling LCD screen, you can continue to monitor what you are shooting even with the camera at ground level. The trick is to keep the camera steady: keep the arms extended, firmly but not too tightly tensed, and try at all times to move smoothly and slowly. It can help to keep the neck strap as taut as possible against your neck.

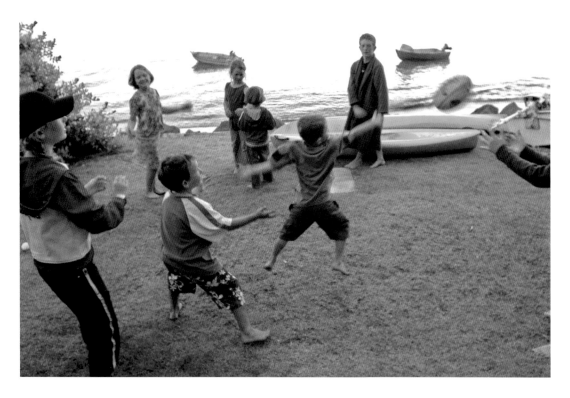

Capturing fast-moving action
It can be tiring to follow all the action continually. Often it is better to hold a steady wide-angle view, such as here, and allow the action to move in and out of frame.

Visibility and safety

In the search for creative camera angles, consider the safety of yourself and those around you. People coming towards you may not see you if you are crouching. Being near to fast-moving vehicles is dangerous and increases exposure to splashes or stones being thrown up from the road. If you must have the shot, leave the camera on a tripod and move to a safe distance.

Following movement

There are three ways to follow moving action. Panning imitates a person's eyes following the action: it is a steady, rolling shot in which the distance between subject and camera changes. Tracking follows the path of a subject, moving in parallel and keeping at the same distance; for this, the camera needs to be on a mobile platform. Either of these movements may be combined with zooming, which can keep a subject at the same size by changing the field of view as it moves (see also pp. 74–5).

Zooming

A zoom is a change in field of view that makes it seem as though the camera is getting closer to or further from the subject. When shooting, the zoom is a good way to move into the detail of a scene after starting with an overview. In the days of linear film editing, it provided a simple transition effect that anyone could do. And they did. As a result, zooming has become overused – and this overuse is a sure sign of a novice camera operator.

Stepping in and pulling out

The easiest way to distinguish yourself from a million other videographers is to step in, rather than zoom in. That is, instead of increasing the focal length in an unbroken sequence to zoom in, do it in large, distinct steps. This is more interesting for the viewer because it adds an element of surprise. Suppose you are videoing a carpenter

at work: you start with the scene-setting shot, then cut to a zoomed view of the tools hanging on the wall, perhaps with the worker just in view. Another cut takes you closer to the worker, showing their posture and the effort they are putting into their work. With the next cut, the viewer is zoomed right into the action – a close-up of the chisel cutting curling slivers of wood. You are trying to mimic a normal visual experience: you take in the scene, your eye is distracted by one thing, you look at something else, then you change your focus to get in close to what really interests you.

Zooming out

We can reverse the usual take on a scene by starting with a zoom into a detail (*right*). This leaves the audience wondering, "Where are we and what is going on?" In this shot, a very young and lonely kayaker could be in trouble in the middle of a huge lake. But a rapid pull back out of the scene puts her into context (*below*) and reveals that she is in no danger, after all.

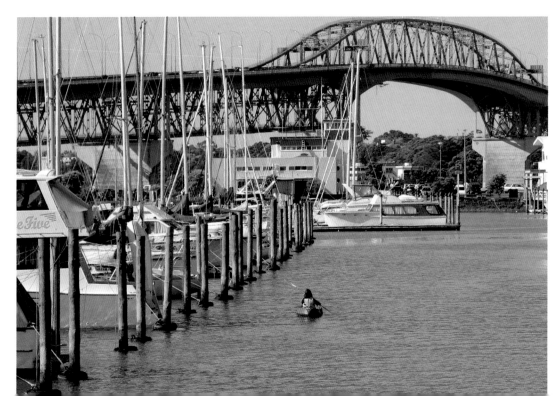

Panning zoom
Zooming can be combined with panning, as shown in the sequence above. An establishing shot (*left*) shows the marina,

before the second shot is achieved through a pan to the right while zooming in. For the final shot in the sequence there is no need for any more panning but the

zoom continues, showing the moored vessel (*right*). Coordinating the speed of the pan with zoom action can be tricky, so do a practice run or two before shooting.

Whip zooming

Experienced camera operators favour the whip zoom, which is the fastest possible zooming. This technique simplifies the editing process, since the zoom movement can be either cut easily or used directly. However, whip zooming requires a manual zoom lever, which is generally found only on professional cameras. You can work around the lack of a zoom lever by first shooting a wide view – an example might be the quiet marina opposite. Next, stop shooting, zoom to a close view of a young kayaker on the water,

and start taping again. When the sequence is cut together, the transition created makes it look as though you whip zoomed. You can follow the same unpredictable pattern when using the opposite movement, pulling out.

Combating camera shake

At the short focal-length settings of the zoom, hand-held work is fine, since small movements are barely noticeable. But with increased focal length, camera shake is a bigger problem. It is always best to have a tripod with you, just in case.

Digital zoom

Modern digital video cameras offer zoom ranges from a modest 10x to a huge 880x. If the latter seems too good to be true, that is because it is. Most cameras offer true optical zoom of up to about 10x – that is, the longest focal length is ten times longer than the shortest. The rest of the range is provided by digital processing: the digital zoom enlarges the central portion of the image. Quality drops rapidly, and beyond about twice the longest optical focal length, image quality is poor (*see pp. 22–3*).

Zoom comparisons
It is clear at a glance that the results from a digital zoom (*above right*) are markedly inferior to those from a true optical zoom (*above left*). At 120x, the image is 12 times

enlarged from a zoom lens at its longest focal length (10x the shortest): 20x may produce acceptable quality, but much greater enlargements magnify image defects that were barely visible at 10x.

Camerawork continuity

The strength of a movie's narrative line depends on its continuity. This does not mean that every scene has to be connected, or that sudden breaks or jump cuts are never to be attempted; nor even that events should be shown in sequence, in the order in which they occurred. Indeed, there is a discernible fashion in film-making, encouraged by films such as *Pulp Fiction*, to place scenes out of chronological order. But continuity does mean that changes from one scene to another should move the action on, follow the logic of the story, and, above all, not distract the viewer. As an obvious example, if you were to show a man entering a car, then cut to a short sequence on the road before he exits the car, when he re-emerges, he must be wearing the same clothes; if not, the lack of continuity will make the scene confusing for the viewer.

On the other hand, suppose you film a bride and bridesmaids entering a room and they close the door on you. In the next scene, the bride emerges from the door in different clothes. Here, the discontinuity makes sense: now she has changed for her journey – a symbolic shedding of the past – and it is not necessary to show any interim action.

Continuity should be maintained in two distinct areas. Screenplay continuity will be considered on pp. 218–23. In this section, we look at continuity in camerawork.

Focus and framing

Maintain your focus from one take to another, particularly when videoing people. If your focus is on the nearest eye, it should remain so even if the subject moves in the next take. And if you frame to contain the head and shoulders, change to a tighter view only for a specific reason – maybe to provide options in editing. When you return to your original framing, ensure you go back to the original focal length. Only extremely costly professional lenses have focal-length markings, so you will most likely need to use "markers" in the subject – for example, noting that the left frame is just beyond the right shoulder, or the right frame nearly touches the edge of a table just out of shot.

Colour

Changes in white balance signal to the viewer a change in circumstances in line with the variation in lighting. It is okay for the white balance to shift to yellow-red when the action moves from outdoors into a building. But if the shift occurs for no obvious reason, the on-screen effect is unsettling. There is a common reason for the change. When you are filming someone on an overcast day, the white balance tends to be quite cool; but if the sun suddenly appears, there will be a change in colour temperature and the scene will look warmer. Off-screen, the sun coming out is not visible, but the change in white balance will be, often accompanied by a slight rise in contrast. The lack of continuity here is an example of the principle of motivating the light (*see pp. 110–17*).

Exposure

You need to maintain an even exposure level between shots. This is difficult to achieve if you work in differing environments – moving from, say, an office to outdoors. The more carefully you shoot, the less exposure correction will be needed in post-production, and the easier it will be to match takes so the edit points are less obvious. Poor exposure consistency is often a cause of poor colour – so even if you match exposure across takes, colour variations may still spoil continuity.

Light and contrast

Distinct from exposure and colour control, you should also maintain the lighting style and the contrast when shooting different angles of the same scene. This is particularly important when you have to interrupt an interview shoot and reconvene at another date. Make precise notes of the lighting set-up – where the light-stands are positioned, height of lamp, light-shaper used, and strength of light – so that you can reproduce the lighting conditions. Failure to do this will, at best, force the editor (or you) into an "A-mode" edit – working with scenes in the order they were shot. At worse, interview footage from different shoots will have to be treated as separate interviews.

Colour continuity

These dazzling jewellery displays appear white to the eye, but the large expanse of overcast lighting – weakly blue and dominant – causes the digital video to see them differently: the camera has rendered the displays strongly yellowed (*above left*). With a different angle (*right*), where most of the light is from the display, the camera responds with a whiter, compensating balance.

Exposure continuity

Deep in a souk in Marrakech, Morocco, the light is stunning and alluring – but it also presents a tremendous technical challenge. Here is evidence that the combination of camera operator and camera was not up to the task: the variations in exposure from one take (*above left*) to another (*right*) are evident and can only be corrected later in post-production.

Light and contrast continuity

Colour balance and contrast can be matched with filters and white-balance adjustments, and you can get away with small inconsistencies in perspective, but you cannot correct them all at the same time. Here, the biggest continuity problem is the soft light when the sun is not out, compared to the contrasty light and clearly defined forms when it is out.

Using a tripod

A good tripod can be an asset for both still and action videoing. When using a tripod, it must be set up with more care for videoing than for stills photography. This is because you will be moving the camera while recording, and you will want the movements to be smooth. The key is to set the tripod up so that it is perfectly horizontal, for which purpose a built-in spirit level is invaluable. For notes on which tripods to choose, see pp. 38–9.

Making usage simple

However well made or designed, a tripod is fundamentally awkward, but there are a few tips that make it easier to use. When extending the legs, start at the top for the sturdiest result: release the top-most lock to extend the first – and usually thickest – section. Fully extend the top section of all legs and lock them, then extend the lower section of the legs until the tripod head is at the height you need. If the tripod has an adjustable central column, extend the legs to just below the height you need, then raise – but do not fully extend – the column. Finally, extend the lower section of the legs to reach the height you need.

To level the tripod when you are on a slope, turn it so that one leg points uphill. Release the lock on that leg's bottom section and push the tripod on the leg while watching the spirit level.

To retract the legs, start at the bottom, releasing the locks to telescope all the sections together. You can then lock them as a group.

Spikes and tips

Good-quality tripods offer a choice of feet: metal spikes or rubber tips. Rubber is kind to wooden floors but is not as stable on uneven outdoor surfaces. In most situations, stability is assured with metal tips, which grip the ground securely.

Silent observation

A tripod is the ideal way to watch unobtrusively from a distance. Since the action below takes place against a static background, any camera movement is very apparent and will be exaggerated by long focal lengths.

●HINTS AND TIPS

The following pointers will help you make the most of your tripod and improve your movies.

● Always use the pan handles to adjust position; never push or pull on the camera itself.

● Check the spirit level each time you move the tripod.

● Do not extend the central column to its fullest extent – you will lose steadiness.

● Set the tripod so that the pan is perfectly horizontal; that is, as it traverses the horizon, it does not track upwards or down.

● Spread the legs out as far as possible – this maximizes stability.

● Ensure the locking screws on the head are loose enough to allow smooth panning, but tight enough to hold the camera in position.

● Do not move too quickly in any direction, unless you are trying to achieve a specific effect.

● When working in a crowded or cramped location, bring the legs of the tripod together to use it like a monopod – this is better than no support at all.

Tripod restrictions

There are some locations where you will not be able to use a tripod. Most shopping malls, for example, ban their use without a permit. On these occasions, you will need a micro, or table, tripod rested on your chest while you lean against a support.

Reduced camera shake

A tripod is essential for camerawork when you set a very long focal-length lens to watch unfolding events, such as a family arriving at the beach and preparing for the day ahead. Camera shake, when greatly magnified, is unpleasant for the viewer.

Working with digital sound

Although the visual element of a movie tends to steal the limelight, it should not be forgotten that all great movies have a great soundtrack. And no film is truly silent; even so-called silent movies were originally presented with music, played by a pianist in the theatre.

Unnoticed by all but hi-fi lovers, the digital revolution in sound recording is every bit as remarkable as it is in digital video and photography. It is simply not so dramatic or high profile, but it has brought true high-fidelity sound to the high street and desktop, where it was previously the preserve of professional recording studios and those with large budgets. Nonetheless, sound is often the weak link in an amateur production. Good sound is vital to the success of a movie, and it depends on parallel skills of discernment and technical competence, just as the visual side does.

The audio chain

Because digital video is a multimedia experience – combining vision with sound – running parallel to the imaging chain is the audio or sound chain.

The quality of sound recording should be appropriate to both the movie and the audience. A documentary on guitar playing obviously deserves the best quality possible, whereas it is less important for a compilation of police-car chases.

As with the imaging chain, the weakest link in the chain sets the ceiling on the quality attainable by the entire system. If in doubt, consult a sound

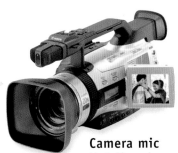

Camera mic
Most video-makers, especially when starting out, will use the camera microphone or connect their microphone directly to the video camera.

The source
It starts with the sounds emanating from a scene or environment. As with an image, you can choose to capture all of it – like a wide-angle view – with a microphone that records over a wide reach, or you can home in on particular sound sources – as with a telephoto view – cutting out peripheral sounds.

Mixing desk
Optionally, the microphone is connected to a mixing or routing device which balances or combines different sources before sending the resultant signal to the recording device.

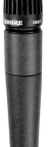

Microphone
The sounds are converted by the microphone into electronic signals.

Cables
These carry the signals from the microphone to one of a number of possible destinations.

professional to ensure that you balance the quality of your cables with that of your microphone and that of the mixers, and so on.

Transparent sound

One reasons that developments in sound may not have been noticed is that a professional sound person wants their work to be "unnoticed". Sound is noticed only when it is poorly mixed, at the wrong level, or is inappropriate. A good soundtrack is simply an integral part of the whole experience. Just as with continuity, sound is noticed only when it is wrong and it distracts the audience.

Great sound is, therefore, transparent – its workings are not visible to the audience. Listen to a fight scene in a martial arts movie with your eyes closed: a good one sounds chaotic and unpredictable, like a real fight. A poorly made movie soundtrack sounds like a bunch of people randomly grunting and making whooshing noises while they kick punchbags. The transparent soundtrack is not noticed, it is enjoyed.

HINTS AND TIPS

To endow your movie with great background sound, you first have to know how to find and capture it.
● When you scout a location prior to shooting, check for ambient noise and sounds as well.
● When assessing the sounds of a place, close your eyes to listen.
● When preparing for a shoot, carry out a sound check.
● Always record at least a minute of ambient noise.

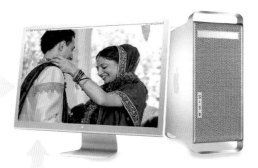

Computer
Together with the movie, the sound is next downloaded to a computer, where it can be mixed or combined with other soundtracks and edited along with the video clips. At the same time, the sound can be processed like any other digital file, to clean up noise and correct the levels so that they match from one edit to the next.

DVD writer
Once the soundtrack has been encoded together with the footage, it can be burnt on to a DVD. Once in this form, you can post copies out to family, friends, and people who contributed to the project.

Sound recorder
Some video-makers prefer to record their sound direct to DAT or MiniDisc. This process can also be carried out by wireless transmission.

Speakers or headphones
Finally, the DVD or other source of the movie is played, with the sound coming out through speakers or headphones.

Using a microphone

It goes almost without saying that the easiest way to use a microphone is also the way to obtain the least satisfactory results. But, as a solo operator – director of photography, producer, continuity, and gaffer all in one – you may have no choice. You will not be able to operate the camera and carry a microphone on a boom, so you will have to attach it to the camera. However, it is very disappointing to find that although you have shot a great sequence, you have recorded a distorted and noisy soundtrack.

The challenge is to get the best out of a camera-mounted microphone. This means placing the microphone as far away from the camera as possible, with a restricted or super-cardioid acceptance, so that its sound recording is fairly directional. If your camera will accept a balanced line input, use a short gun-type microphone feeding a balanced line to the camera.

Hums and buzzes

The most common reason for poor sound is interference from other equipment causing clicks, hums, or buzzing noises. Clicks may be caused by poor-quality switches or damaged sockets. Hums and buzzing could be caused by anything from items of electrical equipment being placed too close together, to equipment such as generators in the street outside, or electrical cable being placed too close or parallel to sound cables: sound and electric cables should run at right angles to each other. Faulty cables or connectors can also cause a number of problems – from clipped or attenuated recordings, to interrupted sound and crackling.

It may seem straightforward to find and isolate these problems, but on location it can be very tricky indeed to track down and eliminate the source of interference. Only experience will help you diagnose the problem and find a suitable remedy quickly. But one thing is certain: if you do not sort the problem at source, you will have even more problems during post-production.

Another potential problem is the "third-man" effect. You can spend hours working out the positioning of microphones and levels to cut out background noise only to discover that the camera makes a noise too. Or that the addition of extra bodies or equipment changes the pattern of noise. The lesson here is that you should test for sound only when everything and everyone is in place.

Noisy backgrounds

When you are working in noisy environments, such as in a nightclub, near a busy road, or in a school playground, you have to confront two further problems. The first is auditory

On-camera sound
Sometimes – while covering a wedding, for example – there is no alternative to recording sound from the camera position. If there is a separate sound system being used – as here, the speaker is addressing to a large party outside – it may be possible to record that sound separately to be incorporated during editing. This cameraman has a microphone mounted above the camera lens on a short boom, and the box on top is a portable light.

Sound report
A well-trained recordist makes a sound report of every take captured on set, with notes of the slate number, conditions, quality, and duration. Such discipline is vital in a double-system recording, in which audio is recorded separately from video.

perspective – that is, how to ensure that the dominant sound stays close to the subject. Suppose you are filming a child unwrapping a sweet in the playground and you want the sounds of the wrapper being torn. If you record from too far away – for example, from the camera position – the soundtrack captures the wrapper's sound only distantly, so it will be drowned out by the ambient noise, such as children shouting. The solution is to record close up, using a separate microphone.

The second problem is how to control levels between cuts, to avoid the soundtrack changing abruptly and unpleasantly. When taping in a school playground, you may stop recording just as a child's raised voise is suddenly heard above the general background noise. One solution is to ensure that a cut and its accompanying change of soundtrack mutually support each other. The classic cut is the closing door. As the door into school shuts, the sounds of the playground diminish. You can also use sound to convey emotional change, so that as the child becomes absorbed in enjoying her treat, the playground sounds recede. However these solutions restrict the sequences you can make. Another solution is to record the background noise separately, and add it to the edit as necessary. We will look at this option in more depth on the next page.

Balanced output

Microphones capable of good-quality capture will use balanced line inputs, whereas the majority of digital video cameras accept only unbalanced inputs. So if you wish to use a good microphone you need an adapter that takes balanced inputs and outputs a two-channel unbalanced signal. Sometimes called impedance-conversion boxes or routing devices, these adapters may also offer a pre-amplifier to boost the microphone signal, as well as some level controls.

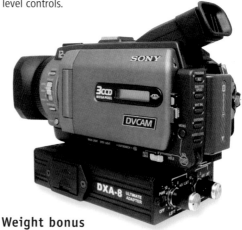

Weight bonus
Impedance-conversion boxes are small enough to fit under a camera, using the tripod socket. On small cameras, this usefully adds to the bulk, facilitating a steadier shot.

Using a microphone continued

Sound effects

Given the ability of sound to reinforce a mood or emotion, one of the most effective ways of improving the impact of your video is by using sound effects. These can occur on screen or off, and can be naturally occurring at the time of shooting or recorded separately. The sounds could be recorded specially for the movie, and they could even be created through digital sound manipulation. It is easiest to record sound effects at the time of videoing, or close to it. For example, the sound of teacups clinking on china during a tea party is likely to be recorded together with conversation.

For the best possible sound effect, you may want the teacup-clinking sound to be recorded "clean" – that is, without any, or with reduced, ambient noise. This is known as recording a wild track – when the camera is not running at the same time as the sound. It is prudent to make as many recordings while on location as you can: the sound is then authentic, and you will not, for example, have to search for suitable teacups later.

Room tone

Nowhere is completely silent: even in the middle of the desert at night, the slightest breeze makes a singing in the sand. While trying to record exciting and beautiful sounds, it is also important to record room tone, or a buzz track – all the soft indistinguishable background noises that arise from life in the space, such as the distant and barely audible ticking of a clock or the rustle of leaves in the wind. You will need some of this for setting atmosphere and during sound editing because sudden noises such as a bird chirping or a dog barking cannot be simply erased – they must be replaced with room tone.

Foley sound

Recording foley sound – artificially made after filming, then edited to coincide with film action – is an art in itself. Seen, or rather heard, in almost every movie, but never noticed, it is custom-made sound to accompany perfectly the on-screen action – footsteps on a driveway, for example, or the jangle of a bunch of keys. Named after Jack Foley,

Using a zeppelin

A microphone that is fully enclosed is the best – if the most cumbersome – method of recording ambient sound and that of the talent. Here, the recordist is taking both a monologue and the sound of the actor walking across the room. Zeppelins offer another advantage much appreciated by sound recordists: they give precious microphones excellent protection against the knocks of production.

a sound engineer at Universal Studios in the 1930s, specialists in foley are called foley artists. They know just the right way to hit a saucepan to make the right clang, just how to walk on gravel so that it sounds like a detective creeping up to a window.

Simple effects like the amplified thumping of a heart, the unzipping of a jacket, and the crunch of tarmac as a car comes to a stop are all easily obtained, and using them is an effective way to give a professional dimension to your movie. For more elaborate sound effects – an explosion, police sirens, or a party, for example – "library sounds" can be purchased on CD.

Hard and soft effects

While sounds are always associated with action in the movie, that action can be off screen (a scream in the darkness) or on screen (someone stirring a cup of tea). Off-screen sounds of, say, birdsong or falling rain represent extreme examples of a soft effect, one in which the timing does not have to be matched with any precision to the video. Any sound effects that need to be timed to

coincide with on-screen action is known as a hard effect – due to the fact that it is hard to synchronize the sound with the action.

It is helpful to recognize that synchronization means different things according to the action depicted. For instance, the clinking noise of a knife being placed on a plate should synchronize precisely with the action. But the startled look of an actor at the sound of a friend calling him should follow after a delay. A simultaneous response may make the viewer think that the call was expected. Thus, two completely contrasting readings turn on just a fraction of a second.

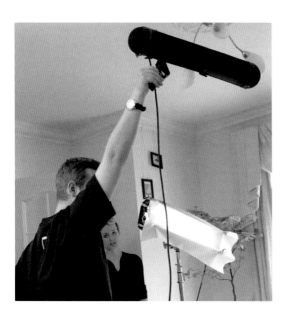

Locating the microphone
The sound recordist has instructed the microphone handler to try recording the sound from a variety of positions in order to discover the best recording perspective – that is, one that is analogous with the need to find the best visual perspective.

Using recorded music

Music is a most powerful way to create a specific mood, build tension, or close gracefully. And with so much great music in existence, there is sure to be something that would be perfect for your movie. Sometimes, the music can become as memorable as the film or more so. To many people, *Brief Encounter* is inseparable from Rachmaninov's second piano concerto, and even if you play *The Good, the Bad and the Ugly* with the sound off, you can still almost hear Ennio Morricone's haunting theme music. Certain movie genres are also defined by the type of soundtrack – rousing orchestral themes are typical of big-budget science fiction (*Star Wars*, for example), while the Danny Elfman scores for Tim Burton's films encapsulate perfectly the fairy-tale qualities of the stories.

So be bold – if you like a piece of music and it works well with your movie, use it. Even seemingly inappropriate music can be used for comic effect: the love duet from Puccini's *La Bohème* for the meeting of two toddlers, perhaps? Or Wagner's *Ride of the Valkyries* playing to the first outing in the new car? The combination of movie and music is so potent that it is wise to test their effect on a favoured few before showing your work more publicly. You may think your choices are faultless, but you do not want viewers falling off their seats with derisive laughter. Beware that when you use commercially available music, you are infringing copyright – in some legislations even if you do it solely for your own private use (*for more details, see pp. 252–5*).

Commissioning music

With musicians of all persuasions enjoying wide access to digital sound samples and composing software, commissioning or composing your own movie music is now a viable option. You may be able to find a young composer who is willing to write for you in return for a small fee and a slice of any profits. By using electronic keyboards and sound synthesizers you can cancel out the need for a band or orchestra to play the music. And by commissioning it, you can ensure that the music perfectly fits the mood you wish to create. Better

Film soundtracks

Unlike on digital video, the soundtracks on film motion pictures are optical recordings. Audio recorded on tape is used to modulate the intensity of a beam of light that is focused on to the moving film, synchronized to the frames. The film is then chemically processed. On playback, a steady beam of light is shone through the soundtrack, which is now a row of light and dark patches. As the film moves across the light beam, the beam is modulated by the soundtrack. The variations are picked up by photocells, whose output activates a loudspeaker.

still, if the music is composed once the editing is complete or nearly completed, the length can be matched perfectly to the edits, meaning there is no need to trim or stretch pre-recorded music to make it fit your movie.

If you choose to commission music, be clear about the rights you are obtaining for the work, but allow the composer to retain overall copyright so that he or she can use the work elsewhere.

Royalty-free tracks

It is possible to purchase CDs with hours of royalty-free music – which means you can use the music without any further payment. There may be some restrictions on high-profile use, such as for advertising jingles, but for the rest of us, these CDs provide a rich resource from which music can be used and elements may be extracted (to obtain the rhythm and beat, for example) and sampled for reconstruction. Music may be stored as MP3 files, giving many hours per CD, but higher-quality productions use CD-quality audio, meaning that less music can be held on each disc. For video work, MP3 quality is more than adequate.

Royalty-free CDs also offer a huge resource of sound effects – from forest atmospherics, to high-tech clicks and beeps and industrial noises. The sound quality of these is likely to be far superior to anything you could record yourself.

Quick fix Problems with sound

One of the challenges of digital video is that you need to master a number of different technical disciplines. Entire books have been published on sound recording alone. On this page, we cover some of the most common playback problems you are likely to encounter.

Problem	Analysis and solution
There is too much "noise" (background hiss), making it hard to hear the audio clearly.	You recorded at too low a level, so when you raised the volume for playback, you also raised the noise level (*see diagrams below*). Record at the highest level that does not distort, and lower the volume on playback to reduce noise.
Noise levels vary from take to take.	Your sound recordist was not paying close enough attention. This can be avoided by ensuring that the headphones used cut out all but recorded sound.
There is sudden unwanted sound, such as a dog barking or a door slamming.	This has to be dealt with in postproduction. With the recording imported and on the video timeline, reduce the volume to zero on the soundtrack at the start of the noise and return it to normal afterwards. Next, copy a clip of room tone of the same duration as the noise and lay it over the noise.
Sounds that can be heard in stereo cannot be heard when played back in mono.	The signals are out of phase. Somewhere in the system, wires were literally crossed, possibly where adapter jacks were used. Always check all of your cables carefully.
There is too much echo in the room, and it interferes with the clarity of voices.	The microphone is too far from the people speaking, so it is also recording too much room tone, creating an echo effect. Place it as close to your subjects as possible, without it appearing in shot, or use clip-on microphones.

Getting sound levels right

All recording will contain noise. The strategy is to separate the audio level from the noise level as far as possible.

The first diagram illustrates that when the audio level is recorded as high as the system will take it without introducing distortion, on playback the audio level is reduced, which also reduces the noise.

If the audio level is set too low, the sound is recorded together with the noise. When raised to proper playback levels, the noise level is amplified too.

If the audio level is recorded too high, loud noises and very high frequencies are lost and not regained on playback: notice the flattened peaks of the waves.

Recording

High level recording without distortion

Low audio signal

Recorded too high: cutoffs and distortion

Playback

Low noise: undistorted audio signal

High noise: interferes with audio signal

Low noise but distorted audio signal

Transitional methods

Many video enthusiasts have very large collections of VHS tapes of family holidays, birthdays, and parties, and these take up a lot of shelf space. In the past, you may not have considered attempting to edit the footage since it would be a difficult and costly exercise. Now you have access to digital video, that has all changed. Not only can you edit your holiday tapes at long last, you can also archive the footage in a compact form – the DVD.

Analogue to digital

Analogue capture is the video equivalent of scanning old photographs to work on them on a computer. Old video content, typically VHS tape, can be easily converted by playing the tape in your VHS recorder through a box that codes the signal in a digital format.

Another source of footage could be an old analogue camcorder producing composite or S-Video outputs. This kind of equipment is supported by software such Windows XP provided the output is fed into the computer through a compatible device such as those available from Pinnacle or Viewcast. The range starts with small devices – such as the Viewcast Osprey-50, Eskape MyCapture or MyVideo, or the Dazzle DVC-90 – that interface between the video source and the computer's USB input.

> ### ●ADVANTAGES OF DVD
>
> The advantages of DVD over VHS are that it:
> - Is more compact and holds more material.
> - Is more durable.
> - Offers better image quality.
> - Offers random access.
> - Can be navigated easily through the chapters that are used to subdivide the movie.
> - Can be viewed on a computer; most modern computers come with DVD players already installed.
> - Can be programmed with interactive features and extra material running parallel with the movie.
> - Takes up less room on your shelf.

More powerful solutions, although a little more costly, are expansion cards fitted into the circuit boards inside the computer. These deliver higher quality (and therefore larger pictures) and improved speeds of operation. It is not necessary to buy special software, since Movie Maker, which is bundled with Windows XP, will capture from these devices, as will the Mac equivalent iMovie.

If possible, choose S-Video over composite: its image quality is superior because of the separation of signals. However, cards accepting S-Video may be more costly.

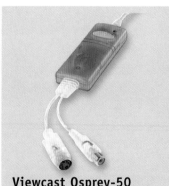

Viewcast Osprey-50
This tiny device takes a composite or S-Video input and outputs to a USB video-capture device for those encoding situations that require the convenience of portability on a laptop.

Eskape MyCapture II
This USB device supports all three principal formats, capturing 320 x 240 pixels at 30 fps with NTSC or 384 x 288 at 25 fps with PAL/SECAM using compression.

Eye TV
Desktop boxes such as this allow you to watch broadcast TV on your computer, also enabling you to record broadcasts to a hard disk for later viewing.

Capturing broadcasts

Another major source of analogue video signals – though not for long if governments in the northern hemisphere have their way – is terrestrial broadcasts from TV stations. There are many desktop units that will tune in to a TV station using either their own aerials or a TV aerial, decode the signal, and pass down a digital stream to the computer. This means you can store TV programmes on your computer to watch at any time. Not surprisingly, this solution is rapidly replacing the cumbersome VHS tape machine for many enthusiasts.

The TV programmes you record will then be in MPEG form (*see p. 23*), which makes them accessible to your editing software. However, do be careful not to breach the copyrights of the owners of the programmes; this applies equally to public-broadcast services as it does to commercial stations.

Legality of recording broadcasts

In the majority of countries, it is legal to record TV broadcasts for your own private use. However, check with your own local legal advisers if you are in any doubt, and certainly if you intend to show your recordings to anyone apart from your immediate family within your

Synchronization problems

When you capture analogue video together with the soundtrack, the two tracks may drift out of synchronization so that the closing of a door or somebody speaking is not heard at the same time as it is seen to occur. Prevention is far easier than cure: to minimize problems, devote all your computer's resources to the task of capture by shutting down all other programs.

own home. Note that in some legislations, such as the European Union, if you use the recordings for some future commercial purpose – to research plot lines for a feature film, for example – you enter a grey area of law and may be expected to pay some licence fees. Furthermore, if you show the recording to a group of people that is not made up of immediate family or friends, some legislations may hold you to be projecting to the public and so require the payment of licence fees. Finally, if it is illegal in your country to receive a particular broadcast – say from a certain satellite or cable station – then you can be sure it is also illegal to record such a broadcast.

Media Center PCs

Microsoft has set up a standard for PC hardware and software called Media Center PC. Machines that comply with the standard offer, among many other features, a tuner to accept TV signals from satellite, antenna, or cable sources, as well as a hardware encoder to capture TV signals to be saved to the computer. In addition, there are video outputs allowing the viewing of results on a TV screen as well as audio in and out sockets. All of this is run through Windows XP Media Center software, which combines the operating system with a number of applications, including those for editing video and authoring DVDs.

Home Media Center
Following in the footsteps of Apple Mac computers, which have long been able to handle multimedia, modern Windows machines now offer integrated multimedia facilities.

Using still images

Sometimes, you may want to incorporate a still image into your movie. When faced with using a still image, many video-makers allow the camera to roam all over the image; this is not the same as animating the print (*see Stop-frame animation, opposite*). The roaming is intended to imitate the way one might inspect a picture: first to pan or look over the picture, then to zoom in a detail that catches the eye – just like starting with an establishing shot, then moving in.

More often that not, the image is likely to be a photograph, but you could also use a painting, a book, or a map. This technique, when used with a map, can be used to show the course of a journey, while many movies of fairy tales begin with the opening of a big book, with the camera moving into the picture on the first page.

Using a rostrum camera

In the past, this roaming effect was achieved by using an instrument called a rostrum camera, a mounted camera pointing at a freely movable

Maintaining quality

A zoom-in from a full-resolution image is still captured at video resolution, but since it involves an interpolation down from a large file, rather than interpolating up from a small file, image quality is far superior. This is the kind of result delivered by proper pan-and-zoom software.

stage, on which a print was mounted. The camera was set to film as the print was moved around with one hand and the zoom operated with the other. Indeed, this may still be the simplest way to liven up video of a photograph if you do not

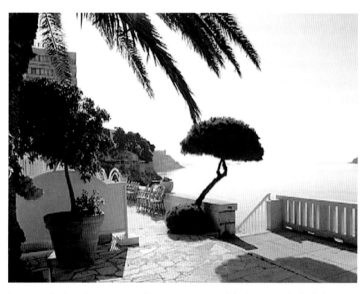

Pan and zoom made easy

If you shot a still picture but no video footage of this landscape, for example, you can still incorporate it into your holiday movie, using pan and zoom. You might start at the top of the image, with a zoom into the hotel (*above, top left*).

Image quality is rather poor, even for digital video, but a rapid movement will make it less noticeable. Then zoom out, taking in more of the video-resolution image – the image quality will steadily improve (*above, bottom left*) – and pan from the top left corner towards the

centre of the image. In the final shot (*above right*), the end of the pan-and-zoom effect, the image quality is highly satisfactory because it is based on a high-resolution photograph. Do not hold this view for long or it will become evident that the palm fronds are not moving.

want to use editing software to achieve the same end, although it is probably easier to keep the image stationary and move the camera.

Mount your picture on a wall or table and set the camera up to point at it. Rehearse the movements across the image, as well as the timing, and ensure the lighting is flat and even across the field of view of the lens. You could also try using different zoom settings or zooming in as you move. Practise until you are happy with the movements before you start to record them. You can crop out jerky movements or slow down playback to make the shot smoother.

Using pan and zoom

The NLE software equivalent of the rostrum camera is pan and zoom, sometimes also called the Ken Burns Effect (after a documentary film-maker who makes extensive use of photographs). The effect digitally simulates the panning and zooming movements after video has been shot. It does so by progressively cropping to a small portion of the image to imitate a zoom or moving across the view in successive frames for a pan. This is a similar concept to digital zooming.

The problem with working on a digital video image is that it relies on interpolation – the calculating and insertion of new pixels to fill gaps

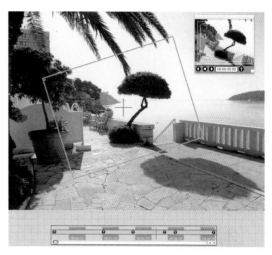

Using specialist software
The Moving Picture utility simplifies and greatly powers pan-and-zoom effects with its ability to work on high-resolution images. You can also rotate the cropping area as you move it. At each turning point, you set a key frame: intermediate frames are calculated between key frames.

in the enlarged image – with the result that image quality of any zoomed-in area can be poor. For best results, you need software such as Moving Picture from StageTools, which can be used as a plug-in to NLE software or as a stand-alone application. Moving Picture allows you to load an image as large as 8,000 pixels square: you can pan around and zoom into it while retaining high quality.

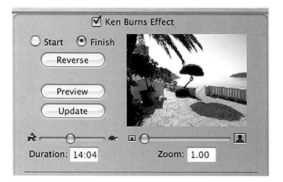

Simplifying the task
This simple but effective NLE dialogue box allows you to set the start point, end point, and the speed of the pan-and-zoom effect, as well as the level of zooming out or in. With zoomed-in views, it is possible to click on the image, dragging it to choose the cropping position.

Stop-frame animation

A variant of using photographs in a movie is to string together single shots and play them back at normal speed. This is applied to models made of clay (but Lego and similar toys are also popular these days). To shoot, say, an arm moving, the model's arm is moved a fraction of an inch, then a single frame is shot. After another small movement, another frame is shot. To speed up the movement, several frames could be shot of each new position. When played back at full speed, the arm appears to move normally. The technique calls for meticulous planning, infinite patience, and great model-making skills. The art reached its peak in Soviet and East European cinema of the late 1990s.

Quick fix Copyright and rights

While you keep your movie-making to yourself, creating digital videos for the entertainment of immediate family, you are not likely to encounter copyright or other rights problems. But as soon as you show your work publicly – and that can be as informal as at a club or wedding party – your work enters another realm, one strewn with traps for the unwary. Copyright and other rights may not seem important while you are developing an idea, but if it takes off, failure to attend to these matters can kill off the project.

Problem

The lens sees all as it sweeps round a room. Recording contemporary life will often include shots of mobile phones, magazines, and books, for example, all of which are protected by trademark and copyright. How do we know which need clearance or permission to use?

Analysis

If trademarked or copyrighted material, such as a magazine cover, is merely decorative, there is no need for clearance for an "incidental inclusion" – one in which it could be any magazine. But if the item, such as a certain type of mobile phone, is featured as something that a

character's life revolves around, then you need to seek advice. In particular, beware if any disparaging view is taken of the object – for example, your hero's life is threatened because it is unreliable.

Solution

If any branded object features prominently, seek legal advice. You may be able to obtain sponsorship through product placement. Otherwise, disguise the object.

Product usage
In a documentary movie, a product that is featured will not attract the attention of lawyers unless you make critical or disparaging remarks about the product – for example, if you say it was the cause of an accident. In works of fiction, prominent placement of a product calls for legal advice.

Problem

You plan to hire a photographer to take production stills for your movie, and you want to be sure you can use the shots both for publicity and in the movie.

Analysis

The issue is whether the work of the production photographer falls under the concept of "work for hire", where this is recognized in legislation. Since the team creating a movie is so large and many people make a creative contribution, the norm is to view all contributions as "work for hire" and belonging to the movie as a whole.

Solution

When you commission a freelance to work on a movie, be explicit about the rights they have over the work they produce for you. If you want to use stills within the movie, you may allow the photographer to retain copyright but

obtain exclusive licence to use pictures within the movie without further payment. If the stills are crucial to the story, the photographer may ask for more money.

Movie stills
A gesture by an actor between takes catches the eye of the editor, and he wants to use it in the movie. To do so, the producer will have to pay the photographer for the rights unless the photographer was commissioned on a "work-for-hire" basis.

Problem

While recording a documentary, you will probably feature numerous people. Some people say it is essential to obtain model releases; others say it is not necessary and that is it impossible anyway.

Analysis

There is no definitive answer because it is conditional on: (a) which country you are videoing in; (b) what you are recording for; (c) what you will say or imply in the finished movie; (d) whether the people depicted have been paid in any way to be in the movie; and (e) how you intend to use the movie. Broadly speaking, documentary work shot in public spaces does not need releases, but you need to be careful if you are being critical about anyone, and especially careful if that person is not in the public eye – that is, not normally subject to public scrutiny. However, even in a public space, people may have certain rights of privacy that may be breached by your video-taping.

Solution

It is not safe to rely on common sense. If in doubt, seek specialist advice. In general, while it is ethically dubious, the further you shoot from the point at which the movie will be viewed, the safer you are from legal action. But in these days of global mobility, it is unwise to rely on such evasions. If the documentary will be used commercially, particularly for promotion or advertising, there is no question: pay fees for models' and actors' releases.

Right to privacy
In a documentary on fishing ports around the world, you record someone watching harbour activity. In Morocco, you may get into trouble for not first asking permission, if you broadcast the finished movie. In France, if you do not ask first, you will liable for breach of privacy whether you broadcast or not.

Problem

What you have recorded has been seen and photographed by millions of tourists over the years, so how can anyone have any rights over it?

Analysis

What is in public view and easily accessed by the public is almost always owned by someone, and that person is likely to have property rights over any depiction of the object. If you simply feature the object in passing, that is an incidental inclusion and an exception to breach of copyright. But if it features in a big way, perhaps being digitally altered for the movie, then you could be in trouble. For instance, a sculpture very similar to one in the National Cathedral in Washington was featured in the film *The Devil's Advocate*, during which it was animated to become an evil, writhing mass. That scene had to be cut under threat of an injunction preventing distribution.

Solution

If in doubt, seek advice and permission, even if you create a model based on an existing original, and particularly if you give it a meaning other than its original one.

Association
If you feature this sculpture from an Italian cathedral in a movie and two lovers identify with it, there may be no problem. But if you associate it with something sacrilegious or heretical, there may be.

Taking still images

There used to be little point in taking still images with a digital video camera, because the resolution was far too low to produce good results. However, modern digital video cameras can capture still images of 3 megapixels or more. Although the images may not always match those of digital cameras of comparable resolution, the ability to record stills on your digital video camera is a bonus.

Two-in-one convenience

The main advantage of making still images on your digital video camera is that you do not have to carry two cameras around. But when would you need to shoot stills? There are times when you are videoing that you might also like a high-resolution still to print out – for example, of a bride who is beautifully lit by the window, or a landscape that would look great as a framed enlargement on your wall. Both modes of recording images serve different needs, and having a single camera that can provide both options is a superb convenience.

Remember that when you are shooting still images, as opposed to recording movie footage, you are not restricted to the orientation of the screen. This is one occasion you can hold a video camera on one side, to create portrait-format

● PROS AND CONS

There are, of course, advantages and disadvantages to using your digital video camera for taking still photographs.

Advantages include:
- Convenience of having two functions in one camera – which means less baggage.
- Ability to review your images on a large LCD (liquid crystal display).

Disadvantages include:
- Shallow depth of field is difficult to achieve.
- Memory capacity may be limited.
- Video lens is usually inferior to a camera lens.
- Exposure controls are limited.
- Resolution is less than in comparable stills camera.

shots. This is also a good option if you wish to create panoramic shots with image-manipulation software, since it enables you to increase the amount of vertical information.

Limited options

The main disadvantage of using digital video cameras for stills is that they are relatively rudimentary in terms of photographic controls. Exposure options are limited – if they are present at all – and there is a reduced range of resolutions or quality settings.

Images from video clips

As well as using your video camera to take stills, it is also possible to extract a still image from a movie clip. This example (*below*) shows that the results are acceptable; but notice how it pales in comparison to a shot taken with a high-quality digital stills camera (*left*). The fawn's coat appears a uniform brown in the video still, but greater variety is visible in the digital photo.

Digital video cameras process colour information with less sophistication than dedicated digital stills cameras. This is because the processing is designed for speed and small files, whereas with stills cameras, speed is not as high a priority as colour fidelity. As a result, images from digital video cameras appear a little coarse in colour, with colour artefacts in regions of high contrast more likely than from comparable digital cameras. This is shown in the lack of subtle hues, as well as in the uneven tonal transitions in the image.

One more factor determining the quality of stills is that the colour space of a video image is limited by the video standards to which all digital video complies (*see pp. 22–3*).

Second-rate colours
As part of a movie, an image of this quality will appear satisfactory. However, out of context, this still, shot with a digital video camera, does little justice to the vibrant colours.

Great depth of field
Even at the longest zoom setting, the depth of field in this shot of vegetation, taken with a digital video camera, appears generous. That is because the focal length can be relatively short to deliver telephoto views, since the sensor in the digital video camera is smaller than in a digital stills camera.

Portrait pictures
At times, you may want a still image in upright or portrait format: there is no reason why you should not hold your video camera on its side to shoot the format you need. Video cameras are generally not made to be used sideways, so the hold may be awkward. It is worth practising your grip on the camera if you expect to take many still shots; this is an increasingly likely proposition as video-camera resolutions continue to improve.

Achieving the "film look"

As digital video becomes more popular, it is being discovered by people with a more critical eye and some with more traditional tastes. To them, video looks hard-edged, lacking in subtlety, with a tendency to burn out highlights – that is, lose detail in a glare of white. Film is the standard by which video is judged, and it is usually found wanting.

What is the "film look"?

The "film look" comprises a collection of disparate features. Firstly, film is shot with entire frames at 24 fps (frames per second). Secondly, and more importantly, at its best, film tonality is smooth, colours are rich, and, above all, film handles a wide lighting or dynamic range. Part of the perceived difference in colour quality between film and video is due to video's more limited exposure latitude compared to that of film – its tendency to burn out highlights with little provocation.

Another feature of film is that the apparent depth of field can be very small compared to that of digital video – that is, it is very easy to throw the background out of focus when shooting film, particularly 35 mm. The reason is that film uses formats that are much larger than the tiny sensors of digital video cameras, and larger formats call for lenses of longer focal length. Depth of field

reduces rapidly with increase in focal length. Digital video cameras use short focal-length lenses, which inherently offer extensive depth of field.

Imitating film

Video that aspires to the film look aims to imitate these features. The most obvious technical feature to imitate is film's frame rate of 24 fps. A number

Diffusion filter

The easiest method of simulating something like a film look is to use a diffusion filter over the lens. Technically, this is a low-pass filter: it lets through soft detail but does not pass jagged, hard-edged fine detail. If you use an auxiliary lens for wide-angle or telephoto effects, you will need diffusion filters over these lenses.

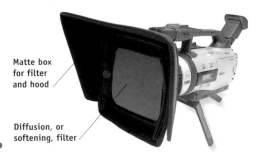

Matte box
for filter
and hood

Diffusion, or
softening, filter

Original

Film effect

Anti-aliasing

Jagged edges, or aliasing, is a natural consequence of the low number of pixels used by the video format to record information. It is exaggerated by the sharpening filters used in the image processing. The result is a harshness of subject outline that is

typical of video. A softening filter – simulated here with a blur filter – blends details together and softens, or anti-aliases, the edges. In a still photograph it looks too soft, but that softness is acceptable in a movie.

of modern prosumer-grade cameras are able to capture entire frames, at a rate of 24 or 25 fps. This may be called the progressive-scan mode, shown as 24P or 25P, depending on frame rate. While a film frame rate of 24 fps gives smooth movement on a cinema screen, 24 fps or 25 fps on video may not deliver smooth movement on a TV screen. Progressive-scan mode is best when you need to take stills frames from moving-image clips or when you wish to transfer video to film.

Lighting can help disguise that you are working with digital video: by using very soft lighting you can avoid burnt-out highlights. Professional-level cameras display warnings – a zebra pattern or flashing areas on the image – to indicate overexposed parts of the frame (*see p. 198*).

Limited depth of field is far harder to simulate. If your camera allows you to set aperture manually, you should first set the largest aperture (smallest f/number) that you can. In bright conditions, you may need to use a neutral-density film to obtain correct exposure. Try to frame as much as possible using a longer focal-length setting, or ensure the background is as far away as possible. But these measures are of no help with wide-angle views. Ultimately, the only way to reduce depth of field is to use a camera with a larger sensor.

Low contrast
No light is too low in contrast for video – even on the dullest of days (as in this detail), the bright side of the shiny surfaces of these gilt Bodhisattva statues in Hong Kong are rendered white on video. On film, there would be golden colour in the bright areas.

Original

Film effect

Colour correction
Another way to improve the look of your video is to process it in a non-linear editing (NLE) software program, all of which provide some – if only basic – colour correction. On the overcast day on which this footage was recorded, colours were lacking in bite and vigour (*above left*). This was corrected with the help of the Color Corrector function in the NLE package (*above right*). Plug-in "film-look" filters may be obtained for professional NLE applications.

3
Understanding and using light

Properties of light

An understanding of light and its properties is essential for anyone working in video. This chapter considers the many characteristics of light, such as quality, direction, colour, and quantity. The effect that lighting has on mood is explored, and there is an in-depth look at lighting set-ups. Quick-fix solutions are provided for exposure problems.

Controlling light

Through the control of light, you can create a different feel for each of your movies, or even a unique look that is all your own and is common to all your work. Extensive illustrations and lighting diagrams lay the foundation for perfecting your camera lighting technique. Learn by practising the lighting ideas shown here, then try experimenting to come up with your own solutions. The quick-fix section on lighting problems will help you avoid some of the most common pitfalls.

Capturing light

By using a range of different lighting techniques, you can endow your video movies with a sense of time and place, imply a mood or feeling, and even create a visual style. All of this adds to your ability to communicate a story.

Awareness of light

Like a photographer, a great videographer is at all times aware of the light. Everyone is familiar with the feeling when a large cloud suddenly obscures a bright sun: it is chilling and it alters one's mood. But what of the quieter changes during the course of a day or between seasons? Or the change of light as you move between the rooms of a house?

The quality of light

Diffused, or soft, light is recognizable from the effect it has on the scenes we view. It manifests itself in weak, blur-edged, or nonexistent shadows. From this, we know that the light is being scattered in all directions, with no concentration in any one direction. This is the product of a large source – maybe a cloudy sky.

In contrast, if we see sharp shadows with a great difference between the lightest and darkest areas, clearly delineated forms and intense colours, then we deduce that the light is concentrated into one main direction. This is the product of light seemingly from a small source, such as a spotlight.

Shifting exposure

A setting sun can help create a romantic wedding portrait. But when the sun is directly in front of the camera, it can affect the exposure reading and render the foreground too dark. Compensate for this by increasing the exposure (*see pp. 106–7*).

Exploiting soft light

In this shot of young cheetahs playing under a cloudy Kenyan sky, the only visible shadow is under the deepest hole of the old tree. The soft light of the overcast day is ideal for bringing out the texture of the cheetahs' fur and its delicate hues.

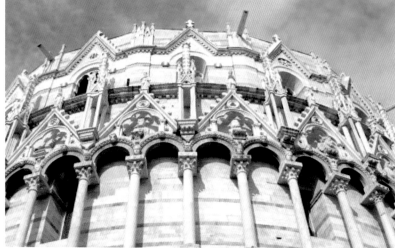

Diffusing light

A thin veil of high cloud (*above*) softens the fierce Mediterranean sun but without eliminating shadows. This is ideal lighting for the intricate stonework of this building in Pisa, Italy.

Using sidelight

In this scene, the strong directional light from the side means that every turn of the deer's head presents a different pattern of light and shade. Just keep shooting to capture great variety.

Lighting styles

One of the most direct ways to impart a visual style in your movies is through lighting. By using one quality of light consistently, you can give a very strong indication of your intentions. Think of the predominantly spooky lighting from below in *The Blair Witch Project* as well as in many other horror movies. Many musicals and comedies make use of even and steady lighting, which indicates a lightness of content and meaning. In contrast, fantasy and adventure movies make much use of dramatic sidelighting – look at *The Third Man*, *Terminator 2*, and *Blade Runner*.

Direction of light

In movie-making, the direction of lighting contributes more than simply an artistic effect. It can dictate the whole direction of movement and gives powerful – if indirect – clues about narrative continuity. Broadly speaking, there are three sets of light direction: above or below, in front or behind, and left or right.

Before considering these sets, think about your instinctive understanding of light. The sun – the source of natural light – always shines from above or from one side, seldom from below. The light's elevation, strength, and direction offer information about the season, time of day, and direction of travel. Any light created by humans originally came from the ground in the form of small camp fires, and lighting from below often casts spooky, unnatural-looking shadows.

Above or below

Lighting from above emulates the light from the sun, and so tends to look the most natural, whereas lighting from below, with its unnatural connotations, is often used to indicate the unknown. In between, horizontal light, from just above or just below head height, can signify domestic lighting and the safety of home.

In front or behind

Our instinct is to position ourselves with the sun behind us, since that affords the best view of anything coming towards us. A subject lit from the front (that is, with the light coming from behind the camera position) appears the least threatening and most comforting because it displays the greatest clarity and detail.

In contrast, a subject lit from behind appears in silhouette; and this black form, displaying no detail, could appear threatening. However, if the light from behind is very bright, the subject is surrounded by a halo of light, suggesting innocence or goodness.

Left or right

During the course of action in a scene or series of scenes, the "handedness" of light – whether it comes from the right or the left – tells the viewer about the direction in which the action takes place.

Suppose your protagonist sets off hopefully with the sun to his right but soon runs into trouble. If he flees with the sun to his left, the viewer subconsciously knows he is running back home. Or suppose you are recording a conversation between two people: if you shoot

Overhead light
With light from above, this scene appears bright and sunny. However, the contrast is too harsh for the video sensors, causing the highlights to be too bright and to burn out (*above*). To avoid this, reduce the dynamic range by filling in the shadows with reflectors or lights (*left*).

over the shoulder of one with the light coming from the left, then you cut to shoot over the shoulder of the other, there should be a corresponding flip-over of light direction – the light should appear to come from the right. If not, it may be that no one notices, but it can be unsettling to the viewer, if only subconsciously.

If you shoot continuously, you will not make such an error, but you may, for instance, take a break then sit your subjects back in different positions because the camera is already set up. Then you will create a continuity problem (*see pp. 76–7*).

Even lighting

Broad, even lighting indoors is an artifice created by the needs and limitations of video-tape and broadcast TV. Houses, in fact, are lit in different ways, with some areas darker than others.

In real life, even lighting can convey overcast skies, a dull day, with a sense of the daily urban grind and the unwholesome atmosphere of the city.

However, even lighting remains the type that is kindest to video – one in which neither shadows nor highlights have to struggle to be recorded. It has been said that no light is too soft for video, and even lighting delivers an abundance of softness.

Back-light
Found keeping themselves entertained at an Italian family gathering, these boys have left behind a brightly lit world, in which nothing can be seen despite the light. A generous exposure for the foreground brings out the details in the boys.

Even light
Usually bathed in brilliant sun, this wall in Marrakech offers a promising backdrop for the comings and goings in the street. In harsh light, the high contrast would degrade the colour in the image. Here, on a dull day, the wall is lit perfectly.

Sidelight
With strong floodlight from the left, the curves of the guitar and sculptural forms of the musician's hands are captured perfectly. The reflective surface occasionally threw light into the lens when the musician moved with the flow of the music.

Colour of light

A great deal of expertise and expense is devoted to the control of colour in traditional film-making. Light sources have to be filtered carefully with coloured gels in order to ensure accurate colour balance and, even then, further corrections are made when the final edit is printed out for distribution. With digital video, the need for consistent colour and accuracy is as great as ever, but electronics can do much of the work. White balance is the process of compensating for the colour temperature of a light source to ensure accurate colour recording.

Colour quality

Digital video cameras make automatic white-balance adjustments for the prevailing colour of the illuminating light. The intention is to ensure that neutral colours, such as whites or greys, are truly neutral; it is then assumed that other colours will be more or less accurately recorded. Thus, we want white walls in a room to appear white when illuminated by afternoon daylight as well as in the evening light. White-balance correction in digital video happens almost as a direct consequence of the way in which colours are sampled then encoded in the video signal, but the system can be confused if it is unsure about a true neutral colour, so you may need to help the camera.

Shifting hues

When shooting from a lift in a shopping mall in Hong Kong, the camera was correctly set to the colour balance for the incandescent lights, to give a neutral cast and generate accurate colours. But as the lift ascended into the daylight, the colour balance was not automatically adjusted. This led to the overall heavy blue cast and caused the red taxis to appear magenta.

Achieving the right colour balance

Under the incandescent lamps of a restaurant, the white china setting looks distinctly yellowish (*below*). But a full correction (*bottom*) renders the red table too dark. A partial correction (*right*) strikes the right balance, providing a more satisfactory image.

Grey-card calibration

The best way to ensure that the camera is measuring a neutral colour for white-balance correction is simply to present it with a known neutral colour. Cards printed with a standard mid-tone grey, can be bought at low cost. First set the camera to "manual", or "hold", then show the card to the camera and set the white balance.

The calibration method varies slightly between video cameras, so check the procedure in your instruction booklet.

Colour temperature

Colour, or the quality of light that gives the impression of hues, does not have a temperature. But the temperature of an incandescent light source is related to the colour of the light it emits: the hotter it is, the cooler or bluer the light; while lower temperatures produce red or yellowish light.

Colour temperature is measured in Kelvin (K; where 0 K is absolute zero): 5,000 K is taken as the colour temperature of domestic lights; 6,500 K is that of tungsten halogen lamps; 9,300 K is a typical daylight colour temperature.

Quantities of light

Digital video cameras, almost universally, operate on automatic exposure control. As with white balance, exposure control is almost a direct consequence of the way in which the video signal is processed. The amount of light reaching the video sensor – that is, the exposure – is controlled both by the shutter time (or the electronic equivalent) and the lens aperture used, both set automatically. In addition, the sensor itself may adjust its sensitivity to the incoming light, also automatically. Unlike digital photography, there is a limit to how long the shutter time can be, for it must fit into the frame rate of the video (for example, 30 frames per second), and of course it needs to be as short as possible in order to capture movement without blur.

Controlling exposure

Most of the time, you will not need to worry about exposure control. While the camera takes care of every setting, the viewfinder or LCD screen displays the video signal that is being recorded, so you have constant feedback on the accuracy of the exposure control.

But no system could get it right in every instance. For example, your subject may be a small target – a face or a flower, perhaps – surrounded by large areas of darkness. Automatic systems are likely to overexpose the image, burning out your subject. Or you may be following a figure moving from light to disappear into shade, and the last thing you want is for the camera to boost exposure when the shot moves into shadow.

To counter this problem, your camera may offer a function called spot metering or memory hold. Using this system, you select a point in the scene as the basis for the shot. Beware that some cameras will hold the exposure until you cancel the setting, while others will revert to normal automatic function at the end of the clip. Ensure that you are familiar with the way your camera works.

Dynamic range
When encountering dynamic range that is too wide, you must decide which tones to leave, which to lose. Here, I judged the tones of the hawk to be more important than the blue skies.

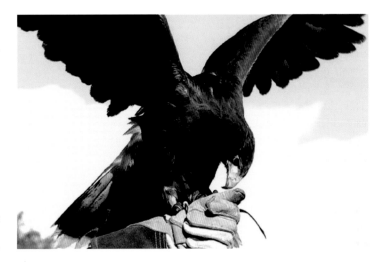

Shifting auto-exposure
This sequence shows how auto-exposure responds to changing light. The camera correctly exposes the close-up of a red-leaved tree in New Zealand, but as we tilt upwards, the bright sky causes a reduction in exposure. Once the exposure corrects for the sky, the tree becomes nearly black.

Photography workshop

The brightness of the light box in this dim library caused an auto-exposure setting that resulted in the underexposure of everything but the light box. But when the light box was partially covered, the exposure system registered the change and, due to a reduction in the luminance range, was able to shift the exposure (you can watch this take place in the video camera's viewfinder) until it provided a good exposure overall. Notice that the image colour also improves during the process.

Working in low light

Another problem is lack of light, making the image too dark. If the camera has tried to give sufficient exposure – by increasing sensitivity – the usual option is to supplement the light (*see pp. 112–17*). This may be impossible or undesirable – for example, if you do not wish to disturb your subject.

Some cameras allow you to switch to "black light", or infrared (IR), sensing. This may use a supplementary IR source or rely on available IR from the subject – all warm-blooded animals and working machinery emit IR – and will enable you to record in total darkness. However, the resulting images will be black and white and rather grainy.

Video exposure

Exposure in a video camera means the same as in photography: the amount of light reaching the sensor assembly depends on the combination of exposure time and the lens aperture (the setting that controls how much light passes through the lens). However, in video, the need to deliver up to 30 frames per second limits the longest shutter time. Modern video cameras add a further control, to vary the sensitivity or gain of the sensor chip. In low light, sensitivity is increased; in bright conditions, sensitivity is reduced.

Quick fix Exposure control

Diffused or soft light is generally easy to expose for: either the camera or you must be very accurate. Hard or contrasty light is trickier. The difference between light and dark may be more than the video sensor can cope with. You must decide which exposure is best. Compromise is necessary, since a perfect exposure is impossible.

Problem: Tracking changes

Exposure changes as you track a subject from one part of the scene to another, so the subject is sometimes too dark, and at other times too light.

Analysis

The auto-exposure system is continually measuring and responding to changing lighting conditions, attempting to deliver correct exposure. If your subject moves into shadow, it will overcompensate, lightening the image, unaware that you are prepared to let the captured image go dark.

Solution

Set the camera to manual exposure, auto-exposure memory hold, or spot-meter mode. These variously named functions all have the same effect, allowing

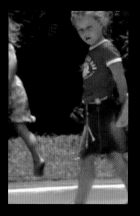 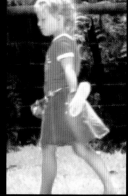

Tracking changes
The camera renders the beginning of the clip at the correct exposure. Although this should have been held or memorized for the rest of the take, it was not (as in the details above). The dark background dominates, resulting in overexposure.

you to set an exposure that is maintained throughout the take. This means you must decide on the single exposure to suit all, which may be something of a compromise. It is preferable, in general, to allow a subject to become too dark when entering shadow rather than allowing it to become too light when moving into the light.

Problem: Near-total absence of light

Sometimes, there is so little light that it is hard to see anything at all, but you still wish to shoot – at a party, for example – and adding light will disturb the subject.

Analysis

There may be little or no visible light, but any scene with live subjects will emit infrared (IR) light, so you need to use a camera that will record using IR light.

Solution

All digital video sensors are sensitive to infrared, but most have a filter permanently mounted to prevent infrared from affecting normal taping. Some cameras, however, allow the filter to be slipped aside when a night-shot or IR mode is set. This mode cannot record in colour but can register images in near-total darkness. A supplementary IR lamp may improve illumination; it is not visible to humans or to many animals.

No light
In a lift with minimal light, the night-shot mode comes into its own, enabling a scene to be recorded where it would otherwise be impossible. The cost, however, is a very noisy (grainy) image in black and white only – but it is much better than nothing at all.

Problem: Back-lighting

The subject appears unnaturally dark against a correctly exposed background. Attempts to correct this allow the subject to appear correctly exposed, but it then lies against an unnaturally bright, overexposed background.

Analysis

The subject receives more light from behind it than it does from in front: the main light source faces the camera, so the main subject area lies in shadow. As a result, there is a very wide luminance range between the subject and the background – far too extensive for the sensor to encompass.

Solution

Using camera exposure controls is only a partial solution because you will not find it possible to select an exposure that does justice to both subject and background. One option is to use supplementary light from the camera side to increase lighting on the subject. This reduces the luminance range to help fit

in with the sensor's range. Another option is to use a graduated filter that is darker in its top half and transparent in the bottom half (*see p. 36*).

Problem...

Scene contrasts
Against a bright hazy sky, the foreground detail is underexposed, yet the sky is not correctly exposed either. A correct exposure

for the sky would make the foreground black. Alternatively, if we expose the foreground correctly, we can leave the sky a bright white.

...solution

Using lights

In the early days of movie-making, extra lighting was essential when shooting indoors. The increased sensitivity of film, along with the miniaturization of film formats, however, has steadily liberated camera operation – in terms of both handling and the amount of additional lighting needed.

Nonetheless, few things can magically transform a location into a space full of romance, mystery, or paranoia better than a carefully positioned light. Using extra lights to improve the look of your videos is a sign of a serious video-maker. You can get by using only the light that is available but, apart from being restrictive, that may prevent the discovery of unconsidered creative possibilities.

The downside of supplementary lights, apart from the extra work they cause, is the need for a power source: you either have to work within reach of a mains power supply or carry a heavy battery around. The trick is to use as few lights as possible and the smallest, yet reasonably powerful, units.

Motivation of the light

If there is one trade secret in movie lighting, it is simply that every light should be "motivated". This means that every light or light source visible to the viewer should appear as an element of the scene, a natural part of it.

A face in the dark becomes suddenly visible when a beam of light rakes across it; then it quickly falls into shadows. This is achieved by someone swinging a lamp across the actor's face, but what viewers see are the beams from a car turning a corner. Lighting a face with a torch is a crude option, but when the script says that it is the only light available, as in *The Blair Witch Project*, clumsy lighting becomes a cult-film signature.

Motivation, furthermore, means that the angle of the light, its intensity, its relation to the visible action, and its colour must also appear a natural part of the scene. This applies especially to the main light, since it is out of shot. Other lights in shot – the table lamp, the light from a corridor, or a candle – provide their own motivation.

Camera-mounted light

The worst possible place from which to light a scene is a lamp attached to the camera. The light is frontal, flat, and it is very difficult to match its brightness to the surroundings. Of course, in many situations, such as working in documentary mode in challenging conditions, a camera-mounted lamp will be the only option. However, minimal reliance on such a lamp is recommended, unless it provides exactly the lighting effect you want.

Basic outfit

The most minimal lighting outfit is a lamp mounted on the camera. But for stationary and more considered work, you need lamps mounted on lightweight stands. The basic lighting kit includes:

- 1 focusing flood
- 1 flood
- 2 stands
- 1 set of barn doors
- Diffusers and gels.

This kit will be useful for head shots, interviews, or supplementary room lighting. It can be costly to put together a more professional outfit, but aim to add another focusing flood, a soft-box, and a way to adjust the brightness of the lamps.

The Dogme approach

Dogme is a cinematic movement that started in Denmark in 1995, celebrating character and real life. One aspect of this is the use of no supplementary lighting at all – only natural light. This stylistic decision is one of the ten rules gathered under the "Vow of Chastity", which eschews all technological intervention such as special effects, separate recording of sound (wild track) from film, and even the mounting of the camera on a tripod. Whatever its philosophical contradictions, one great advantage of the Dogme approach is clear: setting up takes hardly any time at all. *Italian for Beginners* by Lone Scherfig, Dogme's first female director, is a fine example of the style and is recommended viewing.

Additional lighting

In some situations – for example, when videoing in a recording studio – lighting possibilities will be limited. In this example, it was not possible to change the main lighting on the bass guitar, but a spotlight aimed at the wall from an angle added a lively supplementary circle of light. The motivation for the light here is very simple: it is there to create a decorative visual effect by adding variety to the background.

Bright and breezy

With soft, open light at high levels, the gobo window (*see p. 117*) in the background is reduced in intensity, shadows are not heavy, and overall contrast is low. This is not the light for depicting high drama or intense situations, but it suggests summertime and fresh breezes through an open window.

Dramatic effect

This lighting, with its hard key from the side and gobo window in the background, is not meant to be cheerful. Through its heavy shadows and high contrast, it suggests a serious scenario. Since it is easy to make the lighting too high in contrast for digital video, record a test clip before shooting the whole scene.

Lighting set-ups

For video work, the basic lighting set-up is three-point lighting: a key lamp providing the main illumination; a fill, which reduces the shadows; and a back light, which separates the subject from the background. This may seem formulaic, but it is the product of countless attempts to find better alternatives. Even when exploiting ambient light only, Dogme-style, you can see that the director of photography has positioned the subject in such a way that he or she is, in effect, lit from three directions. Any variation usually indicates a special or changing situation because, for example, part of the person blends into the background or details are lost in the shadows. Three-point lighting may be said to be emotionally neutral, which makes it a good starting point for movie-makers.

Setting up

Planning ahead is essential for lighting technicians. It affords you the opportunity to establish clearly the look and lighting you want, as well as the positions of the lights to achieve that look. This will then save you time on set. Planning will also help ensure that you place your lamps in the most suitable positions without having to shift furniture or find yourself bumping into immovable objects such as a chandelier or wardrobe. When building lights for a scene that incorporates movement, such as walking across a room, ensure that the light coverage is sufficient to span the whole movement without a change in brightness – unless, of course, that is what the director intends.

A methodical working practice is also vital. You are dealing with potentially dangerous equipment, so ensure cables are not tangled and that lights are set up safely and out of the way of the cast and crew.

Building the lights

When examining the following lighting sequences, it is important to understand that there is no fixed right or wrong about any lighting set-up. Strong, glaring light in the face with harsh shadows on the wall are appropriate for certain work – thrillers or horror films, for example – but inappropriate for others, such as love stories or Merchant Ivory-type period pieces. By the same token, balanced lighting with no deep shadows and in which everything can be seen clearly is the hallmark of soap operas and made-for-TV movies. You may be able to build tension under such lighting, but you and your actors will have to work hard because the lighting does not add to the emotion of the scene.

Dynamic range

While cine film can work with a contrast range (strictly, a luminance ratio) of about 96:1 (a difference between shadow and highlight of nearly 7 lens stops), consumer-grade digital video is restricted to about 30:1 (a range of under 5 stops) and often less. This far narrower latitude means that lighting for video must be softer – that is, it must offer a small luminance ratio to avoid burnt-out, or "hot", highlights. In practice, this may call for the extensive use of diffusing screens, as well as the filling in of shadows using reflectors.

Range of sensor

This set of images represents the dynamic range that you can expect to be able to record with a typical CCD sensor on digital video cameras – ranging from –2 stops underexposed to +2 stops over. The safe range runs from 2 stops under correct exposure to 2 stops over: in this range, colour is recorded with some detail. In this relatively high-contrast image, notice how the bright patch to the model's left retains its brilliance almost no matter what exposure you set.

One of the joys of movie-making is that you work with a multidimensional event: not just the composition of the shot, not just the dialogue and sound, nor just the lighting. Every element fits together so that, just as the soundtrack is at its best when not noticed, the lighting, too, is best when it is part of the action. Many scenes in *Chicago Cab* (by Mary Cybulski and John Tintori) feature people being driven around in a taxi. Yet, as the street lights recede past the taxi's windows (from a back-projected movie), the lighting on the actors is, inaccurately, unvarying. The majority of viewers will not notice this artificiality, but still the discrepancy will be subliminally jarring.

Key

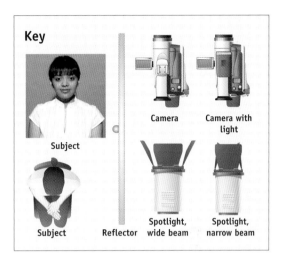

Subject · Camera · Camera with light · Subject · Reflector · Spotlight, wide beam · Spotlight, narrow beam

From the side

Side key light
A single floodlight with a relatively narrow beam or with the lamp placed close to the subject causes several problems. The light is harsh on skin tones, the shadow thrown by the subject is dense and distracting, while the unevenness of the lighting is undesirable. The motivation for the light is poor, being clearly an unnatural set-up.

From the front

Front lighting
Lighting from the front, such as that from a lamp mounted on the camera, can give acceptable results if there is no other way to light and carry the camera at the same time. It is best to keep the subject away from a wall so that their shadow does not appear in frame. Shoot from just below eye level, otherwise the lamp will throw heavy eye shadows.

Lighting set-ups continued

Flexible shade

Lights off-centre but facing the camera can throw flare into the image: even if you cannot see the lamp, its light may hit the insides of the lens hood and bounce into the lens. Once in the lens, light can be reflected backwards and forwards until it hits the sensor. One solution to this is to position a small shade to hide the light: the shade is attached to the camera by a flexible arm, which is then fastened to the camera's hot-shoe or tripod socket. The shade may be replaced by a reflector or used to hold other accessories (*see Flare prevention, p. 35*).

Flood- and spotlights

The flood and the spot are the building blocks of lighting for video. Pointed directly at the subject, the lamps produce a hard lighting, with clearly delineated dark shadows. Their illumination can be softened by shining them through diffusing materials or bouncing them off a reflective sheet or wall. Changing the focus of a lens built into the lamp varies the angle of light from a wide, or flood, to a narrow, or spot, light. For the same lamp setting, a spotlight concentrates the light into a brighter spot compared to the weaker light of a flood, giving you two brightness controls.

Single flood 1

Single flood: poor shadows
With a single light, you can obtain strong shadows, both on the subject and thrown away from her. But you can work with this if, for example, you have a large room in the background with secondary sources of light such as a window. However, here the shadow of the nose is not very pleasing to the eye.

Single flood 2

Single flood: improved shadows
Only small shifts in the position of the light or subject's head can significantly improve the shadow on the face. Here we have the standard arrangement. The end result is that the shadow of the tip of the nose just avoids the shadow of the side of the face.

Defining floods and spots

The wide beam (*left*) from this floodlight shows a clean, circular, and even distribution of light, with a rapid fall-off at the edges exhibiting little colour fringing: this is a high-quality light source.

The spot beam (*right*) is far more intense but also exhibits a very clean and clear-cut profile that is perfectly circular, making it ideal for limiting the light to exactly where it is wanted.

Bounced light 1

Bounced key lighting

The only way to obtain a soft light suitable for skin tone on digital video is to ensure the light source offers a very large area compared to the area being lit. If you do not have a soft-box to diffuse the light, then bounce or reflect the light from a suitable surface. Here, the white walls of the room are perfect for bouncing the key light.

Bounced light 2

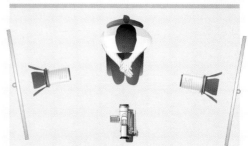

Key and fill lighting

The fun begins when you start using two lights. In this view, the shadows are shown deliberately so you can assess the relative strengths of the lamps – here bounced off reflectors. In this set-up they are almost equal: the lighting is flat, with just a hint of shadow since one lamp is slightly closer to the subject. Flat lighting is best for creating the "film look".

Lighting set-ups continued

Balance through exposure

The combination of lighting with exposure control creates a powerful team that touches every aspect of the image – from its emotional content, through colour accuracy, to composition. Exposure control is not solely about making the correct camera settings, it is about shaping the image to meet your artistic ends. For example, you can turn a threatening silhouette into a light-filled angelic vision simply by altering exposure and making no other changes.

Balancing the exposure

With an exposure set between the bright background and the dark foreground, the framing effect of the window is very strong and the profile of the subject is emphasized. This is the right exposure if you want to emphasize shape and form over detail. A higher exposure, optimized for the face, throws the background into over-white. This is right for showing facial details.

Key lighting 1

Key lighting and a weaker fill

You can see from the shadows as well as the light on the face that the lamp to the model's right is brighter – it is the key light. The lamp on the other side is weaker, so it does not wholly fill the shadow side with light, but it enables a lot of detail to be retained. Position the model a little further away from the wall for the shadows to fall out of shot.

Key lighting 2

Key lighting and a stronger fill

As you adjust the strength of one light against another, the less bright light may become the brighter one. It is then seen as the key light, reversing the direction of the lighting. This is a good way to concentrate the viewer's attention on your subject's best side.

Using gobos

An inexpensive way to create variety in your lighting effects is to cast different shadows on to the background. Gobos (or "cukies") are cut out of metal or heat-resistant material in various patterns to cast shadows of trees, window frames, or abstract shapes (*see right*). They are relatively inexpensive, even those professionally cut with a laser. You can cut out your own, but for safety reasons, ensure you use non-flammable materials such as sheet metal. Shadows can be projected as sharp, hard outlines. For this, you need to set up the projector spotlight so that the gobo slots between the lamp and a projector lens, which can focus an image of the gobo on to the background. For a softer effect, place the gobo in front of a lamp or spot.

A selection of lighting gobos

Key lighting 3

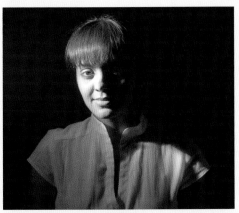

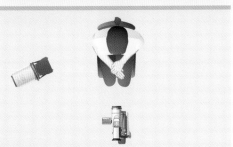

Spot key lighting with fill and underexposure

Modern luminaires are highly flexible and can be used for non-standard set-ups. Here, instead of a broad key light, the lamp has been focused to a narrow spot that accentuates the face while shadow detail is maintained. An exposure for the bright areas helps give the lighting more character.

Key lighting 4

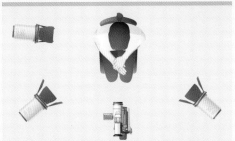

Key lighting with fill and back lighting

By adding a third light, you can add to the illumination on the model, but you will need lights that can be easily controlled. A back light placed behind and to one side of the subject – to provide a glancing beam that just touches on the neck and shoulders – can add interesting highlights, but make sure you do not overdo it.

Quick fix Lighting problems

The main problem with digital video is its limited dynamic range – that is, how much light between darkness and brightness it can manage. With that comes an associated problem of reduced exposure latitude: setting the correct exposure is a finely balanced thing. Here are some simple ways to handle difficult light, plus a lighting technique for compositing.

Problem

Outdoor high contrast due to direct sunlight is impossible to control. Exposure can be difficult, too.

Analysis

Direct rays of the sun are not diffused, but they travel nearly parallel to each other. The result is fierce highlights with very dark shadows. But if you look closely at the shadow side, you will see that there is also some light and that all of that light is diffused.

Outdoor lighting
In the full summer sun of Croatia, a pretty girl caught my eye. With no available shade, there was only one way to record a brief portrait: use her to hide the sun and shoot in her shadow. Her face seemed too dark, but the result was surprisingly good.

Solution

Use the diffused light in the shadows, and shoot in the shadow side as much as possible, especially with people. Try to fill the frame with your subject's face or body so that there is not too much brightness in the background. Note that any brightness in the image is likely to fall outside of legal broadcast limits.

Problem

It is too dark to shoot and you can hardly see anything at all; still, you would like to capture the moment if possible. But you do not want to add any lights, since that will spoil the mood or alert those being taped.

Mood lighting
In a dark restaurant, it was hard to see the food, let alone try to record. Yet I did achieve a result: it is poor in colour, very grainy, and unsharp, but it is a movie. Note that the moving image appears more acceptable than a stills frame from it

Analysis

Lack of light used to spell the end of your videoing or filming options – you had to bring your own lighting to compensate or not shoot at all. With modern digital video cameras, however, what little light there is needs to be amplified a very great deal before an image can be recorded.

Solution

Modern image processors can register low light levels and correspondingly increase sensitivity to amazing levels. In fact, some cameras can tape in total darkness, with a bit of help from an infrared (IR) lamp. Modern cameras are able to record something in almost any circumstance. The downside is that the image will be very grainy: full of noise and artefacts. Remember, though, that image characteristics, even excessive grain, can be exploited for some movie projects, especially those in the thriller and horror genres.

Problem

You need to shoot some footage in order to prepare it for later compositing with images from another video.

Analysis

The action in front needs to be lit with a colour that is easily separated from, in particular, skin tones.

Solution

You need to light the action as blue screen (also called green screen, chromakey, or colour keying). Hang an appropriately coloured screen behind the person you are shooting, and ensure that the lighting on the person does not fall on the blue screen. Blue or green screens are most commonly used because they are opposite colours to skin tones, making it easy for NLE software to pick out all the colour and substitute the other footage. (Of course, if your subject is a mechanic wearing a blue overall, for example, you choose a red chromakey.) Note that MiniDV is not a good format for this process: the sharp, aliased edges of images tend to create jagged composites – evident on the image on the right. A blurring filter may help improve keying, since it softens image boundaries.

Blue-screen shot
This musician is videoed against a blue background – a ready-made blue screen.

This is easily removed by a mask during compositing, and footage of stage equipment can be placed behind him.

Composited shot
Here, the blue has been masked off and replaced by footage of the audio console.

Note that care was taken to ensure that the light on the musician's face matches that on the console.

Problem

To the eye, the lighting is very effective – a strongly back-lit subject against a dark background. But the video camera does not see it that way.

coloured objects. In addition, the exposure should be set so that the brightest whites are not too white. In this situation, that would make the shadowed areas very dark, losing much of the colour and detail.

Analysis

The range of brightness to darkness that a video camera can record comfortably – its dynamic range – is very limited. Although you expect problems in strong sunlight (*see opposite*), you may not expect them indoors, but it is easy for the scene luminance range to be excessive. Also, video standards do not tolerate the recording of super-white – white areas that are too bright – such as paper.

Solution

If you are able to, you need to use reflectors and diffusers: in this example (*right*), a diffuser over the window lighting the musician would help. White objects such as the piece of paper can be replaced with darker

Window lighting
The direct light from the window falling on the paper would give problems to any

recording medium. While it nicely lights up the face and neck, it must be made less white in post-production.

4

Digital video projects

Inspiration

Sometimes it can be difficult to know what project to undertake or, indeed, how to start it if you do know. This chapter is full of ideas for your next video, as well as tips to help you bring your vision to the screen.

Transferable knowledge

Any movie is the sum of its parts, and those parts can be put together in myriad ways to create wildly differing works. Through extensive illustrations of key frames, you will see one way in which each of these projects could be shot and edited. Simple techniques that avoid the need for elaborate equipment and costly sets are also revealed.

Hints and tips

The dozens of hints and tips within these pages will save you time and effort in your movie-making pursuits. You will increase both the satisfaction you feel in making your videos and the satisfaction of the viewer.

The main approaches

Once you have some experience in using your camera and have perhaps invested in a few accessories, you are equipped to create movies – theoretically, at least. There are two main ways to approach making digital video movies.

One school of thought says you have no chance of making a successful, interesting, engaging movie unless you plan it to the last detail. This means writing a script or screenplay.

The opposing philosophy admits that a bit of planning has its place, but says that overscripted movie-making interferes with creativity and runs against the flow of life and chance; the scripted movie is art in a straitjacket. This is the "shoot-and-run" or "run-and-gun" approach.

In fact, there is much to be said for both – each suits a different kind of movie. Make your choice based on your budget and the time available.

Following the screenplay

A full screenplay should enable anyone to make an entire movie without further instruction. But even the most detailed shooting script cannot describe camera movements and framing with precision. The script is a map by which anyone involved in the movie-making process can navigate their way. It can be as detailed as you want to make it, giving timings, camera movements coordinated with dialogue, and actor's actions. This approach is suited to a short video movie – perhaps the story of two strangers meeting, spending some time together, then going their separate ways.

Alternatively, the script can be more like a shot list – a set of notes and headings that ensures all the key subjects and locations are shot. This is best suited to documentary-style work such as a friend's wedding or a "once-in-a-lifetime" journey. In both cases, you must ensure nothing is missed that you will later regret omitting. For more detail on this way of working, see pp. 204–5.

Another advantage of a shot list, even for run-and-gun shooting, is in identifying potential problems. You may know you need a wide shot to set the scene but feel that a panorama would be dull and clichéd; instead you could opt to start with a detail, then zoom out to reveal the scene.

Scripted clips
The script called for typical views of everyday beach life, and that is exactly what was shot. The variety within the clips informs us that the camera operator knew exactly what was needed for the movie and went after it.

> ●**HINTS AND TIPS**
>
> When working to a script, do not feel bound by it, but bear these points in mind:
> - Read and reread the script as you shoot: you will not remember everything.
> - If you feel inspired, vary from the script provided it does not upset your schedule.
> - Remember: the cost of tape is minuscule – shoot more than you think you will need.

A SIMPLE SCRIPT	
Synopsis: To show the importance safety awareness on beach holidays.	
Title: *Beach Aid* script p. 1	
VIDEO	AUDIO
Close-ups of feet splashing through water. Pull out to show groups walking to the beach. Children playing, dragging beach toys with them. More groups coming on to beach. Glimpse of car park behind trees. Track walking groups past sand dunes.	Splashing water. Excited voices and children's laughter.
Zoom to long view of people already on beach, playing in waves. Short clips showing different activities. People running about, sitting, reading, sunning, eating. Pets also.	Sound of waves, distant voices.
Lifeguards taking it easy, chatting, and drinking soft drinks.	Distant whimpering sound from child, partly obscured by sounds of sea. Cries from seagulls.

An audio-visual (AV) script (*above*) helps you plan, anticipate, and structure the shoot. Arranged as about 2 minutes of screen time per page, the script can also help you later, speeding up the editing process.

Shoot first, edit later

The unscripted approach is how we all start with movie-making. We walk out of the door, camera in hand, ready to shoot whatever comes into view. It is also, combined with forward planning, the natural mode of the documentary-maker. With experience, you can record effectively; but initially, less planning means more work later.

It is advisable to shoot more than you need when using a script, but it is essential to shoot a huge amount more than you think you will need when working unscripted. Try to anticipate what you will need for the editing stage later.

HINTS AND TIPS

Unscripted work can be mentally tiring, since you must remember to shoot all the footage you need.
- Shoot from as many angles and positions as possible to give you more options when editing.
- Shoot at different focal lengths and distances from the subject.
- If possible, have someone compile a shot list as you work, so you know what you have recorded – this is especially useful for scenes you did not expect to tape.
- Take at least two more tapes with you than you think you will need.
- Take at least two spare fully charged batteries.

Unscripted clips

An unscripted visit to gardens produced this medley of shots without any order or logic. If you end up with clips of wildly varying lengths, you will create a lot of hard work at the editing stage when trying to balance the importance of each element.

New baby

The arrival of the first baby in a family is often not only a cause for celebration but also for the purchase of the family's first video camera. The subject is a source of joy, wonder, and love. Changes will take place almost by the hour, and the video enables so much of the experience – once edited, of course – to be recalled for years to come.

Storytelling

With a subject that is so easily accessible, the problem is not what to record, but what not to record. Even so, a common error when videoing a baby is to make each take rather short; this causes the movie to jump too rapidly from one scene to another. A video of a baby will be more enjoyable if it tells a story rather than showing a random string of events.

While a day-in-the-life narrative is obvious, it is none the worse for that. You could start, for example, with a view of the room, taking in all the "new baby" greetings cards, before revealing the small movements inside a sleeping basket that signal a little person beginning to wake up. Make the audience do a little work, by asking themselves the significance of the movements; then reward them with the solution as the baby gazes up at the mobile above the bed and the story begins.

A video of a baby is likely to be full of the baby – just as any viewers would expect. So make them wait for it, make them wish to see the baby. Start with something different, perhaps the greetings cards and gifts that announce the subject.

Focusing on the baby is, of course, very rewarding for the parents, but an infant's growing awareness of her new world is endlessly fascinating to anyone. The parents may make embarrassing cooing noises, but these should be recorded, too.

While babies are small, relatively still, and largely unaware of the camera, you can film extreme close-ups without limitation. Make good use of this opportunity, because it does not last for long. The results are almost always worthwhile.

● HINTS AND TIPS

These tips will help make your baby video a pleasure to watch, as well as the envy of all other parents.
● For variety (and veracity), record all aspects baby life as well as changing moods.
● Hold the camera still: when your child becomes more mobile, use a wider angle to allow movement in and out of the frame.
● Get in close: your subject is very small.
● Use contrasts to express your feelings about the baby's vulnerability, small size, and delicacy.
● Do not use extra lighting or video in direct sunlight, since the baby's delicate skin tones will be lost.

Small movements of the cot can be used to indicate the baby's awakening. Tantalize further by cutting to something unexpected, such as the mobile positioned over the bed, before panning down to show the baby.

Before your viewers have a chance to get bored, try cutting to another aspect of the change in life for the parents. The contrast in size and form between adult and baby is always a source of fascination.

It is easy to miss the day-to-day and the prosaic in your movie-making; it may seem that no one would be interested in the mundane details. But even the simple act of putting the baby to bed is rich with symbolism and signs of love, and it can be visually rewarding. Here, we allow a very limited colour palette of whites, with flesh tones in soft light, to create a sense of calm and peace. The movements of the mother's hands contrast with the stillness of the infant. Keep the camera steady throughout the scene.

Birthday party

The key to shooting a good party video is the lighting. Everything else is there in abundance: happy faces, festive decorations, and cooperative subjects. Unfortunately, lighting is also the very thing you are likely to have least control over when recording a party for posterity.

Checking the location

If possible, survey the site before the event. Try to time the reconnaissance trip (or "recce") for the same time that the party is due to take place. If outdoors, check the positions next to a wall that will be out of direct sunlight.

Finding frames

As part of your survey, look out for archways or verandah details – such architectural features can be used to help frame people. You may also be able to shoot through a window from outdoors, providing another interesting compositional device. Best of all, though, is to try to get high up for a good bird's-eye view. If possible, construct a platform that raises you above the action; a stepladder secured to the ground makes a usable solution – but make sure no children climb on it while you are not using it.

Considering extra lighting

See if there is any way you can add extra lights without spoiling the atmosphere. If the party is during the day, draw open any curtains and remove nets. Spotlights or desk lamps (ideally those with low-voltage tungsten halogen bulbs) can boost the lighting without spoiling the mood, since they offer local lighting effects without increasing the overall light levels.

The best option is to video parties taking place outdoors on a day with diffused light. Most people pray for sunshine, while videographers tend to be the only party-goers who are pleased when the sun does not make an appearance.

Set the scene with a close-up of the treats and decorations that turn the house into a party palace. This will start the video in an engaging way, with a wild track of excited background noise. Then pull back for an establishing shot, showing the location.

I noticed a smaller child moving with less assurance and saw an opportunity for a change of pace. By intercutting close-ups of the baby with the faster activity of the older children, you can make the movie more interesting to watch.

● POINTS TO CONSIDER

It can be difficult to stay focused when videoing a party. Bearing these points in mind should help.

● When taping little people, shoot at their height as well as at yours. A tripod may make this easier.

● Take part in the fun when you can: you will appear less of a outsider and more a guest with a camera.

● Keep shooting or pretending to. If you constantly stop and start, you will draw attention to yourself.

● Keep on the job: sitting with the grown-ups is a sure way to miss half the shots you need.

● Do not speak or laugh while filming: this is difficult advice to follow when you are in the party mood.

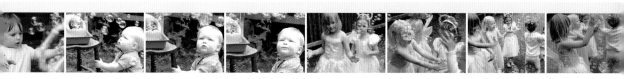

2

Cut to a different location and another establishing shot to show the main areas where the action will take place. Here, we are in the garden. After starting with a wide shot, you can zoom in to focus on the activity in the distance.

3

It is not necessary to cover the arrival of every guest in detail, so cut straight to the party action. This offers an interesting contrast with the pre-party footage, and at the same time gives an immediate sense of the party atmosphere.

5

Once the guests are having fun, they will soon forget about the camera. This medium-shot sequence tracks the children as they chase after bubbles. Do not follow too tightly: children move very quickly, so give them plenty of room in the frame. If you swing backwards and forwards all the time, it can be disconcerting for the viewer and make it difficult to follow what is going on. The relatively small digital video sensors help record activity by giving a good depth of field.

Birthday party continued

Do not follow any action for too long. After the frenetic bubble-chasing scene, the face-painting offers a chance to slow things down. An extreme close-up with a relatively short focal length takes the viewer right into the action.

The party game of Pass the Parcel offers a new angle with a potentially amusing soundtrack. The danger here is to allow the movie to dwell too long on the subject. This is a chance to hone your editing skills, picking out only the very best moments.

Next, we cut back to the party games, this time demonstrating how they are seldom fun for those who are not involved, especially towards the end of a game. Here a sturdy piñata resists destruction with the result that some of the guests have become bored, leaving only the more determined to carry on. This sequence shows how important it is to keep shooting whatever happens. It is easy enough to edit out – or not even load – any parts of the movie that you do not need.

A cut here reveals an surprise spectator. In fact, the family cat was watching a bird, not the game. But by intercutting the games clips with the attentive cat, you can make it seem as though she is transfixed by the amusements.

Or maybe the cat has her eye on the dog, which is accompanying the grown-ups as they arrange the furniture for the next game. Cross-references between the cat and the dog can help create a narrative continuity and structure.

The eventual destruction of the piñata leads to a scramble for the goodies. Get in close to capture the activity and the excited voices of the children. You might also record the comments of the watching adults as a counterpoint to the frenetic scene.

The birthday cake is an almost universal symbol of good wishes on birthdays, so it cannot be missed. Prepare for this element of the party by consulting with whoever is organizing everything, so that you are ready and in a good position for taping.

Always try to give every guest some time on screen. You can ensure that everyone is accounted for by devoting some time to each person in turn, perhaps asking them to perform a party piece or say a few words for the camera.

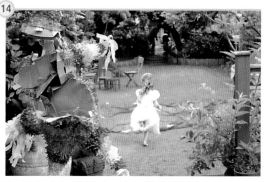

I had intended to finish the video with the birthday girl asleep, exhausted from the party. But as I grabbed some last-minute footage of the now-broken piñata swinging in the breeze, one of the guests ran past and into the distance. Perfect. Fade to black.

Natural history

Movies featuring the landscape, plants, or animals require sustained shots that move smoothly and steadily. Dramatic editing is not usually called for unless, for example, you have the rare fortune to capture a predator attacking prey.

Telling the story

Most nature videos tend to be fairly sedate. The difficulty, then, is in holding the viewer's interest. We are all familiar with the whispered voice-over narration telling us fascinating details about nature and wildlife, but this is usually added later so as not to obscure atmospheric sounds. If you do not wish to add a voice-over track, you must instead move the video along with your footage first, and with the editing second.

Getting the low-down

An effective way of involving the viewer is to present unusual angles or perspectives. The easiest is the low-down, or crouching, position, taking the camera down to ground level. This is especially rewarding for environment or natural-history work: the unusual perspective immediately grabs attention. The swivel LCD screen on the majority of DV cameras gives you an advantage even over the best professional camcorders.

We start with a scene-setting wide-angle view: the establishing shot. The bright sun and blue sky are very attractive but restricted by trees on either side. Instead of the anticipated pan across the scenery, we present an unexpected shot.

Now we move to a different location – a pool a little further down the stream, and we could either snap-cut or cross-dissolve to this scene. The pool is full of young trout, and the sound establishes a link between the stream and the pool.

We can whip zoom (zoom in as quickly as possible) to show more detail of our main subject. Now we can identify the trout easily. But while the fish's movements are a pleasure to watch, the light is not very attractive, so we quickly move on.

Because the trees restrict any sideways panoramic movement, we tilt down from the sky to take in more and more of the grasses swaying in the wind. After a pause to admire the movement, the view moves down towards the stream.

As we show more of the stream, we can allow the audio levels to rise, to capture the sound of the stream and prepare for the next cut. Ideally, we would move closer to the water, which will bring the audio level up naturally.

In direct contrast with the flat lighting of the previous clip, we now shoot a scene that is full of gorgeous lighting, brought to life with several trout coming and going. For a transition, we could try a zoom-out combined with a cross-dissolve. This footage is the perfect backdrop for some voice-over narration revealing some facts about the stream and its importance to the local wildlife community. The gentle splashing of the water, which can be recorded wild, should also be audible.

Holiday

The modern holiday trip is incomplete without either a stills camera or a video camera slung over one shoulder. But recording your trip is not only about creating a way to remember the experience; it can also be part of the experience – one that helps enrich your travels, deepen your understanding of a place, and increase interaction with other peoples and cultures. At the same time, though, be aware of the impact that videoing may have on others holidaying with you and around you.

It does little for one's movie-making inspiration for your friends to say, "Put that camera away." Unlike in photography, in which the camera is up to your eyes for a relatively brief period of time, a video camera may appear to be semi-permanently fixed to your face.

Preparing yourself

It may seem that the easiest approach to the holiday-trip video is simply to pick up the camera whenever the inspiration strikes. The trouble is that you then stand a good chance of returning home with a series of unrelated clips lacking vital continuity links. So plan your video before you travel. Research visual material, and try to imagine how to record and connect your scenes.

Planning and mapping

Planning your video before you travel can be part of the fun of preparation. You can research visual material, try to imagine in your mind's eye how to record a scene – how to join a railway station with a city view, or how to relate a close-up of an orchid to a sunny beach view, for example. You can start to work out what kind of movie you want – something straightforward (travelled there, did that, did this, went home) – or whether to try something more ambitious.

On a recent trip to Tuscany, Italy, we did all the usual things, such as sightseeing in Pisa and Florence. Our video of the trip is presented as a day in the life of a tourist. We start with a shot of a railway station and life there.

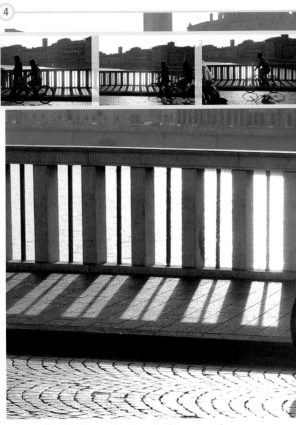

Our wipe from the boy on the phone leads us on to a busy bridge in Pisa with life going on, much animated movement, and the passing by of pretty girls and good-looking boys. We pull back slightly to take in a little more of the bridge and slow

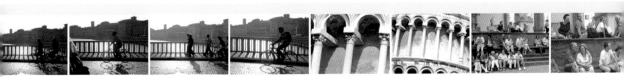

We then pan down the platform of the railway station before settling on a shot of a stylish public telephone. We zoom in on the phone and hold the shot for a second. Just after that pause, a figure walks into the frame.

We pull back to reveal more of our telephone user just as he makes a call. We hear nothing of his conversation because of the ambient noise of the station. As we record, a non-stopping train rushes past. The blur of this gives us a wipe to the next scene.

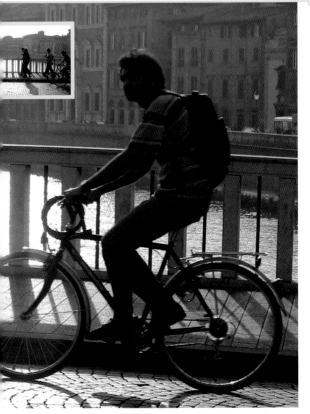

From the bridge sequence we dissolve into a (near) match shot of the columns on the famous Leaning Tower. We then pull back to reveal more of the tower but are careful not to hold the shot too long. Long shots of static objects quickly become boring.

●HINTS AND TIPS

This is a list of things to consider for your video-making holiday. Think about them in advance, since they may mean obtaining permits and extra equipment.

● Find out if you need permission to video anywhere (cathedrals, museums, airports) and how much it costs.

● Ensure your battery charger will work in the countries you are visiting,

● Prepare a shot list; this is a note of the minimum video footage you need in order to make your movie.

● Pack a spare battery or batteries, as well as lots of video tapes to cover every eventuality.

down the action by giving the cyclist more space in which to move. When we edited the video, we saw a similarity between railings in this sequence and the columns of the Leaning Tower of Pisa; this gave us an idea for a dissolve.

Holiday continued

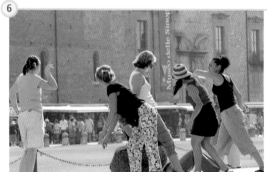

6

From the bridge, we straight-cut to a scene showing some of the things that tourists get up to. These girls are posing for photographer friends who are lining them up against the Leaning Tower behind them.

7

The activity of the girls gives us a cue to observe a little of the local life. Here, some dogs wait patiently while their owners discuss plans for the evening. A good camera microphone will pick up much of what you yourself can hear.

10

A scene such as this, showing a shuttered building with colourful window boxes, calls for a straightforward panning movement. The shot was set up on a tripod so it could be slow and, above all, steady, allowing viewers time to savour the details.

11

We cross-dissolve (*see p. 181*) from the yellow buildings of the previous scene to the golden light of a summer evening. Hold this steady and avoid the temptation to zoom in – this would be distracting when all the viewer wants is to enjoy the view.

12

Next, we cut to a riverside scene of two friends sharing a beautiful evening moment. The street is fairly quiet now, with only the occasional passer-by. At the edge of the frame, a local takes a break on her way from the shop.

13

Just as I zoomed in for a closer shot of the riverside friends, one of them lifted her shirt to scratch an itch. Fortuitous moments such as this add a point of human interest to the movie where there may otherwise have been none.

8

9

Another straight cut to this cat helps suggest that it is watching the dogs with interest. In fact, the two scenes were shot at different times and in separate locations but the viewer need not know. That is the power of video and editing.

If a location is brimful of beautiful shots and bright colours – such as this hotel wall – the delightful problem is what to do with them all. You can simply hold these shots still for just 2 or 3 seconds, as if presenting a series of photographs.

14

We dissolve to a close-up sequence of friends sharing a joke. Unfortunately, they are aware of the camera and seem a little self-conscious. Still, that did not stop them from enjoying themselves and having fun. This sequence can be allowed

to run on into a fade to black. About midway through the sequence you may consider taking down the volume of the scene as you bring in your choice of music to end the movie. Once you have faded out, you can add end titles if you wish.

Quick fix Permits and access

The movie-maker of infinite sagacity and resource is not easily put off when told "You can't film there". A legal, permissible way round any obstacle can usually be found. Here, we consider strategies appropriate to different obstacles. The crucial point to remember and never betray is: honesty is all. Never give an assurance you have no intention of keeping. Do not lie or pretend to be anything other than you are to obtain an advantage. You do a disservice to yourself and other movie-makers (*see also p. 238*).

Public space
Practitioners of t'ai chi may not mind you taping them if they are in an open park, but if you look professional and may be doing it for profit, their attitudes may change. For extended recording, obtain consent first: you may also win their cooperation.

Problem

You are recording in what you consider a public space, and a uniformed person tells you to stop.

Analysis

You may not be in a public space. An area open to the public – such as a shopping mall – may be privately owned or run. As soon as you appear to be professional – using large cameras or tripods – you are likely to be moved on. In addition, use of tripods will be regarded as a safety risk since someone could trip over an extended leg.

Solution

Do not look so professional. Use small cameras, and work hand-held. If you need a large camera or a tripod, obtain a permit. Permission is likely to be given if you say you are taping for private purposes, promise to work safely, and offer a copy of the finished movie to the location owner.

Problem

You are prevented from reaching a good vantage point for videoing by an obstacle such as fence or railing.

Analysis

Fencing and railings are often raised to keep out people as well as prying eyes. At times, though, such obstacles are simply an inconvenience. Assuming that the obstacles were not erected precisely to prevent people taking pictures and, most importantly, you do not breach any laws in so doing, then you have to find an alternative choice of shot. You may even find a better viewpoint.

Solution

You can try to make use of the obstacles in the shoot: perhaps it says something about the mind-set of the owner. Or, see if you can take artistic advantage of the patterns in the railings. Obstacles can force you to find a more creative approach. Alternatively, you can extend the reach of the camera: with modern digital video cameras

Blocked viewpoint
A grand house is protected by railings that prevent a clear view of its façade. So shoot it anyway, but explore other possibilities too. Beyond the railings, for example, is a pond in which the sky is reflected, with a quiet fountain. This is just as interesting as the building and could easily have been overlooked.

it is possible to tape from a camera at the end of a boom or monopod: of course, this is very unsteady and a method of last resort; a better option would be to use a mini camera crane. You will need a video feed from the camera to a monitor to see what you are recording.

Problem

You wish to enter an area or zone restricted to the public at an event or in an official or commercial establishment. Behind-the-scenes activity of a film gala, dressing rooms of a fashion show, high-security areas, and the changing room of a big game, for example, are all difficult to access.

Analysis

You have no rights and no bargaining power. This is going to take planning, effort, time, and probably a good dose of luck, too. Do not expect quick results. Regular or annual events can prove slightly easier because then you have time on your side.

Solution

The key is finding something that you can offer in return for the permits or cooperation. Find out if there is anything that the planners need that you can help them with, and the door will swing open. So the trick is to make an attractive offer. This may take time and planning and, ideally, someone senior on the inside who can put in a word for you. Try shooting your video from public spaces and presenting it to the organizers to show how

Cramped shooting
Shooting a documentary about a big film production is a glamorous prospect, but you may not be welcome simply because there is almost never enough space for all the crew, equipment, props, and actors to fit in anybody else. Your chances may increase if you are prepared to work alone, with just a hand-held camera.

much better it could be with increased access. Once you gain a meeting, show your other video work – your style may be just what they need for a promotional video. Build a reputation for being reliable, safe, and professional – you never know who might give you a reference.

Problem

You have shot some great footage on your travels or holiday, and you want to use it commercially. You are not sure of your rights, nor those of the people you taped.

Analysis

Very many people the world over – some in surprisingly remote parts – are aware of model-release rights: they know that they have a right to profit from your commercial exploitation of representations of themselves. So you must be very careful and not make any assumptions if you wish to exploit your movie commercially – for example, in royalty-free footage.

Solution

Ask your subjects to sign model releases to allow you to use your movie in any way you wish. To ensure the release (essentially a contract) is valid, it is best to pay the subjects a fee. Most people will agree since they feel they are getting something for having done nothing.

Model release
You taped a rugged sailor while on a trip to Dubrovnik. You think nothing more of it until your agent shows it to an art director who would like to use it in a TV advertisement. If you do not have a signed model release you need to weigh up the risks – and perhaps put aside a fund in case a claim is made against you for unauthorized use.

Carnivals and parades

Public events such as street carnivals can provide lively video footage, but because there is so much going on that feels exciting at the time the temptation is to simply stay put, point the camera at the parade and let the action unfold in front of you. But a movie that makes it too easy for the audience is not very interesting to watch. The challenge lies in recording engaing footage that truly captures the atmosphere and the imagination.

Create a story

Narrate the event in a roundabout way. A parade can make for dull viewing if that is all you show, so try to use it as a background, a context, for a people-watching exercise, recording the audience instead. Present the subject of your video by implication, through oblique references and details. The clothes people are wearing and the background noise and music will make it clear what the event is about, but do include a few inserts of parade floats and carnival performers.

Capture the atmosphere

Remember that the sounds of a carnival can be every bit as colourful as what you see. Record as much as you can, and try to reveal the spirit of the event in sound.

Archive the original

You may not know until later quite how important your work will be. Abraham Zapruder used his cine camera to film the US president on a visit to Dallas. The date was 22 November 1963. Little did Zapruder know that his shaky footage of Kennedy's assassination would be the most intensely analyzed and debated piece of film in history.

So shoot and keep shooting, and always hold on to the footage. Tape is inexpensive and MiniDV takes up little space, so there is no excuse for reusing it when it contains documentary material.

This footage is of a parade through central London. There is often a lot of waiting around before a big event gets under way, so try to capture some of the anticipation. Here, a child is kept amused and content with a snack.

In order to work in a good variety of shots, you should use the whole range of your zoom. At the long focal length or telephoto end – as in this shot – you can crop easily to detail, but it is hard to keep the camera steady. If possible, use a tripod.

How do you end your movie? People walking into the distance, perhaps; sounds reducing to silence? On my way home, I noticed the leaves that had been crushed into the road by the parade. Along with the arrow, they seemed ideal for signalling the end.

2

Change perspective with your zoom lens. With extreme close-ups, try to pick up snatches of conversation; with wider views, general crowd noise. You may have to hold on shots of crowds for a few seconds before catching signs of excitement.

3

Once you feel that you have enough crowd footage, change the pace and cut to the parade itself. There will be lots to choose from, so select the most colourful and amusing participants. Being selective is editing before you edit.

5

The soundtrack is an important consideration. Here, the subject is not only colourful, it also provides some jolly music, so it is worth including. Allow the music to carry on even if the movie changes to show a different subject.

6

Where you have the support of sounds from an obvious source – such as the brass band – you can indulge in simple visual abstractions, such as reflections from the instruments. Hold the shot and let the action enter and leave the frame.

8

But then I threw in a surprise by adding the firework display that lit up the night sky a few hours after the parade finished. Since the actual fireworks images did not work well, a number of clips were superimposed during editing to "improve" the effect.

HINTS AND TIPS

The considerations to bear in mind when shooting a public event such as a parade tend to concern issues of planning, personal security, and red tape.

- Obtain passes or letters of permission in advance.
- Dress smartly – this will help you when dealing with officialdom – but try not to stand out from the crowd too much.
- Check out or walk the route or ground in advance.
- Look at the weather forecast for the day, and wear appropriate clothing and footwear.
- Stay aware of your surroundings to avoid pickpockets and surprise movements of crowds.

Wedding

Videoing a wedding can be a stressful experience. It is a task for which you have the burdens of a professional and very few of the advantages. You have to get it right first time – you cannot rehearse or re-run, nor can you give much direction. And you will also be expected to produce high-quality work without the benefit of lots of experience or the authority to call the shots.

Thinking ahead

Always check out the various venues in advance: for the ceremony, official registrations, and the party or reception afterwards, not forgetting the transitions from one to the other. Your aim is not to simply record an event – anyone can do that – but to produce something that people will enjoy again and again. For that, it is essential to keep the action flowing, just like a good feature film. Apart from high-spirited japes at the reception or a shocking speech, you cannot surprise the viewer with twists in the tale; after all, we know what is going to happen to the hero and heroine.

Plan the movie and the types of shot you want to capture before the day. This enables you to be in place in advance, ready to shoot a lead-in – for example, an empty passageway before the bride bursts in, with her dress lighting up the space.

Look for an interesting or unusual angle on the usual head shots and unavoidable portraits. In this clip, I caught the bridegroom keeping his guests entertained while they all waited nervously for the bride's entrance.

There will usually be decorations and balloons that help to create a festive atmosphere – all part of the event and usually forgotten. The happy couple will be pleased to be reminded in your movie of how their wedding venue was decorated.

Cultural variety

As your reputation grows, you may be asked to video weddings from cultures that you know little about. If you are not familiar with the wedding protocols, you should spend time with family members or the person performing the ceremony in order to learn the order of events and the key points that need to be recorded – there may be a literal "tying of the knot" that is central to the service, for example. Also, find out whether there are any sacred moments that you should not tape or any areas where you should not walk.

Use a wide-angle adapter to capture a view of guests listening to the speeches. Be aware, however, that it causes barrel distortion – that is, straight lines tend to bow outwards. This effect can be disturbing to the viewer, so use it sparingly.

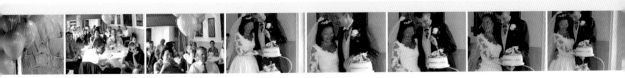

Once you have recorded the obligatory ceremonial entrance of the bride, your work as a creative camera operator starts. Details of the bouquet and dress are more interesting than shots of the guests looking on, smiling.

The tiniest moments are easy to miss unless you are taping all the time. Keep your eyes open, and look around you even as you video. By doing just that, I caught sight of the marriage certificate seconds before it was pocketed safely.

For crucial rituals within the ceremony – and these will vary according to local culture – find yourself a suitable position in good time and start videoing before the main action commences. Here, the anticipatory recording has captured

a delightful moment of amused complicity between the couple before the cake-cutting itself. The latter proceeded with accompanying camera flashes, but without any drama or interest – the best moment had already taken place.

Wedding continued

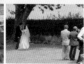

Capturing the vital shots

Weddings cannot be repeated, so it is essential that you remember to record everyone important – each and every relative, especially the parents from both sides – and every major part of the day. This becomes more of a challenge towards the end of the celebrations, when it may be difficult to keep shooting at all, so start early.

It may help to have an assistant with you, whose job it is to keep notes of what you have covered and what remains to be shot. Failing that, make a checklist in advance of the big day, and cross off items as you go.

One trick you can try is to watch what the official wedding photographer does – here organizing the bride's portrait – then avoid it. For one reason, he may appreciate your keeping out of the way. For another, why repeat what the professional is doing?

As the video-maker, you must start recording before the main action really starts, so as to give a sense of casual observation. Here, what seemed like an unpromising grouping became a sequence to cherish, since it led up to the moment when these close friends expressed their feelings towards each other in a group hug. For such sequences, it is very helpful to work with a tripod, particularly if it is late in the day and you are getting tired and perhaps even a little unsteady.

8

No wedding anywhere in the world is complete without an embarrassing relative narrating a tall tale to a captive audience. Keep your eyes open for such an opportunity and keep the camera rolling – you can always shorten it at the editing stage.

●HINTS AND TIPS

It is easy to get caught up in the excitement and bustle of a wedding. However, certain important factors must be taken into consideration, before and during the event.

● Take ample spare batteries and lots of tapes.

● Remember that the camera will record everything, including any comments you make about the bride's dress, so be discreet.

● A tripod is essential if you are planning on directing formal group shots.

● Do not get in the way of the official photographer: he or she has a difficult job to do.

10

A wedding is the ultimate chance for people to flaunt their style. You can shoot simple portraits and edit them together as a gallery of the fashions of the day. No clever camera work is needed: just hold the shot for as long as possible and edit it later.

11

Intersperse the standard, formal shots with some more unusual moments. Once they are edited, they offer opportunities to vary the pace and provide an element of unpredictability that helps keep the viewer's interest.

12

As the celebrations and drinking progress, you may entertain increasingly experimental and adventurous camera angles. There is no harm in experimentation, but try to keep the camera steady, and slow down all movements.

13

Intimate moments are very much on public display during the celebrations, but they may not be so welcome in a movie that will be watched in many years' time. Use some oblique or more abstract shots along with the obvious choices.

Promoting a cause

Video is an ideal medium for promoting a cause that you support. You can easily distribute copies as DVDs or VCDs (*see pp. 194–7*) or place it on a web site devoted to the campaign.

Engaging the emotions

When you are caught up with the importance of an issue, it is easy to forget that a stranger seeing your movie may know nothing about it. Therefore, you need first to engage their emotions and then tell them about the cause. The needs of the campaign must not override the need to tell a story. In this example, a campaign to raise money for a bird sanctuary in Africa is presented through a visit to a falconry centre. The story aims to explain the connection while presenting an attractive subject.

Enthusiasm and anticipation

One of the most difficult things in video-making for campaign work is knowing when to become involved. It is hard to recapture the atmosphere of excitement when one first gets fired up to change the world for the better. As a video-maker working in documentary mode, you need to anticipate – and plan for – the longer term: you may not know the future importance of people, events, or what is being said, so try to video all that you can.

1 Work on the assumption that not every viewer will know from the outset what the video is about. Start with something a little mysterious to arouse curiosity. Here, we used silhouettes against the sky and the sounds of bird-calls and flapping wings.

4 Make the viewer feel involved by closing in on a little action. A cut to an inquisitive visitor handling an owl and asking questions about the campaign allows the narrator to reveal more about the centre and its work.

7 Through the use of some attention-grabbing active footage, you can relax a little with the narration and allow the viewer to consider the information that has been shared. Let the movie speak for itself for a while.

2

A good way to impart initial information is through an expert. Here, a bird-handler is explaining the work of the falconry centre and preservation of birds, including a rare eagle in Gambia. She is talking to visitors on a weekend trip to the centre.

3

Remember not to bore the viewer with the same talking head for too long. We cut to the visitors while the bird-handler continues. This can be a voice-over – in this case, mixed with sounds from the birds in the falconry centre to create atmosphere.

5

While the visitor and bird-handler continue their discussion, we cut to a close-up of a falcon to create some visual diversity. This is also a good time to introduce a new voice to reduce the likelihood of monotony setting in.

6

Next, reveal who the new voice belongs to. It is important to show that your protagonists care about their cause. This bird-handler shows the closeness of his relationship with his charges. Now may also be a good time for a change in the narrative.

8

End the active sequence with a suitable clip – here the bird landing on the bird-handler's glove – and include some narration to draw the movie to a close. Strong imagery will stay in the mind long after the words are forgotten.

9

Finally, cut to a shot that obviously marks the end or coming to an end. A clear sky area is perfect for displaying acknowledgments and contact details for the campaign: the words can be displayed over the last frozen frame.

Portrait of a place

You may fall in love with a place, whether a beautiful holiday destination, somewhere you call "home", or where you met someone special. How would you capture some of that excitement in a movie? What are the best ways to convey the character of a place? This is a different exercise from videoing a straightforward holiday trip (*see pp. 132–5*) because you are concentrating on the character of the place, rather than the enjoyable time you had there.

Shooting all you can

Making a portrait of a place is classic "run and gun" video-making: you will not know what to shoot until you see it. At times you will miss shots that you would have caught had you known more, but this exercise will really open your eyes and make you a more observant videographer.

The beauty of DV is that the amount you shoot is limited only by your budget and the number of hours in the day. Even if you video constantly during daylight hours, the cost in tapes – perhaps half a dozen cassettes – is minuscule compared to the cost of cine film.

Be considerate to family or friends travelling with you. Although this is not a traditional holiday video, try to involve them whenever possible.

The visual essay

A portrait of a place offers as good a structure for shooting as any. At the editing stage, you can turn the essay structure upside down and inside out if you wish, but at least you will have the basic materials to work with. The classic approach helps ensure you shoot constructively.

Overview sequences give viewers a sense of where you are taking them by providing a context and creating a mood. Are we in a mountainous region or a desert? Are we in bright sunshine or surrounded by sombre shadows? Is this going to be fun and light-hearted or a serious documentary?

Panoramic vistas are a good general introduction to a place, especially one with breathtaking views. You could start by videoing the landscape around your base location to create an establishing shot before revealing other aspects of the area.

Signposts and arrows are invaluable "B-roll" material. When used in close-up, they are especially useful for masking errors in continuity, as well as for creating changes in the movie's tone or narrative direction.

Video and environment

Being observant and attentive is a firm foundation for videoing, but you should be aware of the impact of your shooting on your environment and yourself. Including footage of the view as your flight comes in to land may be difficult, for example, because your camera generates electronic noise that could upset sensitive equipment on aircraft computers. Or your recording could lead you to become distracted so that you neglect to watch where you going. An important rule is to stay attentive to everything around you.

Remember to pan slowly: while videoing, the correct panning speed usually feels too slow, but you must impart a sense of affection for this location. Avoid zooming slowly from an overview to a detail – instead, jump closer in several distinct steps.

Activity clips show what goes on in a place and focus on people going about their business, living their lives. Not everything that is depicted on video must be on the move: stillness and relaxation also contribute to the variety of pace and tension.

A particular scene may not seem important or relevant at the time, but you might want to video it anyway. When I first spotted a skier stopping to pick up her mobile phone calls at the top of a mountain, I thought it was an unusual sight. Later I realized that people were doing it all the time; indeed, the most skilled skiers were able to answer calls without even interrupting their downhill run. If you can pick up what they are saying, it may be that they are talking about how much they love this place too.

Portrait of a place continued

6

A big part of life at a ski resort is dealing with mountain gear: a series of short sequences of people struggling to put on boots, gloves, and goggles will convey more about the spirit of the place than the best-written descriptions.

7

In chaotic scenes, such as this school party preparing for the slopes, the old rules of composition apply: try to include elements that unify or structure the scene, and have a focal point – here it is the kitted-up child looking into the camera.

9

Portrait clips take the viewer close to the people in the video, offering an opportunity to become involved in the action or life of the place. It gives the viewer a chance to see what the people there look like and how accepting they are of tourists.

When you present a portrait of a place, you may find that a mini-narrative helps structure the sequencing. By placing a lunch sequence into the movie, you can visually signal to the viewer that you are at the halfway point.

As the autofocusing sensor examines the centre of the image, the camera has focused past the faces to the background. This leaves the portraits out of focus due to insufficient depth of field. You can bring focus to the faces by panning to one of them.

●HINTS AND TIPS

When going away for a location shoot, bear the following points in mind.
● Take your battery charger with you: modern batteries are sensitive to the input voltage, so you must use the charger that came with your digital video camera.
● Buy and mount a clear or UV filter over the lens to keep it clean.
● Use clear plastic bags to save your camera from splashes without going to the expense of buying waterproof housings.
● Wear dark clothes when shooting through a car or coach window to avoid capturing reflections.

Ski slopes are not just about skiing. For some people, the location is a pleasant place to go for walks, enjoy the views, and trudge through snow to restaurants. For long shots with small detail it is best to shoot from a tripod.

Not everything you video has to be stunningly beautiful – you want to show the reality of the location, too. These shots of a snow-taxi trundling about its business provide a change of pace, as well as variety in sounds.

Take the time to feature some of the local architecture in your portrait of a place. You can start with your hotel or chalet, but you should then go on to include any other beautiful or unusual buildings in and around the area.

To drive the narrative, you will need a few continuity links. If, for example, you want to feature a view of the town square, which is dominated by a clock tower, you could first insert a different viewpoint of the tower, perhaps from your hotel window.

Sporting event

The emotional distance between viewers and participants is perhaps greatest in movies of sporting events. Try to bridge that distance: enter into the mind and heart of the athlete, as Leni Riefenstahl did in her film of the Berlin Olympics. Consider the loneliness of a long-distance runner, or the cup fever of a soccer team, for example.

Perhaps you wish simply to record the scene from the point of view of the spectator: cheering on a friend, while documenting their efforts in an athletics meet. Your friend will necessarily only be part of a larger picture of activity, and the chances are that you will see them only for fleeting moments. So the challenge is to create a context for those brief contacts.

Before the event

The key to successful sports recording is planning and preparation. Scout the location beforehand, just as a runner or cyclist would check out a route.

When covering smaller events, contact the organizers in good time to see if they will give you a pass that will allow you access to areas closed to the public. This will give you a wider choice of viewpoints and subjects. If you do get a pass, make sure you are absolutely responsible and reliable or you will make it difficult for yourself and others the following year.

During the event

The most difficult element of location filming is finding a higher-than-normal viewpoint. This means that you will have to arrive very early, before all the good vantage points are taken. Where necessary, you will have to hold your camera up high above your head and monitor the shoot via the fold-out LCD screen. It will be tempting to use the long end of your zoom for most of the time, but wherever you can, use your wide-angle attachment – that will force you to enter closer into the action.

Do not jump straight into the action – build up to it. This shot looks like a pleasant afternoon on a lake. Initially, the viewer notices the swans, but other things are happening. As the viewer investigates other parts of the image, we start to zoom in.

Unless you have shown a title sequence at the beginning, the viewer still does not know what is going on. But now we have their interest, we can cue in a recording of the announcements being made, informing the viewer that this is a triathlon.

HINTS AND TIPS

In order to capture a sporting event on video, you will need to be fast, well-prepared, and on the ball.

● Keep an eye on the professionals: without getting in their way, learn from where they position themselves. If they run anywhere, it is for a reason: follow them.

● Memorize the running order and the layout of an event – you will not have time to refer to maps.

● Drink plenty of water: on hot days, you will need to keep hydrated. You may also have to wait a long time for athletes to arrive, so wear a hat and sun-block.

● For steadiness combined with mobility, try using a monopod rather than a tripod.

This may be one of the rare occasions when a long, very slow zoom is the right approach. As we pull deeper into the image, we start to make out swimmers, lots of them, in the river. The spectators on the bank unknowingly offer an amusing contrast.

Next, we want to be in the thick of the action, as with this close-up of swimmers coming to land. We get a sense of their numbers by holding the camera steady while they enter and exit the frame. A wild track of splashing noises can be easily added.

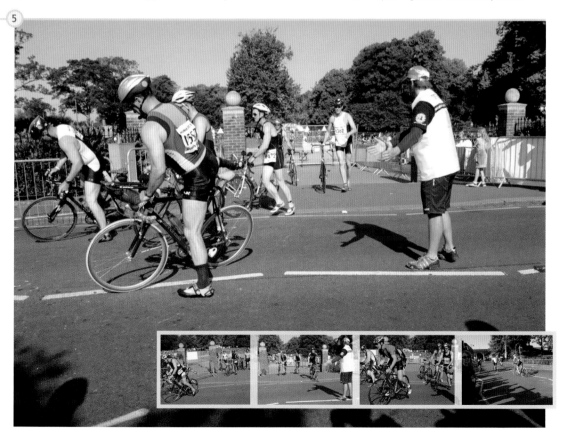

Do not spend too long on the commentator, but go back to the main sporting action. While the announcement track continues you can split-edit to another part of the race. Cut to a group just starting on a circuit. Notice the change from long view at

long focal length, to an extra wide-angle view here. The shadows on the road in the last shot of the sequence hint at what may be coming up soon – because so far we have ignored the spectators.

Sporting event continued

6

Here a group of cyclists is returning from a circuit around town. This may be a good point to narrate a very few key facts – such as how many participants are involved, the oldest and youngest competitors, and so on – before cutting to the spectators.

7

Comments from expert spectators can be an amusing element of the video. Modern sunglasses are useful: asked nicely, these men agreed to being videoed close-up so I could record the reflection of the race in their glasses.

9

To reinforce the fact that some races are starting when others are ending, cut to the beginning of another event. Here, the next wave of swimmers jostle for position at the start. Again, vantage point is important; unfortunately, mine was not so good for this shot.

10

A multidiscipline event such as a triathlon offers good opportunities for cutting rapidly between races. Try some slow-motion and speeded up effects in post-production to create a bewildering swirl of running, cycling, and swimming.

11

Suddenly slow the pace down again to show the exhaustion of participants. You could hold the best frame for several seconds to suggest the feeling that one cannot move again. The viewer will wonder, Is it all over? Is the video about to end?

12

At the end of the event, everyone else can relax in the sun and have a good stretch, but you have to keep working. Now you can obtain shots that show some of the other aspects of sports, such as the bonhomie and the physical exhaustion.

With the next edit, surprise the viewer with sequences on the huge support effort that makes sporting events possible at all. At a football match, it might be a volunteer preparing orange juice for half-time; here, an attendant is handing out cups of water.

Avoiding confusion

Shooting a sporting event can be confusing if you are not participating yourself. But the spirit of the event is always warm, and people are glad to advise you. Make sure you ask stewards or officials for advice on where to go and when.

After the event

If this year you do not get a pass, try to ensure that you do next year by sending the organizers a copy of your edited video, perhaps with a few print-outs of the best frames. You may be invited to record the following year's event.

It is always worth saving one last surprise for the viewer: here, it is the revelation that the race is still going on. I allowed the runner to come right up to the camera, losing focus as she flashed past the camera position. This is a great last frame to hold, showing her determined expression, before fading to white and rolling the credits. Such an ending opens the way to adding another event, perhaps a completely different one, since the white-out can lead into any other shot that is full of light.

Family video album

The video album is the modern equivalent of the family photo album. It brings together sound, movement, and light to recreate memories and past moments in the most direct way. Of course, the video album is subject to a highly selective remembrance of the past, but it can go much further. An ongoing video album is a marvellous way to record children as they grow, preserve the memories of older family members or make a documentary of your day-to-day life.

Preserving the past for the future

While it may seem like favouritism to concentrate on just a few members of the family, that is probably where you should start. If Dad is too busy with work commitments or the teenagers are camera-shy or think it is a silly idea, concentrate first on the most cooperative or available family members. Once you show the doubters a rough cut of what you are doing, they may well warm to the idea.

If any elderly family members have fascinating tales to tell, you could encourage them to recount some to the camera – even if you have heard the stories before, perhaps your children's children could learn something when they watch the movie in years to come. Just let the tape run, and edit out any pauses later.

If you are asked to act as videographer for another family's video, make it easy for yourself by lighting the area evenly. You can then record from many angles without having to alter the lights. For this shoot, we start off with all the family members together.

Adults are usually the most self-conscious, always aware of the camera and behaving awkwardly. However, they may not mind filling centre stage when necessary for the movie, so catch a glimpse of them and move quickly back to the children.

If a child takes himself into a corner away from the bustle and activity, it may be that he simply wants to be alone. If you follow him, do so at a discreet distance using a long focal-length setting from a tripod position.

(2) It is not long before the children run off, leaving the youngest playing with her mother. The longer your video camera runs, the more the family will become accustomed to your presence and behave naturally. Each person's character will then emerge.

(3) You can supplement the main room lighting you have with an on-camera light. But beware of shiny surfaces behind the subjects, such as glass doors, mirrors, and windows. Here, chrome kitchen fittings have caught a flash of light from the camera.

(6) If there is a centre of activity, such as this tunnel, then you need only set up the video camera pointing at it, resting on a tripod, and let the tape roll. You can stand behind the camera to encourage the play or simply get on with other jobs such as setting up lights elsewhere. Change camera angles, zoom setting, and framing from time to time, but otherwise you can do all the important work in the editing. Playing back some of the footage to the children may help encourage more activity.

Promoting a business

If you are known as a video-maker, your boss might turn to you when she needs a promotional video, for example for the web site or as a looped movie (one that runs continuously) for a trade fair. How do you make the most of this chance?

Work professionally

Brief, budget, plan, execute, and post-produce with the discipline of a professional video-maker. The crucial questions are: what is required, how is it to be done, how much can you spend, and when does it have to be done by? Always confirm all the details in writing with a line manager.

Budget and plan

Once you know your budget, you can plan how to spend it. Perhaps the offices need a lick of paint, the plants can be renewed, and flowers brought in. You may need to hire lights or a better camera.

What is coming up on the works calendar? Not the social events, perhaps, but graduation day if you work at a school or college, the launch of a new product, or an open day for the public. These events may take up only a few seconds' screen time but are nonetheless worthy inclusions.

Satisfy the customer

The key is to ensure that the shoot captures the kind of footage wanted by the company's director. The example on these pages shows a video to promote the work of the Guitar Institute, a centre for guitar tuition in London. The director wanted to present an up-to-date image, with a strong appeal to the young aspiring stars of tomorrow.

Consider safety

Be particularly careful if you need to involve other people in the shoot, especially if they are to enter areas to which they would normally not have access. Check with those responsible for insurance and clear all details with your safety officer.

It may seem boring, it may be conventional, but you may have to open the movie with a shot showing the front door of the business premises. However, you can still be creative by fading in the sounds of guitars and voices inside the building.

We pull back slowly to a young female student warming up with her guitar. The sunlight is very strong from the window, burning out the right-hand side of the image, but the client likes the bright, modern feel that the overexposure gives to the shot.

Another cut reveals other guitar sounds and enthusiastic players. The bright sunlight helps create an airy atmosphere but does not conform to broadcast regulations. The use of a Broadcast Legal filter in post-production would tone down any super-whites.

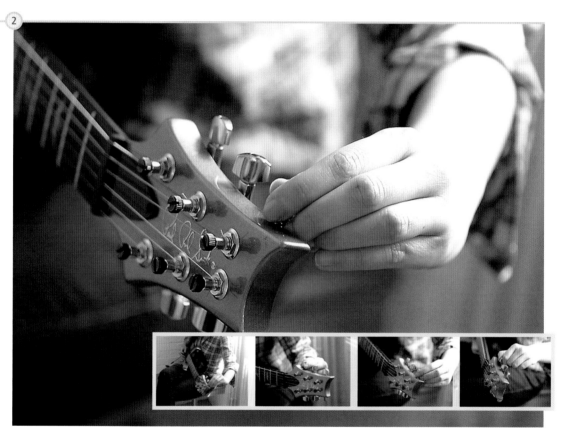

The next logical step from the establishing shot is to show the first thing that a guitarist does with his or her instrument: tune up. We could have the sound of some tuning up mixed in with the general noise of the Guitar Institute starting on a typical weekday morning. The background sounds can be recorded wild and added later. Note, though, that it can be surprisingly difficult to record background that is suitably characteristic of a location and that bears repeated hearing.

In this scene, two tutors "widdle" – play lots of notes very rapidly. The microphone should be held close to the guitarist who dominates the shot, moving as the camera pans to the other. Next, we fade in the sounds of a class elsewhere in the building.

The change in soundtrack cues a change of pace, and we cut to a teacher seen through a window. Over the wild track of a band playing, we can have some narration explaining that we are waiting for a good moment to enter the classroom.

Promoting a business continued

Model releases

If the employees of a company are being videoed for promotional purposes for the first time, obtain model releases – after all, having their picture taken is not part of their job description. In future, it may be deemed that part of an employee's duties is to help promote the company – an element of which is to have their photograph taken for company purposes. If this is added to the job description, there may be no need for model releases each time an employee is photographed.

Cut to a tutor instructing her class. We knew from an earlier reconnaissance trip that this room was rather echoey. In such situations, it is best to clip a radio microphone to the subject, rather than follow her around with a boom.

A change of colour, a snap cut, and a crash of percussion change the mood of the video. Focusing on the drummer tells the viewer about the range of musical genres taught at the Institute without having to say anything about it.

Here, we pull back to bring the guitarist into the shot, showing that interaction between students is almost as important as the tuition. Whatever your subject, you can increase the amount shown in the frame by using a wide-angle attachment.

Between the sequences of the various activities around the building, remind the viewer of the function of the organization – in this case, teaching. Here we cut to a solo player waiting for the start of her lesson.

The sound of a door opening, followed by a wild track of noises from other rooms, leads us to a one-to-one class. This shows the audience, without spelling it out for them, that the Institute offers individual tuition as well as classroom teaching.

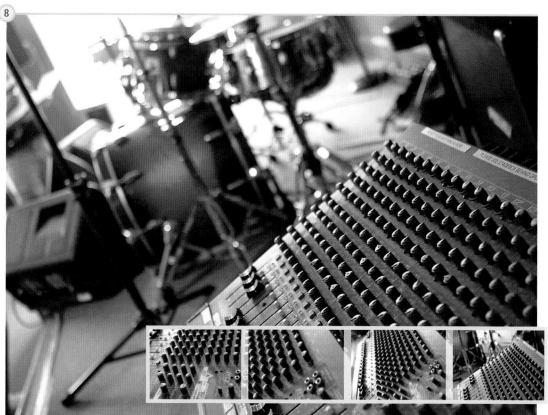

8

Next we cut to some shots of various angles of the mixing desk, while the audio slowly builds with the disembodied voices of musicians chatting and preparing to play. This sequence shows that it is not necessary always to hold the camera level. While it is very disturbing for the audience to have a horizon that is constantly on the move, some variety in the angle of tilt can help add visual interest. Here the camera is tilted around the mixing console as if fascinated by all the knobs and dials.

13

Let the action develop naturally. If you try to direct people doing their normal job, they may overact and perform stiffly. Here we show a close-up of a teacher's hand as he points out a fingering position to his student.

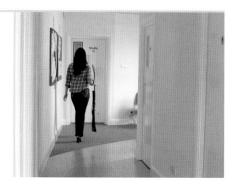

14

We step out into the corridor and see a student walk away with her guitar. It is the girl who was tuning up earlier in the video. This type of closing shot provides a symmetry to the movie, before we fade to the end titles and show the organization's contact details.

Erotic movie

An erotic movie need not feature your most private and intimate moments – a video that is interesting to watch (as opposed to one that is merely sexually explicit) should be able to tell a story.

Ensuring trust

You and your partner must trust each other, so keep everything open and honest. Get your partner involved by having them develop ideas or work out a scenario and storyboard. No one should feel exploited or used. You may even want to draw up a contract stipulating the participants' rights regarding ownership and exhibition of the video.

Creating a scenario

An erotic movie may be as simple as a recording of your love-making: put the camera on a tripod pointing in the right direction, turn on the lights and the camera, and start recording.

Alternatively, it could be a celebration of your beloved. Allow the camera to roam over his or her body, exploring its curves and lines. Such a movie will respond well to cross-dissolve edits – one clip merging seamlessly into the next. The example on the right shows a movie that is coy, almost chaste, but you can easily make one that is it far more adventurous.

Although I had only shot a sequence of the model getting dressed, once I was at the editing stage I wanted to start with some footage of undressing, leading to a shower. Fortunately, a simple reverse-playing of the clip served my purpose equally well.

There is no suggestion yet of the sculptural direction that the movie is going to take. Instead, we follow the relaxed business of a shower, keeping the camera steady, and then allow the model to enter and leave the frame as she towels herself dry.

We prepared for the transition between the showering and the eroticism to follow by reducing the speed of the action. Here, the model slowed down her movements and made them more fluid, giving time to enjoy the beauty of her body.

The inspiration for this short sequence, shot in Italy, was the light there, which surely inspired the work of some of Italy's great artists. The idea was then to take the nude form and cross-dissolve against the nude sculptures that decorate and

enliven the squares and lives of so many Italian cities. Unfortunately, video cannot handle the full dynamic range of the light, and subtleties in the highlights were lost. A decision was therefore made not to use the footage.

Moving slowly into a close-up of the model's body, the footage now becomes more intimate. While she holds still, a sense of intrigue comes over the viewer, not knowing whether the model is not moving or whether they are looking at a photograph.

As we explore the body in slow, deliberate close-ups, we allow the forms to become more abstract and less easy to identify. This would be the perfect point for a cross-dissolve linking these body images to some footage of sculptures.

5

Editing and post-production

Video software principles

Your first encounter with video editing may be very daunting. Entry into the exciting world of non-linear editing will be made easy through clear explanation of the principles, including logging, the rough cut, and edit decisions.

Editing

The techniques of non-linear editing are examined, with their roles and purposes defined. Quick-fix spreads help you correct colour and exposure, as well as offering advice on how to handle common editing problems and techniques for working with transitions and effects.

Post-production

Including creating titles, working with sound, mastering DVDs and VCDs, and streaming to the Internet, this chapter shows you how to refine your movie in preparation for a wider audience.

Editing principles

Video editing does not have the same feel and character of film editing. Hanging lengths of film over a bin, scratching at film with a little blade, and applying spots of glue have all been replaced by the click of a mouse, and the flickering images on a little periscopic screen are now steady brilliant images on an LCD monitor.

Anybody who has ever used a computer has complained about the steep learning curve of one software application or another. Be prepared, then, for the difficulty ahead when you first tackle NLE (non-linear editing) software of any capability. This chapter will explain the principles common to NLE applications and attempt to relate them to what you are trying to achieve artistically. These principles can then be applied to the many applications available. Examples will, of necessity, be taken from the more professional software, since they cover anything that most video-makers will attempt. But you do not have to buy such software to produce rewarding videos.

What is editing?

The following quote, from a web site giving career information, is entirely true yet completely misses the point: "Film and video editors watch all the film footage. They decide which parts are not interesting and cut those parts out. They put the most interesting parts of the film back together." What it misses, of course, is just how those interesting parts are put together.

It may be tiresome to be reminded that the software should always be a servant of the creative intention, but it is a mantra worth repeating over and over again. For the software to serve you, however, you have to master it. This calls for practice, practice, and more practice. But an understanding of the basic principles will speed up the learning process.

Four-point editing

We start with a number of clips or takes: this is the raw footage that you have shot. This material may still be held on the camera's tape, or you may have already downloaded the footage on to your computer. Your movie – also called a "project" in some software – will be made up of a sequence of clips or parts of them.

The nature of non-linear editing means that, under their largely superficial differences, all software applications operate in the same way, namely by manipulation of four points: two in the

Insert edit

The insert edit places new footage into the timeline of an existing sequence. Because the insertion does not delete or replace any material, the overall length of the sequence increases. The simplicity of the move disguises its great power to interrupt action with a visual aside or prompt, allowing you to show two things happening simultaneously but in different places, or the same thing from two different viewpoints.

New clip

Insert edit

Original sequence

New sequence extended by insertion of new clip

New sequence

clip to be inserted, two in the sequence being created. In the clip, the first point defines the start, or "in" point, while the second marks the "out" point, or the end of the clip. These points may be the actual start and end, or anything in between. The time between the in and out points defines the duration of the clip.

In the sequence, you will need to tell the software where to insert the clip: this is the in point in the sequence, while the out point is where the clip will end and another starts.

The key is to realize that when you determine or set any three of the points, the fourth is automatically determined. If you set the length of the clip, then set where to insert it in the sequence, you then know when the clip will end in the sequence. Furthermore, the sequence will get longer. On the other hand, you may set a certain length of sequence to be replaced by a clip – that is, you set the in and out points within the sequence. Now when you mark the clip's in point, its out point follows because the time between the in and out marks must equal the length previously set within the sequence. In these cases, the sequence will stay the same length.

Visualizing the edits

One way to visualize your edits is to imagine a wall of an exhibition with a row of pictures side by side. Suppose you decide you want to insert two more pictures in the middle: if you do not want to lose any pictures already hanging, you must decide where to insert these pictures, then extend the line of existing pictures by shunting them over to make room for the new ones. But suppose the length of the line of pictures is fixed: if you remove any pictures you must replace them. Or, to insert new pictures, you must remove as many as you add.

Another analogy is to view NLE as similar to word processing, in which clips are sentences, or groups of words, and a text is like the video sequence. Edits move sentences or groups of words around: some edits increase the length of the text, pushing all successive words further from the beginning. Others replace or overwrite existing words, keeping the overall length the same.

And just as with word processing – in which the real reason for knowing the keystrokes, short cuts, and functions of the application is to be able to communicate through your writing – the reason for learning how to use NLE software is to tell a story convincingly and effectively.

Overwrite edit

You will use an overwrite edit when you need to add new material to a sequence but cannot increase its length. The most common reason for this is when you need to match the length of your movie to the length of a piece of music or other soundtrack: if the overwrite material fits between cues, you need not worry about synchronization. Often, overwrite edits use material shot at the same time as the main sequence but from a different angle.

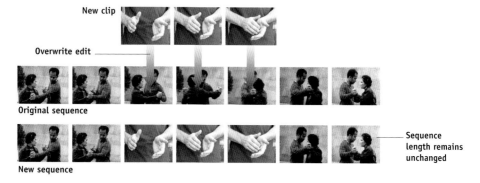

New clip

Overwrite edit

Original sequence

New sequence

Sequence length remains unchanged

The editing process

Editing in video has many similarities to editing text. When editing text, you manipulate and order the basic elements of words and sentences, following grammatical rules, to communicate clearly and effectively. You cut out unnecessary words and rearrange them to make them flow more coherently. And you may drop in little surprises to keep the reader interested.

In video editing, you work with the basic elements of your clips – aided by the soundtrack. Just as the same sentiments expressed by a poet, novelist, or businessman will generate very different texts, so the same clips produce different results depending on the editor.

Broadly speaking, the editing process consists of the following steps:

● Putting the clips into a sequence.
● Fine-tuning the relationships between clips.
● Adjusting the sequence as needed.
● Determining the transitions between clips.
● Balancing the colours and exposure of each clip to create a unified whole.
● Working the recorded sound or music into the movie at appropriate times.

Non-linear editing

NLE is the key to digital video editing, providing what is known in the rest of the digital world as "random access". Whereas film editing involved rolling a reel of film backwards and forwards to find a frame to cut up and join with another piece of film, this is now achieved in seconds and with just a few keystrokes.

Movie clips are data files on your computer and are essentially just like Word documents. You can jump to any point on a clip just as you can jump from one piece of text to another. When a movie is only on tape, you have to reel through the tape to find the start or middle of a clip. This is not only tedious, it also wears down the tape. The non-linear editing process is slowed down only by the time it takes your computer to find the file and display frames from it: on modern machines, scrolling through a video clip is a rapid process.

Your first edit session

For the rest of this chapter, we assume that you have learned, from your video camera's instruction book, how to create an active connection between the camera and the computer so that the camera is recognized. If you have problems with this, see the Quick fix on pp. 172–3.

You have shot hours of material, and a little stack of tapes waits on your desk. What is the best way to start? If you have shot your movie in "run-and-gun" style – that is, without a script – then this is a good time to visualize what story you wish to tell and how the movie will look. This will help speed up the process of identifying shots and sequences that work well, and spotting those that do not move the story on. If you taped by following a script, or even a list of shots, then assessing the rushes – the unedited footage – will be much easier.

If you have shot "dump-truck" style – that is, you shot just about everything that moved and many things that did not, all "just in case" – then you have a long job ahead of you. You will need to review all the footage and log each take. Having to do this just once should cure you of shooting

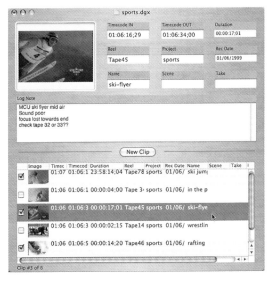

Imagine DV Log-X

This specialist utility offers convenient controls and handy features that speed up the logging process. The application will also control a wide range of devices – from DVCam and DVPro, to analogue video machines.

dump-truck ever again – or you will give the logging job to some other poor soul. Having said that, if you are making a documentary (*see pp. 212–15*), this is really the only way to work.

Logging your footage

Count on the logging process to take at least as long as the total duration of the footage you have shot, probably longer. You will need to watch the whole lot and, although you may fast-forward through some of it, you will also spend time writing up the details. The good news is that the more thoroughly you log the footage, the easier and smoother the editing process will be. The bad news is that, in truth, logging can be incredibly dull and frustrating, because all you want to do is get on with putting together the preliminary edit.

If you are using entry-level software, you may have to do the logging by hand. However, professional software enables you to log details while you review clips – in fact, it is often an integral part of the application. A less costly alternative to professional NLE software is specialist logging software, such as that from Imagine: TPEX for

Windows or DV Log-X for Mac. These can greatly simplify the process by offering automatic incremental counting, automatic completion of entries, and basic storyboarding. Most importantly, the logs can be exported to work with standard non-linear editors for capturing batches of video.

Marking clips

An entire take that has no value to you can be ignored at the logging stage: simply do not log it, and avoid wasting time and space capturing it. But if only a portion of the clip is unusable, you will want to mark the start and end (in video parlance, the in and out points) of the portion you want to keep and, therefore, capture. This job is known as marking clips.

Some editing applications use buttons or keys to set the in and out points. Others use slides in the preview window. It is advisable to leave short "handles" before and after the precise in and out points – a second or two before the in and after the out. Should you mark too tightly, you leave yourself no room for manoeuvre – or change of mind – later, and you will need to recapture.

Logging and capture

Entry-level NLE software applications simplify the editing process by copying media files from your tape to the computer. After shooting the tape, you rewind it in the camera, and as you play back through the software, it compresses the camera's files – from the first to the last take without pause – as it copies it to the computer. Professionals will prefer to start, review, stop, replay, and rewind the tape numerous times to minimize the load of material they capture, thus taking into the computer only what they are sure they will need. However, numerous stops, starts, and rewinds will cause a great deal of wear and tear on a camera's tape mechanism and possibly on the tape, too. For proper logging, the ideal but costly solution is to use a desktop video tape recorder (VTR) controlled by the NLE or logging software via the DV connector from the computer.

```
DV NTSC 48 kHz Anamorphic
DV PAL 48 kHz
DV PAL 48 kHz Anamorphic
DV to OfflineRT NTSC (Photo JPEG)
DV to OfflineRT NTSC Anamorphic (Photo JPEG)
DV to OfflineRT PAL (Photo JPEG)
DV to OfflineRT PAL Anamorphic (Photo JPEG)
DV50 NTSC 48 kHz
DV50 NTSC 48 kHz Anamorphic
DV50 PAL 48 kHz
DV50 PAL 48 kHz Anamorphic
DVCPRO – PAL 48 kHz
DVCPRO – PAL 48 kHz Anamorphic
DVCPRO – PAL to OfflineRT PAL (Photo JPEG)
DVCPRO HD – 1080i60 48 kHz
DVCPRO HD – 720p24 48 kHz
DVCPRO HD – 720p30 48 kHz
DVCPRO HD – 720p60 48 kHz
Generic Capture Template
```

Capture-input options
This pop-up menu gives a wide range of options for decoding the video capture – effectively a format conversion. To save space and speed up editing, a good choice is Offline, which uses compressed images. After editing, the full-resolution footage can be captured.

The editing process continued

Capturing video footage

Once the logging is done, you are ready to capture the video, a process also referred to as uploading. This is the time at which the media files representing your video footage enter your computer. Either the files themselves are uploaded from camera to computer or, more usually, they enter the computer in a compressed version – for example, as QuickTime files. In the latter case, editing decisions are made using proxy files: small-size files standing in for their full-resolution counterparts. Naturally, this procedure speeds up manipulations, particularly if you create transitions. But it slows down the final stage, the render, in which the editing decisions, transitions, and any other effects of the final cut are turned into the completed movie. Even if the end product is of low resolution, the render can still take some time (*see pp. 14–15*).

Considering the edit

The material uploaded from your tapes into the NLE software forms the movie-based equivalent of the rough cut. With all the material sequenced in more or less the right order, and with all the obvious mistakes and technically faulty material omitted, you will be able to see whether you need more footage or whether you have too much. Either way, this is where the fun begins.

The next stage is to "string out", or assemble, the material with more precision and direction. Apart from the content and story, there are several other factors to consider:

• Overall length. Your budget may have allowed for only a 10-minute short, or perhaps you intend to make a feature-length movie, but start short. If you make 1 minute's worth of watchable video out of an hour's take, you are doing very well.

• Pace and rhythm. Will you have long periods between cuts, or will you cut and intercut many times per minute? It may seem that pace should depend on the overall length, but that is not the case. Two minutes of an intense Bergman film can feel like an hour, while an hour of Jackie Chan action can seem like 10 minutes.

• Sound and music. Keep in mind the need for a soundtrack. Do you have the recorded sounds you need to use in a particular clip? Or will you be able to dub (add on) some post-recorded sound? If not, you may have to rethink how you use the clip.

• Continuity. A movie needs continuity – that is, a logical flow between the beginning and the end. This does not mean that everything must be shown in chronological order, even in a documentary, but it does mean that changes in technical aspects such as exposure or colour should be motivated – that is, they must be justified by the action (*see p. 76*).

The timeline paradigm

The timeline is a graphical representation of the content of your movie. You read it by starting at the left and working to the right, passing from one clip to another in the same order that they will be shown in the movie. As you insert clips into the sequence, the timeline lengthens; if you change your mind and delete sequences without replacing them, the timeline shortens. The timeline is fundamental to all time-based digital media.

Poster-frame timeline

The simplest depiction for a timeline is the poster frame. In this mode, the first frame of a clip is taken, by default, to represent the whole clip. The drawback of this option is that it does not show the relative lengths or duration of the clips in the sequence.

Scalar timeline

A scalar timeline represents the duration of a clip as a proportion of the whole. Depending on the software design, one common behaviour is set so that as you add clips and the sequence lengthens, the clips squeeze up to fit more into the screen.

Final Cut Pro timeline

In a professional timeline, such as in Apple Final Cut Pro HD shown here, clips can be displayed with more detail, moved with precision, and viewed at different scales, while many tracks of both video and audio can be accommodated.

Timecode

The smallest unit of video that we work with in NLE is the frame. Frames are identified by a standard code, called the SMPTE timecode, which is written as hours:minutes:seconds:frames. Thus 00:03:06:24 means 3 minutes, 6 seconds, and 24 frames from the beginning of timing. With PAL, which uses 25 fps (frames per second), the next frame will be called 00:03:07:00. Leading double zeros, e.g. for hours, may be omitted. NTSC, however, is not so simple because it uses a frame rate of 29.97 fps.

The standard way to count frames is called "drop-frame", which was constructed to prevent the accumulation of error due to counting whole frames. NTSC drop-frame mode is written with a final semicolon before the frame number – thus 00:03:06;27. Unfortunately not all NLE software programs recognize or work with SMPTE timecode. If you wish to work professionally or expect to export edit-decision lists from one machine or software to another, using standard timecode is obligatory.

Clips, graphics, still images, and sound are handled in tracks that overlay the timeline. These can be thought of as layers of material: one layer can hide another layer, or both can show through. At the same time, an audio layer can play throughout. Basic applications such as Windows Movie Maker carry two video and two audio tracks, but even mid-range NLE can handle 100 tracks of audio.

The most important feature for us is that, in all but the simplest software, the timeline can be displayed at different scales. So you can compress many minutes' worth into view across your monitor or zoom in to a few seconds' worth to pick off material frame by frame.

Timelines can be displayed in two ways. One shows the poster frames – the single frames that stand for the entire clip, usually the first – in a line; this is a useful visual reference. The other is a scalar display: the proportion of the total duration that each clip takes up is represented by the amount of space the clip takes up.

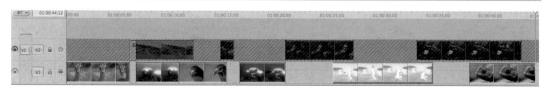

Editing decisions

The visual layout of your NLE software on screen will influence the way you edit your video and how quickly you can work. Professional software may offer as many as nine different open windows carrying information. This might be a concern to a beginner, but it is a delight to the experienced video-maker who needs quick access to a wide range of functions. At its heart, all NLE software works with a core set of three windows: one shows thumbnail pictures of the clips that are held in what is variously called a bin, album, or collection; the second is the viewer or preview window; and the third displays the timeline.

The insert edit

An empty timeline waiting for your first clip can be as intimidating as a blank page waiting for the first touch of an author's pen. But once you have dragged your first clip from your collection to the timeline, the rest is easy. Or it would be, if all we had to do was string together all the great footage we had shot. In a flurry of creative energy, you will soon have the string-out completed. But a quick review will usually indicate the need to interpose a new clip in between two already present in the sequence. This is the first basic edit manipulation – the insert edit (*see p. 164*).

In most editing software, you simply click on a clip and drag it to the timeline. The total duration of the sequence will increase by the length of the newly inserted clip. Wise editors, however, are usually aware of the need to keep the video no longer than absolutely necessary. One way to achieve this is to insert only a portion of a clip: instead of dragging in the entire clip, trim it down to what you need and insert that. When you logged and captured, you should have left handles – brief lead-ins and lead-outs – to enable you to do this. For the same reason, your shooting should have started a little before anticipated action and ended just after.

All NLE applications allow you to mark in and out points in a clip: the in point is the exact frame you start a clip or take, and the out is precisely where you want it to end. You can copy the section between two points and paste it into the timeline or drag the trimmed clip according to your software's procedures.

When you play back the sequence, do not worry at this stage if the changes are sudden or appear too abrupt. Any transitions that need fixing can be smoothed out later.

1 The string-out

Your preliminary stringing out of clips produces this sequence of a tour in the country. But upon reviewing it, you may decide that the transition from trees to a close-up is too sudden and that you need to insert another clip.

2 Insert a new clip

Find another shot of trees that is suitable and drop it in between clip 01 and clip 17. This pushes all later clips on by the duration of the new clip – 11 seconds, 13 frames – lengthening the sequence by that amount.

3 Save as you go

Following each edit decision, it is a good idea to make a practice of saving the change immediately. Remember that you are not changing the actual clips themselves, only making a list of edit decisions.

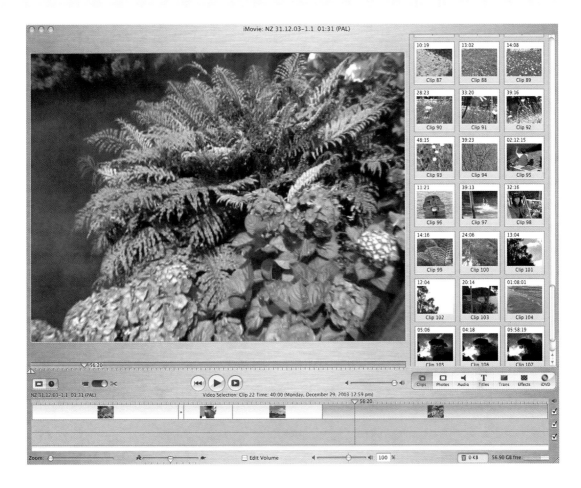

Editing interfaces

These two screens display the basic three sub-windows of NLE software from competing giants Apple (iMovie, *above*) and Microsoft (Movie Maker, *right*). In each case, the collection of thumbnails or clips for a project or video are put to the side of the viewer, or preview window, while the timeline runs underneath, displaying various tracks and the sequence of clips.

Quick fix Equipment communication

It is a technical marvel that any of dozens of digital video cameras work with almost any model of computer. Interface problems with Apple Macintosh computers seem to be far fewer than with Windows-based machines, but Macs are not immune to problems. Some issues that appear to be defects of the image are due to communication problems between camera and computer. But most problems are due to users not following instructions, which can be intricate and involved.

Problem

The image you see appears defective, with streaks, lines, or speckles, sometimes also with poor colour. Or the movie runs jerkily or is over too quickly. Frames may also appear to be missing.

Analysis

Good video depends on continuous flow and constant processing to ensure that data stream smoothly. Any interruption or bottleneck will affect some aspect of the image processing – from rendering transitions, to sending data from one part of the computer to another. The system is set up so that if one element cannot keep up with another, it no longer brings the entire operation down; instead errors are tolerated.

It is important to confirm that the problem is not specific to the movie in which you first noticed it. Play the file in another application or save it under another name and replay. Once you are satisfied it is a general problem, look at the capacity in the hard disk – generally you need at least 20 GB spare hard-disk space. If you use an external FireWire (IEEE 1394) hard-disk, it may be running too slowly or the electronic bridge between the disk read-out and the FireWire controller may be a bottleneck. Some problems are caused by using the wrong settings.

Solution

Solutions involve allocating lots of memory to the software and removing bottlenecks. There could have been problems at the capture stage. If there are artefacts in the rendering of transitions, the computer's processor needs more RAM installed, or a greater amount to work with. Maximize installed RAM by quitting any software you do not need at the time. Upgrade solutions are, in priority: increase installed RAM as much as you can afford and the system can accept; add more hard disks, preferably installed internally. Hard-disk drives should spin at 7,200 rpm or faster and offer throughputs of 8 Mbs or better. Ideally, devote an entire hard-disk drive – at least 200 GB – to your working video files. A final upgrade, to be considered by professional users whose software recognizes multiple processors, is to run two or more processors in the computer. Dual-processor computers are significantly faster than single-processor machines. Another approach for removing data bottlenecks is to reduce the amount of data that needs to be processed: it is not strictly necessary to edit in millions of colours. If you are using a video card for output, check that the compression settings are correct – that is, using suitable codec (compression-decompression) algorithms.

Out of disk space
If you ever see this warning, it may not, in fact, mean that your disk is full – rather, that the amount of spare space in it is insufficient for the software to store temporary files and data. Therefore, the action you have requested cannot be completed.

You do not have enough remaining disk space for that operation.

Try emptying the trash or deleting unwanted files to get more space.

OK

Rendering problems
The artefacts in this image – blurring and smearing – are typical of rendering errors caused by inadequate processor power for the viewing conditions. In this case, it was caused by trying to rush through a transition too quickly.

Problem

You have connected your camera to the computer, turned them both on, but they do not seem to communicate with each other. Error messages may flash, or your video camera may not appear on a list in the software. You may be trying to capture with a video card connected to the camera, but again there is no response. The development of fault-tolerant systems is to be welcomed – since slight errors no longer crash everything – but it makes analysis and cure very tricky. The cause of communication problems fall broadly into: driver conflicts or out-of-date drivers; user error; hardware incompatibilities; and faulty hardware.

Analysis	Solution
Driver conflicts occur when out-of-date drivers are caused to "argue" by the software controlling the devices – usually at the input–output stage. For example, a driver may claim to be using an output socket when in fact it is idle, which stops another driver from using the same output.	Ensure that you have installed the drivers that came with your camera, computer, or video card. Driver conflicts are often solved by upgrading to the latest versions, downloading them from the Internet and reinstalling. If only for this reason, Internet access is essential to the videographer: check on your equipment manufacturer's web site for the latest versions or bug fixes. Do not update unless you need to – do not try to fix what is not broken or you may cause a conflict with something else. Another source of conflict could arise if you have two applications, say Movie Maker and another NLE program, both trying to control the camera.
"User error" is not a euphemism for "stupid user", because it really is quite tricky to do everything right and in the right order. It can be difficult to know, for example, whether you should turn the camera on before plugging it in or afterwards, or whether that is before the upload utility is launched, or after.	First of all, ensure that your machine meets the minimum requirements for the software. If you bought yourself the latest program, it may only be compatible with the latest operating system, with ample RAM. Check the instruction book, tedious though that may be. Check that the camera is in playback or edit mode, not record, and that the camera is powered from the power adapter, not the battery. Use default settings until you know what you are doing, and leave the Advanced Options tab until later.
Hardware incompatibilities occur when components are not built to work together. The wiring in a device that calls itself FireWire may work well with some machines but not at all with others.	Check the certification of compliance or simply compatibility on relevant web sites. Software producers such as Adobe, Apple, Microsoft, and Pinnacle all produce lists relevant to their software or hardware. Make sure you know the difference between a USB and a FireWire/i.Link/IEEE 1394 – both plug into modern digital video cameras and computers, but you cannot have device control via USB. Check that the plugs go in snugly but without needing force.
Faulty hardware is surprisingly rare these days, but a small switch problem can cause many functions to fail. The fault may not be obvious, since the connection is hidden	Check that the specific file or tape is not the problem: try accessing a different tape. If you have worked through all the preceding options, then you may have to conclude that your camera is faulty. Make a note of all the tests you have conducted and submit the evidence to the retailer. You should never attempt to open up or repair a modern digital video camera yourself

Refining the edit

Once you have uploaded several clips and strung them together, you will want to fine-tune the timing of your edits and refine the transitions. It may help your understanding of some edits – such as trimming, cropping, and overwrites – to see their similarity to their word-processing or image-manipulation counterparts. Here we look at the most common of the many refinements that are available in NLE software.

Trimming and cropping
These two actions are essentially the opposite of one another. Trimming removes selected frames from the middle of the clip. The clip is therefore split at that point (*see below*) and its timecode is adjusted to show a shorter time.

Conversely, a crop takes out all the frames that were not selected – usually from the beginning and end of the clip – and this, too, shortens the clip.

Of course, it is also possible to split a clip without first having to trim or crop, and that is to do so directly (*see below*).

Monitoring clip length
When you work through your clips, you will begin trimming and cropping them. Since you are not actually discarding any frames, you can subsequently refine the edits, moving the in and out points or changing the duration of a transition effect (*see pp. 180–3*). But look out for warnings that your clip is too short for all the effects you wish to implement.

Splitting clips

When clips are imported by the NLE, the breaks between one take and another are usually recognized automatically, as is the case with all basic software. Such an approach sends all of the takes on tape

into the computer. Professional-grade software will expect the editor to mark clips with in and out points, so the capture takes in only what is wanted.

Whichever approach is taken, there will be times when it is useful to split a clip into smaller sub-clips. This makes it easier to handle long clips and helps define points at which you can intercut.

In most NLE application programs, you first place the play head – the marker that shows where in a clip a displayed frame comes from – at the point where you wish the split to be introduced. Next, call up the Split Clip command, and the program does just that.

1 Locate the split
To make this clip easier to work with, it first needs to be intercut or split, so the play head is set to an appropriate point in the clip.

Undo Move	⌘Z
Redo Split	⇧⌘Z
Cut	⌘X
Copy	⌘C
Paste	⌘V
Clear	
Select All	⌘A
Select None	⇧⌘A
Crop	⌘K
Split Video Clip at Playhead	⌘T
Create Still Frame	⇧⌘S
Special Characters...	

2 Split the clip
The command to split the clip is applied. Your application may offer a tool looking like a razor blade, which reminds us that the edit is just like cutting through a length of film.

3 See the result
The split clip is now in two parts, each with its own timecode and icons. The overall length of the two clips added together remains as before, because no transition has been applied.

Reversing direction

Some cross-fades and dissolves work better with the frames running in reverse order because the reverse movement in one clip may blend better with the forward movement of the following clip. Another thing to remember when using this effect is that no one can tell whether the original panning movement

is the original (provided, of course, there are no other indicators, such as traffic or people walking). You may have panned a view from right to left but in the preceding clip you filmed someone pointing to the right. By reversing the pan, you can keep all the movement flowing in the same overall direction.

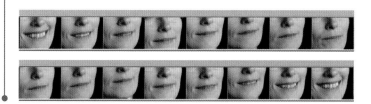

Reverse

To reverse a clip, select the clip or a part of it and call up the Reverse Clip Direction or similar command. In the example on the left, reversing the direction of facial expressions greatly changes the emotional message.

Overwrite edit

Just as you can replace a phrase in a word-processing document by selecting it and overwriting it with a new phrase, so an overwrite edit replaces an existing clip, or part of one, with another.

There are broadly two reasons for making an overwrite edit in video. The obvious one is when you find a superior clip to that in the string-out – perhaps a sharper or better exposed shot.

The less obvious reason takes us a very long way from the word-processing analogy. An overwrite edit offers a simple B-roll intercut – that is, you can interrupt a clip with an aside or flashback, then return

to the clip. The key to this is to keep the audio for the main clip playing throughout – even while the intercut is shown. Typical uses of B-roll take place, for example, when an interviewee is talking about a document, and we cut to show that document, or when you have shot a sporting event and, between takes of the race, you overwrite B-roll shots of the spectators cheering.

For this to work, you have to set the software up so that the existing audio is not replaced when new material is pasted over it. Depending on the software, you may have to select "disconnect sound" or "extract audio with paste over" or similar phrases.

1 Overwriting a shot

During the course of a shot of a lizard looking around, you want to intercut to show a dangerous predator approaching. Simply select a portion of the predator's approach and overwrite – this is usually at the play head, where the frame is stopped.

2 Playing the clip

The selected area of the clip to be overwritten is shown selected – note that not all software will display this. When the sequence is played, the movie will cut straight from the lizard to the predator and back again without any transitions.

Further editing

Digital video editing software is capable of even more than we have already covered, and techniques that were a chore when working with film are now just a mouse-click away. These are not gimmicky transitions but entirely valid editing techniques. The first is a feature that would have been a boon for film editors – the ability to restore to original.

Restore clips

A key feature in NLE software, but one that will not make any real difference to your working methods, is that you do not work on the original files of your clips at all. You are manipulating proxies or smaller files that stand in for the actual files. The editing decisions you make are essentially just a list of instructions to the software. This means that when you thought you had shortened a clip, deleted sections, or split a long take into numerous smaller portions, you have not, because nothing happens to the movie itself. Therefore, you can restore the whole clip very simply, by telling the software to forget all those instructions. This can be quite a drastic command, so it is wise to make a duplicate of the edited clip – store it at the end of the film or save the first version under a different name or version number.

Stills clips

If you wish to stop one frame from a video tape, you freeze-frame it – that is, you hold the tape still while continuing to read it. With digital video you can go further: you can create stills from clips and use them to slow down the action, hold the viewer's attention on some amusing expression, or show something in detail.

Of course, each frame in a movie we watch is a in fact a still image – but each one is slightly different from the last and the next. So a stills clip is one in which we simply show the same picture for as long as we wish. The stills clip is treated like any other clip: you will need to insert it in the appropriate point in the sequence.

One word of advice: the first duration you pick for the stills clip is likely to be too long – even 1 second is quite a long time in a movie, and 2 seconds will significantly slow down the action. At any rate, you can easily change the duration, either by editing on the timeline or by directly changing the properties of the clip.

Should you wish to exploit this effect extensively, you will find that capturing images in progressive-scan mode gives better results than shooting in interlaced mode.

Restore Clip
This dialogue box makes it very clear what will result from the request you have made – you are, in effect, throwing away all of the editing decisions that you have input into the software, so think twice before agreeing to Restore.

Inserting a stills clip
Here, a frame from the middle of a clip is turned into a still clip and appended to the clip collection. If you add it to the sequence it will lie between two clips, almost never where you want it. It is best to split a clip where you make the still and insert it there.

Setting stills clip duration
You can change the length of the stills clip either through the timeline-based controls or directly by entry in the Clip Info dialogue box. Depending on the software, you enter actual duration in time code or number of frames. In iMovie, for instance, if you enter a number, it assumes you mean frames and calculates the duration automatically.

Slow and fast motion

One aspect of digital video that can be bettered by fairly basic film-based cameras is its inability to shoot true slow-motion sequences such as those you see in many movies to highlight an epic or heroic moment. For this to be possible, the rate of capture of frames has to be speeded up, a capability found on only the most costly of broadcast-production cameras.

We can cheat in digital video, however, by instructing the software to interpolate extra frames in between the ones shot. The greater the number of extra frames, the more slowly the movie will appear to run. The effect is not at all as smooth as true slo-mo (slow motion), but it is better than nothing. The problem with this method is that the soundtrack will also be slowed down, so you will need to extract that and replace it with something of the right duration.

The converse is to speed up the action – simply by dropping frames. The clip takes less time to run through and the action seems faster than it should be, but its comical effect limits its use.

Speeding up playback

With fast-motion playback, the action is sped up and the duration of the clip is shortened – compare this illustration with that of the normal-speed length (*below left*).

Normal playback

In this application, iMovie, a simple slider enables slow- or fast-motion playback: it is at the bottom, with hare and tortoise icons. Other software programs implement this effect in different ways – for example, via a dialogue box.

Slow-motion effect

With slow motion, the clip is lengthened and the action slows down – this also lengthens the whole movie. Be aware, though, that the sound is also slowed down and will sound unnatural, so you will need to replace the soundtrack (*see pp. 190–3*).

Stills frame

Creating a stills frame is different from creating a stills clip. It is not strictly an editing move: you simply save a single frame of your movie as a separate image file, usually in JPEG format. This image can be incorporated into another movie or it can be treated like any other image file, to be e-mailed to friends and family or printed out to put in a photo album. The image dimensions of a nominal 640 x 480 pixels at an output resolution of 72 dpi is sufficient for a fair-quality print measuring about 100 x 125 mm (4 x 5 in). However, the way colours are processed for video is much less complete than the processing for a true digital photograph, so colours are less rich and lacking in subtle transitions.

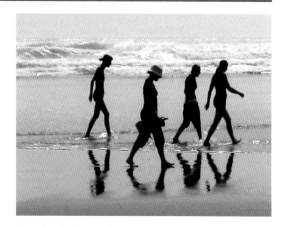

Manipulating stills

A stills frame can be manipulated and printed like any other digital image. This frame from a beach holiday video will be sized to 72 dpi, so, when printing, change the resolution to one suitable for your printer, perhaps 150 lines per inch.

Quick fix Colour correction

One of the unsung heroes of the cinema industry is the colourist. It is the job of this highly skilled technician to match different film stocks and correct all the colour imbalances and exposure errors made by the DP (director of photography). The end result of all the colourist's work is a film that looks as if it has all been shot on one continuous roll of film, with perfectly consistent colour, contrast, and exposure. In video post-production, you will be responsible for all that.

Problem

The overall colour of the movie is inconsistent from one take to another. This manifests itself as sudden changes in colour cast between adjacent cuts.

Analysis

Varying colour balance is due to two related factors: the white balance of the video electronics, and the prevailing colour temperature of the illuminating light. If the colour temperature of the light changes, the white balance of your camera may fail to keep track – either because it is unable to or because you set it manually. For example, the day may be sunny – in the sun, the overall balance is warm – but when a cloud passes over, the colour temperature rises, making the tone more blue.

Solution

To avoid making excessive corrections in post-production, it is best to set your camera's colour balance manually, using a white or grey card before each take: target a neutral patch under the lighting in use and set the white point by pressing the appropriate button or menu choice (*see pp. 104–5*). There will still be small differences even with the most careful camerawork, so you will have to correct clips as necessary in post-production. The key decision is which clip will act as the master, or reference, point; you then adjust everything to that colour balance. This is especially important with takes of the same scene or adjacent cuts.

All NLE applications offer colour-correction tools of varying power and ability. Some will apply the change to the entire clip, some only to the portions you select. The changes you ask for may need to be rendered (applied to all the frames of a sequence) before they can be fully viewed in sequence.

Problem...

Before correction
These two frames, side by side from adjacent clips, were taken moments apart. In the first, a house lamp provides warm colouring; in the other, a wall lit by a skylight has a blue tone. We need to match the warm-coloured clip to the cooler one.

...solution

After correction
It is a tricky adjustment to reduce the reds and yellows in the highlights, but the colour match has improved. However, it now highlights a difference in contrast between the two clips – a result of the right-hand clip having been shot with a little digital zoom.

Colour settings
The three-point corrector for Apple Final Cut Pro looks professional and daunting. Although it is both, it is also a powerful program capable of subtle enhancing effects as well as very large corrections – or, indeed, deliberate colour changes.

Quick fix Exposure correction

The majority of exposure corrections in digital video arise from the need to compensate for the errors or "enthusiasm" of the video camera's automatic exposure systems.

Problem

The overall brightness of a clip is too dark or too light. Another variation of this problem is if an auto-exposure meter reacts to changing conditions before you wish it to do so, as in the frames shown here (*see right*). A more advanced issue is whether the luminance range of the movie is broadcast legal.

Analysis

Automatic exposure systems, however clever and complicated, can do only what they have been programmed to do. Technically, they deliver the correct exposure almost all the time. But such a system has no way of knowing, for example, that it looks unnatural for a room to become suddenly darker as you pan towards a bright window. The best solution is impractical for all but costly studio-made feature films: the aperture is changed by a puller at the same time as the camera is panned. At any rate, even the most careful camera operator makes slight exposure errors, and video is intolerant of errors.

Solution

Exposure inconsistency between clips, or within one clip, has to be corrected in post-production. All NLE software provides some degree of control for exposure and contrast. Unlike colour correction, there are industry standards – at least for the whites and blacks. For home movies you do not need to concern yourself about them, but the key is to avoid whites that are too bright.

Problem...

Exposure before
Starting the pan from right to left, this hotel room and lamp start off correctly exposed. But as the window comes into shot, the bright light from the left makes the auto-exposure close down the lens aperture, making the lamp darker. Taken by itself, the image is correctly exposed, but not just after another shot has been seen.

...solution

Corrected exposure
I partially brightened the first few frames revealing the window to help maintain the exposure on the lamp – it does not matter that the window is now more over-exposed. With the next frames, we lose the lamp so the exposure can return to what was originally shot. For sequences such as this, you may have to correct a few frames at a time.

Waveform for exposure

The waveform monitor is a feature of all professional video editing software. It shows the luma (brightness) and saturation of the image scanning from left to right. Note the waveforms above the topmost line in the monitor, indicating that the lamp in the first image is illegally bright. Notice in the corrected image (*above*) I did not allow the brightest part of the lamp to become white. In the waveform, the peaks would fall below the top line and would therefore be broadcast-legal.

Transitions

What happens between the end of one clip and the beginning of next – the move from the out point to the succeeding in point – is the region of transition. The most basic transition, arguably not a transition at all, is the cut or snap cut – a name that emphasizes its abrupt character. It is also by far the least noticeable transition available.

Transitions were originally invented to smooth the change-over point from one clip to the next. This would give the audience a chance to adjust from the mood and pace of one take before being carried to the next scene, perhaps one filled with very different emotions.

With film, the process was rather hard work, even for the simple fade, and involved laboratory or darkroom processes. With digital editing, the easy application of effects is essentially digital image manipulation applied many frames per second. In fact, the Photoshop application was invented for just this kind of task but was "hijacked" for use in digital photography.

The ease of programming digital effects has given rise to the transition becoming almost an art in itself – so it is easy to use too many in a film. But some pop videos are none the worse for being almost a catalogue of transition effects.

Transition effects

Modern NLE applications come with a ready-built package of transitions, and all major software will accept plug-ins (supplements to the basic application) that extend the range. All will, or should, offer the basic three: cross-dissolve, fade in, and fade out.

Assuming you have defined the out point of one clip and the in point of another, applying transitions involves just two decisions: which transition effect to employ, and its speed – that is, how quickly the transition should run. The latter can be tricky, requiring experience and artistry. If it is too long, your editing decisions will be "spotted": the viewer becomes too aware of the effect and is distracted. If it is too short, it may fail to do the job of easing a change of mood.

For the sake of clarity, the examples shown here were created with stills clips.

Choice of transition
The choices of transitions offered will most likely be all you ever need, unless your movie requires special-effects transitions. You can always create effects in an image-manipulation application and import the images.

Maximizing performance

NLE is very demanding on hard-disk performance. Many computers have energy-saving modes that put the hard disk to sleep whenever possible or after an interval of not being accessed – this is fine for normal computing, but it can reduce the performance and possibly also compromise the quality of your digital video work. Indeed, a hard disk that is slow to wake up can crash the software or at least cause incomplete rendering (production of full-resolution transitions) or dropped frames (missing frames that cause the movie to flicker). It is advisable to turn off hard-disk sleep when working on digital video: open the Control Panel or Energy Saver dialogue box and change the settings.

Cross-dissolve

In this transition, frames near the end of one clip are laid over the beginning of the next clip with the opacity dropping steadily through the duration of the transition. In this way, the underlying clip shows up more and more clearly while the overlying clip gradually disappears. The "cross" in the name refers to the fact that the effect is applied to both clips at the same time. This transition, like several others, works in two directions at once. One of the most frequently used transition effects, the cross-dissolve is regarded by many as their default transition. Remember that it has the effect of reducing the length of both clips.

Blend awareness

The cross-dissolve is a soft, safe transition effect that works with a wide range of movements from one clip to another. But take special care at that brief moment when both images are visible, right at the mid-point of the transition; it is here that you must make sure that there is no unattractive blending of images or colours.

Fade

A fade works in one direction only – actually this makes it an effect, but it is used so often at transition points that it has been adopted as a transition. A fade-in starts with a black screen, then the clip becomes brighter and brighter until it is seen at normal brightness; you use this to introduce a clip. The opposite is the fade-out, which causes the tail end of a clip to become darker and darker until it is black. There are a number of ways, technically, in which the darkening effect can be achieved, as well as factors that determine how convincing or smooth it is. This differentiates professional software from lesser products. The fade is not a cross effect because it affects only one clip at a time. You may wish to fade out the end of one clip and fade in the next. This is achieved simply by placing the two transitions end to end (*see below*).

Fading out and in

Fade-outs work best where the contrast is higher than usual: the lost of luminance intensifies colours and overall shape is retained, as in this singer's back-lit hair. If contrast is low or colours monochromatic, loss of luma makes the image look muddy. Fade-ins work best where the contrast is normal or lower, because it is less clear what the darkness will reveal as the luma is raised. In comparison, a high-contrast subject, such as these bass guitarists, reveals itself almost immediately, appearing merely dark but not mysterious.

Fade-in and fade-out bars

This timeline shows the fade-out and fade-in transitions. The triangles within the bars are pointing in opposite directions, indicating that these clips have opposite effects.

Transitions continued

Using transitions

Depending on the type of transition you use, you may find that it alters the total sequence length. This is because of the need to overlap an end section and a start section equal to the duration of the sequence. For example, a 4-second cross-dissolve or wipe needs to overlap 4 seconds of the end of the first clip and 4 seconds of the start of the next. Therefore, the total running time lost from the sequence is 8 seconds.

Once a transition has been rendered, it is essentially a clip, meaning that it can subsequently be edited just like any other clip, together with any associated audio track. It follows, then, that the speed of a rendered transition can also be altered, by adjusting the playback speed.

Transitions can also be used on stills clips or images, but, as with all transitions, the changes may need to be fully computed – that is, rendered – before they can viewed.

Washes

The opposite of a fade (in cinema, at least) is a wash. Luminance is raised in a wash-out, so that the image becomes brighter and weaker in colours until pure white is reached. It is a deceptive transition in that it is very simple technically but its emotional impact on the viewer can be very strong indeed, especially if the following bright white is held for a few seconds. The wash-in is trickier to use, unless it follows a wash-out. This is because entering a clip from pure white after a cut or a fade is visually jarring. Consequently, washes, like fades, are often used in pairs.

Clip duration
An effect applied to only one clip at a time does not impact on its duration. This clip was originally 5 seconds long; after the application of a 2-second wash-in, the total clip duration is still 5 seconds, including the 2-second transition effect.

Effect-led transition
Exposure-based effects were originally exploited for their special effects rather than used as transitions. Washes and fades – deliberately increasing or decreasing exposure – were popular in the days of film because they were easily

done in-camera. The effect makes it seem as though a spotlight has turned at the camera and then has swung away. Here the wash is used as a transition – from the singer washing to white, then washing back again, this time to reveal the band.

Render bar
The thin red line under the transition (the green lozenge) is not as long as the transition: this means that the render – calculating the transition – is still in progress. If you attempt a preview, you will see a warning or a partly black screen.

The clip before that title or transition is too short; it must be at least 03:14.

Short Clip warning
If a clip is too short in duration to accommodate a chosen transition, you will see a warning such as this. Increase the clip duration by combining other clips or slowing down the playback, as long as it does not interfere with the audio track.

Wipes

Wipes are favourites for moving between parallel storylines – a domestic example might be the dog racing around the garden while Dad reads the paper. In a wipe, the start of the next clip pushes the last seconds of the first clip aside, in the same way as wiping a misted window reveals the snowy world outside. You can set the wipe's direction and pace.

Close/open and warps

Variants of the basic wipe abound: essentially a wipe is a moving mask that reveals the underlying layer (next clip) as it changes in size, shape, or position, simultaneously hiding the preceding clip. Any shape or distortion of mask gives a new way of wiping. The Circle Closing transition is one of the next generation of wipes.

Radial wipe

The radial wipe in this NLE software reveals the underlying next clip with a clockwise rotation, similar to that seen on a ship's radar system in movies. Depending on your software, you may be offered a choice of directions. Because this type of transition renders both clips at once, it reduces the overall length of the sequence.

Circle Closing wipe

Cropping a circular shape from the outside is an effective wipe in scenes that are busy with movement, such as this one shot at a rock concert. The juxtapositions do not look elegant, but they do not need to be – it is the sense of moving in and out of the action that is required. Some versions offer a soft margin to the circle, which is preferable to a hard outline.

Scaling

Scaling down a preceding clip so that it becomes progressively smaller, revealing more and more of the next clip, is a more complicated variant of the wipe. It works best when shifting between very different material. In this example, the two guitarists simply disappear into an abstract, out-of-focus shot of the concert lights.

 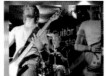

Scaling to nothing

The sequence above shows the most basic scale-down effect: the leading clip shrinks in size, progressively revealing the successor clip. Of course, there are many other ways of scaling down: further examples include incorporating movement across the frame, scaling in combination with fades, and so on.

Titles and credits

Digital technology has made the application of text onto movies, or titling, a much easier job than it was in the past. Titling was once a labour-intensive, skilled job. One method was to film, frame by frame, plastic letters on black, then double-expose it on to the scene that is to carry the text; another was to split beams of light to combine a projected image with the text. But what has been gained in convenience is at the expense of control – you may be limited to the effects built into your software. And, of course, you will need a good design eye to produce an interesting use of text that is appropriate to the film.

Length and mood

Title sequences are often the last thing considered in movie-making, but the name of the movie and much of the information you have to place in the credits may have been decided long before you even started shooting.

Sometimes, the most straightforward method of titling is the most effective – titles can be text on a blank background, for example. This simple, easy, no-nonsense approach is like the curtain rising in a theatre: after little ceremony, we move straight into the action.

A more involved title sequence, in which text is imaginatively woven with some scene-setting footage, may introduce a movie that is more leisurely, one that allows itself time to develop mood and atmosphere. The length of title sequence should be proportional to the movie's overall length – very brief indeed for a short that lasts less than 10 minutes in duration.

Fonts and frills

The choice of font – the design and look of the letter forms that make up the words – is as important as the background against which they are read by the viewer. It is a cliché – but no less effective for it – that blocky fonts, with strokes the same width throughout, suggest modernity or industrial processes, handwriting can suggest informality or youth, and a Gothic font is often used to introduce an element of horror.

Titles effects

Numerous effects that animate titles are available even in the most basic software. Yet the simplest effects – those that fade in and out – are often the most effective. Depending on your software, once you choose the effect, you may have control over the speed and timing, the length of a pause if any, as well as the size and colour of the text. Another level of control is available through altering the speed at which the title clip itself plays: you may want to slow down the playback of the background footage to make it last longer, or you can run titles over a still.

Coordination with action

The best titles work to tell a story as a lead into the larger story. Here, we see the words appear one by one, in time with the sun bursting from behind the cloud. As the sun breaks through, the last word appears, providing an effective cue to the next scene.

Cross through centre

In the cross-through-centre title effect, letters appear jumbled up, converge into a mass, and then finally separate out to reveal the title. Used in this sequence – a prosaic pan across a small garden – it suggests that perhaps some mystery or puzzle is about to unfold.

Zooming titles

A dull stretch of urban development can be transformed into a low-key drama by titles that appear to zoom on to the screen from a distance. Once the title sequence is over, the action should begin straightaway.

Zooming and fading

A zooming-in effect works well when set against another movement, as here, with the flight of a gull. The inexpert tracking of the flight, which causes the gull to move about within the frame, has been put to use to interact with the title. The final frame shows the title fading away, cueing a dissolve or fade.

●HINTS AND TIPS

When you create titles for your movies, you have to put on yet another hat – that of designer. A careful choice of typeface and effects helps set the scene and shape the viewer's expectations.

● Titles do not have to be on the first frame of the movie – they can follow an introductory clip.

● Do not forget to acknowledge and thank everyone who has helped you make the movie, including the tea makers and bottle washers!

● Avoid excessive use of special effects with text – they may distract from the viewer's enjoyment of the rest of your movie.

● If there is a lot to read, allow a generous pause time for your viewer to do the reading.

● Awkward cuts or problems in continuity may sometimes be solved by using titles – but if you use one as a section title, you may need to use at least one more.

Setting the scene
Although generally speaking you should try to avoid busy backgrounds for titles, they can sometimes work with clever use of fonts and colours. This cast list, presented on the inside of the windscreen of a bus, indicates some information to the viewer about the setting of the opening scene.

Using effects

Digital video effects are also known as filters, which tells you that any filters that you may know about from digital photography could, in theory, be found here. The differences are that the filter is applied over a period of time, and the strength of the effect can vary over the duration of a clip.

You need to place a clip on to the timeline before you can apply filters, although, depending on the software, you may be able to preview an effect in other ways. It is best if a small preview window is available, since the effect can be shown in real time. This is important because the majority of filter effects need a good deal of computing power and time to render a full-size viewing.

Choosing effects

The best way to choose an effect is to allow it to choose you. Some – such as a stream of electricity appearing to come from a subject, or a star in orbit trailing stardust – are good for amusement value but cannot be used often. Others – such as those that adjust colours, brightness, and contrast – will be used time and again; the differences between effect and post-production tool are blurred here.

Another group of filters simulates old processes or their low quality, such as one that simulates aged film. Why would anyone spend a small fortune on the latest equipment and edit on computer only to recreate the poor colours and jerky frame projection of amateur cine films? Because it looks great, and when used with suitable subject matter, the effect is surprisingly convincing.

Applying effects

Once you have placed a clip on the timeline, you can then apply an effect. Depending on which application you use, you may have some control over the strength of the effect once you have

Original

Hue shift

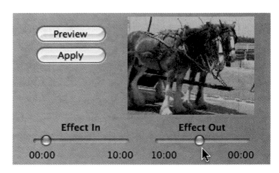

Effects time control
Controls timing the effect set how long after the clip commences the effect should reach full strength, and how long before the end of the clip you would like the effect to start to diminish. Long intervals give smooth, steady transitions. A zero setting at the in point starts the effect at full strength immediately; at the out point, a zero setting keeps the effect to the very end.

Changing the colours
A shift in hue, shown here, can be used to create amusing effects or to give advance notice of a change in place or mood. At the same time, colours can be made more or less vivid, and overall lightness can also be adjusted.

Effects control
Simple sliders allow you to adjust the strength and type of effect. However, the lack of a box to allow you to enter a precise numerical setting will make it difficult to replicate exactly an effect proven to work on another clip.

selected it. You should always be able to control the timing of the effect: one selector determines how long into the clip it takes for the effect to reach full strength – it may be immediate or slow-building; the other control sets the removal of the effect – a zero setting keeps it in for the duration of the clip. Some effects take a certain path – as is the case with Star Dust – while others have a direction – such as Lens Flare: you need separate directional or positional controls for these effects.

Variety of effects

The effects that can be found in NLE software and as additions to applications or as stand-alone programmes are numerous and varied. It is possible to group them by function, which can also help match their capabilities with your editing and project needs.

Effects such as Aged Film, Sepia (an overall low-contrast brown tone), and Monochrome imitate the look of early film. These effects tend to be applied to the whole of a clip or sequence, rather than being introduced gradually.

Effects that adjust colours, brightness, contrast, and sharpness as special effects differ from post-production by degree. If you exaggerate a colour change, you are applying a special effect, not a post-production colour-balance adjustment. Used in this way, effects are often best introduced and removed gradually.

Changing shape and content

A different group of effects alters the geometry of the image but does not change the overall tone or colour. The letterbox- or 16:9-adjusting filters, for instance, simply change the shape of the frames – either by shading off the top and bottom or by distorting the image. Mirror and N-Square also introduce geometrical effects: one mirroring half of the image, and the other repeating it.

Added effects filters introduce entirely new elements into the clip, not based on anything in the clip at all. In this group we find Rain, simulating a heavy rainfall, as well as fun but limited effects such as Star Dust and Electricity.

Mirror

N-Square

Mirror and N-Square effects

Visually interesting effects come from the filter that creates a perfect mirror image of one half of your footage (*top*), while a slider adjustment allows you to choose the number of times the image is repeated (*above*). With moving subjects, these effects can be mesmerizing, and both are well suited to music-video work and artistic projects.

Effects menu

Because the effects are listed in alphabetical order, it is easy to find the one you want – if you know its name. However, if you are searching for an effect based on the function it performs, it is likely to be more difficult. The best way to discover what an effect can do is by trial and error.

Aged Film

Original

Sepia

Old processes

The Aged Film look (*top*) all but destroys your precious video footage in the name of art: it introduces grain, lowers the contrast and saturation, throws in scratches, and makes the frame jump about. The Sepia effect (*above*) is far gentler and is very effective provided it is not overused. Both are often seen in TV commercials.

Strong colour cast

Heavy colour cast

Adjust Colours

A soft touch here will correct colour casts and improve exposure if necessary. But a heavier effect is also useful – here to introduce strongly graphic looks (*centre and above*) that could pave the way for a transition to a modern restaurant interior or an art exhibition. This promises to be far more interesting than the safe and predictable ferry ride of the original clip (*top*).

Original

Soft glow

At times, the crisp, sharp image is not the most appropriate. For this sunny, happy seaside clip, a soft-glow effect blurs both colours and details to dreamy effect.

High contrast

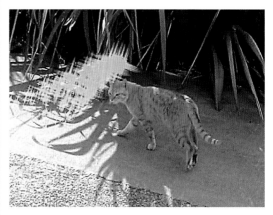

Star Dust

Not all filters are designed for serious work. Effects such as stardust glittering across the frame to suggest a magical feel may charm younger audiences.

Extreme contrast

Brightness/Contrast

As with colour adjustments, a gentle touch on the brightness or contrast filter can greatly alter the look of your movie. An extreme-contrast image (*above*) can look attractive on the monitor screen but may not work well on a domestic screen because the white areas are uncomfortably bright and the black areas are not quite black.

Electricity

Another example of a fun effect is the electric spark, which has its uses for comedy movies or horror films. Both Electricity and Star Dust (*centre*) require heavy processing to render.

Editing the soundtrack

A video-maker's increasing command of the medium is reflected in an increased appreciation of the importance of the soundtrack. When you are starting out, recording sound using the camera's own built-in microphone is not only the most convenient option, it is also the one with the fewest technical difficulties. But as you become more ambitious, you will want to graduate to a mounted microphone; from there the complications increase, but the quality of the sound you record will improve. Here, we explain the basic editing controls for a soundtrack recorded together with the video footage.

Setting levels

Different NLE applications implement the setting of levels in different ways, but this is essentially an audio-control exercise. A pair of separate, good-quality loudspeakers for monitoring is an essential purchase: the tiny speakers inside your computer are woefully inadequate for the task of sound monitoring, and the small units on your desk are not much better. Neither will give you the dynamic range you need.

With the monitor speakers and output levels set to normal, you can play back your video and evaluate by ear whether the sound level is correct. Of course, sound professionals will use specialist meters with what is essentially a calibrated system to obtain broadcast-quality sound. With equipment designed for amateur or consumer use, sound levels are recorded at what is technically too low a level for broadcast, but it is still adequate for domestic purposes.

Time-based adjustments

With the most basic entry-level NLE software, you cannot even adjust the volume. But at the next level of NLE you can, and just as you can gradually introduce and trail off a visual effect, so you can fade sound in and out. In software such as Apple iMovie, introducing a fade is as simple as clicking on the volume indicator on the timeline and dragging the line up or down to increase or reduce audio levels. The position of the transition corresponds to the position on the timeline, so you can synchronize changes with what is happening on screen.

Levels meter
A display such as this is good for an objective monitoring of audio levels: it is graduated in decibels and gives a constant read-out of the state of the audio. The two green lines indicate that the audio is present on both right and left channels.

Waveform diagrams
One of the joys of digital video is the way it increases your awareness of the world of sound. A fascinating exercise consists of relating the waveforms to the sounds you hear. In this highly magnified display, the black bar represents the duration of one frame of NTSC video.

No volume
With the Edit Volume control not activated, the timeline for the clip simply shows the length of the clip and its poster frame (the first frame) – there is no "levels line".

Edit levels
With the Edit Volume control activated, the purple levels line appears throughout the length of the clip. It is located through the middle, indicating its default volume setting.

Low levels
If the volume is adjusted down, the levels line sinks towards the bottom of the display; and if the volume is increased, the line naturally moves towards the top.

Examples shown here are taken from iMovie, the audio-control interface of which is particularly easy to understand.

Editing on the timeline

To select an item in order to make changes to the soundtrack, you need to place it on the timeline. Once this is done, you can set the overall volume or introduce gradual changes, known as fades. In addition, the audio channel can be extracted and worked with independently of the video. This enables you to combine your footage with audio from other sources or move the audio to a different part of the video.

Fades

The gradual rise of a soundtrack to silence, or its fall to silence, is a staple of sound editing. NLE software programs implement this in different ways, but the easiest method is to manipulate the line that represents audio level, either directly on the timeline or in a separate window. The angle of the slope of the line indicates how rapid the change is. It can be quite sudden – like when a door opens on to a busy street – or very leisurely, a slow rise in volume that is barely noticeable until it reaches normal levels – such as the sound of a motorcycle approaching from a distance. The colourful term for this effect is "sneaking in". But the scale or magnification of the timeline can be changed, and this changes the slope.

Cross-fades

The audio cross-fade is a transition similar to a cross-dissolve in video: as one track diminishes to nothing, the other track rises from nothing to normal volume. Although this may sound like just another gimmick, it is actually the most natural way for the soundtrack to follow the visual transition occurring in the movie.

For example, as you walk from the street into the house, the movie cross-dissolves from scenes of the street to children playing in the garden. The soundtrack follows suit: from the street noises of traffic and so on, you cross-fade to the sounds of

children at play. For this transition, you work with two separate audio tracks that are "unlinked" from the video. Unlinking enables the audio transition to follow a rate of transition different to that of the movie.

Extracted audio combined

In this diagram, the audio for the clip (in the top line) is reduced for a few seconds, then raised again. At the same time, the audio in the separate soundtrack (in purple) is raised from zero (fade-in), then lowered back to zero (fade-out).

1 Set fade-in

Here, the sound is set to fade in from its low level at a certain point. One click on the timeline defines the in point for the rise in audio level. Click again on the levels line and drag it up to raise the level and program in a gradual fade-in. Note: the labels for the tracks have been removed to facilitate international editions of this book.

2 Set fade-out

Setting the fade-out is achieved in a similar way to setting the fade-in: click first to define the start of the fade-out, then again and drag down to define both the speed of the fade-out (the steeper the slope, the quicker the fade) and its out point.

Editing the soundtrack continued

Extracting audio

So far, the soundtrack has been treated as part of the video: starting and ending at the same time, synchronized to it. A key step to editing soundtracks on video is to separate the two, a process called "extracting audio". By default, once extracted, the audio remains synchronized to the video, but it is possible to unlock or unlink it. Then the audio clip becomes a data file in its own right, a separate entity that can be split, cropped, have parts extracted and pasted elsewhere, exported, and even used in another video.

It follows that you may be able to combine several audio tracks. Entry-level NLE software may allow you to work with one or two tracks, but professional programs can handle up to 100 audio tracks.

Eliminating unwanted noises

It is impossible when shooting on location to avoid unwanted noises. The easiest to deal with are short, sharp, percussive sounds – high-level peaks – such as doors slamming, dogs barking, or a car horn sounding. It is much harder to deal with noises of longer duration, especially if they are of a low frequency. Sounds such as the roar of an aircraft overhead, an emergency siren, or a burglar alarm going off mean that you will have to shoot another take or record the material separately in post-production.

To eliminate short, sharp noises, try copying a clip of room or ambient tone and dropping it over the undesirable piece of audio on a separate track.

You may need to reduce the level of the track carrying the noise at the point it starts, then raise it again: remember that fades can be very rapid.

Back-timing

An effective editing technique is to synchronize a climax or turning point in the visual action with appropriate music. The technique is called "back-timing", after the method employed in the days of film: given the climax of a piece of music and knowing its duration, the operator timed the film backwards to work out in which frame the music should start.

And that is exactly how it is done in digital editing, except it is much easier: you import the music track and slide it underneath, making the movie and music coincide at a chosen point. With a careful choice of music, you can make it sound as if it had been written, arranged, and performed especially for your movie.

Split edit

Perfect synchronization is often essential – for example, when you can see the subject speaking. However, it is not the only way to edit sound; indeed, a little off-timing can be highly effective.

Two audio tracks
Relatively simple NLE applications such as iMovie allow you to work with two audio tracks (the bottom two). For many purposes, that is all you will need, and it saves the complications of working with multiple tracks and mixing them.

Synchronizing sound
For extra precision in the synchronizing of sound and video, it is easiest to locate the peak in the sound with visual markers, as seen above: the music builds rhythmically to a peak, followed by silence. This makes it easier to synchronize with the video climax.

In a split edit, the audio transition takes place just before or after the action: the deliberate "mistiming" can create tension and expectation in the audience with very little effort.

The split edit is used most effectively in highly charged dialogue: as the hero speaks, the camera cuts to the heroine listening while he is still speaking, then we hear the heroine reply. The visual transition takes place before the change in audio: we see the reaction that the speech is having while the hero is still talking.

Nearer to home, imagine that you are videoing an elderly relative talking about their favourite record and the memories it evokes. You fade in the music for a few seconds, keeping the camera on your relative's face as you watch them recall the music. Only then do you cut to a close-up of the old record spinning on the record player. The change in audio track precedes video, and the effect is much stronger than if you had synchronized the two.

Recording a voice-over

Entry-level NLE programs such as Windows Movie Maker or Apple iMovie make it easy to record a voice-over track for your movie. You attach a microphone to the computer, set the recording mode, ensure you are at the beginning of your movie, then speak. Keep your eye on the level meter to ensure you are speaking at normal levels, not too quietly or too loudly – you may need to practise this beforehand to get it right. Of course, the voice-over track should be recorded as an audio clip in its own right – so that you can add location sound or ambient noise if you wish – but one that is synchronized with your movie.

◗ HINTS AND TIPS

There are some simple rules to observe when working with sound to ensure the best working practices.

● When monitoring audio levels, use a reference point of −12 decibels (dB) maximum for the majority of situations; decrease it to −18 dB to −20 dB if you expect some loud noises.

● Work in a sampling-rate environment of 48 KHz (16 bit) if possible – that is, shoot your digital video with the audio sampling rate set to 48 KHz.

● Do not mix sampling rates (see below): if necessary, change the sampling rate to 48 KHz before working on the files. Never mix sampling rates within a sequence created from mixed sources – for example, digital video and CDs: some systems will not work at all with mismatches; even if they do, mismatches could cause problems further into production.

● Log audio clips as you would video clips if you use material from CDs, the Internet, or other sources. This will allow you to keep track of your material. By default, extracted audio takes on the same name as its parent clip.

Quality of sound

The quality of digital sound varies with the sampling rate – that is, how many times per second a sound is measured to digitize it – as well as the highest frequency that can, in theory, be recorded. For the highest audible frequencies, 48,000 samples per second must be taken. The setting for sampling rates in your sound card or camera, or when importing video, will need be matched throughout.

Sampling rate	Highest frequency	Format/use
48,000	24 KHz	DAT (digital audio tape), hi-fi
41,000	20 KHz	Audio CD, non-Web cross-platform
32,000	16 KHz	Audio CD, Web cross-platform
11,025	5.5 KHz	Analogue broadcast
8,000	4 KHz	Voice

Creating your own DVDs

The invention of the DVD format and its associated technologies has led to the fastest take-up of any new technology of all time. However, the tremendous opportunity it provides to aspiring movie-makers has taken a few years to be realized. Creating a DVD was once a costly industrial exercise. Now, due to a liberalization of DVD standards, DVD burners in every new personal computer, and, above all, inexpensive – even free – authoring software, the time is ripe for a total upheaval in movie distribution. And if your computer does not have its own DVD writer, you can purchase an external writer for little more than a CD writer.

Authoring software

The software applications currently available cater for all levels of requirements – from making a simple DVD carrying just your movie, to creating a professional-level DVD complete with chapters, menus, multi-angle viewing options, stills images, music, and interactive elements. (*See pp. 52–3 for details of DVD authoring software.*)

After you have spent innumerable hours – by turns frustrated, exhilarated, and exhausted – working on your movie and you are happy with the end result and have backed it up, you are ready to burn your DVD. Here we describe the basic steps that are common to all authoring software.

Adding chapters

Chapters are the episodes or acts of a movie. It is customary to add chapter markers at natural turning points or cuts in the movie – a major change of scene or pace, or a big development in plot. Chapters enable your viewers to return to a part of the film they like without scrolling through (as is the case with tape). If you are creating your movie in NLE software that is able to create chapters compliant with DVD standards, then the time to identify the chapter points is when the movie is complete. If not, you should be able to add chapters when you bring your film into the DVD-authoring software. In any event, you should give your chapters descriptive names, such as "Prelude" or "Amy meets Bill".

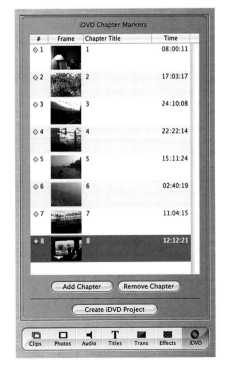

Poster frames
Some DVD-authoring applications allow you to choose the poster frame to use on a button. Here, in iDVD, you select a still image by unchecking the Movie dialogue box, then move the slider until the frame you want is in view.

Chapter markers
By default, chapter markers are placed at the beginning of edits or clips, but they can also be placed anywhere the play head is located. The poster frame is available for the DVD to use to identify the chapter and you can give your chapters either descriptive names or simply numbers, as shown left.

Encoding

The next step – irrespective of what you wish to do with your movie – is to encode it into a format suitable for its destination. This is not as simple as it sounds since there are numerous possibilities. For DVDs, the choice is straightforward: encode your movie as MPEG-2; but within that, there are several choices, so let your software choose the basic default settings to begin with – usually MPEG-2 with VBR (variable bit rate, which compresses the data more efficiently). If you encounter problems with viewing your movie – slightly inaccurate image proportions perhaps, then it could be the encoding. You may have to upgrade to a more sophisticated encoder, such as Discreet Cleaner or Compressor, rather than what is built into your NLE software.

When encoding to MPEG-2 with VBR, you should count on about 4 GB for 60 minutes of video – it may be more or less, according to the nature of the film. Long, slow takes of solitary figures in the desert in the style of *Lawrence of Arabia* will compress efficiently, but jerky footage shot at night – such as the type used in *The Blair Witch Project* – will require a far greater data capacity. If your movie is very long, you can encode as MPEG-1, but the quality will drop to that of VHS tape.

Current Settings

DV NTSC 48 kHz
DV NTSC 48 kHz – 23.98
DV NTSC 48 kHz – 24
DV NTSC 48 kHz Anamorphic
DV PAL 48 kHz
DV PAL 48 kHz – 23.98
DV PAL 48 kHz – 24
DV PAL 48 kHz – 24 @ 25
DV PAL 48 kHz Anamorphic
DV50 NTSC 48 kHz
DV50 NTSC 48 kHz – 23.98
DV50 NTSC 48 kHz Anamorphic
DV50 PAL 48 kHz
DV50 PAL 48 kHz Anamorphic
DVCPRO – PAL 48 kHz
DVCPRO – PAL 48 kHz Anamorphic
DVCPRO – PAL 48 kHz Superwhite
DVCPRO HD – 1080i60
DVCPRO HD – 720p24
DVCPRO HD – 720p30
DVCPRO HD – 720p60
OfflineRT HD (Photo JPEG) – 23.98
OfflineRT HD (Photo JPEG) – 24
OfflineRT HD (Photo JPEG) – 25
OfflineRT HD (Photo JPEG) – 29.97
OfflineRT HD (Photo JPEG) – 30
OfflineRT NTSC (Photo JPEG)
OfflineRT NTSC (Photo JPEG) – 23.98
OfflineRT NTSC (Photo JPEG) – 24
OfflineRT NTSC Anamorphic (Photo JPEG)
OfflineRT PAL (Photo JPEG)
OfflineRT PAL Anamorphic (Photo JPEG)
Uncompressed 10-bit NTSC 48 kHz
Uncompressed 10-bit PAL 48 kHz
Uncompressed 8-bit NTSC 48 kHz
Uncompressed 8-bit PAL 48 kHz

✓ Custom...

Export formats
A full range of export formats is a bewildering sight (*left*): it shows just how many options professionals have to contend with. If in doubt, let your software make the decision for you.

Digital video in multimedia

If you are authoring multimedia discs, you may want to run video within a multimedia presentation. Macromedia Director is a leading application that is able to import digital video in QuickTime, QuickTime VR, AVI, and some MPEG formats, provided these are imported as QuickTime. Digital video movies are always linked – that is, the original video file must be available to the Director projector, preferably within the same folder as all the other material. Since the frames of the video are not the same as those in a Director "movie", the video will run normally. Embedding a video in this way allows the multimedia programmer to use your video as if it were a graphic or image that can be navigated to or called up. Beware, however, of a movie's propensity to increase the size of your presentation file.

Regional codes for DVD playback

Also known as country codes or zone locks, regional codes are recorded on a DVD in order to limit the disc's playability to the areas in which it is sold. Therefore, a Zone 2 disc – sold in Japan and Europe – may not work in a Zone 4 player – that is, machines in Australasia and South America. Discs without locks (also called Zone 0 discs) can be played on any player. Many players – so-called multi-region models – can play discs from any region. In fact, the majority of players are able to play any disc but are locked electronically to certain regions: it is possible to bypass these locks, but it may not be legal to do so. DVDs that you create do not need to carry zone locks, unless you wish to limit their use, which may be an issue if the content of your DVD may cause offence in certain regions.

Creating your own DVDs continued

Designing the interface

The crucial factor offered by DVD authoring is the ability, for the first time ever, to set a mood, or "environment", for the movie. The concept of interface design is similar to creating a web site, in that you create a visual environment to set the scene, provide titles to inform, and offer buttons with which to enter the movie. And, similarly to web design, DVD files must conform to strict rules about file types and location.

The intricacies of interface design are outside the scope of this book. However, help is at hand, since all but the top professional applications offer collections of templates that you can adapt to your own needs. You can change the wording, of course, but you can also select the typeface, as well as its size and colour. You will also be given a small choice of button shapes, which can be labelled. The buttons will be linked with your chapters, so that viewers can use the buttons to navigate their way through the movie.

Preview

Before committing a movie to DVD, which takes time and is not yet a cheap medium, it is a good idea to preview what it will look like. You can catch problems like dropped frames, clips that for some reason were not rendered fully, and other mishaps.

In addition, you can import images from your digital photography collection to serve as backgrounds – indeed, you could even use stills from your movie. Note that TV pixels are usually not square, whereas (generally) they are in digital photography. So be aware that there may be small shifts in the shape of your images. This disparity is recognized in applications such as Photoshop CS that compensate for non-square pixels.

Menu template choice

The choice of menu template styles gets wider with each new software release. You can choose from a variety of backgrounds that resemble, for example, a picture postcard, a birthday card, or an old book. Here (*top left*), a cool, modern design is suitable for urban settings; a swathe of bright red cloth (*top right*) bridges old and new, mirroring the movie, about a modern university. The old-style projector (*bottom left*) displays a scene from the movie with an aged film effect; a clean, modern look with paintbrush strokes (*bottom right*) offers yet another solution.

Button shapes

Templates for button shapes save you from having to design your own. The labels for the buttons can be customized, and some will either show a poster frame or run a sample of the movie within the button. It is also possible to change the button size.

Creating Video CDs

Even if you do not have a DVD writer, you are likely to own a CD burner because they are more or less a standard fitting on modern computers. If that is the case, you can distribute your movies on CD. The quality obtainable is not as high as on DVD, nor is the data capacity – which may have an impact on the length of movies you make. More importantly perhaps, CDs are much less costly than DVDs. There are two CD formats currently used: VCD and SVCD.

VCD format

Video CD uses standard compact discs to hold video that is compressed to the MPEG-1 format. Images measure 352 x 240 pixels in NTSC, and 352 x 288 pixels in PAL – the reduction in image size is effectively a file compression, and it reduces file sizes very effectively. The compression is "lossy", however – which means that data is lost in the process and cannot be recovered.

The use of MPEG-1 means that VCD movies can be played on DVD players, as well as in computers with suitable software. Note, however, that while good quality CD-R discs are easily read by any DVD or CD player, even high-quality CD-RW media (CD-rewritable) are known to present problems for some CD players. A full 700 MB CD of MPEG-1 data works out as around 60 minutes of video with basic stereo sound (two-channels of audio), not surround sound (more than two channels of audio).

SVCD format

Super Video CD, also known as Chaoji VCD, is a format invented by the China Recording Standards Committee in an attempt to counter the dominance of DVD, allowing digital movies to be viewed by a greater number of people than that able to invest in new technology. SVCD is in widespread use in Asia and is spreading globally. It offers higher video quality than VCD, being based on the higher-specification MPEG-2 format. However, this means that they can only hold a movie of about 34 minutes in length.

Another reason for the higher quality, as well as a commensurate increase in the amount of data they hold, is that the image dimensions are larger than on VCD: 480 x 480 pixels for NTSC, and 576 x 480 pixels for PAL. While SVCDs can be played in a computer's DVD or CD drive, they may not be compatible with all set-top DVD players.

Making a VCD

VCDs are easier to make than DVDs because they offer fewer functions; therefore, you have fewer decisions to make. They do not have chapters, so they are best suited for movies intended to be watched in one sitting. In software such as Windows Movie Maker, you simply click in the Disc option to call up the dialogue box, where you select the VCD format, before clicking to create the disc. Ensure that your CD burner is up and running and that you have a blank CD inserted.

VCD burning

Making a Video CD is as easy as dragging the movie file into software such as Roxio Toast, choosing Video, then Video CD, and clicking OK. Note that files are treated like any files on a CD, and further files may be written at a later date up to the capacity of the CD.

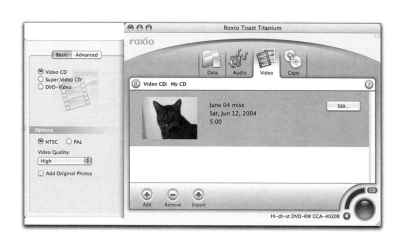

Quick fix Reproduction problems

Once your movie leaves the confines of your desktop, it runs the risk of being lost in incompatible formats, strict broadcast limits, and conflicting systems. Two of the most important problems are considered here. Even though you may not be ready to broadcast, it is good practice to keep to broadcast-legal limits.

Problem

You send your movie to a TV network or professional and they send it straight back. They have not watched it, but they say it has "not passed QC [quality control]" or that it is not "broadcast-legal".

Analysis

In analogue video, which currently also includes broadcast television, the signals carrying the video and timing or synchronization are combined. If the video signal is too strong (for example, if the whites are too bright) or the ratio between the signal and the synchronization exceeds a certain limit (for example, 10:4) then the electronics that draw the screen image may not function correctly, hence the term "broadcast-safe". Colours that are too saturated or strong are also a problem. Another broadcast requirement is that movies use 4:2:2 colour space, but it is not necessary to make this conversion for home use.

Solution

The best solution is to avoid the problem when the image is acquired. First, reduce the lighting contrast to within a 5-stop range. Second, measure and set the camera exposure carefully. If your camera offers a zebra-stripe display, this will indicate if any parts of your scene are super-white (too bright). Professional NLE applications offer a post-production broadcast-legal filter.

NLE range check
A range-check view shows that the luminance is too high (red stripes) at over 100 per cent, while the green stripes show luma values at

90–100 per cent: this clip is not broadcast-legal. The range check view is useful when making corrections in NLE to ensure you stay within standard limits.

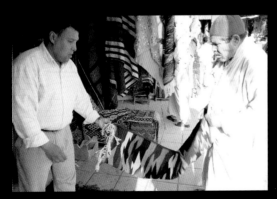

Super-whites in shot
In this shot (*above*), the white shirt of the man in shadows is within limits, but the shirt

of the man in the sun is well beyond limits – it is super-white, with no detail or colour, just a very high video signal.

Zebra stripes
This simulation shows what a zebra pattern looks like in the video monitor (some cameras display vertical bars). Zebra

stripes flash or blink to show the areas of the image that are above 100 or 75 IRE – whatever limits you set in the camera.

Problem

Images that look fine on your computer monitor look terrible – or merely differently coloured – on another monitor. The reproduction of hues is not reliable, and the contrast varies.

Analysis

All monitors reproduce the same signal in different ways unless they are carefully adjusted to a standard – that is, calibrated. Domestic monitors will vary a great deal and there is nothing you can do about them.

Solution

You should assess your images on a screen that bears some approximation to an industry standard, ideally a professional video monitor. You also need to calibrate your production monitor. Professional monitors offer a number of advantages over normal, domestic TV sets. Apart from costly features such as the ability to change scan rates and format, the main advantage of a production monitor is the Blue Only mode. Selecting this sends the blue signal to all three monitor electron guns, which gives you a black-and-white picture built up from the blue channel. This enables you to judge the channel that is typically the one giving highest levels of noise. In addition, the Blue Only mode is needed when calibrating the monitor.

Call up the SMPTE bars (or whichever standard is appropriate) and switch to Blue Only, or observe the screen through a dark-blue filter – for example, a Wratten 47B. Using Hue and Luma controls, adjust the Chroma and Hue (or Phase) controls until the four large bright bars match the small rectangles at their base. Then adjust the brightness so that the middle of the small vertical bars under the third dark bar just reaches black. Finally, the contrast control should be adjusted if necessary.

SMPTE bars
These bars are among the most widely used of standard signals or test patterns for assessing both acquisition and display devices.

Note that there are precise standards for each bar: if the pattern is not accurately generated, it cannot be accurately displayed.

SMPTE Blue Only
The Blue Only view of the SMPTE bars is shown here as it might look before calibration. The small, squat rectangles under some of the bright bars are distinguishable

but should blend with their corresponding large bar. The small thin rectangles under the third dark bar are distinguishable where the middle should blend with the large bar.

SMPTE Blue Only: bars correct
This is what the Blue Only view should look like after correction: all the long bars are uninterrupted by any change of luma, while

the small vertical bar under the third dark bar is just visible. Finally, the small white square in the bottom row appears white but not blindingly. (Compare with the image above.)

Streaming to the Internet

It is remarkable that anyone with Internet access anywhere in the world can look at web pages created elsewhere. It is even more amazing that we can also watch movies online, thanks to video streaming, in which a server computer sends compressed video files over the Internet. These files can be viewed while downloading – the key point being that the viewer does not need to have downloaded the entire file before starting to watch the movie. A simple analogy would be someone drinking from a glass while it is still being filled up.

Basic decisions

Digital video requires very large amounts of data to be processed without interruption. To stream video successfully, you must match the viewing size and the compression levels you will accept with the capacity, or bandwidth, available to your viewer. For viewers connected to the Internet by modem, you should not stream – that is, send a line of data – at more than 36 Kbps (kilobits per second). Those on broadband or ADSL connections can handle 256 Kbps or more. The wide difference between these rates means that you may want to provide two movies, each optimized for a different connection.

The format for video stream will naturally be influenced by the computer you use. If you work on the Windows platform, you work around

Serving video

The special demands of video call for a number of special arrangements at the server that distributes the video to viewers. If you wish to put streaming video on your web site, it is necessary to check that the company hosting your site, which may be your Internet service provider, is able to handle video. If your hosting company can handle video, then all you have to do is upload your video to your web site in the usual way, providing a download link on your site for visitors to click. However, video streaming may be a special facility for which you need to pay extra. Depending on the streaming rates you use, different formats are preferred: Windows Media and QuickTime run best at rates up to 512 Kbps. Consult your hosting company for the latest recommendations. Also bear in mind that video streaming pushes out a lot of data, so you may exceed your account's limits on bandwidth.

Windows Media Technologies – a set of different software for creating, editing, and reformatting content. The core is the ASF (Advanced Streaming Format), to which other file formats such as WAV, AVI, MPEG and MP3 can be easily converted. Movies are watched using Windows Media Player. Apple Mac users will centre their work around QuickTime, using software such

Choosing picture size

For the slowest modem downloads (28 Kbps), you can only stream audio: video can be streamed at about 1 fps (frame per second) for a picture measuring 160 x 120 pixels. At 128 Kbps and in good conditions, a picture of 320 x 240 pixels can be streamed at 15 fps: the result is jerky but better than nothing. At 512 Kbps, you should be able to reach 25 fps with a 320 x 240 pixel image, and this will run smoothly most of the time, with the occasional stammer or hesitation. It follows that streaming video is made possible by high-speed connections, such as ADSL.

160 x 120 pixels

Educational previews
You can learn so much from even the trailers of blockbusters or independent films, such as this one for *Spider-Man 2*. Trailers often show the best bits of the movie. Once streamed to you, a frame-by-frame analysis is possible and highly educational. You will see that even the big studios do not get everything perfect all the time.

as iMovie, and watch movies in QuickTime Player. QuickTime movies are compatible with Windows Media Player and can be watched on Windows machines.

Watching movies online

Thanks to the wide acceptance of QuickTime and now Windows Media Player, there is a very large quantity of material available on the Internet. For better-quality viewing, you can install Real Player (or RealOne for Mac OS); this software must be paid for, but the fee also gives you access to many mainstream movies as well as radio. However, unless you have the very fastest line, even quite small movies will take some time to get started. The

reward for your patience, though, is the chance to watch movies that never make it to cinema distribution. You can also analyze the movies and learn useful techniques in your own home.

There are numerous web sources for movies: a search using the key words "online movies" will bring up hundreds of thousands of matches. Although the quality is variable, it is worth exploring a good number. Their offerings range from Hollywood blockbusters to 60-second independent shorts and animations; you can use these movies as learning tools or simply for inspiration. If you pay subscriptions you may be relieved of advertisements and be able to download better-quality video streams (*see pp. 260–1*).

320 x 240 pixels

640 x 480 pixels

6

Going further with DV

Movie genres

Your progress from making home movies to productions aimed at audiences beyond the family can be rapid and painless. This chapter demonstrates how your video-making skills can be developed and taken further. Various types of movie are discussed, and attention is paid to structure and story.

Developing ideas

Before you can make a movie, you first need to have an idea. Whether it is simple or complex, this is the seed from which the project will grow. Here we look at ways of bringing out the full potential of your idea before the shooting begins.

Writing screenplays

Practical hints for scriptwriting and creating screenplays are outlined, as are some of the different ways of creating storyboards. A quick-fix section offers help for problems commonly encountered with location work.

Approaches

With a handful of short films on your DVDs, and after hundreds of hours spent at the computer following days of setting up and filming, your thoughts will turn to greater things. It is likely you already know what you want to do. Filmic styles, much like other modes of creative activity, tend to choose you rather than give you the choice.

Being different

The futures of movie-makers are no longer held solely in the hands of movie magnates. The boundaries and limits that were formerly fiercely constrained by the need for technical resources of an industrial scale have now been swept away. Working with video, you can shoot hundreds of hours of footage without having to remortgage the house, and the cost of editing that box-load (no longer a truck-load) of tapes is only that of your time. So if you want to do it – whatever "it" may be – you probably can.

One concern of novice movie-makers is the "groove problem" – the notion that once you have made a success of working in a particular genre or style, you will be pigeonholed. Certainly it is easier once you have made, say, a successful pop video to continue making them. You have a track record, and you have a great first item for your showreel. It is then easier to get work of the same type.

But directors can and do cross genres. For example, although Steven Spielberg is often associated with action-adventure movies, his oeuvre also includes a thriller about a deranged trucker (*Duel*) and a tear-jerker about a soft-hearted alien (*ET: The Extra-Terrestrial*). And Lars von Trier, one of the founders of the Dogme movement vowing chastity from special effects and artificial lighting (*see p. 110*), has made one movie using a bank of 100 cameras (*Dancer in the Dark*) and another using 800 lights (*Dogville*). So make whatever you want, however you want.

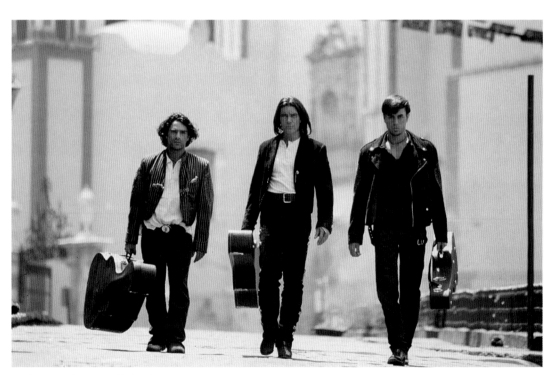

Hollywood goes digital

Robert Rodriguez (*From Dusk Till Dawn*, *The Faculty*, *Once Upon a Time in Mexico* [*above*]) is one of the growing band of directors forsaking film for high-definition video. He was introduced to HD video by George Lucas, who used it for his *Star Wars* prequels. Rodriguez is also credited with being part of the movement that persuaded film festivals to accept entries made on video.

Movie genres

As cinema has evolved, so the styles or modes of film proliferated: documentary, narrative feature, B-movie, art-house, and others. There is now even a semi-official list of 22 recognized genres within feature films – ranging from romantic comedy and thriller to psychodrama and period adaptation. Broadly speaking, though, the trend is now an erosion of any clarity that may have existed in the boundaries between these ways of making movies. For example, a biopic (from "biographical picture") about a comic-book author can exploit special effects to recreate or simulate the world of its subject (as in *American Splendor*), while a romantic feature film may use documentary footage to locate the time and place of the main character (as in *Forrest Gump*).

All of this means that your movie's content or story comes first; leave it up to others to decide which genre your work fits into. In practical terms, the point is that you can create a movie in any style within an affordable budget. But first, you need an idea that grabs you – one that will push you along the road to the complete movie (*see pp. 218–19*); and next comes the writing of the screenplay (*see below*).

Documentary goes mainstream
The Wim Wenders film *The Buena Vista Social Club* was the first to show that documentaries could hit the mainstream movie-going market. It was shot entirely on digital video.

The essential screenplay

At the heart of your movie planning is the screenplay. It is a narrative that maps the movie's journey from one scene to the next, describing location, lighting, props, camera angles, and moves, as well as providing the dialogue (if any) and directions for any actors involved. When you are starting out and learning the craft, it is best to begin with a modest 10-minute short. There will be plenty of time later to progress on to a 100-minute all-action feature or to attempt a screenplay based on a classic novel. If your movie has no dialogue, then you could consider shooting it without a screenplay. But not only do you miss out on the fun of tackling one, you also miss out on the advantages – every one of which will improve your movie. Some of the numerous benefits of working from a screenplay include:

● You know what you are doing, and why. This means you waste less time, effort, and tape.

● Anyone helping you will know what you are doing and why at any point in the proceedings.

● Scripted dialogue can be improved upon while shooting or used as a basis for ad libs or improvisation.

● You can budget around a screenplay far better than you can from just a list of locations or items.

● A screenplay is more directed than a shot list, encouraging a disciplined approach to shooting, which in turn will aid efficient editing.

● A screenplay forces you to visualize the effects of changes of scene and pace, as well as of camera angles and fields of view. For more on storyboarding, see pp. 224–5.

● A screenplay enables you to plan for the editing and post-production processes.

● You can plan for all requirements such as lighting, props, and sound more easily.

● A screenplay will help you when it comes to scouting for locations.

● You can plan a shooting schedule that is economical, rather than shooting the action in the order it occurs within your movie.

● The screenplay offers a springboard for improvisation if the creative spirit descends upon you.

See pp. 222–3 for more on screenwriting.

Types of movie

Taking your movie-making further often goes hand in hand with the move from the family context into the public arena. At this stage, you must raise the standard of both the content and presentation of your work, as well as taking on more responsibilities. The types of movie that you make then become like career decisions – a dynamic compromise between what you would like to achieve, what suits your temperament and skills, and what is possible given your resources and location. In that sense, what you record is an output determined in part by the programming of your personality. For example, if you do not enjoy popular music, it will not cross your mind to shoot pop videos, however much you recognize the pop video as a vibrant, energetic genre that has been hugely inventive with video effects.

Motivating idea

Whatever you decide to do, you will find it helpful to define your movie in one fairly short sentence. Call it the theme, its thesis, or even the mission statement, but it is important to sum up your movie succinctly. The best place to learn how to write such a sentence is to read the blurb on the back of commercial DVD and VHS movies. In the movie industry, these are written after the film is made, but you have to do it the other way around: before you do anything else, write that sentence.

Documentary

Movies based on reporting real events or people's lives seem to promise to write themselves, but you must do a great deal of research beforehand. It is entirely possible to do everything yourself: produce, record sound and vision, and direct. This is hard work, but it is also the least expensive way possible. And you could even find a subject no further away than outside your front door. All you have to do is talk to people, ask around, and research. The frail old man next door could turn out to have been a war reporter; and he may still have a head full of memories and an attic full of news clippings and photographs. Of course, more ambitious subjects are also possible (*see pp. 212–5*).

Artistic projects

You can take any aspect of your visual or aural world and turn it into a subject – the only limits are your courage, personal perspective, and commitment. The budget can be minimal, and you can take all the time you like, allowing the ideas to develop organically. Furthermore, you can work on several ideas at once, which makes the most of your taping excursions. For example, I am fascinated by lights and the way the camera appears to represent reality but actually records only what it is designed and built to do. My current project works with the artificial lights of

Documentary-making
As free-form or as tightly controlled as you wish, documentaries can be made anywhere, at anytime, and with the smallest of budgets and the most basic of equipment. They offer an excellent training ground for feature-length movies.

Artistic creations
In some respects, artistic videos need more discipline than other forms precisely because they can be formless and lack the usual forces that drive them to completion. However, they suit low budgets, and technical quality is not the highest priority.

the city seen in an equally artificial way by the camera. With such a subject, you can even make a virtue of the variable picture quality obtained from consumer digital video cameras.

Music videos

Digital video techniques mesh so well with popular music that they could have been invented for it. Music videos are always short, there is an inexhaustible supply of music for you to work with, and there are numerous unknown musicians only too keen to have their work creatively and imaginatively interpreted. Better still, this is a genre in which anything goes.

Short movies

Working on a short movie is similar to writing a short story: not only do you have to set the scene very quickly, but at almost the same time you must also take the viewer into the action. On the other hand, you do not have to develop a long story line. For example, the short could be about what a child gets up to on the long walk home after school; for a subject such as this, you do not even need any dialogue, just ambient sound. Furthermore, you can shoot straight – as if working with film – or use every trick in the digital video book. Making shorts is, of course, the best possible training for moving on to feature-length work.

Making shorts

Short movies can be treated as an art form in their own right or may be considered as the building blocks for a longer project. The haunting mood of this short – *Breathe,* directed by Samantha Harrie – is tangible in just a single frame.

Hybrid

These categories are far from rigid. In fact, they are only highlights in a continuum of approaches ranging from one that intervenes as little as possible – the "pure" documentary – to one in which every single element is contrived and constructed – the fantasy-world feature. A documentary about a psychic can exploit digital video effects in order visually to "enter" the psychic's mind, while a fictional feature can use documentary techniques of mobile camerawork, available light, and amateur actors to make it seem like a documentary or a true story.

Shooting music videos

Perhaps the fastest-growing art form in history, the music video has become so dominant in just a few frenetic years that there are entire broadcast stations around the globe delivering nothing else. Unique in being driven by their soundtracks, music videos have been a wellspring of adventurous film-making, often thanks to generous budgets and the need to make an immediate impact. But memorable music videos can also be made for almost no financial outlay.

Building blocks

There are numerous variants of the answer that goes along the lines of, "It starts somewhere, something happens, and then it ends". The question is, of course, "What is a movie?"

But the truth is that it is hard to find a movie in which the basic structure is not one in which, first, a scene is set: where we are, what period of history or future it is, and who the characters are and the state of their lives. Then something happens to upset the peace or status, forcing the characters to respond, from which we learn what they are "made of". Or it may not be so dramatic: this phase of the film may explore the details, flashback to explain why things are the way they are, and so on. This leads eventually to the resolution or, in the case of a documentary, a pulling together of all the strands to lead to a conclusion or the need to investigate further.

Defining the structure

Even experimental movie-makers cannot escape this basic structure: their attempts to break away from it – using flashbacks and parallel stories – serve only to reinforce its fundamental nature. And it is a structure common not only to movies, but to plays, novels, and longer poems; it even extends to the design and layout of art exhibitions and, of course, also applies to extended pieces of music. In fact, it is helpful to use the terms from sonata form (a structure that dominated classical European music for centuries). The first part is called the exposition; then comes the development section; and the end is the recapitulation – a reminder of the beginning. If you bring any favourite movie to mind, the basic structure will most likely be just that: exposition, to story development, to recapitulation.

Despite the structure, movie-making has an infinite capacity for creative solutions. This is the point at which the structural elements, or building blocks, that have been considered elsewhere in the book all come together.

Camera angles

As every shot requires you to position the camera so every shot is a creative opportunity. It is all too easy to leave the camera on a tripod that is set at a convenient height. The importance of camera angle is well illustrated by the example of the great director Orson Welles: during the making of *Citizen Kane*, he insisted on a hole being dug in a factory floor to get the camera low enough.

Now that even high-end video cameras are being designed to be shoulder-mounted or hand-held, there is no excuse for not taking the camera off its support and working with fluid camera movements. Also, Steadicams (which dampen or limit small movements), cranes, and mounted booms are relatively inexpensive to hire and easy to use with digital video cameras because they do not need to be as heavily constructed as those used in the motion-picture industry. Another crucial advantage is that a video feed can easily be taken from the camera to a small screen mounted at the base of the support, so recording is easily monitored. And, of course, modern cameras are easily controlled by infrared remote devices.

Composition

From every camera position there are dozens of different potential compositions at a given focal length. And when you multiply that number of compositions by the number of available focal lengths, you will see the huge opportunity for creativity. Unlike a photographer, who only has to compose one image at a time, you have to compose for the entire take, combining camera tracking movements as well as the movements of

Placing the horizon
This composition from the independent short *Al Sur del Desierto* by Galel Maidana shows how a low viewpoint gives dominance to the figure, while the pile of sticks creates a dynamic diagonal line.

your actors. For many years, the nearly square TV format has restricted the creative possibilities for composition – after all, widescreen cinema was invented in the 1950s – but the arrival of the 16:9 widescreen TV format is changing all of that. It means that digital video may return to the compositional flexibility offered by widescreen – placing actors at opposite ends of the frame or filling the entire span with chaotic action, a technique so effectively used in the *Star Wars* or *Lord of the Rings* movies.

Finding an angle
There are dozens of different angles on, say, a conversation under the parasols – from overhead (*left*), through all the intermediate steps, to table-top level or even below. As a cinematographer, you have to find them all, evaluate them, and use them.

Getting close
Video can transform the experience of an ordinary and overgrown garden. Simply by running the camera close to the ground and pushing aside the flowers on the way (*right*), you will bring prominence to things usually beyond the viewer's confines.

Building blocks continued

Close-ups

As the great cinematographer Joseph V Mascelli put it, close-ups are among the most powerful storytelling devices available to the movie-maker. Shot and timed carefully, close-ups – and extreme close-ups in particular – add visual clarity and emotional impact to the storytelling.

Watch any episode of the TV show *CSI: Crime Scene Investigation* for one masterclass after another in the art of the close-up. Notice the ease with which scenes in this series move effortlessly between cut-in close-ups – in which a larger scene is cropped to a magnified view of a portion – and cut-away close-ups. This is where we get near to an object that may be under discussion but was not visible in the preceding scene. Such an object may be seen at different angles: a tiny bit of evidence picked up by the scientist, or presented objectively, to display its features.

Another kind of close-up takes the camera into the personal space of the speaker, pulling the viewer right up to the speaker, perhaps cropping down to only the lips moving; this so-called subjective close-up is also much used in episodes of *CSI*.

Continuity

Good continuity while shooting your movie will smooth and power the editing process, whereas shooting errors in continuity will add difficulties to the job of editing (*see pp. 76–7*).

The core concept in movie continuity is that everything counts – even details that escape the conscious notice of the viewer. Anything that disturbs the flow of narrative or upsets the logic of movement through time and space can distract the viewer from the world you have created. Clean clothes after a street tussle, a change of tie during the course of a conversation, a crooked picture on the wall that rights itself between scenes – these discontinuities are small, easily missed details: subliminally noticeable and a sign of low standards on the part of the movie-maker.

Your movie could suffer from lack of continuity in space. A screenplay may call for different locations, and a documentary may sometimes move around, possibly between continents. Even a holiday video that starts in England and ends up in Honolulu has a space continuity problem to solve: you need a transition shot that takes your viewer from an overcast daily commute to the bright Pacific sun. A short clip of the plane taking off will do nicely – a technique used in countless movies. Without that clue, the jump is too big to understand. And if the move is from one foggy city to another, such a clue is even more important.

Time continuities are obvious, but they are easily lost because it is necessary to record footage in separate takes over the course of several days and at different times of the day. You can lose time continuity simply by forgetting about a clock or wristwatch that is in shot, or that a meal served piping hot in one take is stone cold by the time you adjust the lights to shoot a different angle.

Finally, continuity also depends on technically assured camerawork and is a matter of smoothing out or eliminating any differences in white

●HINTS AND TIPS

Continuity is best ensured by assigning someone to the job. He or she checks that everything, but everything, in frame that is meant to be the same between takes remains the same. And continuity is assured by not making yourself hostage to common sources of problems.

● Avoid shots showing a clock, particularly one with a second hand. Each take will have to start at precisely the same time.

● Avoid using ephemeral props that change quickly – for example, soups or drinks that cool down quickly and need reheating for each take; foods that are likely to melt, such as ice-cream; or drinks that lose their froth or bubbles, such as beer and Champagne.

● Avoid shooting on location on days with quickly moving clouds. The ambient light will change considerably in brightness, contrast, and colour temperature.

● When working on documentaries, remember to shoot journeys between locations. They will be needed to provide for space continuity.

Dreary day
In the prelude to a holiday movie, you can make the coming contrast clear by setting the pre-holiday scene. Here is a dreary commute to work on a cloudy day.

Flight transition
The transition from an overcast day at home can be made quickly and simply with a short sequence of the journey. Even a short clip of the plane's touchdown may suffice.

Tropical paradise
From the touchdown clip, you can slip straight to the tropical sunset – there is no need to shoot collecting the baggage, travelling to the hotel, and getting unpacked unless you really want to. A movie narrative gains its strength and impetus from what you leave out, not from what you put in.

balance, exposure, chrominance, and luminance between takes. (*For more information on these subjects, see pp. 76–7*).

Discontinuities can be intentional, of course, designed to confuse the audience. Such "mistakes" can be seen in *A Clockwork Orange* and in battle scenes such as those in *Gladiator*: the flash of a blade may lead you to expect the next blow to come from the left, but instead it comes from the right.

A switch from colour to monochrome can be used to set emotional stages. The emotive power of glimpses of colour in the otherwise monochrome *Schindler's List* is well exploited.

Editing
The final decisions about the pace and rhythm of a movie are made at the editing stage. There is only one way to learn how to edit and that is to do it – either with your own material or in tutorials. The overall length may be set by external factors – such as a distributor's accountants – rather than by the director. For example, distribution reels for 35 mm movies (called "release prints") are a maximum of 20 minutes long, so no one wants a 63-minute movie, which needs four reels but uses only 3 minutes of the last one. An extra 3 minutes of cuts are likely to be requested.

Documentaries

The central concern in making a documentary is honesty. That does not refer to the way the content is presented; instead, it is to do with whether, in all honesty, you think you can stay the course – long, arduous, fickle in its reward, if not downright thankless – of making a documentary. And you will not get rich either: it is a safe bet that no one has bought a ranch in Montana or a palace in Monaco on the proceeds of documentaries. Very, very few documentaries achieve the high profiles of movies such as *Bowling for Columbine* or *The Buena Vista Social Club*.

The power of obsession

For ambitious documentaries, you need an idea that will carry you through the long haul. Maybe you are fascinated by a never-visited tribe deep in the Amazon, or you would like to document the matriarchal societies of the Himalayan foothills, but you will need to be obsessed by the idea to get you even close to the shooting stage.

Central hypothesis

There is a vital difference between pursuing a subject for a documentary and propounding or arguing for a position, while using the same material. Regardless of how you may feel about the objectivity or subjectivity of the form, a central hypothesis at the outset will make your job easier. It helps shape both the research and the direction of the film, as well as ensuring that you create a narrative that moves at a good pace, rather than a bland presentation of facts.

For example, imagine that you enjoy world music and your research has led you to discover that some wonderful fiddle or violin players have emerged in a very unlikely spot, a Himalayan kingdom. This is exciting because the location promises to be highly photogenic, the subject is unusual – there is a good chance it will attract the attention of a program commissioner – and the soundtrack will be great.

But the movie lacks a focus or direction: it is not saying much beyond "Did you know they play violin in the Himalayas?" But your research also uncovers the fact that certain groups regard the music as a threat to the country's culture. And the differences are drawn along racial as well as religious lines. The story then comes alive, taking on a dimension beyond mere musical curiosity. The struggles of the musicians becomes symbolic of the tensions between the nation's divided communities – fiddle-playing becomes political. And there you have it – a working hypothesis.

Keeping mobile

Documentary movie-making is by nature mobile – taping a kick-boxing lesson (*left*), you too may need to move quickly. But a camera that is too mobile produces video that is tiring to watch, so a balance needs to be struck.

Taping interviews

Video is invaluable as an adjunct to other methods of research or survey work – for example, to provide visual records of the course of an interview (*right*) or for selecting presenters for the documentary.

The steps to take

It cannot be emphasized enough that the keys to documentary-making, as in all movie-making, are research and planning. It is wise to corroborate the story – that is, ask an independent source about the facts you are investigating – even if you are confident your source is reliable. Trawl the Internet, but be aware that not all information on the web is reliable, so visit official sites wherever possible. University libraries can be helpful if you are pursuing genuine research provided you can obtain a reference from a recognized academic – and you will probably find, somewhere in the world, an academic or journalist who happens to be an expert on your subject and is only too willing to help. Exploit your network of friends and contacts, too: you may well know someone who knows someone who knows what you need.

Planning

One factor that distinguishes documentary planning from that for other types of movie is that your freedoms of movement can be highly restricted. You may have a very tight time frame to work in: a gathering of hill tribes may take place only very four years; or next year's Navruz (Islamic New Year) will be at the right time of the

HINTS AND TIPS

A successful documentary is one in which the passion of its maker is tangible. But there are also practical considerations to bear in mind.

● Work within the fields of your expertise.

● Exploit connections with key locals; network with everyone you can.

● When working abroad, identify an honest, effective local fixer.

● Look after any crew, especially local crew if working abroad.

● An exploratory trip to check out locations and the story will be worthwhile, if time and the budget permit.

● Create a cast list of people you interview and give them roles – hero, hero's helper, the enemy, innocent bystander. You are filming a drama based on real life.

year to film in the desert. If only for this reason alone, one of the most important strategies is to have a number of projects at different stages of research and development at any one time. You can work on a project for years, hear nothing but stubborn silence from the embassy about your visas, then suddenly you are given four weeks' notice to pack your bags and go, now or never, as once happened to me.

Documentaries continued

The timeline

Given the dependence of a documentary on timing, or perhaps simply to ensure that its subject is still topical by the time you are ready to offer the movie, it is wise to create a timeline that stretches backwards from the end of the post-production and edit (*see opposite*). How long will it take to edit the movie – will you try to do it yourself (cheap but hard work) or hire a professional (quicker but costly)? How long will the shoot last? How will you prepare the team? How long will you need for research? For an ambitious, "professional" documentary you are not likely to have much spare time out of two years – if everything is counted in, and assuming that you are generously funded (*see p. 236*).

If the timing of the shoot itself is critical, the need for accurate planning is even more important. Precise schedules offer another advantage: your crew know exactly what is required of them, and when. For example, no one can plan if you ask them to be available "early next spring"; it is much easier to commit oneself to "the first week of March".

Being disciplined

The arrival of digital video has created a new danger for documentary-making. The temptation is to shoot vast amounts of material that will take months just to log and review. Cinematographers had to be selective when they worked with precious and extremely costly film. Even 16 mm film is a precious commodity compared to the costliest DV tape: 1 hour costs, say, £18 with DV, but it would require 1,600 ft (488 m) of 16 mm film (running at a slow 18 fps), costing around £500, not including processing.

The discipline needed for working a dual system (separate recording of sound and video) will help slow down the trigger happy. Another way to discipline the shooting is to stick to a script or shot list: anything not strictly necessary should not be shot. But few will have the courage to see this policy through (and quite rightly; one of the joys of documentary-making is responding swiftly and with agility to changing situations).

Daily review

The daily review is the analysis of the progress made each day, and it can prevent you from becoming too distracted. One benefit of working in digital video is the availability of daily rushes – something that in the past only a large Hollywood studio was able to provide for its directors.

At the end of the day, you can upload the shoot on to a laptop computer supplemented with external hard-disk drive and review the day's take. You will quickly see what is superfluous to the story and which new avenues you could investigate. However, it is not best practice to take a partially used tape out of the camera for review. One solution is to start every day with a new tape – this is also a good practice for logging purposes. Besides, you have now backed up the shoot. The downside of the ease with which rushes can be reviewed is that the working day can become very

Working a dual system

Recording sound separately from the video – for example, using a boom mic connected to a dedicated sound recorder – ensures high-quality sound and is known as working a dual system. But if sound is also recorded from a microphone on the camera, as shown here, you obtain a back-up for the sound. Another advantage of the back-up is that, in post-production, it makes it easier to synchronize the wild soundtrack with the video, making the use of a clapperboard not absolutely necessary.

Keeping notes
It is ironic that such a visual and auditory medium relies so heavily on keeping written notes. Keep a record of everything you record, or editing will be harder work than necessary.

long indeed, and after a hard day's shooting, the last thing a camera operator wants to do is sit in front of a video screen for the whole evening.

Obtaining releases
You may think that because your documentary is intended to promote good causes you do not need to obtain model or personal releases. But you would be wrong – litigation is a worldwide pastime. It will be difficult to achieve in practice, but try to obtain a signature against a written personal release for everyone who is interviewed on camera. To be on the safe side, you could even record them signing the document. To seal the release, some payment, of at least US$1, should be made. Most people are willing to participate, especially if they feel they are taking part in a worthwhile cause, and they will be only too glad to be paid even a nominal sum.

If someone refuses to give consent, you must decide whether to use the footage or not. It is customary to seek a release following the interview.

Using a timeline
A successful movie-maker has to be strong on organization and scheduling; being a passionate creative is not enough. A timeline (measured in months before delivery) is an invaluable aid to ensuring minimal loss of time and reduced costs. Use this example as a guide, putting in your own timings.

Sample timeline	
Start research	24 months
Start on script and scenarios	18 months
Obtain finance	12 months
Elaborate research: make contacts, obtain permits	6 months
Recruit production team	3½ months
Book tickets and hire equipment	3 months
Shoot	2½ months
Post-production (log, edit, record narration)	2 months

Short movies and features

The capacity for movies to contain many layers of meaning and the movie-maker's ability to manipulate the passage of time means that the short is an art form in its own right. It needs only the spark of your imagination for it to come alive.

Choosing a subject

You can make an interesting short about anything. To some, this states the obvious; to others, it seems an unlikely assertion. If this notion seems risible to you, perhaps movie-making is not in your blood.

A man wakes up to an alarm clock and makes breakfast. This may not seem the most promising of scenarios, but it is one of the most intriguing parts of *The Ipcress File*, a virtuoso catalogue of film techniques in a few minutes. Two men playing chess. Sounds slow and dreary? In the hands of Ingmar Bergman, this scene of *The Seventh Seal* is an allegory on the meaning of life and death.

You do not need to come up with a brilliant or original idea. Few stories are new, but there are still infinite ways in which they can be told.

Scale of project

Your creativity does not need to be limited by a small budget or few resources. The following is a list of summaries of short movies:

● An after-dinner game of Truth or Dare becomes addictive, with tragic consequences.
● A couple finds a briefcase – what is in it?
● A long, tedious day is spent filling in a job application form.
● A commuter finds himself alone on a station platform and performs a strange dance.

The dinner-party short needed a cast of just five people, the briefcase story needed only two, and the other two each required a single actor. The short movie about filling in the application form did not even need a script – the actor was alone and said nothing – yet it is engagingly funny and sad at the same time.

Awareness of timescale

If a week is a long time in politics, 1 minute of a movie can sometimes feel like an hour. If you are accustomed to the leisurely development pace found in a 2-hour feature-length film, it is a very instructive exercise to watch a few shorts lasting just 1 or 2 minutes. As you watch them, bear in mind that it takes a long time to shoot a minute. I have personally watched a crew of seven plus one actor spend six hours shooting a total of 4 minutes of film, which will end up lasting just 20 seconds in the final cut.

Learning by example

An important development for the aspiring movie-maker is to change your focus on movies from that of the movie-goer to that of the move-maker. Initially, it may not be a change that you like. Instead of being caught up in the drama and emotions of the moment while watching a thriller, for example, you have to concentrate on the details. You will register and recognize shots: an extreme close-up of an eye, followed by a snap-zoom to an interior establishing shot of a dark room, then back to the eye, and so on. But this change in the focus of your attention and your growing skill in analyzing cinematic technique is the start of your education as a screenwriter or director.

● Watch and re-watch movies that you admire. Try to work out why you like them, why the directors did what they did, and how they did it. Is the impact created by the editing or the camerawork – or both?
● Try watching movies without sound as well as with. A good soundtrack controls both the emotional and the visual experiences.
● Watch TV documentaries even if you want to shoot features – you can learn how editing makes the best of limited material.
● Read screenplays of your favourite movies.
● Watch the film-making documentaries found on DVDs.
● Trawl the Internet for movie shorts and independent films to download and study.

Keeping the movie simple

Invisible Light is a short feature movie that demonstrates how effective movie-making does not need intricate plots, large budgets, or elaborate sets. The movie stars two women, one of whom (Choi Yoon Sun as Gah-in) is in the throes of an affair with a married man. On her return from studying abroad, her affair and estrangement from her culture sends her into depression and despair. The second woman (Lee Sun-jin as Do-hee) is the wife of the man having an affair with Gah-in, and she is pregnant with another man's child. The anxieties of the women and their relationships with men allow the writer and director Gina Kim, with cinematographers Peter Gray and Benito Strangio, to work almost entirely close-up with available locations.

Colour design
Using available locations with minimal alteration calls for careful design: the green apple brings some colour variety.

Wide angle
To depict Gah-in's eating disorder, director Kim uses a wide-angle view. This helps signify isolation and loneliness.

Colour palette
A change in the colour palette of a scene can be an effective way to indicate a change of location.

Long focal length
A longer focal length and a more distant view turns the viewer into a spectator, creating separation from the action.

Working with animals
The decision to include animals in your movie should never be taken lightly. Here it worked out just fine.

Evening light
Working at sunset is recommended for experienced crews only. Instead, you can simulate sunset light with filters.

Extreme close-ups
They may offer a good solution to location problems, but extreme close-ups are a test for both the lighting (the luminance range must be very carefully controlled to avoid "hot" highlights on the skin) and the camera operator (depth of field is very limited). It is also difficult for the cast and behind-the-scenes crew: because the viewer is so close to the subject, errors in make-up become very visible, and any awkwardness in the acting can be embarrassing.

Developing an idea

While no one can help you have an idea, you can be guided through the processes of turning inspiration into script, and screenplay into movie. Here are some pointers that are more practical than inspirational, but they should not be ignored – at least not until you have gained in experience and the ability to attract financing.

Showing the story

Primarily, video is a visual medium, and it is at its strongest when it shows the viewer something, and not when it tells by using words. A sequence with voice-over is little more than radio with pictures. But action – someone looking round to identify the source of a sudden noise, two people tentatively kissing, or a cyclist wobbling along a lake shore – grabs attention and involves the viewer, perhaps even provoking an emotional response. A common mistake is to write emotion into the scenes: emotion arises from within the action first and dialogue second.

Choosing an indoor setting

Write indoor scenes whenever possible. That way, you are not at the mercy of the weather, local officialdom and police, or curious bystanders. Sound recording is infinitely easier, too, with far fewer erratic and unpredictable noises to cope with. It is easier to keep equipment safe and secure, and catering may be easier to arrange.

Using one location

A clever low-budget trick is to set your story in one location. It involves less moving about and less setting-up time. Keeping production simple means fewer distractions for the cast, who spend less time getting bored and cooling down emotionally – a common problem for non-professional actors.

Shooting at dawn and dusk

One of the main problems with shooting at dawn is the likelihood that preparation will take place in the dark (*see Night shots, bottom right*). Another issue, though – this time common to shooting at both dawn and dusk – is that there is only a short amount of shooting time available before the light changes, especially when working in the tropics or at the equator. If you need another take, you will have to wait an entire day, with no guarantee that the weather will be the same – and, therefore, no assurance as to whether you can use what you have already shot.

Minimizing location work
Why hire a hotel room when you can beg or borrow a friend's apartment? Make the best use of it that you can, even if it means painting it and repainting it back afterwards.

Recording at dawn
At either end of the day, video-making is a hostage to fortune and the weather. It is no coincidence that the biggest film studios are in the Sunshine State.

Keeping characters to a minimum

The simple reality is that the fewer participants your movie needs, the more likely it is to be made. For a budget movie, one actor is enough and two are ample. When writing about a dinner party, do you really need six people? Three people may be all you need. Try to avoid using extras, too.

Keeping dialogue to a minimum

Your first draft of dialogue is sure to be too long. Use action to move the story on, and set the scene with camerawork, not words. Outside of film noir, a voice-over is often an admission of defeat.

Asking for feedback

Finally, perhaps the hardest act of all: show early drafts to someone you trust – meaning someone you trust to be critical and to tell you the truth. It is too much to hope that they are experienced script readers, but at least they might have some knowledge of movies (*see also pp. 222–3*).

Shooting tests
The low cost of digital video means you can shoot tests and try out ideas thoroughly – as in this skateboard-stunts project – before any fully produced action is recorded.

Night shots

While special effects such as earthquakes, low-lying mist, tornadoes, and even torrential rain are costly to create, night shots may seem within reach of your microscopically small budget. Consider the problems, however. Night shots require much more time to produce: studio lighting set-ups to simulate night time need much more attention to detail than daylight set-ups. No one can see what they are doing, so even finding equipment takes much longer than usual. And much greater care is needed to ensure safe operation. As an alternative, day-for-night lighting may be considered. With this method, you use camera lens iris control to underexpose heavily while leaving ambient light levels high enough to work in. On location, working at night means working unsocial hours, possibly causing a nuisance and disturbance with lights and noise. These factors aside, asking any cast or crew members (if you have them) to work unsocial hours is likely to mean paying them more money or an overtime rate.

Registering your ownership

One of the fears, and a very reasonable one, is that someone will think your story idea is so good that they will commission a well-known screenwriter to write it. Once you get over the compliment that is being paid, you will want to sue. To get off first base you need to prove that not only were you truly the author of the story but that you wrote it first. In countries such as the United States where there is a formal mechanism to register, it is prudent to take advantage of it. The cost is relatively low and the forms are easy to fill in. In countries that do not have a formal mechanism, such as the UK, you can make arrangements with a lawyer to deposit your screenplay, marked with the date of completion, as proof of ownership. A worthwhile further precaution is to send in scripts for review by recorded delivery; some people send a copy to themselves and leave the postmark-dated envelope sealed on receipt (*see also pp. 252–5*).

Quick fix Location problems

The theory is that with proper planning you will not encounter problems. Naturally, life is more complicated than that, and problems will arise even after the most thorough preparation. Part of the challenge of video-making is in the solving of such problems. Entire books are filled with the experiences of movie-makers using their infinite resources and sagacity to overcome obstacles. Here are a few common difficulties.

Tight corners
The clutter that accompanies any video production and shoot can make the most spacious location seem cramped. Crew must be given the time to work steadily and carefully.

Problem

The location you have chosen seemed big enough at the time, but when you arrive with the crew it seems too small, with hardly any space in which to work.

Analysis

It is quite possible there is adequate space: you just need to make use of it efficiently. Before you fire the location scout, see if you can adapt the storyboard or composition to exploit the space. And unpack your equipment tidily.

Solution

Survey the space and work out how best to use it – preferably before you move in – and how camera angles or wide-angle lenses can make the space appear larger than it is. The bulkiest items are usually the lights, so see if it is possible to light the room from outside – outside the room or even from outside the building. Or reduce the number of lights you need: try bouncing off walls, for example. To improve or ensure neutral colours, hang white paper or cloths over the walls (*but see Beware the heat, p. 241*). If you need to remove furniture that is not in shot, do it before the gear is brought in. Dispense with a bulky tripod and support the camera on furniture or beanbags.

Problem

You have taken over a person's home, and they start to become nervous when you begin to unload your truckload of gear and bus-load of crew. You are in danger of being asked to leave.

Analysis

You have failed to prepare them properly. And the amount of crew members and equipment may be unnerving them.

Solution

If it is too late to prepare the home-owners properly, you should at least have prepared the crew. If the house is carpeted, provide everyone with slip-on covers for their shoes: this shows the owners that you care about their home. Tell the crew to wear only trainers or soft-soled shoes: high heels are absolutely forbidden. Take bubble wrap or old blankets on which to place heavy boxes of lights and equipment – this will protect furniture and polished floors. Starting by tiptoeing around the property will give the owners confidence in your professionalism.

Preparation
If you have constructed a set in someone's living accommodation, care of the property shares top priority together with safety and care of your props and equipment. Large lights may draw high current loads, so protect domestic circuitry.

Problem

You will have to film in challenging conditions – extreme cold or wet, or extremely hot and dusty.

Analysis

Working in challenging environments is worth an entire book, but planning and preparation make it possible to work almost anywhere. The main problem with cold is keeping the batteries going and preventing condensation from entering the camera. The main problem with wet is keeping condensation out of all of the electrical connections and preventing the tapes from getting damp. Dust attacks the delicate video mechanisms, but also covers the optics, degrading image quality.

Solution

Professional cameras are extremely sturdy and capable of working in very tough conditions. If you hire equipment, ensure that the rental company knows what you intend to do: they will give you advice on how to look after the kit. Amateur cameras are not built so robustly, in order to save weight and cost. Keep spare batteries warm, close to your body in cold weather; do not breathe near the camera when reloading cassettes. In damp or wet conditions, keep the camera and tapes in a waterproof

case with plenty of silica gel (which absorbs water vapour). Consider using a waterproof cover (see p. 35). In dusty conditions, use a waterproof case for storage or a waterproof cover, avoid changing tapes outdoors, and keep the optics free of dust with a rubber blower, which puffs air to dislodge dust.

Cold conditions
The movie-maker's camera is vulnerable in very cold conditions because the equipment is reliant on electrical power. Wrapping the camera in a protective blimp or padded cover can help protect it from cold, even if that gets in the way of the controls.

Problem

You are commissioned to video an event, such as a wedding, and find you are not the only one doing so. The others keep getting in your way.

Analysis

Now that video-making is so much part of the culture of major life events, any family member could be wishing to video – not to mention the photographers present. And some of them may consider themselves the most important videographer or photographer present.

Solution

The best way to avoid conflict is to agree from the outset to help each other do your jobs, but also establish who has the primary position. The professionals – those who are being paid for their work – should have the best positions and be allowed to shoot before anyone else.

But as soon as they have their shot, they should move aside for the others. And everyone should try not to step into another's line of sight.

Working at odds
With three video-makers and two photographers covering a Hindu wedding, it can be difficult keeping out of each other's way. If the video-camera operator shines his light into your shot, you can be sure you are an equally unwelcome part of his.

Writing the screenplay

On these pages we consider the fairly formal requirements of a screenplay. One might suspect that authors who write about how to write successful screenplays are rather like financial advisers writing about how to make money: if they really knew how to do it, they would be doing it! More often than not, the rewards for doing the real thing are greater than those for writing about it, but fortunately, there are numerous excellent books (many written by successful screenwriters) to show you how to construct a story.

Defining script and screenplay

First, let us dispose of a confusion – one that even many dictionaries perpetuate. The difference between a script and a screenplay is that the script is contained within the screenplay. The script is the text of what actors or narrators say – essentially the words of the dialogue – perhaps supported by indications about the style of delivery or cues as to when to begin speaking.

The screenplay includes all of the above and more: directions – intended primarily for the crew – such as the slugline (interior or exterior scene and location), lighting indications, timings,

and action to take place. Clearly scripts and screenplays are linked to one another, but they are not the same thing.

The format

The beginner screenwriter will be told that the screenplay should be written to follow certain formulaic rules of formatting. There is, of course, no single standard, even within Hollywood, though each studio may operate their own. The point of the format is to enable rapid assessment of the screenplay as to its length, complexity of production, and pace. (It is useful to note that one page of correctly formatted screenplay equates to about 1 minute of screen time.) If your screenplay's formatting is not in the right style, an agent or production company may not even look at it. If you know who you wish to submit to, you should ask them for their formatting rules or a sheet on their house styles.

The elements

Broadly speaking, all screenplays will consist of several distinct elements. One of the purposes of formatting is to separate these elements so that

Making changes
During production, hundreds of conversations can take place over the screenplay, which is continually crossed out and rewritten as filming progresses. The important thing is to ensure that all cast and crew members always have the latest versions of any rewritten pages.

director, cast, and crew can locate them quickly, by position as well as by content. Following is a list of some of the key elements found in a screenplay.

● Action describes what is happening on screen, the scene's visual content. This example is from the shocking prologue of *Un Chien Andalou*, written by director Luis Buñuel and artist Salvador Dalí.

> "A man is sharpening a razor by the balcony. The man looks at the sky through the window-panes and sees ... A light cloud moving toward the full moon. Then a young woman's head, her eyes wide open. A razor blade moves toward one of the eyes."

● The slugline or scene heading locates the scene and is always in upper-case type. Begin with INT. and EXT. for interior and exterior, followed by the location, and the time of day if relevant.

> EXT. FOREST – NIGHT.

● For the script, we need the character name (again in upper-case type) and what they say, the dialogue. A character may be a computer screen, with its display as the "dialogue".

> SCREEN
> Do you want to know what the Matrix is, Neo?

● The use of an adverb in parentheses indicates to the actor how to deliver the dialogue, where it may not be obvious from the words themselves.

> MAXIMUS
> (quietly)
> A people should know when they are conquered.

● The shot indicates a shift of focus or zoom within a scene towards a person or a thing.

> MAXIMUS gazes down at the German position.

Or it can indicate an actor's point of view (POV).

> TRINITY'S POV: the world appears to spin.

● Transitions indicate how one shot or scene moves to the next. Generally you do not need to indicate them since it is obvious that one scene cuts to another. If a dissolve or fade is needed, the editor or director will use it.

● Finally, you will need the house-keeping features, such as act and scene numbers – the greatest variation in formatting is to be found here, with some numbering scenes cumulatively, others only within each act. Some screenwriting books even advise you to omit the numbering, since that will be done after the screenplay has been bought. Another house-keeping feature is the cast list: if several members of the cast are in shot, they are listed at the beginning of the scene.

Within this basic framework, there are also some fairly standard notions about how to show dialogue interrupted by action, addition of titles, or anything superimposed over the scene.

When the thespians take over

The screen- or scriptwriter cannot be too protective of his or her work. Once the actors start speaking the lines, they are sure to come up with suggestions for changes that will improve the dialogue and possibly even change some parts of the script. The wise director and writer will listen to them: if the actors feel uncomfortable with their words, it is likely that the audience will too. Actors who understand their characters often like to add to the script: the poignant last words of replicant Roy (Rutger Hauer) in *Blade Runner* were written by the actor during a rest break.

Working with the words
Actors prefer to love their lines – then they are more likely to be convincing and do not feel they have to act. And it is wise to be guided by their stage experience.

Storyboarding

When a screenplay is accepted, the words need to be turned into visuals – the storyboard – that show the framing and composition at the start of each shot, and perhaps intermediate and end positions as well if the shot tracks and zooms during the take. The process focuses the mind on to the actuality of the scene, forcing you to think about the numerous details that need to be decided. For a low-budget production, a storyboard may seem unnecessary, but having it on paper acts as a quick reminder.

You do not need to be artistic. Storyboards can be very simple, with stick figures for the characters, lines to indicate the room, and labels for camera positions. You could depict a scene with an overview of the room showing camera and actor positions and arrows to show movement.

Another approach is to use software such as FrameForge 3D Studio, which gives you a library of objects so you can build your virtual set. You can set up different camera positions around the set then zoom, pan, dolly, and crane, with all the monitors updating automatically. It is also possible to change the position, scale, and orientation of each object individually.

Calculating duration

One thing that a storyboard does not include is any way of representing duration. If that is a problem for you, a timeline in addition to the storyboard images can be useful. Try stringing the storyboard pictures over a timeline marked out at 1-minute intervals, for example, with enough space to allow for three or four pictures.

Suppose your main character is having lunch and is daydreaming: you might start with an extreme close-up of him eating the last of his pizza, then another close-up of him emptying his wine glass. Pull out to show that he is in a restaurant. He sits back – cut to an extreme close-up as his eyes become heavy, with other diners out of focus in the background – and he lets out a deep

The basic concept

A storyboard is like a cartoon version of your film: each frame summarizes the action and also suggests camera angles and lighting, with notes under each frame on pacing or effects.

Basic line or stick-figure sketch

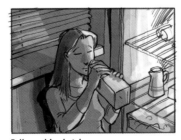

Full graphic sketch

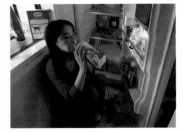

Final scene from movie

Storyboard styles

You do not have to be a great artist to create effective storyboards: a simple stick figure, even more simple than that shown above, can indicate camera angle and closeness of shot. A more elaborate drawing (*centre*) indicates details of the set and the lighting effect required. The actual shoot (*right*) need not follow the drawings exactly (unless stunts are called for, in which case safety may depend on accuracy). Here the DP has used a wider angle than that shown in the storyboard.

Storyboarding software

In FrameForge 3D Studio you can add characters or objects into locations you design, define camera positions and zoom settings, and create snapshots to build a storyboard.

breath. Pan away to the door: a beautiful girl walks in and over to his table. She sits opposite him and takes off her jacket – her eyes fixed steadily on him… This could all happen in less than 1 minute of the movie, or it could take 5 minutes or more. A timeline helps you plan the pace of the action.

Other methods

The storyboard is not the only way to represent the video prior to shooting. One option is not to preconceive it at all. You may be good at inspiring amateur actors but not very good on camera angles: leave that job to the camera operator or director of photography. An experienced DP should be able to work out (and perhaps sketch out) how a scene should look after reading the screenplay.

Another approach is to abbreviate the storyboard, including only the key moments, allowing the detail to be filled in during production. This approach is generally acceptable only if you are directing a very small team.

Where the narrative is not necessarily linear – as it may be in a documentary – a storyboard might not be the most appropriate model. You could try the "dartboard model". In the centre, the bull's-eye, you sketch out the key shots: the climactic encounter, or the historical footage that is central to your video. Around that, encircling the central shots, you place the next most important shots: the face-to-face interviews, or the pictures that provide the facts and establish the context. In the next circle, you place the lesser shots: the establishing pan, the sequence connecting one location with another, and so on. This gives you an overview of the project and may help reveal weaknesses – too many talking heads, perhaps, or that you need some landscapes to vary the pace.

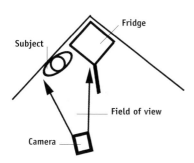

Sketching the set

Another way to storyboard is production oriented. You show the position of the camera, its view, and the positions of props, and then provide a lighting diagram. This can help with planning the management of the set and with shooting the sequence.

Crossing the line

The viewers of your video see only what you frame for them. Suppose you record a two-shot, a couple talking together. You can walk all around them and easily locate the viewer in relation to them. On one side the woman is to your left, on the other she is on your right, and at another she is in front of you. But if you were to video from each of the positions and intercut between them it will look as though the woman keeps swapping sides. That is because the viewer does not have the benefit of seeing the transitions between positions. Camera operators talk about never "crossing the line": takes should always be on the same side of an imaginary line joining the two subjects. This is also known as the 180-degree rule: if two consecutive camera angles are greater than 180 degrees apart, the actors appear to swap places.

7
Advanced video production

Going professional

The gap between amateur and professional work is increasingly easy to bridge. Practical and inspirational advice will help you move your video to a higher level, obtain the highest quality, and work in a professional manner.

Your production

There is more to movie-making than simply making the movie. Here you will find details on how to put together your own production and team. Topics include administration, costings, location planning, and safe working practices.

Reference

A comprehensive glossary and frequently asked questions relating to law and video provide helpful additional information. You will find advice on how to further your knowledge of digital video and learn about the various careers in the video world. The book concludes with extensive web references, as well as suggestions for further reading.

Professional equipment

With each year, the difference in quality between consumer and professional-grade equipment becomes increasingly blurred, despite the best pro gear being so costly that even production companies think carefully before making a purchase. Nonetheless, should you dream of working to the highest quality standards – sufficient to pass broadcast quality control – you will need the best equipment.

Three CCD cameras

With current technology, the best image quality is obtained by cameras using three CCD sensors (some cameras use CMOS chips) – the so-called three-chip or triple-sensor cameras. Each sensor records separate colours before delivering the video signal. The internal arrangement of prisms and beam-splitters with relay lenses leading to three separate sensors for reds, greens, and blues is relatively bulky, so triple-sensor cameras tend to be larger than amateur models.

Sensors in very high quality cameras are also physically larger and offer more pixels than their prosumer counterparts. The large pixels improve signal-to-noise ratios, giving cleaner and clearer signals, and the greater pixel count improves resolution. Additionally, the larger sensor makes it easier to produce reduced-depth-of-field effects.

Access to controls

A hallmark of the serious digital video camera is what appears to be an overabundance of buttons, sliders, and dials. This means that the operator controls many of the camera's functions. The most valuable of these handle the focus, zoom, and iris (lens aperture). It is a joy to work with a manual-focus lens after using autofocus lenses: no longer do you have to worry about the focus changing when a figure walks right in front of the view. Direct control of the iris also means you change the exposure when you want to, not when the camera thinks it is right to do so (which is usually at the wrong time).

You will also find other controls invaluable, such as white balance and on-camera control of audio levels: all helping to ensure that you record the best possible image and sound. This will reduce the time spent on post-production.

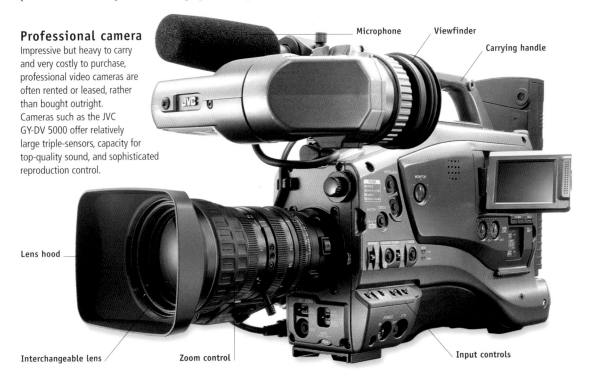

Professional camera
Impressive but heavy to carry and very costly to purchase, professional video cameras are often rented or leased, rather than bought outright. Cameras such as the JVC GY-DV 5000 offer relatively large triple-sensors, capacity for top-quality sound, and sophisticated reproduction control.

Microphone Viewfinder

Carrying handle

Lens hood

Interchangeable lens Zoom control Input controls

Quality lenses

It goes without saying that professional-quality lenses for video are very expensive, sometimes even exceeding the cost of the camera. In part this is due to the small number of video lenses sold, compared to their stills-camera counterparts. Another reason is the need for high-precision focus and zoom mechanisms that allow for smooth remote control at minutely variable speeds – zooms, for instance that can work almost imperceptibly slowly or can whip the viewer from one end of an extreme range to the other in just 2 seconds. The majority of camera operators hire lenses as needed, rather than purchase them.

Balanced inputs

Another characteristic of professional cameras, as well as some prosumer models, is the presence of balanced audio inputs, usually in the form of XLR sockets. The increasing digitization of all processes does not remove the need for the highest-quality components when making recordings, and this applies to the recording of sound as much as to capturing the image.

At present, the favoured method of sound recording is to use DAT (digital audio tape): machines delivering broadcast-quality recordings are affordable, and the tapes are not too costly. A close second, perhaps more robust and easier to edit, is MiniDisc, which offers good sound quality for music, and excellent quality for voice (*see pp. 230–1 for more on sound recording*).

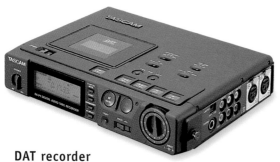

DAT recorder
Rugged DAT (digital audio tape) machines, such as the Tascam DA-P1, are highly favoured for their ability to record the highest-quality sound in location conditions.

Professional formats

There are not really any great differences between the formats found within the DV family. For every proponent of DVCPro you can find, there is also one who uses nothing but DVCam. The professional formats may run the tape a little faster, but more important is the fact that the only way to shoot with the best cameras – with their superior chips, controls, and top-class lenses – is to use the professional formats.

DVCPro is supported by Panasonic, Philips, Ikegami, and Hitachi. DVCam is supported by Sony and Ikegami. There is some cross-compatibility between DVCPro and DVCam. HDCAM and DVCProHD are new formats for high-definition: they are mutually incompatible, but there is some compatibility between DVCProHD and DVCPro. Some relatively low-cost HD cameras are available.

Digital BetaCam or DigiBeta, introduced by Sony in 1994, is regarded as the digital alternative to Super 16 mm film; it is currently widely adopted as standard for broadcast television but the increasing adoption of tapeless systems is beginning to threaten its dominance.

Simulating 35 mm depth of field

A solution to the problem of the extensive depth of field of video cameras is to set the camera to record from an image projected on to a 35 mm format screen using lenses designed for the 35 mm format. This is the route taken by the Mini35 system from P+S Technik (at www.pstechnik.de). It enables 35 mm camera lenses – more affordable than 35 mm cinematographic lenses – to be used with prosumer digital video cameras. The resulting rig is somewhat cumbersome and rather costly, but the total is still far less expensive than the option of shooting on 16 mm or 35 mm film itself. Here the costs of not only equipment is very high, but so is the cost of materials.

Professional sound

It would be a disservice to the superb visual qualities you are aiming at to allow the sound quality to languish at amateur levels of distortion, lack of liveliness, and noise. Unfortunately, in order to obtain improvements in quality, you will need not only yet more equipment (as well as the time to learn how to use it) but also more crew members to operate everything.

Audio mixer

Along with high-quality microphones and cabling, a crucial element in good sound quality is the location audio mixer. This is a control box that accepts inputs from microphones and offers outputs to recording devices such as a camcorder or sound recorder. It has knobs for controlling levels, which are set with the aid of meters that display sound levels.

Although the use of a mixer adds to cost, the advantages are decisive. Quality issues dominate: the pre-amplification for microphones is superior for a far cleaner sound, while the ability to balance levels between different inputs is crucial, especially in interviews or when recording music. Part of the advantage is the ability to monitor what is being recorded so that you can compare what you hear from the microphones to what is being encoded on the recorder. Mixers can also power the

microphones using "phantom power" circuits, which save the camera or recorder batteries from having to support the microphones.

More technical advantages include the ability to produce a reference tone, which provides the best way to ensure that recorded levels are consistent from one take to another or when using different microphones. Furthermore, the high-quality meters that indicate levels enable you to "ride gain" – that is, adjust input levels to match the natural rise and fall of voices or instruments, for example.

Separate sound recording

The problems of uneven sound-recording quality from the camera can be avoided by recording the sound separately, using the dual-system sound method. Sound can be recorded using MD (MiniDisc), DAT (digital audio tape), or a hard-disk recorder. The latter two methods give the highest possible quality, but MD is the least costly.

This method of working requires at least a two-person crew – one for the camera, the other for the sound recording. The sound is far superior to that recorded using a single-system method, and there is the added bonus of having two records for the audio: the video tape and the sound recording itself. This is why this method is known as dual- or double-system sound recording.

PSC Mjr mixer
With two microphone pre-amplifiers, switchable inputs, phantom power, a reference tone, and high visibility meters, this compact two-channel mixer is very popular for location shooting.

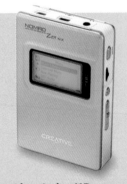

Creative Labs HD recorder
Unlike other MP3 machines, this model can record sound direct from digital or analogue inputs to either WAV or MP3 formats. Files are transferred in and out of the computer via USB or FireWire.

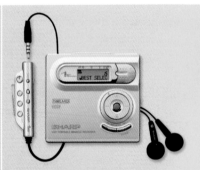

Sharp IMMT80 MD recorder
MD recorders are remarkably compact devices, capable of running a long time and offering random access to tracks. However, sound-handling capabilities are less impressive than with DAT.

Synchronization problems

The disadvantage of working a dual system – apart from the need for an extra person – is that you will have to synchronize the sound with the video at the post-production stage. This is because the sound recording and the video recording may run at fractionally different rates.

Even if they are synchronized at the start by using a slate or clapperboard, after some minutes they may drift apart. The same applies even if a professional jam sync is used (*see p. 235*). This drift in time-base presents no practical problem if the takes are only a few minutes long at most, which is usually the case with shooting acted scenes with dialogue. However, extended takes – such as those recorded at conferences or concert-hall or stage performances – will almost certainly lead to difficulties.

Failure to synchronize will give rise to the very distracting loss of lip sync, in which the subject's mouths are seen to speak but the words they utter appear to come just too early or just too late for the action. These problems can be prevented during shooting only with very costly devices and professional procedures.

For the majority of video work, correction during post-production is perfectly satisfactory and has the added benefit of spreading the cost (you do not need time-base equipment), since you only need to plan for a possibly considerable increase to the editing time.

Monitoring the sound

Just as important as the quality of the sound-capture device – the microphone – is your ability to monitor the sound as you record it. This is akin to checking the focus and exposure in the camera. Just like professional cinematographers who never trust in automatic exposure control, sound recordists never trust mere electronic circuitry to control sound levels.

For high-quality audio monitoring you need headphones that are well insulated against sound from all but the recorded or monitored signal. This means the pads should snugly cover the whole ear and the unit should be adjusted so that the headband transfers the weight to the top of your head, slightly back from the crown. The headphones should enable you to judge the echoes of the space and the quality of sound and effects, as well as whether your pick-ups are capturing extraneous noises such as those from traffic, ventilation, or heating systems. Headphones do not have to be absolutely top quality, but you should never use earphone plugs for monitoring – they do not offer high enough quality to be relied upon.

Sony TCDD8 DAT recorder
DAT is the format of choice for the audio purist working in video: it offers uncompressed sound and a very compact format. However, tapes are costly and access is, like all tapes, linear only.

Sennheiser HD 25-SP
A cut-price version of an industry favourite, these lightweight headphones offer reliable, high-quality monitoring in outdoor situations.

Sony MDR-7506
Substantial yet well padded and comfortable for long periods, these headphones are very popular at a good price for the quality offered. They also fold for compact storage.

Working professionally

Congratulations! You have been offered your first paying job. Your reputation has spread; your confidence and experience with a few short videos may be paying off. Or perhaps you have shown a few stills from a sequence and someone is offering you a little cash for further development. This stage can be daunting, when finally you have got what you wanted. What do you do now?

Assessing the task

This could be a turning point, so you have to get it right – it is that simple. The strategy is to assess what your client wants and match that with what you know you can deliver. If you take on more than you can handle, the consequences will be damaging way beyond the project itself. And if your client is not experienced at working with video, you will need to take the lead. After all, this person or organization has shown some trust in you already. Prove them right by first pursuing a careful list of questions to assess exactly what is expected of you (*see below right*).

Being honest

The next thing you must do is ask yourself whether you can handle this. And if the answer is yes, consider the answer to the next question. "Will the movie be better if I brought in people who have more experience than I do?" And, of course, the answer is the same.

So you must then start to build a team of people to help you. In movie-making, a team will often consist of youngsters with little experience at the top of the hierarchy, with older, more experienced crew members doing lesser jobs, such as key grip (helping to handle the camera) and clapperboard operator. You can benefit from the experience of these older people if you allow them to help you.

The importance of ideas

Dominated as it is with technocratic pressures, it is easy to forget that digital video is really about ideas. Do not become too preoccupied about whether you should shoot DVCam, DVCPro, or, indeed, whether you should hold out for HD.

The hire option

The best option for the independent team is to hire equipment as needed – cameras, lenses, tripods or dollies, fluid heads, lights, sound recording gear, location VTRs (video tape recorders), and even editing suites. Hire costs are fully tax-deductible (capital equipment purchase may not be) and they also occur only when you need to incur them. Furthermore, hire companies give training in the use of major equipment. It is advisable to develop a relationship with a hire company by first hiring small items (a modest set of lights or a tripod). In this way, you learn about their systems and demonstrate your credit-worthiness before attempting to hire expensive high-definition gear. Do not practise false economy: if your camera operator is not familiar with the camera, pay for an extra day of hire so they can get to know how it works. Use it during the dress rehearsal. Finally, return equipment as you picked it up: clean up dirty cables and coil them neatly, and clean the outside of the camera and lenses.

Questions for your client

Here are some of the key questions that should be asked; you will add others pertinent to your case and still more will arise from the answers given. Ask the questions more or less in this order: we all want to know about the money first, but whether it will be enough or not will depend on the production needed.
- When is the movie needed? Is there a specific time of year when it has to be produced?
- What is the intended use? Who are the target audience?
- What quality of video is required? (They may not be able to answer this. You may have to work it out from the answers to the next questions.)
- How long should the movie be?
- Where will the movie be shot – on location or in a studio?
- What facilities, talent, or props will need to be hired, and will sets need to be built?
- What is the budget for the whole production?

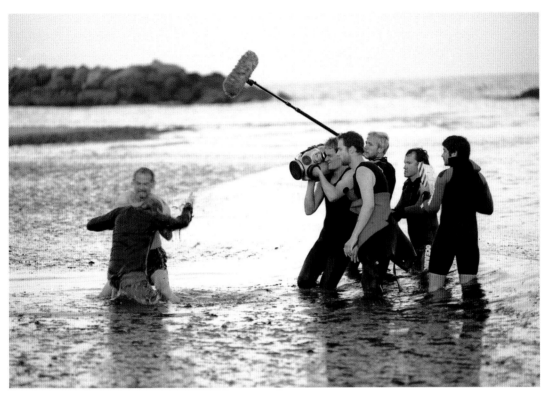

Meeting challenges

One of the joys – and challenges – of working professionally is having to respond to new situations. Shooting in the sea, even close to shore, is not something we all do, so you should be careful and plan for adverse conditions. Here, the camera is inside an underwater housing in case of an accidental dunking, while the crew members are all wearing wet suits.

Great video has been shot on VHS, and most people will view your work on low-resolution TV sets anyway. A well-paced screenplay with good music and dialogue or narration will sweep many a technical failing aside. Image quality supports good camerawork, acting, editing, and so on, but even the highest-definition capture will not conceal poor continuity, embarrassing dialogue, or dull camerawork.

Taking notes

Once you know what you are doing and have put together your team, prove your professionalism by taking care of the paperwork. Make notes of all your meetings, agreements, and action points, and circulate them to everyone. This will help build team spirit. It will also reduce the likelihood of complaints or misunderstandings arising.

Wedding videographer

Making videos of weddings can help pay for your hobby and even become a significant part of your income. It provides excellent camera training and can increase skills for relating to people. This cameraman, taping a Hindu wedding, has forgotten that it is forbidden to step on the carpeted holy area with shoes on.

Production administration

For such a visual medium, movies demand a lot of writing. One day you will be desperately hunting among 50 tapes looking for the take that you know will solve a continuity problem, but unless you keep notes at the time of shooting and label all your tapes, you will be searching in vain. You will probably end up having to view hours of footage to locate what you need.

Logging everything

Every take should be noted down; and on a fast-moving documentary, that can be a full-time job in itself. Because video encourages the camera operator to record at will, it is even more important that notes are taken throughout. The log should state the name of the movie or project; date and time; camera and lens used; act and scene numbers (if relevant); take number and time for each scene; any special features (lens iris, white balance, gain settings); duration of take; comments from the DP (director of photography) or director – for example, "mark" (that is, it is good), "rubbish", and so on. Start a new sheet for each scene on a feature. You can purchase preprinted forms or create them yourself on your computer.

Notes help during the logging process when preparing for non-linear editing (NLE). If you know that a particular take was spoilt for some reason, you can simply fast-forward to the next take, saving a good deal of time. If the director and/or DP are pleased with a take, you know to log that clip with care.

If you run a dual system (*see p. 214*), then you must keep a separate recording log for the soundtracks – this is even more important than for video because it is much harder to identify different audio tracks. It is a good idea for the shoot logger to coordinate her watch with that of the sound recordist so that recordings can be tracked by matching their times (*see Jam sync, right*).

Slating the takes

In all but the simplest productions or shorts, it is best to slate every take – that is, to use the clapperboard (also known as sticks) at the start of each take. Some find this a very disruptive and jolting start for actors. An option is to tail-slate – that is, slate at the end of the take. By convention, tail-slating is done with the clapperboard upside down, but this is not popular with editors. The

Keeping a log

One of the purposes of the shooting log is to help with the editing. Takes that are faulty through actors' errors, unwanted noise on the audio track, or a camera error can be ignored to save time. It is also useful to keep a track of the total time shot, since that ensures that the tape will not run out at a crucial point in a take. Another purpose of the log is to enable technical problems to be identified – for example, if you notice a drop in image quality, it helps to know what the lens setting was; the DP can then be warned to avoid it.

slate should note the act, scene, and take numbers. Very costly slates show timecode as well. Slating before every shot is useful not only for keeping track of takes, it also helps with synchronization – even with timecoding available – and provides a few seconds' handle before the action begins.

People management

Another aspect of logging relates to the people – both crew and cast – working on the set: who was working, and for how long, times and durations of breaks, and so forth. As your work becomes more professional, so must your management of people, and that includes making sure that they work reasonable hours, get regular rest breaks and refreshment, and are generally looked after. Of course, you do this to keep the crew happy. But there is more; should you be in the fortunate position of signing a distribution deal, you may be required to have the project "grandfathered", which means approved retrospectively by relevant unions. For this, proof (not retrospective) that you cared for your team and complied with union regulations will be exceedingly useful.

Asset management

As your ambitions grow and productions become more elaborate, so the items of equipment that you become responsible for will increase. At the same time, you may hire costumes, borrow props from friends, and be lent items by manufacturers or retailers. There is only one way to keep track of everything, and that is with meticulous attention.

It is not a job for the flightily creative spirit; rather, it is perfect for someone who loves making lists and organizing people. You will value these qualities if something goes missing: what looks like a simple power lead could be a data cable costing more than the van hire. Losing an item loaned to you costs you far more than the item: it also costs you goodwill of the supplier, who will be reluctant to lend you anything ever again – and you still have to pay for the loss.

Handwritten lists are fine for small productions, but larger productions will need a database on a portable computer. If there are numerous props, photograph each item with a simple digital camera. This makes identification easier and saves on long-winded descriptions. A database that accepts images on the file, such as FileMaker, is the best for this job. And it becomes an asset for the future: if you need an item again, you will already have the contact and ordering details on file.

Using a slate
The slate is still an essential production tool. It can be held upside down and used at the end of a take if the director prefers the less abrupt start that comes from not slating at the beginning. Modern slates can display a synchronized timecode.

Jam sync

The digital equivalent of the clapperboard or sticks – which make a sharp clapping noise at the start of each take to coordinate the sound with the movie frame – is the jam sync. Some sound recorders that generate standard timecode can be connected to a camera and their timecodes can be synchronized. They will start off with identical timecodes, but over the course of a day, they will drift apart and you will need to jam sync again. This way, errors are minimized and are, at any rate, far fewer than the errors with film. For the highest precision, a master timecode generator sends the same code to both recorder and camera.

Costings and planning

Few financial figures are more painful to look at than those of a movie budget. Whatever you do to economize, it stubbornly remains too big. That is because you are aiming to work to professional standards. The good news is that shooting with digital video is considerably cheaper than exposing film stock. Film costs, including processing, and post-production can easily account for around 20 per cent of total production costs. The bad news is that, while the industry still projects and distributes with 35 mm prints (the final form that reaches the projector booth), you will have to convert video to film. And that can also account for 20 per cent of the total costs.

Budgeting methods

Dealing with money does not come easily to the kind of people who are drawn to work in film. Fortunately, the movie industry is highly structured, so there are plenty of templates and guides to be found. Software such as Showbiz Budgeting, Easy Budget Commercial, or Budget from the Movie Tools suite are all very helpful.

The least costly method is to set up a spreadsheet with separate columns for the items, the unit cost (hire fee per day), and number of units (number of days), with a right-hand column for the product of the two, giving a total for that row.

All these totals are added up at the bottom of each column. Divide up your spreadsheet into separate sections – for example, story rights, actors and other talent, crew, design and set construction, transport, and tape stock. Add other categories, such as long-distance travel and accommodation, when they become necessary.

Include everything that you can think of (the software offers checklists – some of which are very detailed – to get you started), then prepare yourself to be a little alarmed. After a few pep talks to yourself, you will be ready to juggle the figures until the bottom line looks as though it should be attainable.

Tracking cash flow

Working out global costs is only the start of your budgeting. Next you must consider when the money has to be paid out and how much. Fortunately, the cost of video tape is relatively low, but hiring equipment may swallow up a lot of money early on. During the shoot, money will leak out all the time: there will be little expenses that are hard to plan for, because you have to deal with emergencies or equipment failure.

Some budgeting programs offer actualization functions: as you spend you can track the expenditure against your budgets. This sounds

Budgeting screen

This is a typical view from Showbiz Budgeting software: it looks complicated and daunting, but it is an invaluable tool if you have a substantial budget (say equal to twice a skilled person's annual earnings) to manage. It can help you build the budget and also track expenditure against budget.

Obtaining funding

This could have become the most-thumbed section in the entire book but for the fact that everyone's experience boils down to the near-inevitability of years of frustration and misery! There is no magical formula. If anything is clear, it is that only stubborn people – extremely stubborn people – obtain funding. It is not enough to have a great screenplay and a fine crew and cast. This is because people with funds for movies are looking not for those who can make films, but for those who can make money. The search for funding is not about vision but about selling a business proposition to a wealthy patron, for example, who is eager to be a part of the movie business.

wonderful in theory, but of course it needs someone to keep track of the vouchers and enter the information into the system.

If you are putting in your own money, you may need to factor in your own cash flow: a rise in interest rates, for example, makes loans or mortgage repayments more expensive, thus increasing your outgoings. You may not need to have all the budget available before you start rolling, but you do not want to have too little money to keep the shoot going. If there is a break in shooting, your schedule falls to pieces and your crew may break up because of other commitments.

The obvious first peak in cash flow is at the beginning, and the next is likely to follow the wrap, when everyone will have to be paid. The editing may take some time, so there may be a pause in expenditure, but the post-production processes after that can be extremely costly.

Creating the schedule

The timing of the shoot is clearly an integral part of the budgeting considerations. And the shoot itself is closely bound with the requirements of the screenplay. Clearly, if the action swings between, say, two locations, it is not economical to shoot first in one place, then work in the other, before returning to the first. You will shoot all the scenes set in the first location, and then shoot all the scenes in the second. At the editing stage, you will put them into the right order. With multiple locations, you will need to develop a shooting script that makes the best use of the cast, sets, and lighting – and from this the schedule can be developed.

Less obvious items

You will not forget to budget for the director, actors, crew, and equipment hire. Rather than provide a checklist of everything – which would take up several pages of this book – here is a list of the items that are more easily forgotten.

- Photocopying: a screenplay for everyone.
- Copyright registration or lodging of the manuscript.
- Communications: phone, fax, and mobiles.
- Visas and carnets (documents allowing you to import and re-export your equipment) if working abroad.
- Insurance and legal fees.
- Permits, tips, and gifts.
- Wrap party (to celebrate the end of filming and thank everyone for their hard work).
- NLE software and hardware updates.
- Contingency – do not cut it too fine: allow 10 per cent of the total for unforeseeable problems.

Deal memo

Central to your budget is the agreement you have with each crew member regarding their pay. But that is not all. That agreement, deal note, or letter of engagement should comply with union standards, if applicable, or be an adaptation of them. Minimally, it should state:

- Who the contracting parties are (your production company, the freelance crew, and so on).
- The addresses of the parties.
- The name of the project.
- Details of the schedule.
- Any special hazards or conditions (for example, "one scene in the snow").

- A description of the job, responsibilities, and who they report to.
- Fees or daily rate of payment. It is also important to state if no payment is being made.
- Any deferred-payment terms or any promise to a share of profits.
- Any copyright or licensing provisions, if appropriate (such as for production-stills photographer, set designer, costume designer, sound recordist, or camera operator).
- Any special arrangements, such as taxi fare paid for late shoots or extra money for hairdressing.
- The wording of screen credit (which may be subject to union regulations).

Locations and permits

The numerous problems inevitable with working on location – which is almost always the case for documentary-makers – can be seen as a challenge for the committed movie-maker. While the unpredictable and uncontrollable factors of working away from a studio can be harnessed to creative effect, there is no need to invite problems or create unnecessary obstacles.

Finding locations

Suppose your screenplay asks for a scene in a country home, ruined mansion, or hotel. Whatever it asks for, you personally do not have, so you must find it. The location is then the same type of asset as props, costumes, actors, and crew: if you know someone who knows someone else, it can make life much easier. You can hire firms or freelancers to scout locations for you, but first ask all your friends and colleagues: a personal introduction is halfway to obtaining permission.

Using a location manager

A good starting point for planning is to assume there is no such thing as a straightforward location. You, or your location manager, must scout it long before the shoot: go through a checklist of points to confirm (*see opposite*). Use a camera (stills or video) to make some snapshots to show to the director and director of photography (if neither of these roles are your own). Check on the need for permits and fees.

Some locations will simply hand you a piece of paper with the proper authority. Others may require a location release – like a model release – which has to be paid for: this covers access, as well as the rights to use depictions of the location in your movie. When working in modern spaces, created by contemporary architects, it is advisable to obtain location releases. One option is to offer free use of footage that you shoot – for use on the the location owner's web site, for example.

The location manager, or the person entrusted with that job, should be the first to arrive, to ensure everything is ready for the crew, and the last to leave, to ensure the location is left exactly as it was found (that is when the scouting shots come in useful). If anything is damaged, it should be admitted to immediately, apologized for, and an offer made to undertake repairs. Remember, you may need to come back. If possible, have the

Location scouting

The location scout has found a marvellous ruined mansion in Spain. The pictures of the location need not be artistic or beautiful: they should provide a complete view of the location from every angle, preferably at different times of the day.

And they should display not only the cinematic possibilities but also the safety and set-building issues for the set designer, lighting engineer, and even the sound engineers. Do not forget to record the surroundings and access routes, too.

gatekeeper or custodian sign to say that you have restored the site to its original state. Consider giving a small gift as a token of your appreciation.

Unusual locations

With the low cost of air travel, the possibilities of working abroad have very much increased, presenting more exciting, interesting, attractive locations. Facilities such as studios can also be less costly to hire. The Soviet Union, for example, has enormous studios scattered throughout its territories, and studio managers in former Eastern Bloc countries are only too happy to welcome film crews. Your crew may even accept low or zero pay if they know they will work somewhere interesting like Korea, Kyrgyzstan, or Lithuania.

Church permit
Many cathedrals do not allow the use of video cameras, so we almost resigned ourselves to just looking around this one, but we asked anyway. It was being restored so we were welcomed, tripod and all. Always ask: the worst thing you can be told is no.

Checking locations

Apart from ensuring that the location meets the needs of the screenplay, other points to check include:
● Availability of parking, with sufficient capacity for the crew and cast.
● The direction the building is facing, and the times it gets the best and worst light.
● Position and size of windows that may add unwanted light if the day is sunny.
● Dimensions of rooms – they must be large enough to accommodate cast, crew, equipment, and props.
● Any immovable objects that may impede camera movements or tracking.
● Which precious items should be removed before the crew arrives.
● Whether any items, such as works of art, require a release or permission if they appear in a movie.
● Whether there are any mirrors or shiny surfaces that will interfere with lighting.
● State of electrical wiring: ensure it will take the loads imposed by large lights.
● Heights of ceilings – they should be sufficient for lamps or crane camera positions.
● The acoustics of the rooms.
● Whether any ambient noise will cause problems – a nearby military airbase or railway station, for example.

Dealing with people

The paper in your hand, even if it is signed by some high official, is often no guarantee at all – although with some highly hierarchical organizations such as the armed forces, the permit itself will suffice. If possible, ensure that the permit you obtain covers the possibility of delays, or you will have to start all over again if the schedule changes. On the ground, there will usually be someone else to deal with – someone else who you should try to get on your side.
● Once you have a permit, make a scouting visit to the site if possible.
● Introduce yourself to the people in charge. Assure them, assess them, and assist them – their jobs are often lonely and thankless.
● If they prove difficult, try to sell them the idea of your movie: explain the plot, show them storyboards. You never know, they may open up areas that you did not know about.
● If you need extras, or can invent a role for one or two, it could help to try to involve the guardians of the location in your movie. After all, who has never dreamt of being in a movie?
● If they prove particularly helpful, reward them – maybe a signed print with a small gift. It costs you little but could mean a lot to the recipient.

Working safely

Although everything to do with working safely involves using common sense, that quality is the first to go once you enter complicated, fast-moving situations. Furthermore, common sense cannot be relied on when a long shoot makes everyone tired and emotional. The substitute, then, is discipline applied to a few simple rules that all crew must respect and be familiar with.

Sharing responsibility

The first and most important rule is that everyone on set is responsible for the safety of everyone else. In particular, the crew have an absolute responsibility to ensure total safety for the members of the cast. Actors cannot be expected to watch out for lights and microphone booms and trailing leads – certainly not while they are on the set. Once off set, of course, they have to mind their head, arms, and feet, just like everyone else.

Defining the area

On larger-budget productions, a set manager will be responsible for making sure that the set functions safely and that all operations proceed smoothly, ensuring that nothing impedes the flow of movie-making. Working with smaller budgets, and therefore with people taking on multiple roles, it is still useful to appoint a person – the

continuity boy or girl, or the director's assistant – to check that there is a clear demarcation between the set and the production clutter, and that nothing is on the set that should not be. Shooting can proceed only when he or she gives the all clear. A tool box left in the set area may not only ruin a take – it could also cause an actor to trip over.

Working on location, it is even more important to define the set area and to work tidily, mainly because it is very easy to lose small items in unfamiliar surroundings. If working outdoors, use brightly coloured tape to enclose the area, so that members of the public do not wander into view. Use warning cones next to piles of cables, electrical boxes, and supports of heavy lights to keep people from venturing too close.

Tidying the electrics

Cabling and leads for lights and sound can be a real problem for any production that uses more than a single camera and sound recorder. Props may have to be powered too.

With planning, it should be possible to position the leads so they cause the least obstruction to the traffic of cast and crew. If necessary, cables should be enclosed in tunnels so that they are kept tidy and can be stepped on without damage being caused.

Tangled wires
With separate items of equipment needing to be powered and leads going to and from mixers, a dangerous tangle will soon develop unless cables are continually tidied up. In this shot, power cables are perilously close to the tracks in the lower left of the picture, and there is even one lying across the track, where it could easily be damaged. The cables also lie across a busy route for crew. Some, but not all, of the potential problems were dealt with soon after this shot was taken.

Rules for safe working practices

Freelance workers in the film industry enjoy the discipline of the medium in which everything is subservient to getting the footage "into the can". But some people on the set may not be very experienced, especially on a small-budget production. So it is useful to set some rules at the beginning of a shoot and make sure that everyone is conversant with them.

- Everyone must know where the first-aid kit is located and who the nominated first aider is.
- Before a take, everyone turns off their mobile phones or pagers or leaves the set: only the first aider may keep their phone on, set to silent alert.
- Anyone has a right to stop a take if they believe a dangerous situation is developing.
- Running on set is forbidden.
- Only gaffers and the best boy are allowed to touch high-power electrical equipment.
- Only nominated crew are allowed up on platforms, ladders, or cranes.

Public safety
Working in public areas calls for extra caution and care: while concentrating on making the video, the crew must also be aware of danger from curious or unobservant members of the public. This camera operator is using headphones that allow her to listen to the soundtrack without cutting out ambient noise.

Cables should also be kept well away from tracking (portable rails on which a truck or dolly rides). An experienced gaffer should be called in to check the safety of all but the simplest lighting set-ups.

Beware the heat

Luminaires used in film and video production generate wonderful floods of light but also tremendous heat. If they are placed too close to objects, they can melt, scorch, or even set light to them as heat comes out of the lamp both from the front and around the housing. Keep lamps well away from wallpaper, paintings, plastic items, and furniture. If you attach gels (transparent coloured sheets) over the lamps, ensure they are heat-resistant and that the air can circulate freely around the luminaire. The gaffer or best boy should constantly monitor for overheating. Lamps should be turned off or to "trickle current" whenever they are not needed.

Shooting safely

The word "safety" is also used in conjunction with ensuring that the editor has plenty of footage to work with. Tape is not as precious as film, so it is no longer necessary to shout "Cut!" the precise second that a scene has been shot in order to save on costs. Filming should continue for several seconds after the scene is acted through, for a number of reasons:

- Handles – a few seconds before and after the clip – may be needed for fades and other transitions.
- Echoes can be allowed to die away naturally. This helps with the audio editing later and will help create a more natural sound .
- Actors' expressions and gestures may suddenly become more natural once they think shooting is over. A few seconds of footage of natural gestures or uninhibited laughter, for example, can come in useful during the editing stage.

Glossary

16:9 Ratio of width:height of a widescreen TV screen.

180° rule Camerawork and editing indication to avoid consecutive positions or cuts in a scene that point in directions greater than 180° apart.

1080i High-definition format using 1,080 active lines with interlaced scanning.

24p 24 frames per second progressive scan: a video simulation of cine film.

25i 25 frames per second interlaced, of PAL/SECAM standard.

25p 25 frames per second progressive scan.

3:2 Ratio for pull-down to convert 24 fps film to 30 fps: the first frame is held for three video fields, the next for two fields, and so on.

30° rule Rule of thumb that the camera angle on a subject should change by at least 30° between cuts.

30i 30 frames per second interlaced, of NTSC standard.

30p 30 frames per second progressive scan.

4:2:0 Sampling scheme in which one chrominance channel is sampled at half the rate of the luminance channel, and the remaining channel is sampled at less than a quarter of the luminance channel.

4:2:2 Sampling scheme in which the two chrominance channels are sampled at half the rate of the luminance channel.

4:3 Nominal ratio of width:height of a standard domestic TV screen.

480p Format using 480 lines per progressive scan frame. Also a mode of watching HDTV (high-definition television) on standard-definition sets.

720p High-definition format using 720 active lines with progressive scanning.

A

A/B-roll Editing technique using two analogue players.

accessory shoe Open slot on top of a camera into which a light or microphone may be attached; also called hot shoe.

action safe area Central 95 per cent of active picture area that can be seen on a video screen.

active picture area The portion of a TV picture that contains the image, excluding portions carrying synchronization signals.

acquire To transfer movie clips from camera or player to computer for NLE (non-linear editing). Also used to mean filming or recording transmitted video.

AFM Audio Frequency Modulation: method of processing high-fidelity audio signals.

A-frame The first and only film frame captured complete on adjacent video fields.

AGC Automatic Gain Control: electronics that monitor the strength of an incoming signal and maintain correct levels.

AIFF Audio Interchange File Format: uncompressed file format for audio; widely used for digitally sampled recordings.

aliased Stepped or jagged appearance of lines or borders caused by a low resolution of video chip.

ambient noise Background noise such as the sound of wind, traffic, and so on.

A-mode Editing method that uses scenes or takes in the order they were shot: usually applied to working with film reels.

analogue An effect, representation, or record that is proportionate to another physical property or change.

anamorphic Optical effect or design that squeezes a wide view into a narrow format.

angle The same scene and action filmed from different viewpoints or perspectives.

animation In digital video, the process of changing features, such as colour and text, over time.

aperture Lens setting that controls the amount of light entering the lens. A large aperture (say, f/2) lets in more light than a small aperture (f/22). Also, anachronistically, known as f-stop.

APS Automatic Picture Search: facility built into digital video cameras that enables the beginning of a clip to be located.

artefact Visible or audible feature that was not present in the original or is a distortion of the original, such as flickering, ghosting, or streaking.

aspect ratio Ratio of a frame's width to its height. Also picture ratio. Usually 4:3 (or 1.33:1) or widescreen of 16:9 (or 1.78:1).

authoring Process of creating DVD programmes, including the designing of interface, collecting the materials, organizing into chapters, adding extra content, and writing to disc.

auto-exposure Camera-controlled settings aimed at giving correct exposure.

auto-iris Automatically controlled iris diaphragm or lens aperture used in digital video cameras as one of the controls for exposure.

autoplay Feature of players or software to play a DVD or VCD on insertion.

AVI Audio-Video Interleaved: codec and protocol for sound and video promoted by Microsoft.

Glossary continued

B

backlight switch Control that increases exposure to compensate for strong lighting coming from behind the subject.

balance Comparison of the volume of the channels of stereo or multiphonic sound.

balanced Said of a cable or connector that has three lines to separate the signals from power.

bandwidth Measure of the amount of information needed by a system in order to handle a stream of video or sound signals.

bars and tone Broad patches of colours and an audio tone used to calibrate audio and video signals.

batch capture Using software to capture all the marked clips from a tape in one pass, rather than one clip at a time.

best boy Assistant to the gaffer.

Betacam Tape format widely used in broadcast video, particularly as Betacam SP and Digital Betacam.

Betamax Analogue video format withdrawn in 2002; recognized by professionals as superior to VHS, its rival format for the domestic user.

B-frame Bidirectional predictive: a type of frame used in MPEG coding based on both preceding and following frames.

bin In non-linear editing, a folder containing and organizing working digital video clips. Named after the cloth basket over which strips of film were hung.

black level Measure of the black portion of a video signal: 7.5 IRE for NTSC, 0 IRE for PAL.

black striping Recording blank footage on tape prior to shooting in order to lay a timecode.

blooming Effects visible when phosphors on a TV monitor are excited to too high a level – details soften, contrast is distorted, blacks are poor, and mid-tones are inaccurate.

blue screen Evenly coloured blue background against which a subject is filmed to provide footage for chromakey work. Also synonymous with chromakey.

BNC Connector type used in electronics: features a coaxial cable with a central pin with rotating metal collar for locking.

Book A, Book B, and so on Standards defining DVDs: Book A: the physical format; B: DVD-Video format; C: DVD-Audio format; D: DVD-R format; E: DVD-RAM format.

boom Long pole used to extend the reach of a microphone, especially to hold it out of shot, above the action.

broadcast-legal Video images that comply with broadcast standards for brightness range and colour.

broadcast quality Video signal that meets the appropriate national broadcasting standards – for example, FCC or EBU.

B-roll Footage used to intercut into primary sequence or soundtrack – for example, to illustrate an interviewee's comment. Also footage used to provide cutaways.

burning Process of creating a CD by writing data to the disc.

bus-powered Equipment that needs only one cable, which carries both data and power.

button On screen, an area of projected image that is active and can be clicked on with a pointer or cursor to start an action such as play or fast-forward.

C

cable basher Person responsible for ensuring cables and trailing leads do not "bash" into equipment or personnel.

camcorder CAMera-reCORDER: the combination of video camera with a device to record the video.

capstan Part of a tape player that spins and – pressed against the pinch roller – draws the tape through the machine.

capture Process of making a video or digital-image recording. Also, process of recording one source of video on to another, such as from analogue to digital.

cardioid Type of microphone that accepts sound from a wide angle, including a little from behind.

cassette Housing for tape consisting of a plastic shell and reels for tape; may contain a microchip for memory and a switch to prevent recording.

CCD Charge-Coupled Device: semi-conductor sensor used to capture light and form the video image; may be single, covered with a filter pattern, or used in a set of three.

CCIR 601 A standard or protocol for digitizing video; also known as D1.

cell Unit of video of any length on a DVD; used for organizing or grouping content.

channel Set of data or signals relating to a specific range or measure – for example, the left and right channels in stereo sound or the luminance or chrominance channels of video.

chapters Sections or bookmarked parts of a DVD programme that allow the user to navigate through the movie, jumping from one section to any other.

chroma Colour information data, measured independently of light levels.

chromakey Replacement of areas of the same colour with image from another video. The subject is shot against a uniform blue- or green-screen background (hence the alternative name of "blue screen") in preparation for replacement during compositing.

chrominance Measure of the depth or richness of colour.

clamp White or black clamp: adjustment to luminance levels to bring them into legal or standard limits.

clapperboard Small sign with a hinged arm that can be closed quickly to make a loud noise to aid synchronization of soundtrack and movie. Usually written on to indicate scene, take number, and time.

clip A single take or section of a movie consisting of an unbroken sequence of frames.

coaxial Type of cable or socket in which a central conductor core is surrounded by insulation material. Often abbreviated to co-ax.

codec COmpression/DECompression: routines that code and decode signals from video or sound.

cold Negative polarity in an interconnect or circuit.

colour correction Use of filters or post-production techniques to alter white balance, in order to produce true neutral colours.

colour space Method or model for describing the way colour is processed in the camera; may refer also to compression of colour signal.

colour temperature Measure of the colour of illumination of a scene.

comb filter Electronic filter that alternately accepts and cuts out certain frequencies, and which, when matched to signals carried at different frequencies, separates the information. Used to decode composite video signals.

combo drive Drive that is capable of reading both DVD-ROM or DVD-RW and CDs, as well as writing CD-R media.

component video Video signal transmission using three components: luminance, luminance minus red (Pr), and luminance minus blue (Pb) – for example, in DVD video. Provides superior quality to composite video.

composite video Video signal transmission that combines the chrominance and luminance channels. The receiving equipment must separate the signals using a notch or comb filter.

compositing Blend or superimposition of two or more different images to create a new but visually coherent image.

compression Process of reducing the file size of a video or music recording.

contrast Measure of the difference between the brightest part of a scene, or the brightest that can be recorded, and the darkest part of a scene, or the darkest that can be recorded.

crew Personnel preparing for or producing a movie, as opposed to the talent.

cross-dissolve Transition in which the end of a clip fades to nothing while, at the same time, the next clip starts from invisible to become fully visible.

cross-fade Transition between two audio clips: as the first fades to nothing, the next rises to normal levels.

CRT Cathode Ray Tube: type of monitor or display using a large glass tube with electronics at one end and a phosphor-coated viewing area at the other.

cue Fast-forward movement or search of tape with display of picture. Also, event or word used to signal another event, such as the start of actor's speech.

cukie Cucoloris: mask with cut-outs used with a light source to project shadows. Also known as gobo.

cut Simple, immediate transition or change from one video clip to another, or from one sound source to another.

cutaway Movie clip that interrupts a sequence in order to, for example, illustrate an item mentioned by interviewee. Also used to conceal editing problems.

D

DAT Digital audio tape.

data rate Speed at which data can be transferred from a source; usually measured in Mb/s or Mbps (megabits – not megabytes – per second).

dB Decibel: measure of ratio of power between two signals. 3dB is and sounds like a doubling in power, -3dB is a halving of power.

de-interlace Process of preparing video signals for use on, for example, computer screens. A de-interlace filter converts two interlaced frames to create a single still image.

depth of field Measure of zone or distance in front of and behind zone of best focus over which a subject appears acceptably sharp. Appears much greater than with still images because of movement.

device control Feature of digital video camera that allows it to be controlled by NLE (non-linear

Glossary continued

editing) software in computer when connected by FireWire/i.Link/IEEE 1394.

digital zoom Increase of the apparent magnification of an image through software processing; there is no actual increase in magnification.

disc key Data passed between DVD and DVD player to allow decryption of the disc.

dissolve Fading or diminution of a signal while another rises to replace the fading signal.

Dogme, Dogme 95, or Dogma Style of movie production using hand-held camera, available light, no effects or exaggeration, and minimal post-production work.

Dolby Digital Method of coding sound that is internationally accepted. Compression method for NTSC discs.

Dolby Surround Method of encoding surround sound (three-dimensional) in a stereo signal.

dolly Movement of the camera position in towards a scene or out from it along camera-lens axis.

down-mix Combine several audio channels into two stereo channels.

DP Director of photography: person in charge of camera positions, moves, and settings.

drop-frame timecode NTSC protocol that drops two frame numbers a minute, except for tens of minutes, to compensate for the non-integer frame rate.

drum Cylinder around which the tape is wound during recording or playback for reading data on tape.

Dutch angle Camera position in which the camera is held at an obvious angle to the horizontal.

DVCam Professional digital video format: records 8-bit images, 5:1 compressed, with 4:1:1 colour sampling.

DVCPro Standard definition used in broadcasting, running DV format at twice the consumer format speed; records 8-bit images, 5:1 compressed, with 4:1:1 colour sampling. Also known as D-7.

DVD Digital Versatile Disc: method of storing data using microscopic changes into two or more layers in a CD-like disc. Depending on format, 4.7 GB capacities and higher are available.

DVD-Audio Sound-only version of DVD.

DVD-Video File format, based on MPEG-2, for video used in DVD, currently offers widest compatibilities. DVD-Video (fast editable) is a variant usable on DVD-RW or DVD+RW discs.

DV Stream Raw video format used for recording video image, prior to processing such as compression or gamma.

E

EDL Text file annotating the edits making up a sequence, based on timecodes of clips. It enables projects to be moved between different NLE systems and to coordinate large editing projects.

encoding Conversion of analogue video or sound signals into a compressed digital form.

establishing shot A take that sets the scene, describing the context in which action is to take place.

export Software feature that allows a movie to be converted into different file formats.

eyeline Axis extending from imaginary line between two actors' eyes.

F

fade Effect that gradually turns the picture to a plain background – for example, fade to black means the image becomes darker and darker.

fader Sliding controls in audio mixing that alter balance of tracks.

field Half of an interlaced frame, containing either all the even-numbered or all the odd-numbered scan lines making up the image.

FireWire Name used by Apple Computer Inc for IEEE 1394 connectors. *See also* i.Link.

foley Sound effects created and recorded separately from the video for use in a movie, often synchronized to the action – such as a door closing, for example.

format Rules or protocol controlling the way data is coded and organized in a recording.

fps Frames per second: rate at which cinematographic film is recorded or displayed.

frame One portion of a sequence of pictures that makes up the movie, shown at varying rates according to the video standard. May be interlaced or progressive scan.

freeze A single frame of a movie displayed on screen for a period of time.

f/stop *See* aperture.

G

gaffer Electrician or lighting technician on a movie set.

gain In video: measure of level of white. In audio: measure of loudness level.

gamma Curve that defines contrast characteristics of a frame. Its shape may be varied to simulate, for example, the "film look".

GB Gigabyte: one decimal million bytes (in some cases may equal one binary million).

generators Clips synthesized by software from existing frames to be used as backgrounds, titles, or composited elements.

genlock GENerator LOCKing: a system of devices that enable a TV monitor to accept two signals at a time in order, for example, to combine graphics with a video image. Also, circuitry or signals that lock video and audio tracks together.

gobo A mask with shapes cut out of it for use with a light source to project shadows for lighting effects. Also known as cukie or cucoloris. Also, any device used to shield a microphone from extraneous noise.

H

handles Spare frames at the beginning and end of clips to allow adjustment in timecodes.

head Start or beginning of a clip or take. Also, component of recorder that writes data to the tape or reads from it.

HDMI High-Definition Multimedia Interface: a digital interface between audio and video sources and an audio or TV receiver.

HDTV High-Definition Television: any format that offers higher definition than the current standard.

Hi8 Analogue recording format using 8 mm tape, with resolution of 400 lines.

histogram Software display of distribution of luminance values in a frame.

hot Positive polarity in an interconnect or circuit.

I

IEEE Institute of Electrical and Electronic Engineers: international organization setting standards for the electronics industry.

i.Link Name used by Sony Corp for IEEE 1394 connectors. Also known as FireWire.

image stabilization Electronic or optical technology designed to compensate for camera shake. Elements in the lens may move, or the sensor itself is moved.

incoming Said of a clip that is on the B-side of a cut or the right hand of a transition: the next in time.

in point Start of a clip or sequence defined by an edit.

insert edit An edit in which material is added into an existing sequence. No material is removed, therefore the timeline is increased.

interlaced video Video signal made up of two fields of alternate scanning lines.

IRE International Radio Engineers – usually refers to light intensity scale: 100 is pure white, 0 is black.

J

jog Viewing a clip one frame at a time, backwards or forwards.

JPEG Joint Photographic Experts Group: organization setting standards for compressed formats for images. JPEG 2000 is a complex form of image compression.

jump cut Editing that produces a sudden or abrupt change of subject, scale, or tone between two shots – usually from the same camera position. May also refer to an abrupt change with no attempt to maintain continuity.

K

key colour Colour that is to be removed with a composited image during chromakeying – usually blue or green to provide the best contrast with skin.

key frame Frame or graphic that is used as basis or target for a transition or animation. Also the control that uses two defined key frames in order to calculate the transition from one (the basis) to the other (the target).

keying Process of removing a key colour with a mask, prior to compositing.

key light Light source providing the main, usually brightest, illumination on a subject.

kicker Lamp placed on the same side as the fill lamp, used to emphasize detail or facial contours.

knee Point on the tone-characteristic curve that can be adjusted to change tone reproduction .

L

Laser Disc Disc similar to a DVD but 30 cm (12 in) in diameter, for storing a movie in analogue form.

lav Short for lavalier-type microphone, which is worn on around the neck on a chain or string.

legal Video signal that meets broadcast standards.

letterbox Shape of broadcast or projected feature film whose picture ratio is greater than that of the screen format; top and bottom of the screen are left blank.

linear editing Editing system using tape or film that must be spooled or wound past successive clips in order to access a specific clip. Antonym of non-linear editing.

line level Low signal carrying data between components in an audio system – for example, from mixer to recorder. Known as +4dBu.

log List of entries about each movie clip detailing name, scene, grade or quality, duration, and so on.

Glossary continued

long shot Composition in which people or objects are seen from a distance; often an establishing shot.

loop Short recording of a sound that plays continuously without break – for example, a drum beat, water flowing, or a piece of music.

LP Long Play: when video tape is run at a slower speed to increase recording time, but at lower quality.

luma Colloquial form of luminance; may be used to refer to video gain.

luma key Filter used to select or mask off a certain brightness value, usually based on the brightest or darkest part of the frame.

luminance Measure of the amount of light emitted or reflected from a subject.

M

master clip Footage of a take as originally shot, from which portions may be taken for editing.

match-frame edit Process of synchronizing a video frame with a sound cue.

medium close-up Framing that takes in a person from the head to below and just wider than the shoulders.

medium shot Framing that takes in a person from the head to below the knees.

MicroDV Micro digital video: format for video making use of very small cassette tapes.

MiniDV Mini digital video: format for video using small tapes holding 60 minutes of movie at standard-play speed.

MOS Video recording made without sound; often cited as deriving from German director Erich von Stroheim's instruction to shoot "mit out sound".

motion path Route of an animation or changes of shape, based on position of key frames within the TV format.

MP3 MPEG-1, Layer 3: audio compression component of MPEG-1, widely used for music. Note: not supported in DVD-Video or DVD-Audio.

MPEG Motion Picture Experts Group: organization setting standards for movie picture compression formats.

multicast Streaming video to many users from a single server.

N

native System that uses files or data in their original form without, for example, converting or compressing it for faster handling in off-line editing.

night-time mode Feature of Dolby Digital that allows movies to be listened to at low volume without impairing audibility of speech. On digital video cameras, a feature that allows recording in absence of visible light, using infrared light.

NLE Non-linear editing: editing based on an ability to access any part of any clip directly without having to pass any other clip. Based on random access of digitally stored movies.

noise Unwanted elements in a signal: in audio, heard as hiss or crackle; in video, seen as flecks of light or odd colours.

non-interlaced video Representation of video used on computer screens where there is no need to interlace the frames. Also known as progressive scan.

non-square pixel Broadcast pixels are not square: NTSC pixels are narrower than square, while PAL pixels are wider.

NTSC Colour broadcast encoding standard used mainly in North America and Japan, with a nominal resolution of 525 lines and frame rate of 30 fps.

O

off-line clips Movie footage that is registered in a log but not held on computer hard disk.

off-line editing Use of smaller compressed or proxy files during editing, to lower the workload on the computer.

one-chip Digital video camera using a single CCD chip as a sensor, as opposed to triple-sensor or triple-chip cameras.

one-shot Short soundtrack of a single event, such as a door slamming, or a door bell ringing.

opacity Measure of how much can be see through a layer or image.

OTS Over the shoulder: framing a shot so that part of the back of a person's head is visible, framing a second person who faces the camera.

out point End or stopping point of a clip in an edit.

over-black titles Titles placed over a solid colour (not only black) instead of over an image or sequence.

overlay Superimposition of an image or text on to video footage.

overscan The excess of scanning lines of a video image, such that it is larger than a TV screen. It allows for differences in TV sets or may contain information.

overwrite edit An edit in which a clip is replaced by another of equal length, so the sequence duration is not changed.

P

PAL Phase Alternating Line: colour broadcast encoding standard used in most areas of world, except for North America and Japan.

pan Distribution of sound between the left- and right-hand channels, determining stereo sound position or movement of mono sound between channels. Also, a camera movement that follows action – usually in a horizontal plane – from a fixed position.

pan and scan Simulation of panning movement after video has been shot by cropping to a small portion, then moving across the view with successive frames.

pan/tilt Horizontal and vertical movements, respectively, of the camera, around an axis vertical to the camera-lens axis.

parade scope Type of wave-form monitor that separates red, blue, and green into separate displays.

part of title Technical term for chapter or section of a DVD title.

PCM Pulse Code Modulation: format of digital serial signal used in CD sound encoding.

pedestal Black level: for PAL it is set at 0 IRE; for NTSC, 7.5 IRE.

phantom power Provision of power to microphone by applying a voltage to the wires carrying the audio signal – for example, two pins of XLR carry the same voltage, usually 48v.

pink noise Uniform or steady level of audible noise.

PIP Picture-in-picture: placement of a stills picture or video within the frame of the full-frame picture or video through the use of masks.

pixel Picture element: the smallest element of a digital image; may be square or slightly rectangular. *See also* non-square pixel.

plate Image that replaces the key colour during compositing.

plug-and-play Collaboration between computer operating system and hardware intended to make it easy to use new equipment. No software installation is needed, so you simply plug in the equipment to use it (in theory).

pre-production Movie-making phase prior to shooting. Includes research, script-writing, building talent and crew, storyboarding, set design, and production or location permits.

point source A source of light that appears to be emitted from a small point.

port Input or output socket built into equipment to accept appropriate connector.

poster frame Single frame taken from a clip to stand for or represent the clip.

post-production Movie-making phase following shooting. Includes capture and log, editing, special effects, sound editing, rendering, and outputting.

practicals Lighting that can be seen in shot: may not be used actually to illuminate the scene – for example, candles to set period or atmosphere.

pre-roll Blank tape for 2–3 seconds before recording on the tape commences; needed for timecode accuracy.

production stills Photography of movie being made, including key moments from the action and behind-the-scenes documentation.

progressive scan Recording an entire frame at a time; used to create the "film look".

prosumer Equipment capable of professional or near-professional quality results, but designed mainly for use by experienced amateur.

pull-down Slowing down of frame rates to enable one format to be rendered in another, in ratio 3:2 for 24 fps to 30 fps.

Q R

QuickTime Application for viewing multimedia. Also standards created by Apple Computer Inc for integrating video and sound into applications.

rack focus Using change of focus of lens during a take without change in camera position to direct viewer's attention. Requires digital video cameras with a manual focus control.

rendering Process of turning editing decisions and applied transitions into the final video, including any changes to the format and levels of compression.

resolution Measure of detail visible: in video, usually measured on the horizontal axis for a distance equal to the height of the picture.

rim Lamp placed behind subject's head that is used to highlight or rim light the hair (or outline of the head if the subject lacks hair).

ripple edit An edit affecting a selected range of clips in such a way that a trim of one affects the others.

roll edit An edit affecting two clips that share an edit point.

rostrum camera Set-up or rig used to simulate movement in and around a two-dimensional subject, in order to animate a print.

rotoscope Process of creating an animated matte or mask that indicates the shape of an object or actor at each frame of a sequence for compositing.

Glossary continued

rough cut Edit of clips into the scripted or storyboarded order but not refined as to timing and synchronization with sound.

RT Real time: effect, transition, or other change that can playback on screen immediately, as opposed to needing time to render.

S

safe title area Central part of the picture that will not be clipped or cropped by any screen it is viewed on. Usually some 80 per cent of the total image area. Also called title safe area.

sample rate Usually applied to audio: the rate at which sound is analyzed during digitization: for CDs, the rate is 44.1 KHz; for digital audio, it is 48 KHz.

scanning In video, the movement of the electron beam across the face of a CRT monitor screen.

SCART Syndicat des Constructeurs d'Appareils Radiorécepteurs et Téléviseurs: type of multiple-pin connector used between TV and VCR.

scratch disk Hard disk reserved for working files during NLE (non-linear editing): it must turn at at least 7,200 rpm, have ample capacity, and not be set to power down when not used.

scrim Semi-transparent fabric used for lighting effects: appearing opaque when lit from in front and translucent when lit from behind.

scrub Viewing a clip by manipulating the play head – that is, at a variable speed.

SECAM Sequential Colour with Memory: colour broadcast encoding standard used in Europe, with frame rate of 25 fps and 720 x 546 pixel dimensions over 625 lines.

second unit Camera crew that shoots action from a different position compared to the main or first unit, to give vast increase in editing freedom.

sector Physical group of data recorded: on a DVD, a sector contains 38,688 bits of channel data and 2,048 bytes of user information.

sequence Short for a sequence of edited cuts.

set-top player DVD or other player designed to work with a domestic TV set.

shotgun Type of microphone with a long barrel to accept sound from narrow angle.

shuttle Viewing a clip backwards or forwards at variable speed.

slate *See* clapperboard.

slip edit Editing decision in which a clip within a sequence is changed by moving the edit points so that the duration of the whole sequence is maintained.

slugline Scene heading in a screenplay indicating location of action, time of day, and possibly production information, too.

SMPTE/EBU timecode Format for timecode in the form hours:minutes:seconds:frame number. The maximum frame number for PAL is 24; for NTSC, it is 29.

sound report Annotation of recorded sound, listing each different take with settings.

SP Standard Play: recording or replaying a videotape at normal speed.

spark Electrician in the production team. Also called a sparkie.

sprite Graphic that can move, following set rules, within another graphic.

stereo Stereophony or stereophonic: sound reproduction that aims to give impression of depth and distance.

stop-frame animation A movie shot one frame at a time, with small changes to positions of models made from, for example, clay or Lego pieces.

straight cut Changing directly from one clip or take to another without any transition effect.

streaming video Video broadcast over the Internet in which the recipient can view the start of video while the rest is being loaded.

subsample To take fewer measurements when digitizing, in order to reduce flow of data.

super-white Brightness level of video higher than 100 IRE; a white higher than the legal level.

surround sound Sound or entertainment system that uses more than the two channels of stereo sound with the intention of creating a three-dimensional sound stage.

SVCD Super Video CD: format originated in China and used in Far East, based on MPEG-2, offering quality level between those of VCD and DVD.

S-VHS Version of VHS offering higher resolution – 400 lines rather than 240 lines.

S-Video Super-Video: a signal transmission protocol for video that separates the luminance and chrominance channels. Also known as Y/C.

swish pan Rapid panning movement that blurs the image.

sync, or synch To synchronize – that is, to ensure than two events occur simultaneously or that signals run at the same time.

T

take To shoot or record a movie. Also, one of possibly many attempts at shooting a scene.

talent Actors or extras taking part in a movie; as opposed to the crew.

telecine Device for transferring a cinematographic film to a video format.

tilt Movement of the camera upwards or downwards, rotating around an axis at right angles to the camera-lens axis.

timecode Reference data stored with each frame, displaying cumulatively in the format hours:minutes: seconds:frame number. *See* SMPTE/EBU.

titles Text and pictures at the start or end of a movie to introduces the film and/or list credits.

title safe area *See* safe title area.

track Element or component of information, such as alternative languages or subtitles for a DVD movie.

tracking Following the action, keeping the camera at a constant distance from the action in a movement at right angles to the camera-lens axis.

trimming Process of removing excess movie clips during the editing process by deleting frames.

triple-sensor Set of three CCD sensor chips used to capture red, green, and blue separations of the image; the best solution where highest image quality is needed. Also called triple-chip.

twitter Flickering of horizontally oriented detail due to interference with interlacing lines.

two-shot Framing that shows both parties in a conversation or interview.

U V

unicast Streaming video to a single user from a server.

VBI Vertical Blanking Interval: that portion of a TV signal that is left clear – blanked of picture – in order to allow screen redraw. Now used for captions and other data.

VCD Video CD: video format that uses MPEG compression to record to ordinary CDs, delivering quality similar to VHS.

VCR Video cassette recorder: recording and playback device for video, generally reserved for analogue devices. The commonest format is VHS.

VHS Video Home Services: obsolescent analogue video format used for recording TV broadcasts for later playback and (less so now) video film rentals.

video capture card Special circuit boards fitted with processors and memory designed to convert analogue video to digital. It slots into an expansion bay on a computer.

voice-over Recording of narration or spoken text made separately from movie footage that runs along with the moving images.

VR Virtual Reality: images designed to involve the viewer or audience in the action or to place them within a virtual space that represents a real or invented space.

W

wave-form monitor Graphic display of distribution of brightness and saturation in a frame.

webcam Digital camera attached to a computer to allow other computers to view images from the camera through an Internet connection.

white level Brightest permissible image: it should be lower than the maximum for the monitor screen.

widescreen Format whose width-to-height ratio is nominally 16:9.

wide shot Framing that shows a wide-angle view of the scene, to take in as much as possible – often used as an establishing shot.

wild track Sound recording made separately from the video; sound recording not synchronized to action.

windjammer Fluffy or furry cover for a microphone, designed to reduce wind noise.

wipe Transition in which the first clip is erased or wiped like a windscreen blade to reveal the next clip.

X Y Z

XLR Ground Left Right: type of connector and cable providing balanced audio lines.

Y Symbol for luminance; a channel of Y/C video.

Y/C Video signal transmission that separates the Y (luminance) channel and the C (chrominance) channels. Also known as S-Video.

YCrCB Colour space defined by three axes of luminance (Y) and colour difference signals, the red and blue.

zebra pattern Display available in high-quality cameras shown as alternating black and white stripes that appear in bright areas. Used to discover illegal video levels.

zoom ratio Ratio between longest and shortest focal length of a zoom lens; may include optical and digital zoom lengths.

The law and video-making

There are broadly three areas of law that most concern movie-making: relations with suppliers of talent, crew, and post-production facilities; copyrights; and contracts with distributors and studios. The latter is outside the scope of this book, so here you will find general advice offering indications of the legal issues – it is not a statement of pertinent law, nor is it a substitute for such. Movies are a specialist and complicated area of law. You are always best advised to talk to a specialist lawyer before agreeing to or signing any document or even exchanging letters.

Be aware that a verbal promise to do something or offering a proposition that is agreed to or accepted by the other side may, in some cases, have the effect of creating an enforceable contract.

WORKING WITH OTHERS

I am playing with the video camera with friends just for fun, so why worry about legal matters?

Of course, if you are simply videoing some of the activities of friends spending time together, there is no need to create any legal relationships. But as you become more serious and focused about your movie-making, there can be a subtle change in the way you shoot and, with it, your relationship with those in front of the camera. One day you may find yourself thinking, "This is looking good, maybe I have the beginnings of something worthwhile", or you may consider streaming the material to your web site. That is when you need to think about creating legal relationships with everyone who has worked with you on those movies, both for what has already been shot and for further developmental shoots.

No one is being paid to work on the movie, so what is the need for contracts?

There are many good reasons for contracts. The best one is that you never know whether your movie will be lucky and become something of a success. You want to ensure that those who deserve to share the reward do so – and people will work for you more willingly if they can see that you do not wish to cut them out of any success in the future, however remote the chances. Another reason for contracts is to help avoid misunderstandings. For example, someone may have thought that when you said they will not be paid, you meant "not paid right now". Written contracts go a long way to defuse arguments.

Do I need releases from the actors?

On the basic principle that it is better to be upfront, clear, and transparent, your cast should sign releases to allow you to use their performances and depictions of their likeness in any form and any medium, in relation to the movie. So you can create posters and put clips and stills frames on the Internet or in magazines without restraint. Releases protect you in the happy event one of your actors becomes famous: their agent or studio may want to control use of early material.

Note that if the film is used for a purpose other than that specified in the release, you should obtain a new release. For example, if you obtain releases for cinema screenings but an art director from an advertising agency wants to intercut some of your footage into a TV advert he is working on, this then becomes advertising rather than a movie. In such a case, you should obtain new releases (for which you may have to pay extra fees) before you agree to this use.

I am planning to shoot a documentary. Should I be aware of any legal issues?

The main requirement is to obtain a personal or model release from everyone who has a prominent role in the movie – that is, if they speak on camera or if they are the main or only person on screen for more than a few seconds. It is not necessary – nor possible – to obtain releases from people in the street or in the background.

If your documentary is investigative, then you may be taping people who do not want to be taped, and you may wish to shoot covertly. You may say critical things about someone, an institution, or organization. In all of these

circumstances, obtain specialist legal advice before starting your movie.

Broadly speaking, you are on safer legal ground with critical coverage of issues – a potentially dangerous waste dump, or the state of the education system, for example – for which you can claim "public interest", because it is important for the public to be informed; you may claim that any abridgement of your movie-making threatens freedom of expression and right to information. However, with critical coverage of a person – you may claim they cheat at game shows or run corrupt businesses, for example – whether they are celebrities or members of the general public, your subject will have access to human rights, privacy, or breach-of-confidentiality laws to pursue you.

Furthermore, people have a separate right not to be portrayed in a false light, particularly one that is injurious to their reputation or tends to bring them to disrepute – even if your movie will bear different interpretations, only one of which is critical of a person. The last thing you need in your career is an action against you for defamation. Before any public showing, ask a specialist lawyer to review the movie and provide a written "clearance report".

I am shooting in a public area with a police permit, but what if a member of the public ignores my instructions and gets injured?

If you are not insured against claims from third parties, you could still be successfully sued even if that person ignored your warnings. If an accident occurs, be very polite and caring. At the same time, document the incident with your video camera, take statements, and make it clear that you have a whole record to support a defence that the person endangered themselves despite everything you did. It sounds harsh, but never apologize or say anything that might suggest that you take the blame for the incident, particularly if you think it is actually not your fault. The crux is that you should always take out insurance against accidents and claims from both the public and members of your team at all times, for any size of project.

I am worried that someone will make a claim against me for an accident on set.

Any production of any size should prepare and plan for the worst, and it is wise to obtain insurance. There are various policies to protect you against different kinds of claim. Public liability insurance covers claims from a cast or crew member who injures themselves on set. But you may accidentally infringe a trademark or unintentionally breach someone's copyright. It may even be sufficient for someone simply to believe that you have stolen their story idea for you to be hauled to court – for this, you need E&O (errors and omissions) insurance.

The crucial point is that you should take out the insurance as early as possible – it is useless to take out insurance after a claim has been made against you because you will have to declare the problem, and insurance is likely to be refused. Consult a lawyer or insurance broker as early in the pre-production as possible – if only to learn how expensive it can be. But it is certainly cheaper than dealing with a claim against you.

A separate insurance to consider is protection of your computer files against accidental loss. Note that some insurers do not recognize computer data as having intrinsic value that can be insured, so check with your underwriter.

The photographer doing my production stills wants to retain copyright over all the images she shoots for me.

Photographers are taught to hold on to copyright in all circumstances (unless they are extremely well paid). You may try to explain that there is a difference of culture when working in movies compared to stills: in movies, everything is much more collaborative and it is usual for all sorts of creative people – such as artists, musicians, and cinematographers – to give their copyright up to the production company. Or you may consider whether you really need to have the copyright.

It may be that you need a licence to use the pictures freely for the film – for promotion or merchandise, to use as stills within the movie, or

The law and video-making continued

any other purpose associated with the movie. The term of the licence – how long it lasts – can be set at one or two years or be equal to the life of the movie. At the same time, you may negotiate limitations on the use the photographer may make of the film – obviously not to promote a rival film or production company, for instance. But you would want to encourage her to use the pictures in exhibitions, her web site, and so on.

Stipulate that such uses credit the film. Do not be greedy and attempt to negotiate a cut of any prints or rights on pictures that she manages to sell; you want to encourage her to make full use of her pictures because they promote your film.

COPYRIGHT AND RELATED ISSUES

I am worried that my brilliant screenplay will be stolen.

The fact is that in this litigious age, few studios would risk stealing an idea when they could simply pay you for it. Work such as screenplays, which are protected by US law, can be registered in the US with the US Copyright Office even if you are not a US citizen or resident – any unpublished work from anywhere can be registered; works published in a country with a copyright treaty with the US can be registered too. At the time of writing, the fee is $30.

In other countries, post a copy to your lawyer for safekeeping. First make an arrangement with a local lawyer to store your manuscript in their archives – the cost can be quite low. Then send it by a service that records delivery in a way that is legally recognized. You are now safe to send out your screenplay to production companies.

I have heard there are some treatments that cannot be protected.

The *scènes à faire* doctrine says that if a treatment or scenario flows naturally (and logically) from a certain initial premise, with little variation possible, then that treatment cannot be offered protection. The clearest example is also the most

famous instance. Consider the arrival of an alien on Earth – there is a limited number of ways that the encounter could go, dictated by the logic of the situation: the aliens are welcomed (we do not threaten each other), they are shot at (we are a threat to them), or they shoot at us (they are a threat to us). None of these scenarios are protectable in US law, and if protected at all in other legislations, only weakly so. In theory, should someone come up with a truly innovative scenario, then the discussion may open up.

What about using non-disclosure agreements to protect my ideas?

This is not a good idea. You will have enough trouble getting your script seen without making people sign a legally binding document first. You have some protection if you precede your description of your idea by saying that you are telling your listener in confidence. However, if you tell all your friends about the idea, even only in outline, the communication loses the property of a confidence since it is your actions that bring it into the public domain.

Your best protection is to write up as much as possible. A five-line plot summary is all but impossible to protect since any good screenwriter can take the ideas and re-cast it in completely different words. A 200-page screenplay cannot be stolen without rewriting the whole thing. However, a recent case established that a work can be deemed to be copied without repeating a single word of it – "altered copying" – if substantial elements of the story, plot, or characterization are reproduced.

However, any feature-length movie is full of ideas, smart one-liners, or twists in the tale. You cannot protect against a small part of a movie being copied. After all, can you say that your screenplay is absolutely 100 per cent original?

Can I use recorded music in my movie?

Be aware that if you use commercially available music, you are infringing copyright. However, that may be acceptable if you make the copy

solely for the purpose of research or for educating yourself. If there is a chance that your movie might be used commercially, you should first seek copyright clearance (particularly in Europe). Remember that the movie and music industries have highly developed worldwide systems for identifying plagiarism.

Above all, do not create a movie on the assumption that you can use music freely. This cautionary tale explains: a student movie-maker creates a movie, without dialogue, based on the symphonies of Beethoven. It is a brilliant success at film school but proves impossible to screen publicly because he could not afford to pay the licence fees for the several different orchestras' recordings he had used. Nor could he afford to hire a symphony orchestra and concert hall to record all the music. The movie gathers dust.

I have been told that there is a way to defeat the copy-guard system on my recorder. Is it illegal?

The argument goes like this: if some device is there to stop you from making illegal copies, then it is illegal to overcome these devices. However, if it is not illegal to make a copy for your own use, then certain recent cases have raised the proposition that the copy-protection device may itself be illegal if it unreasonably abridges your rights as a consumer to do what you wish to in the privacy of your own home. So it may depend on your full purpose in defeating the copy-guard system.

Surely, if I am sold CDs or DVDs or software that will copy material, I have the right to copy what I like?

No, you do not. Licences for software for CD or DVD recordings will state something to the effect that it is "only for reproduction of non-copyrighted materials, materials in which you own the copyright, or materials you are authorized or legally permitted to reproduce". The latter clause applies if you work in a company where your job involves copying company material or in an educational institution, where some copying for research and teaching purposes is permitted.

I saw a great sculpture on the side of a building and would like to use a replica in my movie.

As ever, it is prudent to seek permission for any use of anything that may belong to someone – and everything these days belongs to someone. If the object is regarded as a work of art – such as the sculpture – then you are on very weak ground if you feature it in a movie without permission. US law recognizes a right of public display in decorative works of art created for display: this right would be infringed with any unlicensed display, such as in a film. And if the owners object to the way you used the artwork or what is implied by it, your movie could be in serious trouble.

I commissioned a fashion designer to create costumes for my fantasy sci-fi, and I have discovered he has marketed a line of lookalike clothes. Can I stop him?

It depends on the contract you had with him. If you explicitly stated that the copyright of, and design rights in, all that he created for you for the fee you arranged would be held by you or the production company, then he cannot exploit his designs without your permission.

But why stop him? Join forces with him, work together, and share the marketing and profits. If you were not so explicit, you may have an argument if the designs were wholly conceived for the movie. Explain that it is the industry norm that rights in everything created for the movie's production is usually vested in the owner of the movie (the doctrine of "work for hire"). But if you saw some designs and asked for them to be developed for you, your position may be weak because the designs for your film are based on existing work. Your position would be strengthened in proportion to how much input you gave to the evolution of the design.

Learning about digital video

As a medium of the age, digital video has benefited from the advantages that modern technology has to offer. Chief among these is the Internet, which offers vast amounts of information, advice, help, and access to expert help on movie-making and editing. In addition, there is an enormous library of films that can be rented, borrowed from school and college libraries, or bought relatively inexpensively.

Learning from films

You have to go a long way to find a successful movie-maker, director, or screenwriter who has not watched countless films, and their favourite films countless times. Indeed, your interest in making movies was almost certainly inspired by films that you have seen and that have impressed you. So watch and learn from as many films as possible. In particular, look and learn from films made in Europe, the Middle East, and the Far East. The majority of these are made on budgets that are a tiny fraction of those lavished on Hollywood productions, so they are closer to what you can afford and achieve. And do not forget the black-and-white classics of Eisenstein, Bergman, and Kurosawa, for instance.

Try to watch actively – that is, make notes of what you thought worked and what did not. Replay scenes to understand how the cutting and editing made the action effective. Many directors delight in hiding film, literary, and self-references in their movies, repaying repeated viewings. If you are playing a DVD, you can slow down the action and analyze camera movements and timing to split-second precision. Time the camera holds and movements with a stopwatch: you may be surprised how long they last. A test of a good camera operator is the ability to hold the camera absolutely still for 10 seconds without itching to zoom, rack focus, or pan.

Learning from the Internet

You can learn a great deal from the vast amount of information on the Internet. However, what you find online is of variable quality and sometimes downright wrong. Some areas, such as digital video technology, are very well catered for, covering the range from beginner to expert, some of it to textbook quality. The nature of the subject matter is, however, so complicated that it is easy to find inconsistencies between one "authority" and another.

The quality of help for scriptwriters is exceptionally good, if only because the information is provided by professional writers, and there appears to be a genuine wish to provide top-class information. It is also easy to find information about non-linear editing using professional-level software: Final Cut Pro is particularly well served with several discussion forums. However, other areas – such as camerawork, directing, lighting, and sound – are not provided for to an equal extent.

Learning from books

As with the Internet, two areas of digital video practice are extremely well served by books, and many excellent works are available. Again, digital video technology is one, and here it is fair to say that books from Focal Press dominate the range, and deservedly. The other area is, again, screenwriting: there are numerous books on the subject – from the formalities of formatting, to inspirational texts on creating great story lines.

As for software application guides, while the giants battle it out to decide which NLE software application shall dominate, a number of books are already available for the main contenders, but they are not nearly as numerous as guides to, for example, Photoshop.

Organizing your learning

Having decided you are serious about your ambition to work in movies, it will do no harm to approach the business as if you are making a film. You plan, and you work backwards from where you want to get to. You work out how much time each step is going to take: will you spend three years at college (can you afford it?), or will it be more efficient to attend intensive 12-week classes?

You could even consider working as a "gofer" (a general runabout, as in "gofer this, gofer that") on a film set, but this is difficult work to find.

If you know what you want to do – direct, record sound, or take command of the camera – you can go on a specialist course. If not, a degree course would be an option, since this allows you to sample different tasks. It is perfectly natural for you to take some time to decide what job it is that you are both good at and want to do. Unfortunately, these are not always the same thing.

As with any course, the better your preparation, the more you will learn and the more selectively you will be able to focus on the range of skills being offered. So, read, practise using the skills you have, try to make a movie, try to edit a sequence: you may not do any of these things very well, but the exercise will highlight what you need to learn. Some people master camerawork easily – they may be innate photographers – but have no clue how to direct. Some learn to use software quickly but have no idea how to pace a series of cuts. Finally, all schools are difficult to get into, and the better the school, the more likely it is that you need to show some work before being accepted – a draft screenplay, a short showreel, production stills of sets you have lit, and so on.

Attending courses

A good way to focus your learning is to attend a film-school course. There are numerous schools all over the world and many web sites, such as filmeducation.com, with international listings. Many offer intensive courses, some are part-time. Degree courses such as Bachelor of Arts in film studies will offer a mix of movie-making, history, and critical theory of film, but many are weak on preparation for working in the industry.

Shorter courses can be as long as a year or as short as a weekend. The longer courses will cover a range of topics from direction and writing, through production and editing. Shorter courses will concentrate on one topic: camera operation, editing, or screenwriting, for example. In some courses, students working on different skills are brought together to work in creative teams. This can provide an excellent foretaste of the exhilarations and frustrations of operating in a real-world situation.

If you attend a course to learn NLE, you will naturally choose the software most appropriate to your interests – the training may include Xpress Pro, Final Cut Pro, Premiere, and possibly Vegas. If you attend a class for Avid Xpress DV (which provides a development path to Avid Xpress Pro, widely used in studios and broadcasting), ensure that it is taught on your preferred platform: Windows XP or Mac OS X. Current versions of Premiere are Windows only, Xpress Pro and both versions of Final Cut are Mac OS X only.

Mixing with other students

One of the biggest advantages of attending a course, particularly if it lasts a few months, is the network of fellow students around you; the contacts you make may prove invaluable for your future projects. You will encounter kindred spirits who are equally interested in video, and you will be working within a melting pot of talent from which production teams are created. Your fellow students will also be your fiercest and best critics. And that criticism takes place in an atmosphere in which everyone wants to learn, hone their skills, and master the craft.

Getting the best out of your course

It is disappointing and frustrating as a teacher to meet students who have paid out of their savings to attend a course but who will not obtain the best from the course because of poor preparation. Read up extensively on your subject before attending. If you do not know what to read, try to obtain reading lists from the tutors. Shoot some video of your own or work on a production – or at least try to find a student or TV-production shoot that you can watch from the sidelines. Try to obtain any sort of work experience at a local TV station. Finally, prepare a list of questions that you would like answered by the end of the course, as well as projects you would like to shoot.

Careers in digital video

Thanks to its nature, which demands dozens of things to go absolutely right and absolutely at the right time (often simultaneously), the television and video industry has created numerous specialist jobs – some sources count as many as 75 different vocations within the industry.

The range of careers

The specialist jobs cut across different fields – from the highly technical to the wholly practical, from the thoroughly creative to the essentially managerial and administrative, from moving image to sound and stills. There are also specialists for before the production, specialists for during the production, and of course specialists for after the production.

As a result, it is safe to say that you can find a niche in the industry whatever your talent, wherever your skills lie, and whatever their level. You may not have a degree nor feel creative but if you are good with your hands you could work in set construction or train to be best boy (helping out the electrician).

Not everyone dreams of being a director – being at the top of a team is stressful. But however great the director is, he or she gets nowhere without someone who can hold a microphone steadily, someone who ensures the set is clean, and someone who notates all the script changes.

Crossing over

An important aspect of developing a career in the production side of the movie industry is that skills acquired in one field – say, in video – can often be translated, with training and refinements, to others, such as feature-film making, broadcast or cable television, corporate communications, multimedia, or events production. The careers may be entirely different, working to a different ethos, timescale, and budget, but many of the skills are transferable. And as digital technology spreads throughout the whole of the industry, certain skills – with NLE software, for example – are becoming highly marketable throughout.

Pre-production

The specialists needed before a single frame of film is shot range from the scriptwriter to the production designer, wardrobe supervisor, and prop manager. Some will work throughout the film, but others, such as location scouts, may be strictly limited to pre-production. However, the smart operators try to make themselves indispensable for the duration of the production – for example, a location scout can help with managing the location transport and logistics for looking after crew and talent.

Career categories

There are broadly four classes of careers in production. Starting at the less obvious, let us consider the easily forgotten specialists. These include people like the foley artist (who makes sounds such as the jangle of keys or a pen scratching on paper), the effects specialist (who makes explosions, fake glass for breaking, and the squibs used to simulate gunshot wounds), carpenters and artists (responsible for set construction and painting backgrounds), costume makers, and the storyboard artist.

All are highly skilled jobs needing the right talent and experience. They are also much in demand, yet generally there is far less competition for these than for the more "glamorous" jobs.

Technical specialists

Next are the technical and creative specialists who come more easily to mind. The sound engineer or recordist, camera operator, gaffer or lighting engineer, grip (who manoeuvres the camera), NLE editor and systems support (computer and software maintenance), and music director. In addition to these, big-budget films may call for engineers who can build remote-controlled models, designers for specialist equipment and optical effects, and architects and engineers for large sets. To be successful at these jobs you need a combination of top technical fluency in your medium as well as a creative flair. They are attractive jobs that can be

rewarding for those willing to put in extremely long and taxing hours. Anyone who can offer the skills at the requisite level together with a pleasant personality is almost assured of work.

Support classes

There is another layer of support without which no production could operate. These tasks may not be particularly technical, yet they require specialist knowledge and an understanding of the medium and the way it operates. While they may not be considered very glamorous, they provide part of the apprenticeship in movie-making and offer an excellent stepping stone to more prominent creative positions.

This range of jobs includes casting direction, logging of takes, continuity coordination, production stills, research, financial control, asset control (looking after and managing possibly hundreds of costumes and props), make-up artist, and floor manager.

Prize jobs

The prize jobs – such as director, director of photography, art director, editor, and composer – appeal precisely because they call for the highest levels of creativity and total command of the movie medium, as well as the relevant technical facility. The challenge is in the multiple skills of the top rank that each requires. None of these people achieved their roles overnight: a director of photography may have been key grip or focus-puller for years, a director wrote screenplays, the art director worked as an architect before entering films, the composer penned advertising jingles.

Post-production

Finally, do not forget the post-production opportunities. These are broadly either highly technical: telecine operation (converting between film and tape), colourist (grading films or video for quality), or ADR (automatic dialogue replacement) supervision. Their highly technical

nature does not mean you need a degree in physics to do them (although it helps), but you need to be the type of person who works happily with detail, understands the fundamental issues, and above all is a perfectionist.

Distribution and promotion

This leads in turn to a whole additional world – from managing film distribution, to the publishing of DVDs. Then there are promotional events and advertising to handle, as well as film festivals to run. The management of side products such as merchandise based on films, subsidiary rights such as video and computer games, or piano or guitar arrangements of the theme music creates another raft of specialists.

The downside

Governments that assiduously support their country's film industry – such as Canada, New Zealand, and Australia – understand well how many jobs the industry generates.

However, while the glamour and excitement of working on a film or TV programme can be taken for granted, one aspect of the work cannot be. Unless you have the good fortune to land a salaried job early in your career, your first years will be a bumpy ride. Short periods of intense and exhausting work can be interspersed with featureless deserts in between.

You may be well paid while you work, but the intervals between can be long – and you only get paid if you work. And when you work, you may realize you never knew what hard work was. The hours can be long and very unsocial, the working environment can be too hot, too cold, too windy, and frequently all the discomforts rolled into one. If, for example, you think that filming in the Sahara sounds romantic, the chances are that all you see of Morocco is the airport and the roads; the next two weeks you will be working from a very hot and sweaty tent wondering how so much sand can get into your bed and equipment – and why does the script not ask for more night scenes.

www.resources

GENERAL DIGITAL VIDEO

www.moviemaker.com
One of the best sites for the aspiring movie-maker, distinguished by first-rate writing throughout – a must-visit and must-bookmark site for regular doses of inspiration.

www.creativecow.net
A lively site highly populated with discussion groups, reviews, tutorials, and feature articles on just about anything to do with creative visual and time-based digital media. Well worth bookmarking, but be warned: you could spend a lot of time browsing.

www.videohelp.com
Appropriately named treasure trove of data, how-to articles and explanatory guides. Worth bookmarking.

www.labdv.com
Excellent site with a wide range of information, from the introductory to the highly technical, on many aspects of digital video.

www.practicaldv.com
Modest portal offering a helpful range of short articles as well as information including lists of film courses in the UK and North America.

www.camcorderinfo.com
News, reviews, and features on many video cameras, as well as many user groups and technique guides.

www.dv.com
Free registration is needed before you can access useful parts of this site, but there is a fair range of information aimed largely at the experienced videographer.

www.atomiclearning.com
Paying subscribers have access to an enormous amount of tutorials, but a good number of tasters are available for free.

www.kenstone.net
Kenneth Stone offers helpful advice and information on many aspects of digital video; strong on Final Cut Pro.

www.videonetwork.org
This site is part of an initiative supporting the making of video for positive change and includes independent, activist, and experimental video-makers. Lots of useful, practical advice.

CINEMA AND FESTIVALS

www.imdb.com
The Internet Movie Database is a superb resource on films with extensive filmographies of directors, writers, history, and news – plenty to keep film lovers happy for hours. Add to your Favorites.

www.res.com
For listings of digital cinema festivals and screenings. Also some streaming content and reviews.

www.filmunderground.com
www.24fps.com
These linked sites provide information, contacts, help, and advice for the independent movie-maker, with upcoming projects and forums.

www.filmfestivalrotterdam.com
Active site with library of numerous stills from movies featured in the Rotterdam Film Festival.

www.britfilms.com
A portal to all things to do with British movie-making. Includes an excellent directory of links to film festivals around the world.

www.advancedmovingimage.com
Reviews of creative use of moving-image media; being developed but worth keeping an eye on.

CAREERS AND BUSINESS

www.videouniversity.com
Study courses and tips for those wishing to turn their digital video skills to business use, with useful links and information.

www.khake.com
The Vocational Information Centre's site offers advice about careers: click on "Photography and Film" and "Visual Arts".

COPYRIGHT

http://fairuse.stanford.edu
Excellent coverage of fair-use issues from the viewpoint of US law; also wider intellectual-property matters.

www.dfc.org
The Digital Futures Coalition runs a lively site useful for keeping up with the copyright issues of the day and access to key documents.

TV HISTORY
www.tvhistory.tv
Comprehensive and fascinating history of television, with thousands of sets illustrated and useful links.

DVDs AND VCDs
www.dvddemystified.com
A useful set of frequently asked questions (and answers) covering all aspects of DVD authoring and use, with links to technical sources.
www.dvdrhelp.com
Highly informative site with a great deal of practical information, downloads, and a user forum, including DVD hacks.
www.labdv.com
Technical resources with links on DVD and Super VCD.

MICROPHONES, RECORDING, AND INTERCONNECTS
www.ramelectronics.net
Essentially a reference for modern interconnects, with useful data and some links to help, installation instructions, and technical background.
www.sounddevices.com
The technical documents provided on the Sound Devices site provide clear and concise information on sound recording, microphones, and interconnects.
www.kenstone.net
Practical advice on location sound recording and other aspects of digital sound.

NEWS REPORTING AND TV
www.reporterworld.com
Handy site offering an interesting mix of clothes and equipment for field use, books, films, advice, and useful links, including government sites.
http://SYPHAonline.com
Comprehensive guide to software and equipment for the professional video-maker.
www.broadcastvideo.com
Marketplace for equipment and freelancer listings throughout the world. Good range of links.

www.broadcast.net
Portal for the broadcast TV industry: information, standards, links to manufacturers and suppliers.

SCRIPTWRITING
www.moviescriptsandscreenplays.com
Extensive links to numerous sites offering new and classic scripts, as well as advice and help.
www.writemovies.com
Portal for movie news, contests, and a treasure trove of scripts – a must-bookmark site for the film lover.
www.screenstyle.com
Portal for buying books and software on scriptwriting, with lots of advice and help.
www.iscriptdb.com
Portal to film-scripts database.

SOFTWARE AND EQUIPMENT RESOURCES
Non-linear editing
Adobe Editing and effects software.
 www.adobe.com
Apple Editing, effects, and titling software ranging from amateur to professional.
 www.apple.com
Avid Industry-standard software.
 www.avid.com
Canopus Editing, conversion, and encoding software; some accessories.
 www.canopuscorp.com
MacXware Media Edit Pro software for video editing with picture-in-picture abilities and painting effects.
 www.macxware.com
Roxio Basic editing software; leading burning software.
 www.roxio.com
Sony Editing and media-related software, including Vegas.
 http://mediasoftware.sonypictures.com/
Strata Basic editing software.
 www.strata.com
Ulead Intermediate-level editing and DVD-creation software.
 www.ulead.com

www.resources continued

Screenwriting

Final Draft Applications for screenwriting and audio-visual scripts; for Apple and Windows.
> **www.finaldraft.com**

Movie Magic Screenwriter Applications for creative writing, including screenplays.
> **www.screenplay.com**

Sophocles Screenwriting software designed to improve story navigation; Windows only.
> **www.sophocles.net**

Media Services Portal to a very wide range of software for the media industry.
> **www.media-services.com**

Scriptware Popular screenwriting software.
> **www.scriptware.com**

VIDEO SOURCES

www.artbeats.com
Stock footage: valuable to see what professionals make of very short clips.

www.dvworldclips.com
Video clips from around the world.

www.gotfootage.com
Broad range of material for download.

www.filmdisc.com
High-quality royalty-free clips.

ROYALTY-FREE MUSIC AND SOUND EFFECTS

www.shockwave-sound.com
Royalty-free music, sound effects, and loops.

www.chrisworthproductions.com
Royalty-free music, some full-length.

EFFECTS

Digital Juice Supplier of royalty-free graphical content for video: transitions, effects, animated overlays for PIP, still images, and more.
> **www.digitaljuice.com**

Moving Picture Effective tools for the digital equivalent of rostrum camera work, and animating images over video.
> **www.stagetools.com**

Pixélan Supplier of plug-ins for "organic" transitions and effects working in NLE applications from Final Cut Pro to Movie Maker.
> **www.pixelan.com**

Stupendous Comprehensive range of iMovie plug-ins, with an extensive amount of film-look effects.
> **www.stupendous-software.com**

Virtix Plug-in effects for Final Cut, iMovie, and After Effects.
> **www.virtix.com**

UTILITIES
Encoding

www.discreet.com
Range of post-production software, some industry-leading, running on a variety of platforms.

www.pixeltools.com
Expert-1 is an encoder for MPEG that promises superior quality to real-time encoders. Offers good levels of control; Windows NT or Silicon Graphics.

Colour correction and look

www.redgiantsoftware.com
Plug-ins to standard software to change the look of video.

www.synthetic-ap.com
Utilities for colour correction, calibration, and colour bars, tone generation, and other post-production work.

Logging software

www.imagineproducts.com
Software for speeding up the logging-in process: HD Log-X for Mac OS X, TEPX for Windows, and other management utilities.

PRE-PRODUCTION TOOLS
Scriptwriting

www.finaldraft.com

www.scriptware.com
Specialist software facilitating the formatting of scripts, screenplays, and production schedules. Also, budgeting, legal forms, and more.

www.movietools.com
Home site of *The Guerilla Film Makers Movie Blueprint*: free screenplay software and inexpensive software for producers.

EQUIPMENT MANUFACTURERS

ABC Products Camera stabilizers, mounts, and balance accessories.
www.abc-products.de

Apple Computers and accessories.
www.apple.com

Audio-Technica Microphone systems and audio accessories.
www.audio-technica.com

Avid Industry-leading NLE software and systems.
www.avid.com

Azden Microphone systems and audio accessories.
www.azdencorp.com

Canon Video cameras and professional lenses for video.
www.canon.com

Dedo Light Highest-quality compact lighting units.
www.dedolight.com

DHA Lighting Gobos, projection equipment, lighting effects.
www.dhalighting.com

Flarebuster Accessory holder, anchored to a hot shoe, for shade or reflector.
www.flarebuster.com

Gitzo Tripods and related accessories.
www.gitzo.com

Hitachi AV equipment, including monitors, recorders, and camcorders.
www.hitachi.com

Hollywood Lite Stabilizers and vests for camera-operators.
www.hollywoodlite.com

JVC Range of video equipment, from consumer to professional, plus wide range of electronic equipment.
www.jvc.com

KonicaMinolta Exposure and colour-temperature meters.
www.konicaminolta.com

Lee Filters Comprehensive range of colour and effects filters for lamps (in foils and rolls) and for camera lenses.
www.leefilters.com

Manfrotto Tripods, accessories, and background supports.
www.manfrotto.com

Miglia Interface and conversion products, expansion cards, and mass storage.
www.miglia.com

PAG Batteries for professional systems, portable/on-camera lighting.
www.paguk.com

Panasonic Video equipment, from consumer to professional, plus a wide range of electronic equipment.
www.panasonic.com

Pinnacle Video cards, software from amateur to professional and broadcast.
www.pinnaclesys.com

P+S Technik Professional accessories for video cameras, including 35 mm simulation.
www.pstechnik.de

Sachtler Tripods, stabilizing systems, and lighting.
www.sachtler.com

Samsung Digital video cameras, digital cameras, and other electronic goods.
www.samsung.com

Sanyo Amateur video equipment plus wide range of electronic products.
www.sanyo.com

Sennheiser Microphones, headphones, and other audio equipment.
www.sennheiser.com

Sony Range of video equipment, from consumer to professional, plus electronic equipment.
www.sony.com

Steadicam Industry-standard camera stabilization from the most sophisticated to affordable lightweight models.
www.steadicam.com

ViewCast Video capture cards, streaming, and codec solutions.
www.viewcast.com

Wacom Graphics tablets covering all requirements.
www.wacom.com

Further reading

The outstanding publisher for cinematography and video is Focal Press. If you wish to tackle more advanced video practice, its catalogue will include at least one title that you will find invaluable. The American Society of Cinematographers also publishes some of the industry's "bibles", which you will sooner or later find indispensable.

303 Digital Filmmaking Solutions
Chuck Gloman; McGraw-Hill, New York; 007141651-X
Claiming to "solve any shoot or edit problem in 10 minutes" is overhyping it, but this book contains substantial nuggets of advice and information. An entertaining read. Worth skimming through.

Clearance and Copyright
Michael Donaldson; Silman-James Press, Los Angeles; 187950572X
Excellent and surprisingly readable coverage of main practical intellectual-property issues for the movie-maker. Dips into related issues such as errors and omissions insurance, hiring your own composer, and copyright on the Internet. The many useful forms and precedents are alone well worth the cost of the book. Intended for the US market but useful to anyone in the business. Recommended.

Content Rights for Creative Professionals
Arnold Lutzker; Focal Press, Oxford; 0240804848
Solid coverage of copyright and trademark law, as well as rights management in media, film, and the Internet. Also discusses competition and anti-trust issues, patents, and a broad-brush view of international perspectives. Worthwhile as reference, with CD containing legislative documents or links to them, as well as valuable legal precedent forms.

Capture, Create and Share Digital Movies
Gateway Press, Poway, California; 1577292847
Comprehensive introduction to digital video, featuring different software solutions; fully illustrated and with step-by-step instructions. Windows only.

Digital Moviemaking
Scott Billups; Michael Weise Productions, Studio City; 094118809
Pithy, down-to-earth advice and even provocative

at times, the text is peppered with many asides contributed from the industry. These demonstrate the author's extensive range of contacts – always a sure sign of a successful movie-maker. Very helpful on the technical background, but liable to be dated as technology advances.

Digital Video in Easy Steps
Nick Vandome; Computer Step, Southam, UK; 1840782153
Lively, highly illustrated, and an easy read suitable for beginners. It covers many of the basics in simple language, but there is a lack of in-depth information.

Directing the Documentary
Michael Rabiger; Focal Press, Oxford; 0240806085
A classic text, now into its fourth edition, this book is not only packed with sound advice it also exudes the kind of thoughtful wisdom that can be garnered only from a movie-maker with an extensive filmography. The latest editions are not greatly enhanced by its coverage of new forms of pseudo-documentary such as reality TV. However, this is essential reading for the aspiring documentary-maker.

End of Celluloid, The
Matt Hanson; Rotovision, Switzerland; 2880467837
This is a lively, kaleidoscopic survey of modern trends in the world of the moving image, taking in animation as well as video-making and cinema, from art-house to epic features. Illustrated with stills from numerous productions.

Exploring Careers in Video and Digital Video
Paul L Allman; Rosen Publishing, New York; 082392542
Wide-reaching advice on careers and training requirements, drawn from personal experience, with range of largely US-based references. Useful for entry-level strategies.

Filmmaker's Handbook, The
Steven Ascher and Edward Pincus; Plume, New York; 0452279577
This book deserves its reputation as the best single-volume reference to movie-making for both film and video. Strong on the technicalities with less

emphasis on the creative and business side, but if you can afford only one (weighty) volume on film and video, this is highly recommended.

Five C's of Cinematography, The
Joseph V Mascelli; Silman-James Press, Los Angeles; 187950541X
Classic text that has stood the test of time and fashion, fully illustrated with stills from classic Hollywood films. Each essay on camera angles, continuity, cutting, close-ups, and composition is worth a book from lesser authorities. A must-have for the aspiring movie-maker.

Guerilla Film Makers Movie Blueprint, The
Chris Jones; Continuum, London-New York; 0826414532
Idiosyncratic, lively, and practical volume covering the whole business of independent movie-making. Making a virtue of leaving nothing unsaid, it covers everything from how to format screenplays, to making arrangements for catering, and the all-important questions of marketing and distribution. Highly recommended.

How Video Works
Diana Weynand and Marcus Weise; Focal Press, Oxford; 024080614X
Technical text suitable for those wishing to enter the engineering or camera-operation side of the digital video industry. Despite its deceptively low-key title, it is an update of a standard textbook for the industry and a must-have for the digital video camera operator.

Introduction to Digital Video, An
John Watkinson; Focal Press, Oxford; 0240516370
Despite the title, this book is a technical, thorough account of the fundamentals of digital video second only to the industry standard *The Art of Digital Video*. It ranges from colour theory and video principles to discussions of conversion, compression, coding, interfaces, and output.

Jerry Hofmann on Final Cut Pro 4
Jerry Hofmann; New Riders, Indianapolis; 0735712816
Even if you use other software, there are so many

insights and clear explanations of features and functions found in all NLE applications that any video editor can learn from this book. Essential reading for users of Final Cut Pro; others should borrow the book and at least read the introductory paragraphs for each chapter.

Practical DV Filmmaking
Russell Evans; Focal Press, Oxford; 0240516575
The approach here is very "film school", with a list of must-see movies and complete with a short chapter on film theory, but it is none the worse for that. A number of practical projects are scattered throughout the patchily illustrated text. Written in a teacherly style; recommended to those who can learn by reading.

Producing Great Sound for Digital Video
Jay Rose; CMP Books, San Francisco; 1578202086
Comprehensive, thorough manual for working with sound, though some of the technical information is hard to follow. Clearly built on a lifetime of practical experience working with sound.

Real World Digital Video
Pete Shaner and Gerald Everett Jones; Peachpit Press, Berkeley; 0321127293
Condensed, practical, and down-to-earth coverage of the entire process, slanted towards intermediate and advanced-level worker. Recognizes and treats in a very even-handed way the scripted and improvisational styles of movie-making. At times it confuses itself by trying to cover too much, but it is still highly recommended.

Video Manual
Michael Grotticelli; ASC Press, Hollywood; 0935578145
A superbly concise guide to video. Although intended for professional movie-makers, if you want a small book you can carry around with you, to learn from every page, this should be it. From a fascinating history of television, through lighting basics to recommendations for tape storage, this book covers it all.

Index

Index continued

Index continued

Acknowledgments

Author's acknowledgments

This book owes its existence to the bright energy and inspiration of my publisher Stephanie Jackson, who overcame all objections and dithering on my part to commission it. Many thanks to art editor Simon Murrell, as well as to David and Sylvia Tombesi-Walton, who made sense of my attempts at writing. Also to the entire team at Dorling Kindersley for their superb support at every level.

My thanks go to Avid, Adobe, Fotoware, Imagine Products, Stagetools, TV History, Ulead, and Extensis for technical assistance. Many thanks to Paul Kirkham and all at the Guitar Institute for their help and cooperation. To Jessica, Emma, and Tom, thank you for your welcome and hospitality. And to Louise, Andy, and Emily for their help and tea. Further, my warm thanks to Alice Hunter for arranging the production shoot.

Above all, and as always, my greatest gratitude goes to the one who makes it all possible – my lovely wife Wendy.

Publisher's acknowledgments

Dorling Kindersley would like to thank the following individuals for their contributions to this project: Adèle Hayward for start-up project management, Hilary Bird for compiling the index, and Patrick Mulrey for the artworks.

Sands Publishing Solutions would like to thank Michael Calais for editorial assistance. We would also like to thank Tom Ang for his patience and assistance every step of the way.

Picture credits